IRISH ART

IRISH ART

in the Romanesque Period (1020–1170 A.D.)

FRANÇOISE HENRY

Cornell University Press

ITHACA, NEW YORK

SBN 8014 0526 2

Library of Congress Catalog Card Number: 76–82117

N
6784
.H4413

Text printed in Great Britain by W. & J. Mackay & Co. Ltd, Chatham, Kent
Colour and monochrome plates printed by Les Presses Monastique and L'Imprimerie Darantière, Dijon, France
Monochrome gravure plates printed by L'Imprimerie Braun, Mulhouse, France

Contents

v

ABBREVIATIONS USED IN THE TEXT

B.L.	*Bodleian Library, Oxford*
Br.M.	*British Museum, London*
N.M.D.	*National Museum of Ireland, Dublin*
O.P.W.	*Office of Public Works in Ireland*
R.I.A.	*Royal Irish Academy, Dublin*
St.M.	*Stockholm Museum*
T.C.D.	*Trinity College, Dublin*
V.L.	*Vatican Library*

List of Maps and Drawings

List of Colour Plates

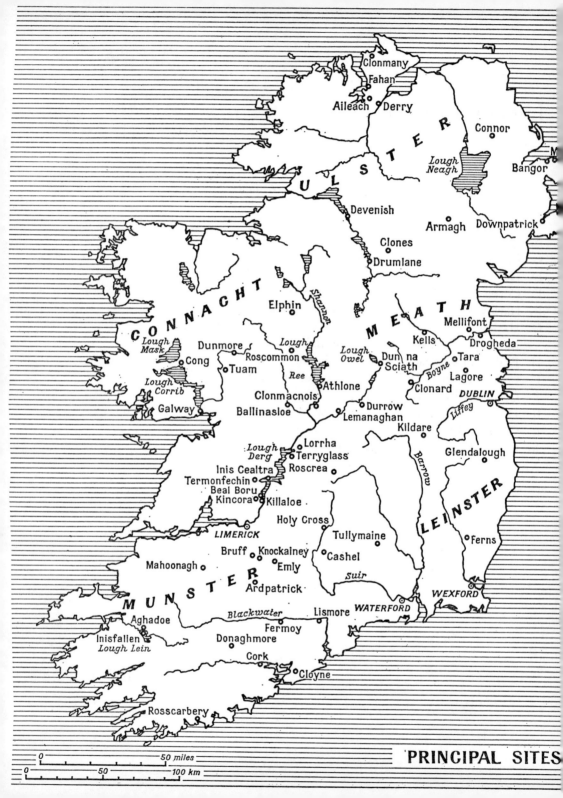

PRINCIPAL SITES

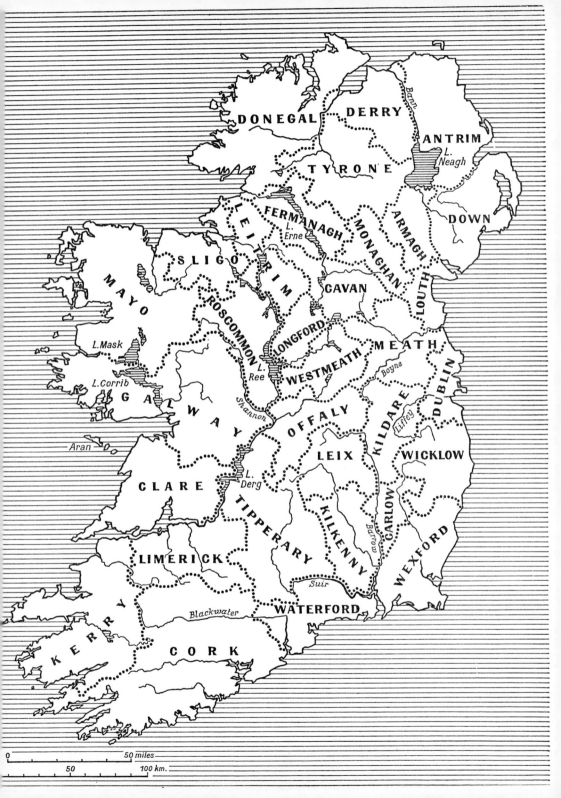

DONEGAL

DERRY

ANTRIM

Bann

TYRONE

L. Neagh

DOWN

LEITRIM

FERMANAGH

L. Erne

MONAGHAN

ARMAGH

LOUTH

SLIGO

CAVAN

MAYO

ROSCOMMON

LONGFORD

L. Ree

WESTMEATH

MEATH

Boyne

L.Mask

L.Corrib

GALWAY

Shannon

OFFALY

KILDARE

Liffey

DUBLIN

Aran

LEIX

WICKLOW

CLARE

L. Derg

KILKENNY

CARLOW

Barrow

WEXFORD

TIPPERARY

LIMERICK

Suir

KERRY

Blackwater

WATERFORD

CORK

0		50 miles
	50	
		100 km.

Preface

UNLIKE THE other two volumes of this series[1], this book owes nothing to the 1940 edition of *Irish Art*. There, the story had been allowed to stop with the Viking invasion. Here it is taken up at the moment when the Vikings were defeated at Clontarf in the early eleventh century, and the subject of this study is the revival of Irish art in the eleventh and twelfth centuries up to the coming of the Normans in 1169–70. To many readers, its subject matter may appear less hackneyed than that of the other volumes, and consequently more unexpected. The eighth and ninth century manuscripts are known to a large public and so are the ninth and tenth century stone crosses. The Book of Kells has a large circle of admirers. But surprise is the usual reaction to the mention of an Irish art of Romanesque time, masterpieces of metalwork of the eleventh and twelfth centuries, or stone crosses with high relief figures. I was a witness myself to the wonder and curiosity aroused at the Barcelona exhibition of Romanesque art a few years ago by the Dysert O'Dea cross and the replicas of the Lismore crozier and the cross of Cong, and I was able to measure thus the degree of obscurity which still surrounds outstanding Irish works of this period. The only monument which has perhaps won some recognition, Cormac's Chapel in Cashel, is the least characteristic, and, when all is analysed, the least Irish of them all. Many other Irish churches, though small in size, and often minute in scale of ornament, show a much more delectable version of Romanesque art, where various imported elements have been cleverly remodelled according to the spirit of Irish ornament.

In metalwork and manuscript decoration, the artists seem, in fact,

[1] F. Henry, *Irish Art in the Early Christian Period to A.D. 800*, London (Methuen), 1965; F. Henry, *Irish Art during the Viking Invasions (800–1020 A.D.)*, London (Methuen), 1967.

deliberately to conform to old traditions. The bright colours of animated initials create on some twelfth century vellum pages an effect very akin to that of the text pages of the Book of Kells. And the sprightly little beasts of the cross of Cong, with their bodies marked by regular hatchings, are of the same race as the animals which cover eighth century metalwork. That resurgence of motifs, after the troubled times of the Viking occupation and the brilliant but slightly foreign episode of the High crosses, is the measure of the vitality and continuity of the tradition from which they spring. It also stresses the remarkable faculty of that art to absorb and adapt new elements, incorporating them quite naturally in its own rhythms.

The conditions of artistic production are probably evolving during this period. Though the monasteries still play an essential part as patrons of art and nurseries of artists, the presence of lay craftsmen can be detected here and there and never before have kings relied so wholeheartedly on art as a source of prestige as they did in the twelfth century. The O'Briens at Killaloe and Limerick, Turlough O'Conor at Roscommon and Tuam, Cormac Mac Carthy in his kingdom of Desmond, and Dermot Mac Murrough in Ferns, play an essential part in the art of the late eleventh and twelfth centuries and loom very large in the story told in these pages.

The sources for the history of this period are infinitely more complex than those of earlier times. The Irish Annals, however, still supply the greatest bulk of our information. For this period, some of them, such as the Annals of Inisfallen, the Annals of Tigernach, the Chronicle of Marianus Scottus, include entries contemporary with the events related. But the later compilations, chiefly the late medieval Annals of Ulster and the seventeenth century Annals of the Four Masters, often fill their gaps and complete their too brief entries. The fragment of Annals known as the Book of Mac Carthy is an invaluable source of information for the events concerning Munster. Some documents now lost can sometimes be apprehended through their analysis or mention in the works of the seventeenth-century historian Geoffrey Keating, of Ware, and even occasionally of the later compiler, Archdall.

It is probably necessary to point out that the word *Scottus* still means

xiv

in that period Irish and not Scottish, a use which only begins to alter towards the end of the twelfth century. The nickname Marianus Scottus, dubbed on two Irishmen who lived in Germany and the name Schotten-kirche given in Germany and Austria to churches all founded by Irish monks are proof enough of it.

The same thanks as appeared in the first and second volumes of this series are due for the preparation of this one to the authorities and Department of Archaeology of University College, Dublin, to the staff of the National Museum, Dublin, and that of the National Monuments Branch of the Office of Public Works. I want to thank more specially the director, Dr Lucas and the Keeper of Irish Antiquities, Dr Raftery, of the National Museum, Dublin; Mr Percy Le Clerc, Inspector of National Monuments; Dr Hayes, for a long time director of the National Library of Ireland; Mr Brendan Ó Ríordáin, in charge of the excavations of the Viking city of Dublin; Père Hyacinthe Laurent, O.P., in the Vatican Library; and Dr Hunt, Keeper of Western Manuscripts in the Bodleian Library.

I want to stress what all the chapter on manuscripts owes to Gene-viève Marsh-Micheli, as it sums up the chief points of a joint study published by us in the *Proceedings of the Royal Irish Academy*, the basis of which was established by researches which she had been making for a long time in various libraries. Many friends in Norway have also helped me in the past in investigating the connections of Scandinavian and Romanesque Irish art, especially Björn Hougen and Charlotte Blind-heim. I hope that they will not be too shocked by the conclusions I have finally come to in this respect. As usual I have been drawing mercilessly on the assistance of some friends who contributed to giving the book its final shape; amongst them will Maureen Murphy, William and Aíne O'Sullivan and Michael Herity, who have been especially helpful, find here my best thanks?

As for the previous volumes, the greatest part of the photographic illustration is due to the admirable work done by Dom Angelico Surchamp, O.S.B., and Mr P. Belzeaux. I want to acknowledge with gratitude the facilities granted to them and to me in the preparation of this book and its illustration by the President and Council of the Royal

Irish Academy; the Board and the Librarian and Vice-provost of Trinity College, Dublin; The Franciscan House of Celtic Studies, Killeany; St Columba's College, Rathfarnham; the Trustees, Department of British Antiquities and Department of Manuscripts of the British Museum; the Bodleian Library; the President and Fellows of Corpus Christi College, Oxford; the Vatican Library; the Museums of Stockholm, Oslo and Copenhagen, the Municipal Libraries of Dijon, Le Mans and Amiens.

The maps are based on maps of the Ordnance Survey of Ireland.

Topographical indications in brackets refer to the Irish counties of which a map is found in the beginning of the book.

The French edition of this book, published by the Editions Zodiaque, appeared in December 1964.

1. Historical Data

THE HISTORICAL background of Irish Romanesque art is not as hazy as that of the earlier periods.[1] Though a general survey of the history of Ireland in the eleventh and twelfth centuries is still lacking, various aspects of the ecclesiastical history of that time have been studied recently and even the political history is beginning to emerge from the dry texts of the Annals. In consequence we need do no more, in many cases, than outline the general trend of an evolution, stressing only the details which are especially important in relation to artistic development.[2]

We left the story at the moment when the battle of Clontarf had just been fought near Dublin in 1014, crushing the ambition of the Scandinavians and forestalling a domination of the country similar to that which, at the same time, left England under the power of the Danish king, Canute. After two centuries of struggle the might of the invaders was broken for ever. Still, this endless state of warfare had been exhausting. In spite of the beneficial ten years of Brian Boru's reign before Clontarf,

[1] *Vol. I*, pp., 17 sqq. and *Vol. II*, pp. 1 sqq.

[2] J. F. Kenney's book, *The Sources for the Early History of Ireland*, vol. I, *Ecclesiastical* (New York, 1929, the only volume published), which is so invaluable for the study of earlier periods, is unfortunately very brief on the eleventh and twelfth centuries. The best general studies are the chapters concerning this period in E. Curtis, *A History of Ireland* (London, 1936 and 1961), and Id., *A History of Medieval Ireland* (London, 2nd ed., 1938), and Part I, chap. II of: A. Gwynn, S.J. – D. F. Gleeson, *A History of the Diocese of Killaloe* (Dublin, 1962), embodying the substance of articles published during the twenty previous years by A. Gwynn in *Irish Ecclesiastical Record, Irish Historical Studies*, etc. (for the detailed bibliography of these, see: F. X. Martin, O.S.A., 'The Historical Writings of Reverend Professor Aubrey Gwynn, S.J.,', in: *Medieval Studies presented to Aubrey Gwynn, S.J.*, ed. by J. A. Watt, J. B. Morrall, F. X. Martin, O.S.A. (Dublin, 1961), pp. 502 sqq.); see also the very useful article of J. Ryan, S.J.; 'The O'Briens in Munster after Clontarf', *North Munster Ant. Journ.*, 1941, pp. 141 sqq., and: B. Ó Cuív, 'Ireland in the Eleventh and Twelfth Centuries', in: *Course of Irish History*, pp. 107 sqq.

the monasteries, the intellectual and artistic backbone of the country, were still deeply shaken by the ceaseless attacks of the tenth century. From 920 to 980 or 990, their history had been marked by repeated plunderings, fires and destructions. Coming as it did shortly after the heavy raids of the middle ninth century, this long period of upheavals had marked the end for several of them, notably the great monastery of Bangor in the north-east. In others, life was gradually coming back to normal. Ruined buildings were re-built, reliquaries re-decorated, schools re-opened. But this was a slow process, hardly completed by the middle of the eleventh century, in those of the great Irish monasteries which had survived.

This may well explain the break which occurs at this time in the hitherto so homogenous development of Irish art. The forty year period during which the Viking incursions practically came to a standstill (875–915) had seen the brilliant achievement of the figured crosses. But the new spate of invasions which took place in 915–20 put a brutal stop to this. The High Cross at Durrow which probably dates c. 930 seems to be the last of the whole series.[1] The later part of the tenth century probably saw very little artistic activity and whatever may have been made at that time has disappeared. To understand this void it suffices to recall a remark of the author of the *War of the Gaedhil and the Gaill*: he tells us that Brian Boru 'sent professors and masters . . . to buy books beyond the sea, and the great ocean; because their writings and their books in every church and in every sanctuary where they were, were burned and thrown into water by the plunderers, from the beginning to the end'.[2]

From the first half of the eleventh century have come to us chiefly restorations of older objects such as the Soiscél Molaise[3] and the British Museum crozier,[4] or a manuscript such as the Southampton Psalter[5] which is in fact hardly more than a slightly decadent replica of an earlier manuscript. Only towards the second half of the century appear illuminated manuscripts in a new style and the first of the great objects of metalwork which are the crowning glory of this period. When, after

[1] *Vol. II*, pp. 139–40. [2] *War*, pp. 138–9. [3] *Vol. II*, p. 120, Pls. 58–9.
[4] See p. 87. [5] *Vol. II*, pp. 106 sqq.

nearly a century and a half of interruption high crosses were carved again, it was in a very different spirit from that which pervaded the tenth century monuments.

There are several indications of a renewed interest in studies in Ireland in the eleventh century and of the fact that it was again becoming a centre of attraction for foreign students. The first is given by the story of a Welshman, Sulien, who was born around 1011.[1] One of his sons, in a long poem which contains most of what is known of the whole family, tells us:

> Exemplo Patrum commotus more legendi
> Ivit ad Hibernos sophia mirabile claros

(as had been wont with his fathers, he came, eager for learning, to the Irish, renowned for their marvellous sapience). In actual fact, gales had first carried him to Scotland where he stayed awhile. But, undaunted by difficulties he finally succeeded in reaching Ireland in 1045 where he spent several years, studying and being trained as a scribe and illuminator. He probably left in 1055 and then set out at Llanbadarn Fawr, on the west coast of Wales, to teach what he had learned. Among his pupils were his four sons, one of whom, Iewan, was responsible for the decoration of the 'Psalter of Ricemarcus'[2] and probably also for that of the *De Trinitate* of St Augustine in the Library of Corpus Christi College, Cambridge (Ms. 199).[3] From these manuscripts we can conclude that it was possible to obtain in Ireland at that time an excellent training in manuscript decoration. What else Sulien learnt there is difficult to guess, but he would hardly have stayed ten years if he had not felt that he benefited by the teaching available.

Other texts show that in 1091 one of the divisions of the town surrounding the monastery of Armagh was called 'the Third of the Saxons' (Trian Saxan). One may assume that it was reserved for the English students in the monastery schools.[4]

[1] H. J. Lawlor, *The Psalter and Martyrology of Ricemarch* (London, 1914), pp. XIII sqq.
[2] Ibid., *Vol. I*, p. 20; *Vol. II*, Pls. 46, 47. [3] *Vol. II*, Pl. P.
[4] *Vol. II*, p. 42.

Different kinds of documents give hints of the teaching given in the great Irish monasteries at that time. L. Bieler and B. Bischoff have shown[1] that two stray leaves bound into a volume of the Phillips collection (Ms. 21162), now in the British Museum (Ms. Egerton 3323) come from Glendalough and can be dated to 1106 by a gloss. They belonged originally, one to a copy of the *De Abaco* of Gerbert of Aurillac, the other to the *Ars Grammatica* attributed to Clemens Scottus. Both these works were current textbooks in the Continental schools of the time, but Gerbert's treatise, of comparatively recent date, indicates clearly that the Irish schools, far from keeping obstinately to ancient authorities, were eagerly welcoming new ones. Adapting themselves to a world where more famous schools than theirs had developed abroad, the Irish were now sending to these new centres of learning some of their students who seem to have sent home detailed reports of the lectures they were attending. This is at any rate the conclusion which can be drawn from the commentary accompanying part of the Gospel text in a manuscript written in Armagh (Br. M. Harley Ms. 1802).[2] Glunz has shown that the text of this commentary seems inspired by a first redaction of the *Maior Glossatura* of Peter the Lombard. The manuscript is clearly dated to 1138,[3] while the *Glossatura* only came out in its final form six or seven years later. Glunz concluded that we have here a copy of notes taken in Paris at the lectures of Peter the Lombard around 1138 and brought back or sent back to Ireland. The key to this mystery is probably to be found in the obit in the Annals of Ulster, at the year 1174, of Flann O'Gorman, who, for twenty years (1154–74) had been head of the Armagh schools and for twenty-one years prior to this (1133–54) had studied 'amongst the Franks and the Saxons'.[4] It seems that he

[1] L. Bieler – B. Bischoff, 'Fragmente zweien frühmittelaterischer Schulbücher aus Glendalough', *Celtica*, 1956, pp. 211 sqq.

[2] Henry – Marsh-Micheli, *Illumination*, pp. 148 sqq.; R. Glunz, *History of the Vulgate in England from Alcuin to Roger Bacon* (Cambridge, 1933), pp. 211 and 328 sqq.

[3] See p. 65.

[4] 'Flann Ua Gorma[i]n, arch-lector of Ard-Macha and of all Ireland, a man learned, observant in divine and human wisdom, after having been a year and twenty learning amongst the Franks and Saxons and twenty years directing the schools of Ireland, died peacefully on the calends of April [March 20], the Wednesday before Easter, in the 70th year of his age' (*A.U.*, 1174).

kept his monastery in touch with the progress of his studies.

Besides this teaching of universal type, the Irish schools obviously devoted a lot of care to the study and gathering of texts in Irish. There is every reason to think that collections of Irish texts had been made prior to the period we are at present studying, but none has survived, and the eagerness to preserve what had escaped from the frightful holocausts of the ninth and tenth centuries explains only too well the appearance of great digests like the Book of the Dun Cow written in Clonmacnois around 1100 (Dublin, R.I.A., Ms. 23. E. 25), the slightly later Rawlinson Ms. B. 502 (Oxford, Bodleian Library), which may have originated in Leinster, and the Book of Leinster written by an Abbot of Terryglass in the middle of the twelfth century.[1] In many cases, the texts they contain – epics, poems, genealogies, etc. – have been not only copied but re-modelled and re-written. So that they are the product of an intense literary activity which is manifested also by the writing, in the late eleventh or early twelfth century of the *War of the Gaedhil and the Gaill*[2] – a historical work of great merit, in spite of its gongoresque tone – and by the production of annals such as those compiled in Clonmacnois in the eleventh century by Tigernach and his collaborators[3] or the Annals of Inisfallen, probably started in Emly.[4] On the whole, one gets the impression of an intellectual life partly oriented towards the past and the preservation of traditional lore, and partly directed eagerly towards the most daring novelties of contemporary thought.

These eleventh- and twelfth-century monasteries have sometimes been described as a decaying institution. Nothing is further from the truth. There is every reason to think that they came back to life after the disasters of the tenth century and that most of them were flourishing again towards the middle of the eleventh century. This, however, does

[1] See chapter on Manuscripts.

[2] The ascription of the book of Mac Liag, Bard of Brian Boru is unlikely (see: *War*, pp. XX sqq.). The book is now generally considered as being slightly more recent than the time of Brian Boru.

[3] E. Mac Neill, 'The Authorship and Structure of the Annals of Tigernach', *Eriu*, 1913–14, pp. 30 sqq.

[4] A. Gwynn, 'Were the "Annals of Innisfallen" written at Killaloe?', *North Munster A.J.*, 1958, pp. 20 sqq.

not apply to all the small, struggling foundations devoid of powerful protectors. It has been rightly pointed out[1] that the obituaries of professors (fer léginn) are at that time infinitely more numerous for a few important monasteries, Armagh, Lismore, Clonmacnois, Clonard, Kildare, Glendalough, than for any others, and that there is no trace of the scattering of teaching which is one of the striking features of Irish monasticism in the seventh and eighth centuries. In fact, towards the end of the twelfth century, teaching becomes more and more centralized, until in 1162 a synod gathered at Clane decreed that nobody could teach in an Irish monastery unless they had been through the Armagh schools.[2] The increased burden put thus on the Armagh staff is probably the reason why king Rory O'Conor granted 'a gift of twenty cows a year' to the professor who, in Armagh, was teaching literature to the Irish and Scottish students.[3]

None the less, abuses had crept into the organization of the Irish Church in the course of the tenth century. St Malachy, for example, described with vehement indignation to St Bernard the powerful place taken in Armagh by lay abbots. Quite obviously, some families jealously kept the administration of a monastery in their hands for generations – the O'Duffys in Connacht, the Clan Sinaich in Armagh. To judge the exact import and meaning of such facts it will be necessary to wait until more detailed studies have been made of the subject. In any case there was nothing more than the usual type of abuse which occured periodically in medieval monasteries, and the most remarkable fact may still be the violent protests which it raised. As for the other 'irregularities' mentioned by Lanfranc and Anselm when writing from Canterbury to Ireland,[4] they are probably partly explained by the abysmal ignorance of things Irish which is evident in the letters of both of them. In some cases there may also have been misunderstandings arising from the application of old Irish laws which had survived centuries of Christianity.

[1] Lawlor, *Ricemarch*, I, Introduction; K. Hughes, 'The Distribution of Irish Scriptoria and Centres of Learning from 730 to 1111', in: *Studies in the Early British Church* (Cambridge, 1958).
[2] *A.F.M.*, 1162, *A.U.*, 1162. [3] *A.F.M.*, 1169.
[4] Kenny, *Sources*, pp. 757 sqq.; A. Gwynn, S.J., 'Lanfranc and the Irish Church' *I.E.R.*, LIX, pp. 1 sqq.

On one important point, however, the Irish Church was bewildering enough for any observer from outside used to an ecclesiastical organization fashioned on the Roman administrative structure. We have seen that, from a very early time, monasteries constituted the backbone of the Irish Church. It showed no trace of territorial dioceses, nor of organized hierarchy.[1] Though Armagh had claimed a supremacy based on its foundation by St Patrick, it had established it by prestige methods similar to those used by the high king to manifest his power. Like his own, Armagh's authority was always liable to be called in question. Besides, it is hard to define the relations between Armagh and powerful groups of monasteries such as those founded by St Columba and governed by his successor (comarb), first from Iona, then from Kells, and finally from Derry. At the head of each monastery was an abbot whose authority derived from the fact that he was the successor of a saint in whose name he governed. In the monastery there was also a bishop who cut at first a rather poor figure, but whose importance grew slowly. He was there to fulfil the duties of which a priest is not capable and to administer those of the sacraments which are his prerogative, but he took obviously no part in the administration of the monastery nor of its surrounding territory. This system worked in Ireland for centuries without appearing anomalous to the Irish. When they came to evangelize England, they adapted themselves to conditions that were different and they administered territorial dioceses, without these new ways having any consequences for the home organization. Amongst the various reproaches hurled at the Irish at the Synod of Whitby in the seventh century, it is remarkable that this point was not raised.

Only, it seems, towards the middle of the eleventh century did the Irish begin to realize acutely the strangeness of their ecclesiastical organization and this probably to a great extent as a consequence of comparisons with the Scandinavian cities on Irish soil which were playing an important role in Irish life. Though the domination of the 'Foreigners' had ceased, they had nevertheless stayed in the trading posts founded during the struggle. They received no more reinforcements from Scandinavia, their links with their home-countries were

[1] K. Hughes, *The Church in Early Irish Society* (London, 1966).

7

nearly severed, but their towns were still prosperous: Dublin, where they had settled in 841, and Limerick, Waterford, Wexford, established later. These cities had not become completely integrated into the life of the country, and in the course of the eleventh and twelfth centuries the Annals go on mentioning occasionally 'the Foreigners of Dublin', 'the Foreigners of Limerick'. The Latin *Life* of St Kevin, written in Glendalough at that time says of Dublin: 'It is a powerful and warlike city of which the inhabitants . . . are expert in the management of fleets'.[1] So these towns represented an element which was out of tune with Irish life and its main traditions. When they became Christian, they did not try to integrate themselves into the local monastic system, but conformed with the hierarchical framework which was normal outside Ireland.

An episcopal see was founded in Dublin before 1036, towards the end of the reign of the king of Dublin, Sitric, who, as the son of a Leinster princess may well have been brought up as a Christian, and whose father, Olav Cuaran, had been baptised and had ended his days as a penitent in Iona. The first bishop of Dublin, Dunan (or Donatus)[2] was probably consecrated in Canterbury as were his successors after him. He built in the centre of the city,[3] on a patch of land given by Sitric, a cathedral dedicated to the Holy Trinity which may have been only a wooden construction. There were two novelties foreshadowing changes: the setting up of a territorial diocese, however small, and the Canterbury consecration. Canterbury may have been chosen partly because it was the nearest archiepiscopal see, but perhaps even more because it was in a country governed at that time by the Scandinavian king, Canute. Dunan died in 1074. Meanwhile, William the Conqueror had landed in England and Lanfranc had become archbishop of Canterbury and was trying by all possible means to extend the authority of his see. So, when the people of Dublin sent Dunan's successor, Gilla Pádraig[4] to be consecrated in

[1] Plummer, *VV.SS.Hib.*, I, p. 249: 'et ipsa civitas potens et belligera est, in qua semper habitant viri asperrimi in preliis et peritissimi in classibus'.

[2] For the history of these bishops, see: A. Gwynn, S.J., 'The first Bishops of Dublin', *Repertorium Novum*, 1955, pp. 1 sqq.

[3] See plan *Vol. II*, Fig. 2.

[4] See: A. Gwynn, op. cit., and: Ibid., *The Writings of Bishop Patrick, 1074–1084* (Dublin, 1955).

8

England, he was made to swear obedience to the archbishop as one of his suffragan bishops. With only slight variations his successors, Donngus (1084–95) and Samuel (1095–1121) had to conform to the same oath. The same thing happened to the first bishop of Waterford in 1096. In the twelfth century, however, there is a marked change of attitude. In 1107, the first bishop of Limerick, Gilla espuig (or Gillebertus), was consecrated in Ireland and in 1121 the consecration in England of Samuel's successor, Gregory, provoked such violent reaction that he was temporarily expelled from Dublin.

By that time the whole situation had altered completely. The idea that the Irish Church ought to be organized like the rest of Christendom was making headway, especially in the territories of the south-west administered by the O'Briens, their correspondence with St Anselm who had succeeded Lanfranc, a journey on the Continent made by Gillebertus sometime before his accession to the see of Limerick and perhaps other events unknown to us; everything was paving the way for a change. Finally Gillebertus' treatise *De Statu Ecclesiae*[1] gave shape and expression to the latent tendencies. It summed up graphically the principles of ecclesiastical hierarchy by a diagram showing the pyramidal structure constituted by primate, archbishops, bishops and priests. Gillebertus explained that there must be an archbishop-primate at the head of a country's hierarchy with, under him, at least one other archbishop; that an archbishop must get the *pallium* from Rome; that all ecclesiastics must submit to the jurisdiction of the bishop in his diocese, including the abbots of the monasteries which happened to be in that diocese. Nothing could have gone more abruptly against Irish custom than this denial of the all-powerful rights of the abbots, so that there were some violent reactions. But they soon calmed down and already on the very threshold of the century a dramatic gesture shows an attempt at conforming with the system expounded by Gillebertus. Armagh was the obvious seat of the primate, but then where was the seat of the other archbishop, under its jurisdiction, to be situated? King Murtough O'Brien answered the question by granting Cashel, the ancient Munster capital city 'to God and to Patrick'.[2]

[1] Kenney, *Sources*, pp. 763–4.
[2] 'To God and to Patrick' is given only by Keating. The most detailed account

A few years later, in 1110 or 1111, Gillebertus, who, by then, had become pontifical legate in Ireland, called a synod at Rathbreasail.[1] There, the northern half of Ireland was divided into twelve dioceses depending on Armagh (five for Ulster, five for Connacht, two for Meath) and the southern half had seven dioceses in Munster and five in Leinster, all suffragan sees of Cashel. The seventeenth-century historian Keating has preserved for us the list and the limits of the dioceses, which he found in the Book of Clonenagh, now lost. It makes strange reading, and it is surprising that amongst the monasteries just transformed into episcopal sees important ones such as Clonmacnois and Kells are omitted.[2] Between the lines one can read disagreements which may have been short-lived, as the list was soon modified, making place for Clonmacnois.

In 1152, another synod was called at Kells which remodelled the Rathbreasail list. The number of archbishoprics was brought to four; to Armagh and Cashel were added Tuam and Dublin. Dublin had been left out of the Rathbreasail scheme because of its links with Canterbury. Now, the Viking stronghold, hardly a century Christian, was put on the same level as Cashel, the old Munster royal seat, and became in fact the archbishopric of Leinster. As for Tuam, its importance derived entirely from the power of the Connacht king, Turlough O'Conor. This division

is found in *A.C.*, 1100: 'There was an assembly of all the subjects of Ireland at Cashell in the presence of King Mortaugh, and in the presence of Downan Ua Dunain, archbushopp and Elder of Ireland, with the clergy of the kingdome, where the king of his meer motion and free will graunted to the Church and all devout members thereof such a grant as none of his predecessors the kings of Ireland ever graunted to the Church before, which was his cheefest seat, court and town of Cashell,[1] to be held in common by all spirituall men and women in perpetuum to them and their successors'. ([1] 'Cashell – the king of Cashel after that transferred his residence to Limerick. His palace stood on the site now occupied by St Mary's Cathedral.') A briefer account is given in *A.F.M.*, 1101. See: Kenney, *Sources*, p. 765, note 45, Ussher, *Whole Works*, IV, p. 503, p. 110, Lawlor, *Vit Mal.*, pp. XXXV–VI.

[1] The exact location of Rathbreasail is not known. It is assumed to be in the Tipperary plain. See: Gwynn-Gleeson, *Killaloe*, p. 117.
[2] For Keating's text on the subject, see: J. Mac Erlean, S.J., 'Synod of Ráith Breasail, Boundaries of the Dioceses of Ireland (A.D. 1110 or 1118)', *Archivium Hibernicum*, 1914, pp. 1 sqq.

reflected also the near disappearance of the kingdom of Meath and the complete obliteration of its prestige, as each of the old kingdoms except Meath, had its archbishop. The four *pallia* were probably given at Mellifont by Cardinal Paparo who was sent for this purpose by Pope Eugen III.[1] However, this synod, like the preceding one, merely legalized arrangements which had been already in the making for some time. From the beginning of the century, one can feel the growing ambition of the bishops of Dublin. Around 1108, St Anselm rebuked Bishop Samuel for having a cross carried before him as if he was an archbishop.[2] In 1123, Turlough O'Conor had a metal cross made for the 'bishop of Connacht', Domnall O'Duffy, who is called by the Four Masters in his obituary 'aird espucc Connacht', which can be translated either as 'archbishop of Connacht' or 'principal bishop of Connacht'. Given the precedent of Dublin it is hard to dismiss the feeling that Turlough, when commissioning the 'Cross of Cong' did not only mean it to be a reliquary[3] but also a token of Connacht's right to an archbishopric.

About the same time, monastic houses with Continental rules started appearing here and there in Ireland. There were a few Benedictine abbeys and priories:[4] at Fermoy (Cork; 1109), at Erinagh (Down; 1127), and, on the north bank of the Liffey, just across the river from Dublin, St Mary's Abbey.[5] The Irish Benedictine Abbey of Würzburg had a daughter-house at Rosscarbery (Cork).[6] The Canons Regular of St Augustine had monasteries in Ireland from an early date in the twelfth century.[7] It is generally assumed, though without definite proof,

[1] A. Gwynn, S.J., 'The Centenary of the Synod of Kells', *I.E.R.*, 1952, pp. 161 sqq., 250 sqq.

[2] Gwynn, *The First Bishops of Dublin*, pp. 18–9.

[3] See p. 107.

[4] Dom Hubert J. de Varebeke, O.S.B., 'The Benedictines in Medieval Ireland', *J.R.S.A.I.*, 1950, pp. 92 sqq.; H. G. Richardson, 'Some Norman Monastic Foundations in Ireland', in: *Medieval Studies A. Gwynn*, pp. 29 sqq.

[5] A. Gwynn, S.J., 'The Origin of St Mary's Abbey, Dublin', *J.R.S.A.I.*, 1949, pp. 110 sqq. The Abbey of Holy Cross (Tipperary), perhaps founded in 1109 as a Benedictine abbey, may be added to the list; see: P. Power, 'The Cistercian Abbeys of Munster', *J. Cork H.A.S.*, 1938, pp. 1 sqq. and Dugdale, *Mon. Angl.*, II, p. 1035.

[6] Archdall, pp. 76–7.

[7] P. J. Dunning, 'The Arrosian Order in Medieval Ireland', *I.H.S.*, 1945, pp. 297 sqq.

that they ran the priory of SS. Peter and Paul in Armagh consecrated in 1126. In any case, Cormac Mac Carthy founded for them before his death in 1138 an abbey in Cork dedicated to St John[1] and probably a few years before in Cong (Mayo) Turlough had restored an old foundation recently destroyed and settled them in it.[2] St Malachy did no more than give a wider scope to these Augustinian establishments, while his foundation of Mellifont in 1142 was the starting point of the swarming of Cistercian monks into a number of houses scattered through the whole country.[3]

All these changes, whether ecclesiastical re-shuffling or new foundations, are due chiefly to the efforts of a few outstanding prelates: Gillebertus of Limerick, Malchus of Waterford, Cellach (or Celsus), archbishop of Armagh, and his successor, St Malachy (Máel Máedoc Ua Morgair).

Of Gillebertus little is known except some of his writings,[4] though one can guess that his influence was tremendous, especially after he became legate. He had travelled abroad and seems to have been in Rouen, at the same time as Anselm, when William the Conqueror died (1087). His *De Statu Ecclesiae* borrows heavily from foreign sources and introduces some notions highly disconcerting for Irish readers. What, for example were they to make of the comparisons of the various levels of the ecclesiastical hierarchy with the secular Continental hierarchy of knight, count, duke, king? Duke, count or knight were words without significance for them, while kings in Ireland were too many to be counted.

Celsus[5] belonged to one of those families of lay abbots already mentioned, the Ua Sinaigh of which seven members had occupied the see of Armagh before him, probably without ecclesiastical consecration. He, unlike his predecessors, was conscious of the abnormality of his position

[1] See p. 157.

[2] This can be deduced from the Charter of Dermot Mac Carthy relating to the foundation of Gill Abbey in Cork (see above reference).

[3] See pp. 185 sqq.

[4] See pp. 9–10; Kenney, *Sources*, p. 763 (No. 651); his death is mentioned in the *Chr. Sc.*, 1145.

[5] Lawlor, *Vit. Mal.*, pp. XXXIV sqq.

and he had hardly succeeded his great-uncle, in 1105, when he got himself ordained. He was then consecrated archbishop, probably during a stay in Munster.

Beside these shadowy figures which can be apprehended only through a few of their actions mentioned here and there, Malachy stands out in bold relief which may unjustly throw into shadow those of his contemporaries who lacked the good fortune to have as affectionate biographer the greatest saint and one of the best writers of his time.[1] Malachy's meeting with St Bernard was one of these rare instants when two souls belonging to the same spiritual family acknowledge each other. The echo of this fraternal link which led eventually to their sharing the same tomb can be felt in the pages of the *Life* which Bernard, shortly after having assisted Malachy in his dying moments, wrote from the memory of what his friend had told him and from what he gathered from those of his brethren whom he was able to interview. We can then see him as if he was standing in front of us, the man 'who passed without tumult through all the tumults', who was 'courteous or else humble and full of reserve', and whose rare smiles were 'an expression of affection, or drew affection to him'.[2] Indeed if it had not been for his journey and that momentous meeting, he would only have been another name casually mentioned in the Annals, while all we know of him helps us to guess at the stature of these other hardly defined figures which surround him.

He was born in 1095, the son of a professor of the Armagh schools, and he came probably from one of the great families of the north of Ireland. He fell under the influence of Imar O'Hagan, the founder of the priory of SS. Peter and Paul. Then he went to Lismore to study with Malchus, the bishop of Waterford-Lismore who had been a monk in the

[1] St Bernard, *Vita S. Malachiae episc.*, *AA.SS.*, Nov. XII; J. Mabillon, *Sancti Bernardi Abbatis Claraevallensis Opera Omnia* (1839), I, 2, cols. 1465–1524; *Pat. Lat.*, CLXXXII, 1073–1118. Trad. and comments: H. J. Lawlor, *St Bernard of Clairvaux's Life of St Malachy of Armagh* (London, 1920) (quot. as: Lawlor, *Vit. Mal.*).

[2] 'Sine turbatione versabatur in turbis', 'Aspectus eius aut officiosus, aut demissus, et cohibitus intra se', 'Risus aut indicans charitatis, aut provocans, rarum tamen et ipse' (*Sermo S. Bernardi abbatis in festivitate Sancti Malachiae*). See also Lawlor, *Vit. Mal.*, 43.

13

Benedictine monastery attached to the cathedral of Winchester – another of these saintly figures who can be known only through his wide-spread influence. During one of Malachy's visits to Lismore he was entrusted with the care of a high-born penitent, the king of Desmond, Cormac Mac Carthy, who, when defeated by Turlough O'Conor, came to receive 'a pilgrim's staff' in Lismore. About this time Malachy found himself in a position to revive a celebrated monastery, Bangor, on the north-east coast of Ireland, which had been destroyed by the Vikings a good number of years previously. Having been granted the desolate site of the monastery, he took with him ten monks from Armagh; they built a wooden church and lived in a welcome solitude. At the synod of Rathbreasail, a diocese had been established in this neighbourhood with a see at Connor (Antrim). Around 1124, Malachy was persuaded to take up its administration. But while he was bishop of Connor he seems to have still resided at Bangor. This is all the more remarkable as it meant that he was in fact conforming with the Irish tradition which expected a territory to be administered by the abbot of its chief monastery. The diocese's boundaries corresponded roughly with the country which had been governed by the abbot of Bangor. St Bernard, who obviously felt uneasy about this, explains it by saying that Bangor was 'near the city' (Connor), while in reality they are more than twenty miles apart. One may guess that Malachy did not want to abandon his recently founded monastery and also felt that he was expected by the people themselves to direct the new diocese from the old monastery. It was a miserable population that surrounded him and he may have wanted to humour it; the disappearance of Bangor had left it completely deprived of spiritual ministration and it had fallen into a desperate state of moral anarchy. Malachy, touring his diocese in all directions on foot and undaunted by difficulties, put his strength into rescuing them and seems to have succeeded fairly well in the span of three years. Unfortunately Bangor was destroyed around 1127 by Conor Mac Loughlin, king of the northern part of Ireland. Malachy had to flee 'with a crowd of disciples' – a hundred and twenty are mentioned. He went to his friend of Lismore days, Cormac Mac Carthy, who had regained the throne of Desmond, the southern part of Munster, and whose usual residences seem to have

14

been the old 'forts' of Rath Aíne, Bruree, Bruff, etc.[1] some distance
south of Limerick. The *Monasterium ibracense* then built by Malachy[2]
was probably located in this neighbourhood. It may have been at Emly
(Imlach Ibuir), only 4 or 5 miles distant from Rath Aíne, or at Tully-
brac, near Bruff.[3] In any case it was not far from the royal residences, as
St Bernard tells us that the king was constantly visiting it 'in attire a
king, but in mind a disciple of Malachy'.[4] He had cattle brought there,
and gave gold and silver to pay for the buildings. Malachy, liberated
from the weight of episcopal duties, devoted himself entirely to monastic
life, taking his turn in all the labours of the brethren. St Bernard does
not mention any more than he did for Bangor the rule followed in the
monastery. It may have been that of the Canons Regular of St Augustine,
possibly introduced in Armagh by Malachy's master, Imar, but there is
no proof of it and it remains quite possible that the monks did in fact
follow one of the old Irish rules, perhaps with especial emphasis on
psalmody and regular offices.

He had been there for only two years when died, on the neighbouring
hill of Ardpatrick, administrative centre of the possessions of Armagh
in Munster, Celsus, the archbishop of Armagh. He bequeathed his charge
to Malachy. This last wish failed, however, to foil the intrigues of Clan
Sinaigh which had held the abbatial chair of Armagh for so long, as, in
spite of his appointment of Malachy one of the members of the Clan,
Murtough, became 'successor of Patrick' on the morrow of Celsus'
funeral.[5]

Malachy stayed three years more in his monastery, but finally he
yielded to the entreaties of his old master, Malchus of Lismore and to
those of Gillebertus, and he tried to break the system of hereditary

[1] See p. 29.

[2] Lawlor, *Vit. Mal.*, 18; Lawlor (p. 40, note 4) accepts the identification of
'ibracense' with the barony of Iveragh in Kerry, first proposed by Lanigan (*Ecclesi-
astical History of Ireland*, IV, p. 92, note 73) and often repeated since. This seems
inacceptable in the general context, as quite obviously the monastery was very close
to the place where Cormac lived, close also probably to Ardpatrick where Celsus died.

[3] Where a graveyard with some medieval remains may mark the site of an old
foundation.

[4] Lawlor, *Vit. Mal.*, p. 41.

[5] *A.U.*, 1129.

successions. He managed to do it only after great trials and, probably, attempts on his life. He spent three years in Armagh; then, when he felt that order was well established, he resigned the primacy in favour of Gilla Mac Liag, abbot of Derry (1137). He went back to Bangor but not this time as bishop of Connor, as he had already provided for that see, but of the neighbouring diocese of Down.

Some two years later he left Ireland to go and ask the pope for the *pallia* of the two Irish archbishops. St Bernard tells of him travelling by way of Scotland and York. He seems to have started by travelling on foot, as was his custom. One may wonder what were the halts on this journey. If he called at Melrose (Berwickshire),[1] of old, the usual resting-place for the Irish on their way to Lindisfarne, he found there a recently settled group of Cistercian monks from Rievaulx, the great Cistercian monastery founded in 1128, which he is most likely to have visited also,[2] as it lies on the old road from Durham to York. This was probably his first contact with the monks from Citeaux. We are told in any case that in York he met the prior of the Augustinian abbey of Kirkham who pressed on him his horse to alleviate the hardships of the long journey.[3] Like many other travellers of that time he probably crossed the Channel from Dover to the ancient harbour of Wissant, near Calais. He went then towards Arras and stopped at the Augustinian monastery of Arrouaise,[4] whose rule he asked to have copied with a view to introducing it into the chapters of Irish cathedrals.

By way of Bar-sur-Aube he arrived at Clairvaux where, for the first time, he met St Bernard who has given us in a few sentences his memories of this visit: 'by the sight of him and by his word I was refreshed'; 'so, accepting the place and us and gathering us into his inmost heart, he bade us farewell and departed'.[5]

The impact on Malachy of this encounter was such that, on his arrival in Rome, he begged Innocent II to allow him to settle in Clairvaux. Far from seeing his dream coming true, however, he was made pontifical

[1] 'Old' Melrose, of course, in a curve of the Tweed; the present site was only occupied some years later; see Vol. I, p. 83.

[2] Sir Charles Peers, *Rievaulx Abbey, Yorkshire* (London, 1948).

[3] Lawlor, *Vit. Mal.*, 36. [4] See: Dunning, op. cit. [5] Lawlor, *Vit. Mal.*, 37.

legate in Ireland in place of Gillebertus, obliged by old age to retire. The pope agreed to the establishment of an archiepiscopal see at Cashel but said that a synod had to be assembled to make formal application for the *pallia*, so Malachy went back to Ireland, leaving on his way four of his companions to be trained at Clairvaux and perhaps some others at Arrouaise.[1]

Back in Ireland, he exercised his legatine functions with great zeal. But he also laboured towards the introduction into Ireland of the monastic orders with which he had become acquainted on his travels. In 1142 the monks he had left in Clairvaux arrived in Ireland together with a few French monks sent to him by St Bernard and Mellifont was founded a short distance from the old monastery of Monasterboice. A contemporary text declares that he founded 'forty-four abbeys of monks, canons and nuns'.[2]

He waited for a favourable occasion to settle the question of the Irish archbishoprics. In 1148, having heard that Eugen III, the Cistercian pope and ex-pupil of St Bernard, was in France, he called together a synod which entrusted him with a request for the *pallia*. He again crossed to the south of Scotland, where he founded a monastery, and then set his foot on the now familiar road to Clairvaux where, two or three days after his arrival he fell fatally ill.

This singularly attractive figure deserved a detailed study, in so far as he was typical of the contradictions so manifest amongst those who laboured for Irish ecclesiastical reform. It has become too much of a habit to see in Malachy the man who introduced into Ireland the Cistercians and, with them, foreign ways, a Continental type of architecture and a contemptuous attitude towards the old traditions of Irish art. This is hardly true. On the one hand, Continental art and Continental habits had been seeping into Ireland for a good while. On the other, nothing can be more Irish than the decoration of the manuscripts made for Malachy and in some of the monasteries he had founded.[3] A scrutiny of his ways and actions reveals in fact how deeply he was steeped in

[1] Lawlor, *Vit. Mal.*, 39 and 35.

[2] A. Wagner, *Visio Tugdali Lateinisch und Altdeutsch* (Erlangen, 1882).

[3] See pp. 67 sqq. F. Henry, 'Irish Cistercian Monasteries and their carved Decoration', *Apollo*, 1966, pp. 260 sqq.

17

Irish tradition. Much has been said, for example about his 'buying' of the 'staff of Jesus', the venerated relic of Armagh;[1] the truth of the matter is probably that the candidate to the abbacy of Armagh had to make an offering to obtain the reliquary-crozier which was one of the insignia of his office, and Malachy simply conformed to tradition. He may have conformed to it in more ways than we know. We have seen him governing from a monastery one diocese and then another – a blatant return to the old Celtic ways. His reforms have probably more bearing on moral topics than on administrative points, and the reason why he was so totally swept off his feet by his first contact with Clairvaux is that all his life he had been first and foremost a contemplative pushed against his will into active life and that in Clairvaux he found what seemed to him the perfection of contemplative life.

Another of these prelates whose life is known in some detail, Lorcan or Laurence O'Toole, gives the same impression of an essentially contemplative mind wrenched from its seclusion in order to cope with some of the greatest upheavals which tore at the life of Ireland in the twelfth century. He was born in 1128, the son of a Leinster chieftain.[2] When still a small child, according to a well-established custom, he was sent as a hostage to the court of the king of Leinster, Dermot Mac Murrough. He met with remarkably harsh treatment, even for the ways of the time. When his father realized that he was practically left to starve, he threatened the king, who finally agreed to send the child to the monastery of Glendalough, where his father could collect him. But Laurence took immediately to monastic life and asked his father to leave him in Glendalough. About 1153 he became abbot of the monastery. Then in 1162 he was made archbishop of Dublin as a successor to Gregory. His predecessor's consecration in Canterbury had been the origin of riots in the Scandinavian city; there were no such difficulties about Lorcan who was consecrated by the primate of Armagh, Gilla Mac Liag. His life in Dublin was ruled by the same principles of selflessness as had been his

[1] *A.F.M.*, 1135: 'Maelmaedhog Ua Morgair, successor of Patrick, purchased (*do chendach*) the Bachall-Isa and took it from its cave on the 7th day of the month of July'.

[2] His *Life*, written in Latin in the thirteenth century by a canon of Eu, has been published by C. Plummer: 'Vie et Miracles de Saint Laurent, archevêque de Dublin', *An. Boll.*, 1914, pp. 121 sqq.

more retired existence in Glendalough. Taking up one of St Malachy's ideas, he established in his cathedral Canons Regular of St Augustine following the rule of Arrouaise, and he lived amongst them. In many ways he still clung closely to Irish tradition, for example when he spent Lent in St Kevin's cave at Glendalough, above the upper lake, where his nephew, now abbot of the monastery, used to bring him messages sent from Dublin and take back his answers.

He seems to have been conscious of the threat of a Norman invasion. When it came, he found himself, as archbishop of Dublin, in the thick of the fight. His efforts tended towards some kind of pacific accord between the high king and the invaders. This finally brought him over to England first and then to France, in his efforts to meet Henry II and make a settlement between him and the Árd-rí, Rory O'Conor. Worn out by his labours and his travels, he collapsed at Eu, on the Normandy coast, where he died in 1172.[1]

These two striking saintly figures give the measure of the spiritual resources still to be found in Ireland at that time. The remarkable spreading of Irish monasteries on the Continent and especially in Germany, gives also the impression that the monasteries of Ireland must have had plenty of vitality to be able to swarm abroad in this way. The very ascetic colour of the life of those of the Irish monks abroad about which we know something definite, comes to reinforce this impression.

These monasteries were in regions which earlier had seen the labours of missionaries educated in Ireland. The monasteries of Willibrord and his companions in Frisia, the tomb of St Kilian at Würzburg, remained as witnesses of these ancient activities.[2] From the tenth century on, the Ottonian emperors renewed the foundation charters of several monasteries in the valleys of the Maas, the Rhine and the Danube, on the express condition that abbots and monks, whenever possible, would be Irish.[3] This is the case for the monastery at Waulsort, near Dinant, and for that of St Symphorian in Metz. In 975, the monastery of St Martin of

[1] His relics are still preserved in the Collegiate church at Eu. His twelfth century tomb, with a recumbent effigy, was mutilated at the Revolution, most of the face being sliced off. It was restored later and is kept in the crypt of the church.

[2] See Vol. I, p. 39. [3] Kenney, *Sources*, pp. 608 sqq.

19

Cologne was given over to the Irish and in the eleventh century that of St Martin of Mainz seems to have had a majority of Irish monks.[1] There are in the Irish Annals for that time mentions of Irishmen who died in Cologne, obviously in St Martin's monastery.[2] Amongst them there is an abbot of Dunshaughlin[3] and a dethroned king of Leinster.[4] In the Abbey of Fulda in the eleventh century lived the monk Anmchad, who had come from the Irish monastery of Inis Cealtra[5] and somewhat later Moel Brigte, a monk from the north of Ireland who went later to St Martin of Mainz and who is known under the name of Marianus Scottus of Mainz.[6]

Ratisbon became also an Irish centre.[7] A small Irish community was established there in 1076 in the shadow of the convent of Benedictine nuns of Obermunster. It was known as Weih-Sankt-Peter and it was the abode, amongst others, of Muiredach Mac Robertaig, a monk from the north of Ireland who came to Germany on his way to Rome and remained there. He is known as Marianus Scottus of Ratisbon. A few years later, Ratisbon saw the foundation of a much more important Irish monastery, that of St James, better known as the Schottenkloster (the monastery of the Scotti or Irish). It became the mother-house of a whole string of Irish monasteries in Germany and Austria: Würzburg, founded in 1134, Nürnberg in 1140, Constanz in 1142, Vienna in 1159, etc.

The monastery of St James of Ratisbon was built between 1111 and 1122 by Abbot Dionysius who came from the south of Ireland. In 1133, he was succeeded by Abbot Christian Mac Carthy, a relation of the king of Desmond, Cormac Mac Carthy. He came to Ireland in 1134 or 1135,

[1] This can be deduced from episodes in the life of Marianus Scottus of Mainz.
[2] See the quotations in Henry – Marsh-Micheli, *Illumination*, p. 124, note 3.
[3] *A.F.M.*, 1027. [4] Id., 1052.
[5] Henry – Marsh-Micheli, *Illumination*, p. 118. [6] Id., pp. 126 sqq.
[7] The literature on the Irish monasteries in Germany is extensive. See references in: F. O'Brien, 'The Expansion of Irish Christianity to 1200', *I.H.S.*, 1944, pp. 131 sqq. Also: W. Wattenbach, 'Die Congregation der Schottenklöster in Deutschlands', *Zeitschr. für Christliche Archäology und Kunst*, 1856, pp. 21 sqq. and 48 sqq. (a translation of the first part with notes by Reeves has appeared in *U.J.A.*, 1859, pp. 227 sqq.); J. H. Hogan, 'The Irish Monasteries of Ratisbon', *I.E.R.*, 1894; J. P. Fuhrmann, *Irish Medieval Monasteries on the Continent* (Washington, 1927); D. Binchy, 'The Irish Benedictine Congregation in Medieval Germany', *Studies*, 1929, pp. 194 sqq.; A. Gwynn, S.J., 'Some notes on the History of the Irish and Scottish Benedictine Monasteries in Germany'. *Innes Review*, 1954, pp. 5 sqq.

perhaps on the occasion of the consecration of the chapel built by Cormac in Cashel. He came again at a later date and died in Cashel where he was buried.

Some of these Continental monasteries had been founded as resting places for Irish pilgrims on their way to Rome or the Holy Land. Pilgrimages from Ireland were numerous during the eleventh century, either by way of Scotland, the Low Countries and Germany, or through France, even sometimes probably by sea all the way to the south-west coast of France. The Annals relate six or seven journeys of important persons, starting with that of Sitric, king of Dublin, and of a prince of Meath in 1028.[1] In 1063 or 1064 Donagh O'Brien, king of Munster, was deposed and undertook a pilgrimage to Rome in penitence for the murder of his brother; he died there in a monastery attached to the antique church of San Stefano Rotondo.[2] Names of outstanding pilgrims become scarcer in the twelfth century, possibly because these journeys were so common as not to be worth mentioning. Still, in 1134, the Annals of the Four Masters mention the death in Rome 'on his pilgrimage'[3] of Imar O'Hagan who had been the master of St Malachy in Armagh.

There is no definite mention of Irish pilgrimages to Compostela before the text relating to the foundation in Dublin in the early thirteenth century of a hospice for pilgrims to St James' tomb.[4] But the very fact of this foundation shows that the pilgrimage was by then well-established and of long standing.

If we now turn to the political history of that period, we find it still dominated by the rival ambitions of the five kingdoms which had already played an essential part during the preceding century: Munster to the south, Connacht to the west, Leinster and Meath to the east and centre, and, in the north, Ulster, now divided into several kingdoms. For a long

[1] 'Sitric, son of Olav, and Flanducan, King of Bregia, and many others went to Rome', *A.U.*, 1028; cf. *A. Tig.*

[2] *A.C.*, 1063, *A.F.M.*, 1064; in 1095, 13, the *A.I.* relate the death of Eógan, 'head of the monks of the Gaedil in Rome'.

[3] I.e. in retirement, far from his original monastery.

[4] R. Hayes, 'Ireland's links with Compostela, *Studies*, 1948, pp. 326–7.

time the high kingship had belonged alternately to the members of two
powerful dynasties, the Northern Uí Néill who ruled part of Ulster, and
the Southern Uí Néill, kings of Meath. Then, in 1002, as a consequence
of the fight against the Scandinavian invaders, Brian Boru, who came
from a younger branch of a Munster family, the Dál Cais, broke this
regular pattern by wrenching the high-kingship from Máelsechlainn, of
the Southern Uí Néill. After Brian's death at Clontarf in 1014, Máel-
sechlainn regained the throne. Then, for a long time, there was no
universally accepted Árd-rí (high king), and those that are mentioned
are described as 'king with opposition'. Some of them belonged to the
O'Brien family, the descendants of Brian. Two other dynasties, however,
gradually gained in importance, the Mac Loughlins in the north (a
branch of the Uí Néill), and the O'Conors in Connacht and they also
supplied candidates for the high kingship. The methods of succession
begin to change at that time, the succession from father to son tending to
supersede the complicated traditional rules of succession.

One of the striking features of this period is the gradual decay of the
kingdom of Meath, which wore itself out in its rivalry with Leinster and
the consequent fights. By the twelfth century, it had lost most of its
importance. As for Leinster, it had never really taken part in the
competition for supreme power, and was usually content to throw its
weight on the side of one of the candidates. It remained faithful to this
policy through the eleventh and twelfth centuries, until the moment, at
the end of this period, when a sudden flaming up of ambition proved to
have catastrophic consequences.

The history of the first part of the twelfth century is dominated by the
figure of Turlough O'Conor, king of Connacht from 1106, and high king
from 1119. His reign was marked by an endless series of military
expeditions through the whole of Ireland and off-hand interventions in
the organization of the other kingdoms. To weaken Munster, he divided
it, giving Thomond (the north-west) to Conor O'Brien, whilst he gave
the south (Desmond) to Cormac Mac Carthy, the king whom we have
seen immediately before that living as a refugee and penitent in Lismore
in the care of St Malachy.[1] In 1138, however, Cormac was murdered by

[1] See p. 14.

Turlough O'Brien. In consequence, another division of the southern territories took place somewhat later. Meanwhile Turlough O'Conor treated the kingdom of Meath in the same fashion. He divided it into three parts, leaving the prince of Breifni[1], Tiernan O'Rourke, to infiltrate towards the south-east until he found himself involved in the traditional rivalry between Meath and Leinster.

Turlough O'Conor, judging from the annalistic entries, seems to have fostered the prestige of his dynasty and his kingdom by a strange mixture of brutality and magnificence. This ambitious policy, as we have seen, brought about, amongst other things, the establishment of an archbishop's see in Connacht.[2] When he died in 1156, the kingdom of Connacht passed to his son, Rory (Ruaidhrí) who became high king; but easy going and wavering he failed to measure up to the ordeal of the Norman invasion.

It was easy to foresee that one day the Normans who had settled in England in 1066 would try to get into Ireland. The efforts made by the archbishops of Canterbury to establish their domination over the 'Britanniæ' of which Lanfranc boasted to be the primate[3] was only one facet of that ambition. The luscious, cattle-laden Irish pastures were a tempting prey in the eyes of the Norman knights always greedy for new estates and ready for a new adventure; for the Plantagenêt king whose demesnes had so fantastically extended in western Europe in a short time, Ireland was one more fief – and a tempting one – to add to his possessions.

When, however, the conquest came, it was not as the result of a deliberate plan, but nearly by chance, more as a piratical enterprise than an organized military expedition. The pretext was supplied by the king of Leinster, Dermot Mac Murrough, whose reign started in 1126. Like many of his contemporaries he was a figure full of the strangest contradictions, whose activity one can follow only in the intermittent and laconic entries of the Annals. In 1129, he raided the monastery of Kildare and kidnapped the abbess. A few years later, he left little Laurence O'Toole to starve nearly to death. But then he appears as founder of

[1] Modern counties of Cavan and Leitrim. [2] See p. 10.
[3] Gwynn – Gleeson; *Killaloe*, p. 104.

monasteries: the Cistercian Abbey of Baltinglass and the Augustinian Priory of Ferns were both due to his lavish gifts. He usually lived in his castle of Ferns (Wexford), at the foot of Mount Leinster, beside the old monastery surrounded by a circle of crosses which at the time was lost in the depth of nearly impenetrable forests. Whilst Turlough O'Conor was interfering in the affairs of the other kingdoms Dermot manoeuvred cleverly enough to emerge around 1150 as king of the whole of Leinster and of the Scandinavian cities of Dublin and Waterford.

He may then have aspired to the high kingship. Just at that moment, the defeat of Turlough O'Brien by Turlough O'Conor at Moin Mhór, near Cork, again changed the balance of power in the surrounding kingdoms. Dermot meant no doubt to take advantage of it, but strangely enough this was the very moment he chose to antagonize Tiernan O'Rourke whose encroachments in Meath we have seen. Dermot ran away with his wife, Devorgilla, a Meath princess – an incident which has been magnified out of all proportion. She in fact fairly soon went back to Breifni and then appears in the Annals as a benefactress to Clonmacnois where she restored the Nuns' Church. Tiernan, for fifteen years, persisted in claiming obstinately the huge compensation of a hundred ounces of gold legally due to him, and he finally obtained it by the very year when Dermot Mac Murrough came back to Ireland with the first Norman contingent.[1]

Meanwhile Rory O'Conor had become Árd-rí – the first high king without opposition since Brian and Máelshechlainn. He raided south Leinster, expelled Dermot from it and burned his castle at Ferns. Dermot fled to Bristol where he got in touch with a crowd of adventurers, half-Norman, half-Welsh. He went to France to claim Henry II's backing and found the king too engrossed by his struggle with Thomas à Becket to pay great attention to an expedition to Ireland. Henry approved the enterprise, but took no direct part in it. Dermot then went back to Ferns, where he hid in expectation of his accomplices' arrival.

[1] *A.F.M.*, 1167. One may wonder if part of that compensation was used by the repentant Devorgilla in the work of completion of the Nuns' Church at Clonmacnois which is mentioned in the same entry (see p. 40). Devorgilla died in 1193 (*A.F.M.*, 1193).

There were successive landings so that the full force of the invasion was only felt in 1169 and 1170.[1] In two campaigns, the tactics and the armour of the knights – these moving fortresses – succeeded in doing what the Vikings had been unable to achieve in centuries, so that Henry II was able to come in 1171 to inspect the new conquest made by some of his subjects. Most of the Irish kings paid homage to him, except Rory and the northern princes, and so did most of the great ecclesiastics.

When he left, the greater part of Ireland became the prey of the Norman barons who proceeded to divide it as suited them into a number of feudal estates. Nothing was sacred to them. In Durrow and Clonard they built castles with the stones of the old monasteries. They plundered Armagh. Their greed sucked Clonmacnois dry. First, in 1178 and 1179, the town attached to the monastery was sacked. Then in 1202 there arrived William de Burgo who tore from the churches vestments, books, chalices, altar-cloths and everything he could lay his hand on. He and his companions 'left the croftes, gardens and houses of the town wast and void, like an empty chaos without any manner of thing but their empty and foot-trodden grounds'.[2]

In many ways, the Norman invasion marks in Ireland the end of a world, and certainly the death of original artistic endeavour. For centuries after that, art in Ireland was almost completely dominated by foreign models, and the old fire of invention was nearly always lacking, though the great sense of proportion and the decorative feeling of the old style survived for a long time.

[1] F. X. Martin, O.S.A., 'The Anglo-Norman Invasion (1169–c. 1300)', in: *Course of Irish History*, pp. 123 sqq.
[2] *A.C.*, 1202.

2. The Sites

In its general lines, the picture of the inhabited sites – towns, palaces, monasteries – is not very different in the Ireland of the eleventh and twelfth centuries from that of the preceding periods.[1] The evolution from scattered habitat to city life was still taking place and the towns which already existed in the tenth century continued to gain in importance, whether merchant towns founded by the Scandinavians on river estuaries – Dublin, Limerick, Waterford, Wexford – or monastic cities such as Armagh and Kells. Dublin, which did not exist in the eighth century, became, in the twelfth, the chief city which the Normans hastened to take and made the capital of the 'Pale', the territory they held most securely.

Meanwhile the old monasteries went on. The chief ones, adapting themselves to new conditions, became episcopal sees and sported stone churches with carved doorways. New crosses were still added to the old ones for the decoration of the courtyards, but in fairly small numbers; whether the earlier monuments left little room for new additions, or whether it was felt that carvings on the doorways of churches were to a certain extent a substitute for those on the stone crosses is doubtful.

One may first wonder – as this has its impact on buildings and new foundations – where the kings of the various kingdoms, the O'Briens and Mac Carthys in Munster, the kings of Connacht, those of Meath and Leinster, and the Northern Uí Néill lived at that time. In many cases the answers remain problematical and, in any case, one must always bear in mind the fact that each dynasty owned a whole set of fortresses which were used in turn according to circumstances.[2]

[1] Vol. I, pp. 76 sqq., Vol. II, pp. 33 sqq.

[2] Making all allowances for poetic licence, a line relating to a king of Meath in an entry in the *A.F.M.* (1022) may be relevant here:

> 'Three hundred forts had the King, in which flesh and food were given'.

For the eighth and ninth centuries it was possible to get some idea of one of these princely seats, the crannog of Lagore where the Southern Uí Néill settled when Tara was abandoned. Lagore was excavated by the Harvard Archaeological Expedition to Ireland, but all traces of the buildings on the crannog had been destroyed by draining operations prior to the excavation, so that we can get a fairly clear idea of the size of the establishment but only an extremely hazy notion of its lay-out and appearance. After its destruction in 848, during the first serious fighting with the Vikings, Lagore was re-built and surrounded by a new palisade. The Uí Néill probably still lived there from time to time until the end of the tenth century. But the account of King Máelsechlainn's death in 1022 shows him established at Dún na Sciath, near Lough Ennell.[1] From there, when he felt death coming, he asked to be carried to Cró Inis, a small island in the lake with a hermitage or small monastery.[2] Later on the Annals of Inisfallen refer to one of the Southern Uí Néill as 'prince of Dún na Sciath'.[3] So the fort was probably in use during the greatest part of the eleventh century. In addition, the Southern Uí Néill, like other Irish princes, seem to have had a residence beside one of the chief monasteries of their kingdom. At least this is what we may deduce from a statement in the Annals of Clonmacnoise when Murchad O'Máelsechlainn, king of Meath, is described as dying in Durrow 'in his own house'.[4]

Dermot Mac Murrough, who was king of Leinster from 1126 to 1170 seems to have lived in Ferns in a stone building older than the castle, whose remains still stand almost at the gate of the monastery,[5] but probably he sometimes also lived further west, beyond Mount Leinster, in the Barrow valley.

Several texts mention the palace of Kincora (Ceann Coradh), built by Brian Boru near the place where the Shannon flows out of Lough Derg. This was quite near the monastery of Killaloe (Cell dá Lua) which had its origin in an ancient foundation a little lower down the river where

[1] To the south of the present town of Mullingar.
[2] *A.C., A.F.M., A.U., Chr. Sc.,* 1022.
[3] 'Domnall, son of Beoll, prince of Dún na Sciath', *A.I.,* 1095, 13.
[4] *A.C.,* 1153. [5] *M.C.,* 1165, 4.

St Flannan, a member of the Dál Cais family to which Brian Boru belonged, had lived in the eighth century. Its place was marked by a small oratory on an island (now moved to Killaloe). Killaloe itself was a creation of Brian, who founded a monastery on the actual site of the modern town. He built there a church which has completely disappeared. To Killaloe, members of the royal family were often brought when nearing death. Marcan, one of Brian's brothers, was abbot of Killaloe and at the same time of Inis Cealtra, a monastery established on one of the islands of Lough Derg which also enjoyed the protection of the O'Briens. In 1076, Gormflaith, wife of Turlough O'Brien died in Killaloe and we are told that she was buried in Inis Cealtra.[1] Brian showed also some interest in the monastery of Tuamgreiney, on the shore of the lake, where he helped in the erection of a round tower (now disappeared) which was no doubt near the church whose tenth-century west wall has survived to our day.[2]

Kincora was repeatedly attacked. In 1009 and 1061 we are told of its destruction by Connacht armies.[3] The palace was obviously re-built, as in 1086 Turlough O'Brien and then his son died there. In 1088 it was razed to the ground, this time by a Leinster force, and it seems to have been again destroyed by troops from the north c.1100.[4] But none of these episodes was definitive and it is not until 1116 that the Annals of the Four Masters announce its final destruction by Turlough O'Conor who also razed Boromha, a fortified dwelling which seems to have stood quite near to Kincora.

Boromha, or Beal Boru, was partially excavated in 1961 by M. J. O'Kelly.[5] Under a mound of earth built by the efforts of a band of Anglo-Normans to erect there a feudal moat, the excavations revealed a rath of the usual type, surrounded by a circular earthen rampart with a stone revetment on the outside. The excavation of the central part was made difficult by the presence of numerous trees. However, it proved possible to explore a wooden house with central hearth, the inside measurements of which were about 13 feet 4 inches by 8 feet 4 inches. Two silver coins,

[1] *A.I., A. Tig.*, 1076. [2] Vol. II, p. 70. [3] *A.C.*, 1009, 1061.
[4] *A.F.M.*, 1101.
[5] M. J. O'Kelly, 'Beal Boru, Co. Clare', *J. Cork H.A.S.*, 1962, pp. 1 sqq.

minted in Dublin in the eleventh century, found one inside, the other just outside the house, date it fairly precisely. It yielded also one of those stone trial pieces which have been mentioned already.[1] It seems likely that the main dwelling-house still remains buried in the central part of the rath, but the coin finds give in any case eloquent confirmation of the texts relating to the site.

In fact the O'Briens seem to have taken up residence in Limerick already before the final destruction of Kincora and Boromha. This appears from an entry in the Annals of the Four Masters and others in the Annals of Inisfallen[2] which show various members of the O'Brien family expelling each other in turn from Limerick between 1101 and 1116.

Cashel had been for centuries a royal seat. When first Mahon, and then Brian, became king of Cashel, they may occasionally have resided there. Brian built ramparts on the Rock.[3] But after the giving of Cashel to the Church, it probably ceased to be the residence of the kings.

In spite of the fact that Cormac Mac Carthy's name is constantly associated with Cashel because of the chapel which he built on the Rock, his usual residence was obviously elsewhere. That part of County Limerick which extends between the modern villages of Hospital and Newcastle-West was probably from ancient times a territory of very special significance. The shores and islands of Lough Gur are covered with remains of habitations, tombs and prehistoric sanctuaries. Names like Bruff (Brugh na Déise, the residence of Deisi), Bruree (Brugh Ríogh, royal residence), are also typical. Cormac's name is associated with two sites in that territory: the inscription on the shrine of St Lachtin[4] seems to describe him as 'of Rath Aíne'; the Annals of the Four Masters tell us that he died 'in his own house',[5] a statement which is more explicit in the Book of Mac Carthy:[6] 'he died in his own house at

[1] Vol. II, Pl. 57, p. 132.
[2] *A.F.M.*, 1101; *A.I.*, 1114, 4; 1115, 2; 1116, 4; see also below, p. 31, where it is to Limerick that Murtough O'Brien brings back the stones of Aileach, and the note added by Denis Murphy to the account of the giving of Cashel in the *A.C.* p. 188, note 1.
[3] *War*, pp. 140–1.
[4] See p. 103; this part of the inscription is very hard to decipher.
[5] *A.F.M.*, 1138. [6] *M.C.*, 1138.

Mahoonagh' (Magh Tamhnach). This points to two of the places where he did live. Cork would be another. At Mahoonagh (Castle Mahon, near Newcastle-West) a medieval castle stands probably on the site of the rath where he died, and near Rathanny House (Limerick) which occupies probably roughly the site of Rath Aíne, there are several large raths which have never been excavated.[1]

Turlough O'Conor, when he was not galloping on the roads on various military expeditions, seems to have lived in Tuam (Galway) or in Roscommon, or perhaps also on Inis Creamha on the east side of Lough Corrib where the Connacht kings seem to have established residence in the eleventh century.[2] He built several castles which were probably made of wood on stone foundations, amongst them Dunleo (Ballinasloe) erected in 1124, which was burnt in 1131,[3] another in Galway in 1124, destroyed in 1132.[4] During the very dry summer of 1129 he built a bridge on the Shannon at Athlone, with a castle for its defence; the castle was destroyed by lightning in 1131, rebuilt, and destroyed again by the Meath forces in 1134.[5] Turlough died at Dunmore some eight miles north of Tuam (Dún mór, the large fort; Galway).[6] To the west of the modern village of Dunmore, near a ford on a small river and beside the ruins of a medieval castle, there are traces of a vast fortification on the top of a rocky hillock consisting of the remains of a rath and of two round stone platforms, perhaps bases of wooden towers; the ridge from one to the other seems to have been fortified. Only an excavation might show whether this is in fact the remains of Turlough O'Conor's castle which was destroyed in 1158,[7] or whether it is only a later ruin.

As for the Northern Uí Néill, they still seem to have used – if only for

[1] There is also a circular enclosure on the top of Knockainey, the hill above Rathanny which is mentioned in connection with Cormac's son: 'and Ua Conchobhair [Rory O'Conor] escorted the Lord of Desmond [Cormac's son] with his forces, southward through Thomond as far as Cnoc-Aine' (*A.F.M.*, 1167). The siting of a royal seat near the border of the royal territory is in no way unusual, as shows the position of Kincora.

[2] *A.F.M.*, 1051. [3] *A.C.*, 1131.

[4] *Chr. Sc.*, 1128: 'the castle of Bun-Gaillmhe was burned by a fleet of the men of Mumhain'; cf. *A.F.M.*, 1132.

[5] *A.F.M.*, 1129; *A.C.*, 1131; *A.C.*, 1135. [6] *A.C.*, 1154. [7] *M.C.*, 1158.

purposes of prestige – the dry-stone fortress of Aileach in the Inishowen peninsula, from which they derived their dynastic name. This is indicated by the well-known story of Murtough O'Brien's expedition to the north in 1101 where he laid waste Inishowen, burned a great number of churches and raths around Fahan Mura and Árd-Stratha (Strabane) 'and he demolished Grianan-Oiligh (Aileach), in revenge of Cenn-coradh (Kincora), which had been razed and demolished by Domhnall Ua Lochlainn some time before; and Muircheartach (Murtough) commanded his army to carry with them from Oileach to Luimneach (Limerick) a stone [of the demolished fortress] for every sack of provisions which they had'.[1] From this text it appears also that the royal monastery of Fahan Mura still played an important part at that time.[2] But the old foundation of St Columba in Derry was beginning to take its place. Domnall Mór Mac Loughlin died in Derry in 1121 and it may be that in this case also there was a royal residence beside the monastery.[3]

These few indications, though they do not help us much to visualize the general appearance of one of these royal residences, allow us at least to understand a few fairly constant features, especially the link between the royal castle and a monastery at the gate of which it sometimes stood. In Killaloe, in Ferns, in Derry, perhaps in Tuam and Durrow, the set-up remains the same. The other aspect is the habit, common to all these kings, of moving constantly from one castle to another, a habit which they shared with most medieval lords. Brian, with his love for novelties, had perhaps tried to settle his dynasty in a definite residence, and had only succeeded in making it thus more vulnerable.

Of the towns we know a little more. The city of Dublin in the eleventh and twelfth centuries was probably still contained within the same limits as at the time of its foundation[4] and it is likely that the position of the walls of the 'City' which remained the central core of the extended town in the Middle Ages was still roughly that of the Viking ramparts. The town was still built of wood, even partly of wattle-work, judging by the ruins of houses in the top layers of the High Street excavations.[5] These

[1] *A.F.M.*, 1101; see also *A.U.*, 1101. [2] See Vol. I, pp. 127 sqq.
[3] *A.F.M.*, 1121. [4] Vol. II, pp. 34 sqq. [5] See Vol. II, pp. 37–8.

houses were sometimes fairly large and craftsmen used them as work-shops as well as shops. One of them, for example, was occupied by a man who made objects carved in bone, combs, buttons, knife-handles, etc. In the now Christian town these houses surrounded the cathedral of the Holy Trinity (now Christ Church) which had been founded before 1036 on a patch of ground given by Sitric. It may have been a wooden church and it was obviously on the site where stands the Romano-Gothic stone church, so that it has totally disappeared.[1]

This wooden building may have been used as a cathedral until the Norman invasion. In 1172, Laurence O'Toole and the Norman chiefs decided to replace it by a stone building more in keeping with the current fashions. Of this there remains the transept, probably built from 1175 to 1190 in a rather dry version of Norman Romanesque. There were now several other churches within the city, amongst them the church of St Columba which the Normans replaced by a church dedicated to St Ouen (St Audoen). The monastery in the island of the Poddle may have been rebuilt at that time. In any case churches were erected there: St Michael-le-Pole (St Mac Tháill of the Poddle), a small church with a round tower;[2] another church dedicated to St Brigid; and the church of St Patrick *de Insula*, perhaps a wooden structure, which was replaced by a new church built in 1191 and finally by the present thirteenth-century structure. The town was extended to the north bank of the Liffey with the erection of the church of St Michan and of St Mary's Abbey, a cell of the Benedictine Abbey of Savigny which passed to the Cistercian order with the other Savignan monasteries about 1147.

Limerick was also adapting itself to new circumstances. It had been re-built after having been burnt by Mahon and Brian in 968, but it was the prey of several other fires (1062, 1108, 1124, etc.).[3] The town was

[1] On this and the other Dublin churches mentioned, see: D. A. Chart, *The Story of Dublin* (London, 1932).

[2] See Dunraven, II, p. 155 (from a drawing of Beranger).

[3] *A.C.*, 1062; *A.U.*, 1088; Domnall Mac Lochlainn and Rory O'Conor 'burned Limerick' (cf. *Chr. Sc.*, 1084); *A.F.M.*, 1108: 'All Limerick was burned on the night of the festival of Patrick'; *A.I.*, 1108: 'Luimnech was totally burned save the market outside'; cf. *A.U.*, 1108 (burned by lightning); *A.L.C.*, 1124: 'Luimnech was all burned, except a little'.

built on an island, and one of the texts relating to it gives a curious bit of topographical information: the Annals of Inisfallen say that in 1108 the town was entirely burnt, except for the market, which was outside the city proper. Since 1107, it had had a bishop, consequently a cathedral church,[1] and it became so intimate a part of Ireland in spite of its Viking origin that about that time a royal residence[2] was established in the town. After the Norman conquest a vast stone cathedral was built, started in 1172 by Domnall Mór O'Brien.

The general plan of Armagh no doubt remained roughly the same as in the early eleventh century,[3] but builders were at work. The stone church which became the cathedral in the twelfth century had remained for 130 years without part of its roof which was wrenched off by a gale in the late tenth century. In 1125 Cellach had it entirely re-roofed,[4] obviously to fit it to its new dignity of primatial and cathedral church. According to the Four Masters, the Priory of SS. Peter and Paul in Armagh 'which had been erected by Imhar Ua hAedhagain (Imar O'Hagan), was consecrated by Cellach, successor of Patrick'.[5] It was on the north slope of the hill, just outside the Rath. The building indicated there in a plan of Armagh dating from the beginning of the seventeenth century[6] seems to have had arches supported by columns. But the drawing is not very clear and it may be that the priory had been re-built between the twelfth and the seventeenth centuries. Nothing is left of it now. Some of the crosses indicated as landmarks in the description of a fire which partly destroyed the town in the twelfth century may have been carved in the Romanesque period, but all that remains are fragments of earlier crosses.

Elsewhere also, the transformation of a monastery into an episcopal see seems to have brought about all sorts of alterations. Derry has kept no traces of its medieval city, nor of the pre-Romanesque monastery. But it is possible to follow through unusually vivid entries in the Annals the modifications to the monastic town brought about in the twelfth century. Derry, (Doire Choluim Chille – the Oak-Wood of St Columba) was one of the important monasteries of the north of Ireland. In the

[1] See p. 169, note 1. [2] See p. 29. [3] Vol. II, p. 40 and Fig. 2.
[4] *A.F.M.*, 1125; *A.L.C.*, 1125. [5] *A.F.M.*, 1126. [6] Vol. II, Fig. 2.

twelfth century it replaced Kells as the metropolis of the Columban order. But the town suffered all sorts of vicissitudes. In 1134 and 1135 it was burned and sacked. In 1146, a violent 'storm prostrated sixty trees at Doire-Choluim-Chille and killed and smothered many persons in the church'.[1] It seems from this entry that Derry had kept a wood of the trees to which it owed its name and that the wind played havoc with them. 1149 seems to have seen a new fire. We know from Keating that the town had become an episcopal see in 1111, at the Synod of Rath-breasail.[2] Sometime later, the head of the order of St Columba, Flath-bertach O'Brolchain, who resided in Derry, claimed the privilege, glorious for the Order, of being made a non-territorial bishop, and obtained it in 1158.[3] This may well have been the reward of his untiring activity over many years. In order to restore his devastated town and churches and raise monuments worthy of the title he aspired to, he travelled through the length and breadth of Ireland, collecting every-where gifts of all kinds. The list of them makes picturesque reading, and is probably typical of the way such works were financed.[4]

In 1150, he visited the territory of Cinel Eoghain,[5] at that time the most powerful sept of the Northern Uí Néill. The king gave him 20 cows and a 5-ounce gold ring, to which the monarch added his horse and his battle-dress; his people gave horses and cattle. In 1151 he went to Antrim, where the Lord of Sil Cathasaigh abandoned him his horse, his fighting gear and a gold ring of 2 ounces; the clansmen contributed horses and sheep. In 1161, he accompanied the king, now Árd-rí, on an expedition into Meath, where he recovered the jurisdiction of the churches of St Columba in Meath and Leinster, which had hitherto been denied to him, possibly Kells and more probably less important monas-teries such as Swords and Moone. Then he ventured as far as Ossory,

[1] *A.F.M.*, 1146. [2] See p. 10.

[3] At a synod, assembled by the primate, on the Hill of Mac Taidhg, near Trim (Meath). It is mentioned in *A.C.* and described in *A.F.M.*, but the most complete text is in *A.U.*: 'It is on that occasion the clergy of Ireland, along with the successor of Patrick and along with the Legate, appointed a Chair for the successor of Colum-cille, that is for Flaithbertach Ua Brolchain, the same as [for] every bishop and the arch-abbacy in general of the churches of Colum-cille throughout all Ireland'.

[4] *A.F.M.*, 1150, 1151, 1161. [5] Present Co. Tyrone.

where he was entitled to a tribute of 140 oxen; worried probably at the thought of having to drive them all along the 150-odd miles to Derry, he asked to be given their equivalent in 'pure silver' – namely 420 ounces.

Meanwhile, building operations were going on. He established a lime-kiln. Then, in 1155, the Annals state that 'the door of the church of Derry was made by the successor of Colum-cille, namely by Flathbertach O'Brolchain'.[1] This, however, was only a beginning, and, in 1162, he and the king set to work on a complete remodelling of the town's structure and lay-out. Its transformation suggests that Kells was the model: 'Total separation of the houses from the churches of Daire was made by the successor of Colum-cille (namely Flaithbertach) and by the king of Ireland, that is by Muircertach Ua Lochlainn; where were demolished eighty houses, or something more. And the stone wall of the Centre was likewise built by the successor of Colum-cille and malediction [pronounced] upon him who should come over it for ever'.[2] The main church seems to have been vastly enlarged, or even re-built.

In Tuam also, a good deal of re-building took place. Though it is not as clearly described, important modifications seem to have taken place. The monastery had been founded in the seventh century by St Jarlath. According to the Annals of Tigernach, King Turlough O'Conor and 'the successor of Jarlath' erected in 1127 an enclosure around the monastic buildings of Tuam. Then the king gave a piece of land to the abbey and its hostelry.[3]

The same plan seems to underlie the two undertakings: in both cases an enclosure was erected to separate the ecclesiastical quarter of the city from the lay residential town which had grown beside the monastery in the course of centuries. In both cases too there is obviously also at stake the prestige of a dynasty which needs to be exalted by the presence of an archiepiscopal see or the metropolis of a great order. As in Dublin for the erection of the cathedral, the king presided over all the bishop's undertakings. His care for the enlarged foundation did not stop there:

[1] *A.U.*, 1155.
[2] *A.F.M.*, 1162, *A.U.*, 1162 (*A.U.*: 'ocus denam caisil in erlair la comarba'; *A.F.M.*: 'caiseal an urláir do dénaim lá comarba'.
[3] *A.Tig.*, 1127.

in 1140, Turlough O'Conor founded in Tuam a priory of Canons of St Augustine dedicated to St John the Baptist, and he took his share of the raising of the two great crosses which probably stood in the enclosure he had erected.[1]

Besides these monasteries which were striving towards a more orderly appearance and arrangements inspired visibly by those of Armagh and Kells, others were content simply to add new buildings to the old ones. This is the case with Clonmacnois[2] which has preserved one of the most important groups of twelfth century monuments. The monastery has already engaged our attention,[3] but the moment has come to consider it in more detail.

It had been founded in the sixth century by St Ciaran at the foot of an esker, made of a series of abrupt gravel-heaps left by a prehistoric glacier, which borders the Shannon to the east. The river, emerging from Lough Ree and soon to widen again into Lough Derg, spreads largely and over-flows into marshes on the low and boggy shore to the west. From the slopes of the esker one commands an endless landscape, wild sometimes when the sea-wind drives hanging curtains of clouds and rain, or at other times infinitely melancholy. Yet its lonely appearance is deceptive, as the river used to be one of the main highways of the country, so that this apparently forlorn retreat was in fact on a harbour of a great water-road. This gave the monastery an outstanding importance, but more than once it also caused its ruin, as the waters of the river brought the greedy Viking fleets.

It is likely that the monastery spread from a fairly early period over an extensive site, but unlike Armagh and Kells it retains no trace of the ramparts which almost certainly surrounded it. At present the main group of ruins is enclosed by the graveyard wall (Fig. 1). But this only represents a tiny fragment of the surface which was originally built up. To the east of the old graveyard, there are extensive traces of old buildings. To the west, a later castle may well be on the site of what the Annals of

[1] See p. 124.

[2] For the monuments of Clonmacnois, see: T. J. Westropp, 'A Description of the Ancient Buildings and Crosses at Clonmacnois, King's County', *J.R.S.A.I.*, 1907, pp. 290 sqq.; also: Brash, pp. 61 sqq.

[3] *Vol. I*, pp. 82–3; *Vol. II, passim.*

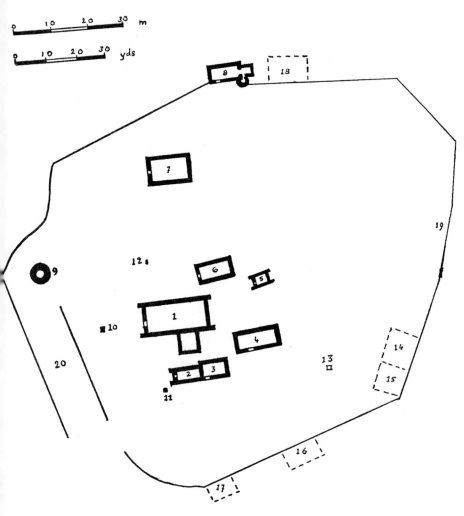

Fig. 1. Plan of the cemetery of Clonmacnois (after Ware, Brash and Macalister): (1) cathedral; (2) Temple Doulin; (3) Temple Hurpain; (4) Temple Rí; (5) St Ciaran's Church; (6) Temple Kelly; (7) Temple Conor; (8) Temple Finghin; (9) round tower; (10) Cross of the Scriptures; (11) South cross; (12) North cross; (13) site of a cross, shown by Ware; (14, 15) sites of the houses of the abbot, etc.; (16) site of the bishop's chapel; (17) site of Temple Gauney; (18) Temple Killian; (19) cemetery wall (modern); (20) Museum of funerary slabs.

Clonmacnoise, in their approximate spelling, call Lisanabbeye – the fort of the abbot.[1] Further east still there is an isolated church surrounded by a few remains of walls, which is usually called the Nuns' Church.

The situation of the monastery nearly in the centre of Ireland put it in close contact with territories ruled by several dynasties, whose patronage it enjoyed. This does not apply only to local chieftains, such as the kings of Teffia,[2] who had their burial-ground in the churchyard of the monastery, or the princelings from beyond the Shannon, but to the main ruling families. Clonmacnois was on territory belonging to the kings of Meath and always enjoyed their protection. But the lands beyond the Shannon, just opposite the monastery, were in Connacht, and in the twelfth century, its king, Turlough O'Conor, showered gifts on Clonmacnois. Sailing down the Shannon, Munster was close at hand, and kings of Thomond and Desmond vied with each other in their endowments. Even Leinster was not very far away to the south-east. So, from all directions rivals for prestige stressed their ties with the monastery, and kings' funerals drove towards it. In the late tenth century the O'Conors of Connacht had already claimed burial rights in Clonmacnois against a gift of six endowed priories. The Mac Carthys also bought their right to be buried into or beside the church called Temple Finghin. The burials in Clonmacnois of the bodies or heads of kings of Meath and of members of the O'Brien family are repeatedly mentioned.

The monastery obviously had numerous cells and affiliated houses. In 1076, the Annals of Clonmacnoise mention 'the houses of religion belonging to Clonvicknose'. For some of them, the link went back to the time of their foundation, as was the case with the monasteries on the islands in Lough Ree which also owed their origin to St Ciaran. Some, such as Lemanaghan (Offaly), went back to very early gifts.[3] Others were compensations for sacrilege, violated oaths, and so on, or offerings for burial rights.

[1] *A.C.*, 1133.

[2] Petrie, *Chr. Inscr.*, I, Introduction; R. J. Best, 'The Graves of the Kings at Clonmacnois', *Ériu*, 1905, pp. 163 sqq.

[3] *A.F.M.*, 645: 'Diarmait, son of Aed Slaine granted it [Lemanaghan] to Clonmacnois in thanks for their prayers'. See also *A.C.*, 642.

The monastery in consequence was certainly rich and influential. It was also a centre for studies and artistic endeavour. No example of the work of its scribes older than the late eleventh century has come down to us.[1] But there is every reason to assume the existence of an important scriptorium before that date. Máel Muire, one of the late eleventh-century scribes employed in the copying of the Book of the Dun Cow, belonged to a family descending from Ferdomnach, the Book of Armagh scribe, where the tradition of manuscript work had probably been handed down from one generation to the next.[2] The Annals also mention during the eleventh century the work of compilers and chroniclers[3] done in the monastery and obviously copied there.

There are also indications of artistic activity such as the making of the shrine of the Stowe Missal in the middle of the eleventh century[4] by a Clonmacnois goldsmith. It is, however, the work of the masons and sculptors which is known in the greatest detail. Stone crosses had been erected in Clonmacnois in the eighth and ninth centuries.[5] In the early tenth century King Flann and Abbot Colman built a church there.[6] Its foundations may still survive, supporting the present walls of the cathedral and giving it its plan of a rectangular nave with antae to the east and west. They also raised a cross in front of the church. And it is likely that the round tower to the north-west of the cathedral was erected at that time.[7] The small church called St Ciaran's Church and part of the walls of 'Temple Doulin' may also be anterior to the twelfth century. This is all we can gather of pre-Romanesque Clonmacnois.

The subsequent buildings are much better known, whether from texts or surviving ruins. The plan (Fig. 1) shows clearly the scattered and irregular arrangement, though the reason for it remains unknown. In the centre stands the cathedral, with the Cross of the Scriptures at some distance from its door, and the round tower a little farther off. To the south, Temple Doulin and Temple Rí, to the north the ruins of Temple Kelly and the tiny church of St Ciaran; then, at the bottom of the slope, Temple Conor, still standing and roofed, and Temple Finghin only partly ruined.

[1] See p. 49. [2] Henry – Marsh-Micheli, *Illumination*, p. 113. [3] Id.
[4] See p. 82. [5] *Vol. I*, p. 139 sqq. [6] *Vol. II*, p. 2. [7] *Vol. II*, p. 52.

It is known that Abbot Cormac, in the late eleventh century, had undertaken the re-roofing of the cathedral which was only finished after his death in 1104.[1] This was apparently only a repair of the tenth-century building. In the twelfth century its west front was probably seriously damaged. For an unknown reason, the door of the gable wall was rebuilt off centre and it was then decorated with sumptuous foliage-capitals certainly of late date (Pl. 110).

The tenth-century round tower was badly damaged, possibly in the course of fights with the Vikings, and shows obvious traces of repairs. The upper courses are much coarser than the lower part in which the blocks of stone are cut with wonderful accuracy. It is likely to have been originally higher than it is now. In 1124, the Annals of the Four Masters record that the 'cloictech of Clonmacnois was finished' by O'Malone (Ua Máel Eoin), successor of St Ciaran.[2] The Chronicum Scottorum has the same event under the date of 1120 and adds that Turlough O'Conor participated in the restoration. This was not the first time he showed his interest in the monastery: some ten years earlier he had bestowed upon it an extraordinary collection of miscellaneous metal-work objects which went to enrich the cathedral treasury.

O'Malone's successor was, like many of his predecessors, abbot of Roscommon and Clonmacnois. The links between the great Shannon monastery and the kingdom of Connacht then became very close, as is shown by the fact that Turlough was buried 'beside the altar of St Ciaran' and not in his family's burial chapel. This chapel, Temple Conor, was obviously, from its appearance, erected in the twelfth century; it is rectangular in plan, with a sober decoration around the door and the east window.

Other Clonmacnois churches were built in the twelfth century: Temple Finghin, Temple Kelly, and the Nuns' Church. This last was some distance from the main group. It replaced an earlier church, possibly a wooden one, which had been consumed by fire in 1080 together with the houses in the Nuns' enclosure. We learn from the Four Masters that in 1167 the Nuns' Church at Clonmacnois 'was finished by Derbhforgaill (Devorgilla), daughter of Murchad Ua Máelsechlainn'.[3]

[1] *A.F.M.*, 1104; *A.C.*, 1100 (*recte* 1104). [2] *A.F.M.*, 1124. [3] *A.F.M.*, 1167.

Devorgilla, the king of Meath's daughter, would be a normal patron for a church of the great Meath monastery. But what exactly did she give? It might have been the roof or some part of the inside decoration, so that the date when the church was thus 'finished' does not give clear indication of when the construction was begun.

The same text goes on to tell us that 'a church was erected at Cluain-mac-Nois, in the place of the Dearthach (wooden church)' by Conor O'Kelly, chief of the Uí Maine, whose territory was just on the other bank of the Shannon. Little has survived, unfortunately, of this fairly small church, except the foundations, and nothing remains of its carvings.

Temple Finghin, judging from its sculptured decoration, is likely to be more or less contemporary with the Nuns' Church, the present structure, there also, replacing an earlier one which is mentioned in 1015 in the Chronicum Scottorum.

So, apart from additions or repairs to existing buildings, the twelfth-century architectural activity at Clonmacnois can be summed up as the construction of a few small churches, several of which seem to have re-placed wooden chapels.

Let us now turn to Inis Cealtra. It was a very ancient monastery on a small island in Lough Derg, some 40 miles south of Clonmacnois.[1] There also builders were at work. Like all the monasteries of the Shannon, it had suffered badly from Viking attacks. In 922, they are said to have 'thrown in the water its relics and its shrines'.[2] Brian seems to have contributed to the re-building of the monastery of which his brother Marcan was abbot. He built a church there with antae, and also possibly the round tower. The monastery then seems to have grown in importance and to have remained closely linked with the O'Brien family. Of its library nothing has survived except the 'Psalter of St Caimin' – a few pages of manuscript, – yet enough to show its high quality.

In the twelfth century, several churches were erected or enlarged on the island. Their secluded position has enabled them to survive in a wonderful state of preservation, together with the enclosures surrounding

[1] R. A. S. Macalister, 'The History and Antiquities of Inis Cealtra', *P.R.I.A.*, 1916, pp. 93 sqq.
[2] *War*, pp. 38–9.

them which occupy about one-quarter of the surface of the island (Fig. 2). On the highest point of the island was a small chapel dedicated to St Michael, now completely ruined. The main group of buildings is further down to the east and consists of the round tower and the church of St Caimin which is Brian's church modified in the twelfth century. The original rectangular church with antae became the nave of a more elaborate church; a choir was added by opening a large chancel-arch into the east wall, and a carved door has been inserted in the west wall. The nearly square choir is built with extreme care, in beautifully cut stones.

A cemetery, surrounded by a wall with a semi-circular headed door-way extends beyond the choir. The closely packed tombs are covered with large stone slabs, a number decorated with crosses. A few of them, now placed for safety inside the church, also have inscriptions, two of which can be dated respectively to the eighth and ninth centuries. Two cross-bases rise from this field of gravestones, and in the middle are the ruins of a small chapel, or perhaps of an ossuary.

In addition there are the ruins of a small twelfth-century church surrounded by an enclosure and of the Church of St Mary, remodelled in the Middle Ages, but older in its origin. To complete the appearance of the monastery one must conjure up all the huts and wooden buildings which probably filled most of the space between the stone churches. This is, of all the groups of monastic ruins in Ireland, that which lends itself best to a reconstruction of its past appearance and its situation in the lake's vast expanse of water, surrounded by high hills, contributes not a little to its impressive appearance.

Glendalough, sheltered for centuries by the surrounding mountains, has remained almost as intact. We have seen[1] that the monastery, which went back to a foundation of St Kevin in the sixth century, was enlarged in the eighth and ninth centuries into a monastic city of some substance. It grew further in the Romanesque period.

The site itself could hardly be described better than in the words of the monk of Glendalough who in the eleventh or twelfth century wrote there a Latin *Life of St Kevin*. He tells us that 'the blessed Kevin, wandering alone across desert places, came one day by a certain valley situated

[1] *Vol. I*, p. 82; *Vol. II*, p. 45.

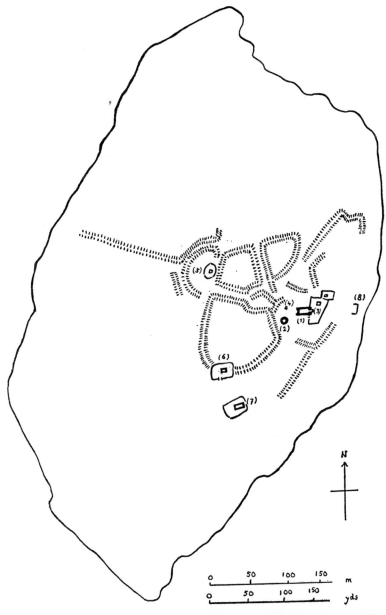

Fig. 2. Plan of Inis Cealtra: (1) St Caimin's Church; (2) round tower; (3) cemetery; (4) base of a cross; (5) St Michael's chapel; (6) St Brigid's Church; (7) St Mary's Church; (8) former landing-stage.

43

between the slopes of high mountains and watered by beautiful streams. Shining torrents falling down the slopes from all parts emptied themselves into two lakes'.[1] It was, at the time of the monastery's prosperity, a wild and wooded spot, difficult of access, approached by brigand-haunted mountain paths.[2]

In the early twelfth century, the valley, for a length of a mile and a half was dotted with various establishments depending on the monastic city which was built in the broadest part of the valley, at the meeting of two streams. Its chief building was the cathedral, erected in the eighth century and since repaired many times.; near it was a round tower dating probably from the tenth century, when the monastery was exposed to the raids of the Dublin Vikings who attacked it several times. The Church of St Mary was at the other end of the enclosure and the rest of the city probably consisted of wooden constructions which have now disappeared. We have already seen what is known of the teaching available there around the year 1100, when the monastery had completely recovered from the Viking raids.[3] The Rosslyn Missal, written in Glendalough at about the same time gives some idea of the work of its scribes. All this activity is completed by that of the masons who erected several new buildings in the eleventh and twelfth centuries.

Two small churches were built between the wall of the 'city' and one of the streams which was probably considered sufficient protection; one is usually called 'St Kevin's Kitchen'. The other is the tiny shrine dedicated to St Ciaran of Seir (Offaly) with which is connected a poem in Irish copied on the last page of the Rosslyn Missal where St Kevin welcomes St Ciaran to Leinster. A little further down the valley, Trinity Church, built originally in the tenth or early eleventh century,[4] was altered by the addition of a round tower at its west end.[5]

It is only in the middle of the twelfth century that the appearance of the Glendalough churches was again deeply modified, during the government of Laurence O'Toole who was abbot from 1153 to 1162. His biographer, a canon of the collegiate church at Eu, in Normandy,

[1] Plummer, *V.V.S.S. Hib.*, I, pp. 236–7 (Vita Sti. Coemgeni).
[2] As show some episodes in the Life of St Kevin quoted above.
[3] See p. 4. [4] *Vol. II*, p. 48. [5] See p. 153.

where he was buried, says that he showed a great zeal in church-building whilst abbot of Glendalough.[1] This corresponds exactly with some works which bear the mark of that period: the enlargement of the old cathedral by the addition of a vast rectangular choir, made necessary perhaps by the presence of a chapter of canons; the building of a small funerary chapel (the so-called 'Priest's House'), situated like that of Inis Cealtra in the centre of the burial-ground (in Glendalough, to the south-west of the cathedral); restorations like that of the hermitage of Temple-na-Skellig; and finally the building of a small priory down the valley from the city, on the right bank of the stream (St Saviour's Priory).

[1] Plummer, *St Laurent*, p. 135.

3. The Decoration of Manuscripts

A.D. 1020–1170

BY THE eleventh century, the history of Irish illumination is already a long one,[1] starting in the late sixth century or early seventh with the initials of the Cathach, passing through a brilliant period in the eighth century and the fantastic virtuosity of the Book of Kells in the ninth century. Fragments only have remained of the tenth-century manuscripts, a scarcity easily explained by the Viking depredations. We have seen already that the destruction was such that Brian Boru had to send beyond the seas for new books to replenish the plundered Irish libraries.[2] We shall have to ask ourselves the origin of these imported manuscripts. But let us see first what has survived of the Irish manuscripts of the eleventh and twelfth centuries.

In appearance, they lack the sumptuousness of the great evangeliaries of earlier times. Figured scenes are almost totally lacking, and the decoration consists essentially in ornamented capitals representing the whole range from simple letters drawn on a coloured background to complicated mazes of ornaments. Nevertheless, some of these books are still remarkably attractive and keep something, in their enigmatic meanderings, of the enchanting quality of some of the text pages of the Book of Kells. In fact, the repertoire – beasts and vegetables – does not depart radically from that of earlier manuscripts, but the treatment is more fluid, with less deliberate sharpness.[3]

[1] *Vol. I*, pp. 58 sqq. and 159 sqq.; *Vol. II*, pp. 58 sqq. [2] See p. 2.

[3] The decoration of most of these manuscripts has been published in: J. O. Westwood, *Palaeographica Sacra Pictoria* (London, 1843–5); Id., *Facsimiles of the Miniatures and Ornaments of Anglo-Saxon and Irish Manuscripts* (London, 1866–68); J. T. Gilbert, *Facsimiles of National Manuscripts of Ireland* (Southampton, 1874 sqq.), but for nearly a century it has attracted very little attention, though some of these manuscripts are mentioned in: J. Bruun, *An Enquiry into the Art of Illuminated Manuscripts of the Middle Ages*, published in 1897. For an attempt at a systematic study, see: Henry–Marsh-Micheli, *Illumination*, quoted throughout this chapter as: *Illumination*.

The humble appearance of their decoration and the poor state of preservation of several of them have meant that for a long time these manuscripts were completely neglected. They must be given now the place they deserve in the history of Irish art. Besides their own artistic quality, their interest rests also in the fact that they are important chronological and geographical landmarks. So that it is useful to turn first to them in order to get some idea of the evolution of Irish art in the eleventh and twelfth centuries.

Except for the Cambridge and Edinburgh Psalters,[1] none of these manuscripts is earlier than 1070. But about twenty manuscripts belonging to the hundred years prior to the Norman conquest (1170) have survived. From the point of view of text, they are extremely varied. Beside evangeliaries and psalters, there are text-books and also a few large compilations of poems, as well as epic and historic texts in Latin and in Irish.

There are three Gospel-books, fairly small and written in minuscules like the 'pocket Gospel-books' of the eighth and ninth centuries: the two Harley Manuscripts – 1023 and 1802 – in the British Museum, and Ms. 122 of the Library of Corpus Christi College, Oxford. To this can be added the only other New Testament text which has survived from this period, a copy of St Paul's Epistles in the National Library, Vienna (Ms. Lat. 1247), written in Germany by an Irish scribe.

The three psalters, in their general presentation, are a continuation of the tenth- and early eleventh-century psalters, such as those of the Cotton Collection,[2] and of St John's College, Cambridge.[3] They follow the same division into three Fifties of psalms, and, like them, they have a decorated capital at the beginning of each psalm. The British Museum Cotton Ms. Galba A.V. charred in the fire which played havoc with the Cotton collection in the eighteenth century is now no more than a pathetic ruin. On the other hand, the two other psalters, Add.Ms. 36.929 of the British Museum and Ms. Lat. 65 of the Palatine collection in the

[1] St John's College, Cambridge, Ms. C.9; Edinburgh, University Library, Ms. 56; See *Vol. II*, pp. 106 sqq.
[2] London, Br.M., Cotton Ms. Vilellius F.XI; see *Vol. II*, p. 107.
[3] See notes above.

Vatican Library are in a wonderful state of preservation and have kept all their brilliant colours. To these can be added the so-called 'Psalter of St Caimin' in the Franciscan Library, Killiney (Dublin), which in fact consists of only the very long psalm 118, written with extreme care and lavishness.

There are three missals, which, as far as their text is concerned, are practically Roman missals: one has passed from Drummond Castle, in Scotland, to the Pierpont-Morgan Library in New York, another belongs to the Library of Corpus Christi College, Oxford (Ms. 282), and the third, known as the Rosslyn Missal, is in the Advocates' Library in Edinburgh (Nat. Libr. of Scotland). Two other books are likely to have been written for liturgical use: they are the two very similar collections of hymns in Latin and in Irish, one in the Library of Trinity College, Dublin, the other in the Franciscan Library at Killiney.

The textbooks are represented by two fragments from Glendalough (Br. M., Egerton Ms. 3323) and a copy of Boetius's *De Consolatione* (Florence, Laurentian Library, Ms. LXXVIII, 19).

The collections of historical texts and miscellanea in Irish and Latin are: the Chronicle of Marianus Scottus of Mainz, written in Germany under his dictation by an Irish scribe (Vatican Library, Pal. Ms. Lat. 830); a fragment of the so-called 'Annals of Tigernach' which is copied in the first pages of Rawlinson Ms. B. 502 in the Bodleian Library; the collection of miscellaneous texts, poems, genealogies, etc., which constitutes the 'Lebor na Huidre' (Book of the Dun Cow) in the Library of the Royal Irish Academy, Dublin; and the so-called 'Book of Leinster' (T.C.D. Library and Franciscan Library) which has been identified with the manuscript referred to in old texts as the 'Book of Noughaval'.

Some of these manuscripts are fairly well dated: Marianus Scottus' Chronicle was copied in 1072 and 1073; The Vienna Epistles of St Paul in 1079; the Book of the Dun Cow was partly written by Máel Muire Mac Célechair, who died in Clonmacnois in 1106, and in consequence can be attributed to the late eleventh or early twelfth century; one of the pages from Glendalough is dated by a marginal entry to 1106; the colophons of Harley Ms. 1802 show that it was written in Armagh in 1138; the compiler of the 'Book of Leinster' was an abbot of the mon-

48

astery of Terryglass, near Lough Derg, who copied most of it between 1151 and 1161.

For other manuscripts it is only possible to establish the place where they were written, but not their exact date. From these various landmarks emerges a classification which may be arbitrary up to a point, but still facilitates the study of these very varied works.[1]

The first conclusion one is tempted to adopt is that the important monasteries such as Clonmacnois, Glendalough, perhaps Armagh, remained faithful to a very traditional type of ornamental capital.

The Book of the Dun Cow and the first part of Rawlinson Ms. B. 502 seem to be the work of a group of Clonmacnois scribes.[2] The Annals of the Four Masters tell us that one of them, Máel Muire Mac Célechair, who belonged to a famous Clonmacnois family, was killed by brigands in the cathedral of Clonmacnois in 1106. Other features also contribute to link the manuscript with Clonmacnois. Tigernach Ua Broein to whom were attributed the Annals a fragment of which constitutes the first section of Rawlinson Ms. B. 502, was abbot of the monastery where he died in 1088. Eoin Mac Neill has shown that he was far from being the only author of this compilation, but he certainly contributed to it.[3] As for the 'Dun Cow' which gives its name to the other manuscript, it had been the faithful companion of St Ciaran, the founder of Clonmacnois, when he was on his way to study in Clonard, and his Latin Life tells its story in detail. Its skin was kept in the monastery and was held in such veneration that lying on it when dying was believed to ensure a happy journey to the other World. It is not clear what was its link with the manuscript. Perhaps the book was kept wrapped up in the skin or simply locked in the same chest.

[1] See mentions of some of these manuscripts, from the point of view of the texts, in: Paul Walsh, *Irish Men of Learning* (Dublin, 1945), also: Dom Louis Gougaud, 'The Remains of Ancient Monastic Libraries', *in*: *Féil-sgríbhinn Eóin Mhic Néill* (Dublin, 1940), pp. 319 sqq.

[2] R. I. Best and O. Bergin, *Lebor na Huidre, The Book of the Dun Cow* (Dublin, 1929), Kuno Meyer, *Rawlinson B.502, a Collection of pieces in prose and verse in the Irish Language, compiled during the Eleventh and Twelfth Centuries* (Oxford, 1909), R. I. Best, 'The Rawlinson B.502 Tigernach', *Eriu*, 1913–14, pp. 30 sqq.; *Illumination*, pp. 114 sqq.

[3] E. Mac Neill, 'The Authorship and Structure of the Annals of Tigernach', *Ériu*, 1913, pp. 30 sqq.

These manuscripts are the oldest which can be certainly attributed to the Clonmacnois scriptorium, though it obviously had been at work for centuries. Their decoration is in no way prepossessing and consists chiefly in enlarged letters ending in finely drawn animal heads. Except for a slightly more elaborate capital in the Book of the Dun Cow, this is exactly the repertoire of ornamental letters which is found in the tenth- and early eleventh-century psalters. These are no more than current calligraphic devices where ornament plays only a secondary part.

However it remains possible that the Psalter of St Caimin[1] was written also in Clonmacnois and in this case the physiognomy of the scriptorium would appear richer and more complex. Before the seventeenth century when it reached the Franciscan historian, Michael O'Clery, it had been kept for centuries in the monastery of Inis Cealtra where St Caimin lived in the seventh century – hence its traditional name. Inis Cealtra is very near Clonmacnois, and as the main text of the psalm is surrounded by commentaries and glosses written in a tiny spiky minuscule very similar to the hand of one of the Dun Cow scribes, it may be another work of the same scriptorium. Linguistic reasons seem to date the glosses to the late eleventh century. Thus the manuscript would be contemporary with those described above and may represent another aspect of the work of the same group of scribes and illuminators.

It is fairly large (10 inches by $13\frac{1}{2}$ inches) and appears at once as a different type of work from the two other manuscripts. It is a luxury book, written with great care in a very regular and well-formed Irish majuscule. Special care has gone into the lay-out of each page. The capitals are still very simple, but they are inserted in the text with a great feeling for harmony and the brilliant spots of colour in the first letter of each verse give a vibrant tone to each page. This very elegant presentation allows us to guess at the sumptuous appearance of the lost liturgical manuscripts of Clonmacnois, made for use on the altar and meant to enhance the beauty of its decoration.

This copy of the very long psalm *Beati immaculati* (Ps. 118) may

[1] W. H. Hennessy, 'On a Manuscript written by St Caimin of Iniscealtra', *I.E.R.*, 1873, pp. 241 sqq.; Mario Esposito, 'On the so-called psalter of St Caimin', *P.R.I.A.*, 1915 (C), pp. 78 sqq.; *Illumination*, p. 117 sqq.

well have constituted a separate volume as its recitation is often com-
mended in Irish texts. It remains possible, however, that it only repre-
sents a fragment of a luxury psalter which would have had at least 200
folios. If such is the case, the beginnings of the three Fifties, which are
the usual divisions of Irish psalters, were certainly lavishly decorated
and it would then be rather futile to evaluate the style of the whole book
from one single psalm.

At the same time, Glendalough seems to have used a repertoire of
capitals very similar to that of Clonmacnois. A very simple example is
found on one of the textbook pages identified by Bieler and Bischoff[1]
(Fig. 3), that torn from the *De Abaco* of Gerbert of Aurillac, which
bears on its lower margin this curious entry in Irish: 'We are here in
Glendalough (ingliid [glind] dalacha) on the day of Pentecost. It is a
pity that Tuathal is ailing', to which the scribe had added shortly after-
wards: 'Even more of a pity that he died last night and will be buried
presently'. It seems possible, both from a palaeographical and linguistic
point of view to identify this Tuathal with the abbot of Glendalough who
died in 1106, according to the Annals of Ulster.

This small initial would be negligible but for its similarity to those of
the Drummond Missal, another Glendalough manuscript, which is now
in the Pierpont-Morgan Library in New York (Ms. 627)[2]. This is a
small volume (6 inches by 4½ inches) written in Irish minuscule with the
intrusion of majuscule forms in some parts of the text. It contains a
missal preceded by a calendar and has Irish poems written here and there
in the margins, and a poem in the form of a dialogue between St Kevin
and St Ciaran of Seir on the last page. A commemoration of St Kevin
found in the text of the missal itself leaves little room for doubt that the
book was written in St Kevin's monastery of Glendalough. From names
mentioned in the calendar, it was written sometime after 1061, probably
in the early twelfth century.

[1] Egerton Ms. 3323 (ex Phillips 21162), fols. 16 and 18; see: L. Bieler – B.
Bischoff, 'Fragmente zweien frühmittelalterischer Schulbücher aus Glendalough',
Celtica, 1956, pp. 211–20; *Illumination*, pp. 120 sqq.

[2] New York, Pierpont-Morgan Library, Ms. 627; see: G. H. Forbes, *Missale Drum-
mondiense, The Ancient Irish Missal in the possession of the Baroness Willoughby de Eresby,
Drummond Castle, Perthshire* (Burntisland, Edinburgh, 1882); *Illumination*, p. 122.

Fig. 3. Capitals from the Drummond Missal (except *a*, from Egerton Ms. 3323).

Its decoration consists only of ornamental capitals with animal heads, some small spirals and colour fillings. In style, they fit perfectly well with the capital in the *De Abaco* of the Egerton manuscript (Fig. 3). The designs are full of vivacity and inventiveness and occasionally rise to a majesty which one would hardly expect on such small pages, but in inspiration they remain strictly traditional.

It was probably at about the same date that a scribe from Armagh decorated the small Gospel-book No. 1023 of the Harley collection in the British Museum.[1] He drew his inspiration partly from the Book of Armagh, written in the same scriptorium and already for three centuries one of the precious possessions of the monastery of Armagh. We shall examine it in more detail later. At present it suffices to mark its place in this archaic style of decoration to which can also be attributed the manuscript of the Epistles of St Paul written in Germany by Muiredach Mac Robartaig, a monk from the north of Ireland who came to Germany in 1067 and settled in Ratisbon where he came to be known as Marianus Scottus. It is a volume of 160 folios, written in a Continental type of minuscule, but with glosses containing Irish words and a commentary whose script has definitely insular features. At first, the capitals at the beginning of each Epistle are simply large letters without ornament. Gradually, however, their ends sprout into stunted spirals, then into little animal heads, or a small knot of interlacing, revealing the nostalgia of the scribe for a type of decoration which he had known in Ireland before his departure.

However, side by side with these manuscripts, and perhaps in the same scriptoria, new decorative styles were developing. To the zoomorphic elements which constituted the chief embellishment of the capitals were added vegetable forms, either leaf-shaped terminals or else a blossoming of scrolls and palmettes. So far, in Irish decoration, plant ornament was rare and generally confined inside a few well-defined frames. The sudden vogue for this wild vegetation raises problems which will be discussed later, when its origin and development can be evaluated in view of all the elements of chronology and style supplied by the study

[1] See p. 63.

53

of the various other techniques. So far, we can only register the fact itself.

This vegetable ornament in the manuscripts usually takes the shape of a sort of half-palmette curled at the top, often placed at the end of the tail or a paw of the letter-beast, but also found separately, for example on the outskirts of the network of interlacings which surrounds the animal's body, where it may form a sort of lace-like fringe.

The best examples of this motif are found in manuscripts of the late eleventh or early twelfth century, but it lives on during the whole twelfth century and constitutes at the end of the century the chief decorative element of the psalter of Cormac (Br. M.).

The earliest dated manuscript where it is found, Ms. 830 of the Palatine collection in the Vatican Library,[1] shows this motif already fully developed. This again is a manuscript written in an Irish monastery in Germany, partly by another Marianus Scottus, Marianus of Mainz, whose real name was Moel Brigte. He has given us in the manuscript itself a few data on his wandering existence. He was born in Ireland in 1028 and entered the monastery of Mag-bile (Moville; Down). In 1056 he went into exile, on the advice of his abbot, Tigernach Bairrcech as a penance, it seems, for a trifling fault. He settled in the Irish monastery of St Martin of Cologne, then went to Fulda. He was ordained in the monastery which had developed near the tomb of the Irish saint, Kilian, in Würzburg. Then he became a recluse in a walled cell in Fulda; later he was transferred to another cell in the monastery of St Martin in Mainz, where he died in 1082 or 1083. He had undertaken in his reclusion the writing of one of those world chronicles so fashionable in Ireland at the time, on a similar pattern to that which Tigernach and his collaborators were writing at about the same date in Clonmacnois. He completed his work in Mainz, and for a few months another Irish exile shared his reclusion and copied the text under his direction. Most of what we know about the scribe is found in a marginal note written in a strange mixture of Irish and Latin. It reads: 'It is pleasant for us to-day, o Moel-brigte, incluse, in the incluse's cell in Mainz, on Thursday before the feast of Peter, on the first year of my (penitential) rule, that is in the

[1] B. Mac Carthy, *The Codex Palatino-Vaticanus, No. 830* (Dublin, 1892); Kenney, *Sources*, pp. 614–6 (No. 443); *Illumination*, pp. 126 sqq; for the text: *P.L.* CXLVII.

year in which was killed Diarmait, king of Leinster; and this is the first
year I came from Scotland (Albain) in peregrinitate mea (in my
pilgrimage). Et scripsi hunc librum pro caritate tibi et Scotis omnibus,
id est Hibernensibus, quia sum ipse Hibernensis (and I copied this book
for the love of you and all the Scots, that is to say the Irish because I am
myself Irish)'. This gives us first an itinerary – through Scotland
towards the Continent – which seems to have been frequently used, and
also a very precise chronological indication. Dermot (Diarmait, son of
Máel na mbo, king of Leinster), was killed by the king of Meath at the
battle of Odhbha, in the early part of the year 1072. The scribe must
have started on his journey shortly after this event, as in that year the
28th of June, eve of the feast of Peter and Paul, fell on a Thursday. He
may have gone on with his work during the end of the year and perhaps
the first months of 1073. He left the manuscript unfinished and Marianus
completed it, inserting in the contemporary part of the chronicle a
series of entries concerning his own biography which often start by
'Ego Marianus . . . (I, Marianus . . .)'.

One may wonder what significance can be attributed to the mention of
Diarmait's death in connection with the origin of the scribe. Both the
Annals of Ulster and the Four Masters tell us that in 1071, Kildare,
Glendalough and Clondalkin were burned, probably in the confused
fighting which preceded the death of Diarmait. If the scribe belonged to
a monastery which suffered in that year, it might have been the cause of
his departure. But these references to outstanding historical events were
common enough as a means of dating and it would be rash to draw any
other conclusion from this mention of the death of Diarmait than the
fact that the scribe probably belonged to one of the two kingdoms
directly concerned, Leinster or Meath.

The manuscript has 70 folios of irregular sizes, on an average of about
10 inches by $11\frac{1}{2}$ inches. The scribe wrote a beautiful, clear Irish minuscule
which shows, here and there, some Continental features. Whilst most of the
smaller initials in the text are of Irish shape and are filled with red in the
usual Irish way, there are occasionally all through the manuscript, initials
in red ink of current Continental pattern. Marianus, however, who had
lived for a long time abroad, wrote in a minuscule of Continental type.

This mixed character is manifest also in the decoration. There are, inserted in the text, a few diagrams, two figured drawings,[1] and also several ornate capitals (Pl. 9). A page of slightly smaller size than the others has a Crucifixion and a Deposition in a definitely Ottonian style of drawing; it could possibly be an insertion, borrowed from another book. Still, the other drawing – the Fall and another Crucifixion – has been executed on a part of a page otherwise occupied by the text of the Chronicle, and it shows, on a much smaller scale, some features similar to those of the larger drawing. It may be that Marianus asked a German monk to add these two pictures to his text. But it is not impossible also that after fifteen years spent on the Continent he had mastered not only Continental script but the local style of drawing and perhaps he wanted to show off this accomplishment. As for the capitals,[2] they are obviously due to the scribe and belong to a different world. One of them (on Fol. 26r), drawn in a thick black line on a red background is of the type of archaic capital common in the Clonmacnois manuscripts. The others are made up of ribbon-shaped animals bent to the shape of the letter, closely akin to those in the Southampton Psalter or the Book of the Dun Cow. But they are accompanied by foliage motifs and one of them is all wrapped up in the knots of soft tendrils (Pl. 9). This is a completely new type of ornament of which we have only seen some indications so far in details of the Edinburgh and Ricemarcus Psalters.

The same ornament reappears, with a great luxury of variants and changes, in both volumes of the *Liber Hymnorum*, the Irish Hymnal, which contains Irish and Latin hymns.[3] Nothing is known of the origin of these manuscripts, and they are mentioned for the first time in the seventeenth century, one as entering the Library of Trinity College, Dublin, the other being in the hands of the Franciscans of the Priory of Donegal, who took it in the middle of the century to their monastery of Louvain. From there, after complicated wanderings, it finally

[1] *Illumination*, Pl. XLIV. [2] Id., Pl. VI.

[3] T.C.D., Ms. E.4.2; Killiney (Co. Dublin), Library of the Franciscan House of Celtic Studies, Ms. A.2; J. H. Todd, *Leabhar Imuinn, The Book of Hymns of the Ancient Church of Ireland* (Dublin, I, 1855, II, 1869); J. H. Bernard – R. Atkinson, *The Irish Liber Hymnorum* (London, 1898); L. Bieler, 'The Irish Book of Hymns, a Palaeographical Study', *Scriptorium*, 1948, pp. 117 sqq.; *Illumination*, pp. 129 sqq.

Colour plates between pages 56 and 57
A. and B. Two pages of the Psalter of Cormac

Et anima mea turbata est
ualde. Et tu domine usquo.

Conuertere domine. & eripe animā
meam. Saluum me fac. ppr
misericordiam tuam.

Quoniam non est in morte. qui me
mor sit tui. in inferno au
tem. quis confitebitur tibi.

Laboraui. in gemitu meo. lauabo
per singulas noctes lectum mm.
lacrimis stratum mm rigabo.

Turbatus est a furore oculus
meus. inueteraui inter
omnes inimicos meos

Discedite a me omnes. qui opera
mini iniquitatem. qm exau
diuit dominus. uocem fletus mei.

Exaudiuit dominus. deprecat
onem meam. dominus oratione
meam suscepit

erubescant. & conturbentur uehement̄
omnes inimici mei. conuentantur &
erubescant. ualde uelociter.

Domine dr meuy inte sperani.

XPR DE SINAGOGA. incipit

Domine deus meus inte speraui:
saluum me fac. ex omnibus per
sequentibus me. & libera me.

Ne quando rapiat ut leo ani
mam meam. dum non est qui re
dimat. neque qui saluum faciat

Domine deus meus. si feci istud. si
est iniquitas. in manibus meis.

Si reddidi retribuentibus mihi ma
la. decidam merito. ab inimicis
meis inanis

Persequatur inimicus animam
meam. & comprehendat. & conculcet
in terra uitam meam. & gloriam
meam. in puluerem deducat.

came back to Ireland and is now in the Franciscan Library in Killiney.

Both books are very similar in text, without being identical, and they seem to be two versions of the series of hymns used in the Irish monasteries or in one particular monastery. They seem to go back to a common exemplar whose date, for linguistic reasons, can be ascribed to the early part of the eleventh century. The Killiney volume appears to be a slightly later recension done in the scriptorium which had produced the Trinity copy. The evidence from the decoration point of view confirms the linguistic data and allows us to date the Trinity volume to the second half of the eleventh century, the Killiney one to the early twelfth.

Before trimming, their pages must have been practically the same size (about 12 inches by 8 inches). The Trinity manuscript is written in an archaic type of Irish majuscule for the Latin texts and three different sizes of minuscule for the Irish texts and the commentaries, while the Killiney manuscript is written in a large, and bold minuscule with a small spiky minuscule for glosses and prefaces.

The decorative scheme is the same in both books: each hymn begins with a large capital, especially elaborate for the first hymn of each collection, and the first letter of each verse is picked out in bright colour. Both are in a deplorable state of preservation, a fact which may partly explain why so little notice has ever been taken of such remarkable decoration.

The Trinity manuscript must originally have been brilliantly coloured (Pls. 2, 3). The painter used freely green, red, yellow and purple, and varied his effects by the use of hatchings and dotting of one colour upon another. This is a very old device of Irish painters and the illuminator of the St Gall Gospels had already obtained startling changes of tone by the use of over-dotting.[1] The general effect, taking into account the bright and varied tones of the fillings of the verse capitals, must have been intensely bright, with something of the wild sense of colour which is a characteristic of these late books. Most of the capitals are very close in design to those of Marianus' Chronicle, though the foliage-patterns, more elaborate and usually picked out in golden yellow, constitute a sort of scintillating fringe around the animal (Pls. 2, 3). The beast itself may

[1] *Vol. I*, pp. 196 sqq.

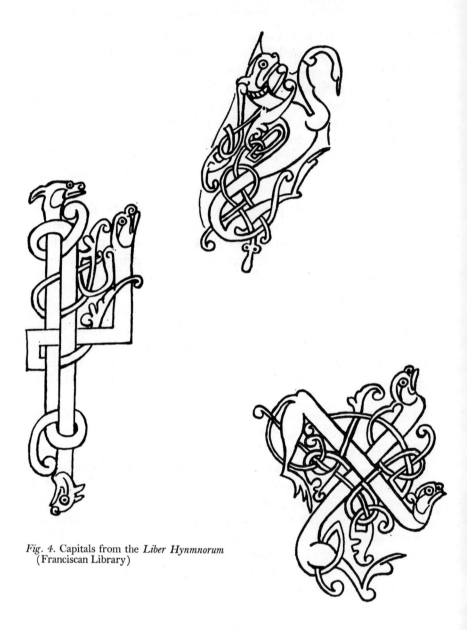

Fig. 4. Capitals from the *Liber Hynmnorum*
(Franciscan Library)

58

not be fully defined and most of its legs are generally absent. But this does not in any way impede its impetuous leaps and bounds which still keep a good deal of the spontaneity of its far-off ancestors in the Book of Kells. In spite of the more Baroque appearance of these capitals, they are probably not much later in date than those which Marianus' scribe was drawing in Mainz in 1072, so much so that one could imagine him being trained before his departure from Ireland in the very scriptorium which produced the two copies of the *Liber Hymnorum*.

The capitals of the Killiney manuscript are drawn more finely (Fig. 4) and may not have been as vivid in colour. The foliage, which is now no more than a line drawing, was probably originally painted in a golden tone. But green appears only occasionally. The designs have a remarkably incisive quality and the animals are sometimes more coherently built than those of the Trinity volume. Some of them are quite wonderful, for example the arachnean network of the large capital on the first page, or a little Chinese-looking dragon. This dragon shows a detail which we have not met so far: it is caught not only in the strands of foliage, but in the knots of a little snake with a head seen from above, which we shall meet soon again elsewhere.

The second section of Rawlinson Ms. B. 502,[1] generally ascribed to *c.*1120 for linguistic and paleaographical reasons, shows the same decorative features as the Killiney *Liber Hymnorum*. It has been savagely trimmed, to the point of interfering with some capitals, so as to bring it to the same size as the first section, when they were bound together, and is now $11\frac{1}{2}$ inches by $8\frac{1}{2}$ inches. It consists of 70 folios written in two columns in a very regular Irish minuscule. The beginning (fols. 19–40) is occupied by the Saltair na Rann – the psalter of the Quatrains – a long biblical poem in Irish. Then come poems, genealogies, etc., chosen in such a way as to point to a Leinster monastery as the place of origin of the manuscript. Of all the miscellaneous collections of texts, Book of the Dun Cow, Book of Leinster, Rawlinson Ms. B. 502, this last is without comparison the most accomplished as to presentation. The vellum is darkened and the colours are faded, but in their pristine freshness, the pages of the Saltair na Rann, with the five or six red, purple and yellow

[1] See p. 49.

59

initials at the beginning of the stanza must have given an impression of pleasant harmony. The beginning of each new chapter of the book was stressed by the addition of green to the colour-scheme used on the other pages, and by the presence of an especially large capital consisting of a green and purple letter-beast accompanied by thin golden-yellow inter-lace on an orange-red background (Pl. G). The genealogies are framed in an odd way, which is found also in other manuscripts: the lists of names are separated by vertical bands of various tones which end at top or bottom by animal heads and paws (Pl. 12). This is a new version of the animated frames so frequent in eighth-century manuscripts.

The small capitals are very similar to those of the Killiney *Liber Hymnorum*. Like them, they often consist of one single animal, though the drawing has here a more naturalistic character. Fish, bird, snake, are hardly bent at all to the shape of a letter. Others suggest it by spontane-ous acrobatics; they are bound in the fine knots of their tails tied to the right, to the left, and sprouting each time into a little half-palmette. The tracery of some of these letters sometimes attains a singularly poetic accent, for example in the drawing which, by a simple play of meandering foliage-stems conjures up the outline of an erect bird with wings half fluttering.[1] As in the Killiney manuscript, small snakes with pointed jaws lurk in the network of interlacing surrounding the beasts of the large capitals. They are very similar to the thread-like snakes which constitute part of the decoration of St Lachtin's reliquary, made shortly before 1121 for a Munster church. This fits in well with the 1120 date usually given, for linguistic reasons, to the manuscript.

Thus various aspects of the same decorative style, spread out over a period of fifty years (1072–1120), are represented in these four Manu-scripts, Marianus' Chronicle, the two versions of the *Liber Hymnorum* and the Oxford codex. It seems to live on without losing anything of its vivid power of invention until late in the twelfth century, as it forms the basis of the decoration of the Psalter of Cormac which can hardly be earlier than the second half of the century.

Other decorative schemes were, however, developing at the same time. We have seen some traces of them in the Killiney *Liber Hymnorum* and

[1] *Illumination*, Pl. XVI, C.

the Rawlinson Ms., both books with a dominant vegetable motif belonging to the first quarter of the twelfth century. The most striking of these new themes is that of the great beast surrounded by snakes. This forms the fundamental pattern of the decoration of the Missal of Corpus Christi College, Oxford and it reappears constantly in other books dating from the second or third quarter of the twelfth century.

The 'Corpus Missal'[1] is a small book, about $6\frac{3}{4}$ inches by $4\frac{3}{4}$ inches, written in Irish minuscule. It is somewhat battered: its wooden binding is partly broken and its pages are darkened and uneven. It is kept in a leather satchel also no doubt of Irish origin, but too tight-fitting to have been made to contain it when it was complete (Pl. 1). Nothing is known of its history before it came to the College, and as it has no colophon, it is impossible to know when it was written. Warren who studied it in detail, ascribed it to the monastery of Clones (Monaghan), for very unconvincing liturgical reasons. On the other hand, the prayers for the king of Ireland and his son which it contains may well have been intended for Turlough O'Conor, so that the missal may have been written for a monastery founded or restored by Turlough. Nothing gives a definite chronological indication. But the close analogy of the decoration with some of the panels of the Cross of Cong, made between 1123 and 1136 makes it likely that it also belongs to the end of the first quarter of the twelfth century. Warren dated it much later, between the Synod of Kells (1152) and that of Cashel (1172), because he thought that a missal so close to the 'Roman' missal could only have been written in Ireland at such a late date. As we have seen, such a view comes from a complete misconception of the way in which the reform developed in Ireland. As in the case of the Glendalough Missal (Drummond Missal), a date in the early part of the century is perfectly possible.

At first glance, one is struck by the great importance the decorated capitals assume on such small pages. They were very violently coloured, with a combination of a sharp blue, a deep tone of purple and a brilliant

[1] F. E. Warren, *The Manuscript Irish Missal belonging to the President and Fellows of Corpus Christi College, Oxford* (London, 1879); *Illumination*, pp. 137 sqq.; A. Gwynn, 'The Irish missal of Corpus Christi College, Oxford; *Studies in Church History*, I, pp. 47 sqq.

yellow, enhanced by backgrounds of sealing-wax red. The drawing is equally exuberent. All the large capitals are made of blue or purple ribbon-shaped monsters tied up in the multiple knots of crawling snakes with heads usually seen from above (Pls. 4, 5, J). These beasts have the usual round heads of the fauna of Irish manuscripts, but they are generally shown in action, their jaws half-open, their large eyes staring, their long claws raised in attack. Beside these elongated, aggressive little monsters there are also occasionally reptilian forms of vaguely prehistoric mien heavily progressing across the page. The few indications of Continental connections lie in the use of coloured backgrounds, and the presence of a small grotesque figure similar to the mock-atlantes which support the columns of arcadings in some of the Ottonian manuscripts and reappear frequently in the eleventh- and twelfth-century Limoges manuscripts.

Though the wild accent of the decoration of the missal has few real parallels amongst Irish manuscripts of the twelfth century, its repertoire, ribbon-shaped monsters and snakes, reappears sporadically in most of them, from the *De Consolatione* of Boetius in the Laurentian Library to the Rosslyn Missal, Pal. Ms. Lat. 65 of the Vatican Library and the Book of Leinster (T.C.D. Library). In many cases it is combined with examples of the foliage style.

Let us now leave all these unlocalized manuscripts to turn our attention to the scriptoria of the north of Ireland whose works are much easier to study. There the chief scriptorium was at Armagh, but other centres, probably connected with impulses given by St Malachy, can be linked with it.

Of all Irish monastic scriptoria, that of Armagh is the only one whose history can be followed for centuries. In the early ninth century, one of its scribes, Ferdomnach, wrote the Book of Armagh (T.C.D.)[1] which contains, besides a collection of documents relative to St Patrick a New Testament with the Gospels treated as a separate volume and decorated with splendid pen-drawings of the Evangelists' symbols. Later, probably towards the end of the same century, a scribe trained in the same script

[1] *Vol. II*, pp. 99 sqq.

and working probably for Abbot Mac Durnan (888–927) wrote a small Gospel-book decorated with brilliantly coloured miniatures,[1] nearly repeating in a few of its pages compositions of the Book of Armagh. This tradition of small Gospel-books written in minuscule, but elaborately decorated was still alive in the twelfth century, as witness Ms. 1802 of the Harley collection in the British Museum, written in Armagh in 1138 and another book in the same collection, Ms. 1023, which obviously comes also from Armagh and may be slightly earlier.

It is in consequence with this last manuscript[2] that we shall begin the study of the Armagh scriptorium in the twelfth century. It is a small volume, 8 inches by $5\frac{1}{2}$ inches, thus very nearly the same size as the Book of Armagh. It is written in Irish minuscule, by several very similar hands. The text is Vulgate, though with many Irish readings, some with close parallels in the Book of Armagh. There are glosses, mainly explanations of words, in Irish and Latin, which have been inserted by the scribes of the main text. There are also thirteenth- and fifteenth-century additions in English hands which may have been written either in Ireland or in England, and consequently give no indication as to the history of the manuscript before the time it reached Robert Harley, Earl of Oxford, in the eighteenth century.

The volume is incomplete and the greater part of the Gospel of St Matthew is missing, so that it is impossible to know whether it originally had prefaces and canon-tables. As usual the decoration is mainly at the beginning of each Gospel and consisted of a drawing of the Evangelist's symbol on the left page and the beginning of the text with a large capital on the opposite page. The symbol of St Luke has been torn out, so that only the symbols of Mark and John remain. These pen drawings of symbols recall the Book of Armagh, though the style, as might be expected, is very different (Pls. 6, 7). The capitals, elegantly drawn in black on a background of coloured mosaic, have the usual little terminal paws and animal heads. This fidelity to old models brings us back into the atmosphere of

[1] *Vol. II*, pp. 102 sqq.

[2] E. S. Buchanan, *The Four Gospels from the Irish Codex Harleianus numbered Harley 1023 in the British Museum* (London, 1914); Kenney, *Sources*, p. 648 (No. 482), Zimmermann, p. 109, III, Pl. 215, *c, d*, 216, *c.*; *Illumination*, pp. 146 sqq.

the Clonmacnois and Glendalough manuscripts of about the same time.

The other Gospel-book,[1] though belonging to the same tradition, admits all sorts of borrowings from new fashions. It is slightly smaller than Ms. 1023 ($6\frac{1}{2}$ inches by $4\frac{1}{2}$ inches) and must have been practically of the same size as the Book of Mac Durnan before its pages were trimmed. It is written in Irish minuscule. It seems obvious that the book was planned from the start to receive in the wide margins a commentary surrounding the main text in the way of the glossed Bibles which were becoming so fashionable on the Continent at that time. In spite of this and though the commentary was written in an unbelievably small script, it often overflows on fragments of vellum inserted here and there. A moment came, though, when the scribe had no longer any commentary at hand. He then reverted to a normal lay-out without extra-wide margins. We have seen the curious history of this commentary.[2]

It is obvious that a few pages are missing at the beginning of the book and it starts in the middle of the preliminaries. Then comes the genealogy in St Matthew's Gospel which is treated as an independent text, separated from the text of the Gospel by eight folios of glossaries, arguments and Latin and Irish miscellaneous texts. Irish scribes always have a tendency to consider St Matthew's Gospel as starting only after the Genealogy, but none of them so far had done it with quite the same impudence. As we shall see, each Gospel ends with a colophon giving the name of the scribe: Máel Brigte Ua Máeluánaig.

The history of this manuscript is strange enough to deserve mention. It is impossible to know when it left Ireland. In the beginning of the eighteenth century, it was in the Royal Library in Paris, where it was described by Père Richard Simon in his *Bibliothèque critique*. He had read the colophon in a most fanciful way and attributed the book to 'a monk

[1] R. P. Simon, *Bibliothèque critique* (Paris, 1708), pp. 271 sqq.; *A Catalogue of the Harleian Manuscripts in the British Museum* (London, 1808), II, p. 229; R. Flower, *Catalogue of the Irish Manuscripts in the British Museum*, II, p. 429; W. Reeves, in *P.R.I.A.*, 1851, pp. 45 sqq.; W. Stokes, 'The Irish verse notes and glosses in Harl. 1802', *Revue celtique*, 1887, pp. 346 sqq.; Kenney, *Sources*, p. 648 (No. 483); Zimmermann, pp. 109, 255–6, III, Pl. 215, *a*, *b*, 216, *b*; *Illumination*, pp. 148 sqq.

[2] See p. 4; R. Glunz, *History of the Vulgate in England from Alcuin to Roger Bacon* (Cambridge, 1933), pp. 211 and 328 sqq.

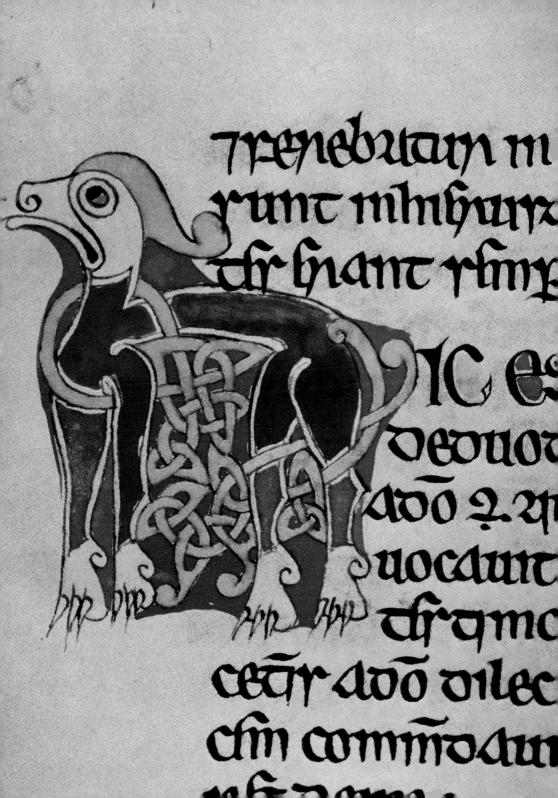

7 reneburani m
runt mihi hui
dr hianr rfiuf

IC es
deduou
ado 2 ap
uocaiut
drqmo
cetr ado dilec
cfm commodau

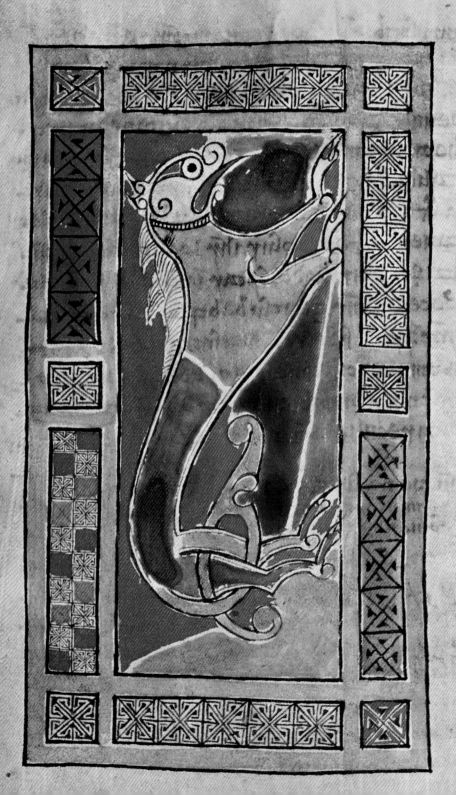

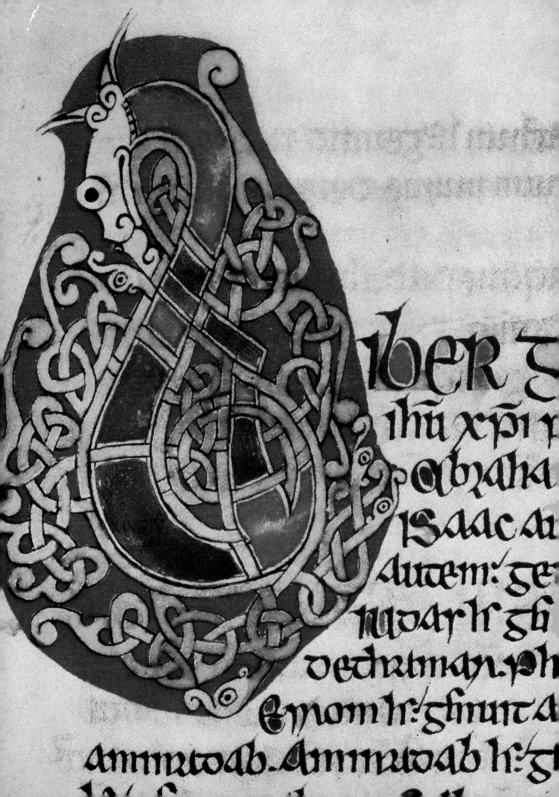

ber g
ihu xpi p
Abraha
Isaac au
autem: ge
rudar lr gn
dechiman ph
emom lr/gñuit A
aminicadab. Aminicadab lr/g

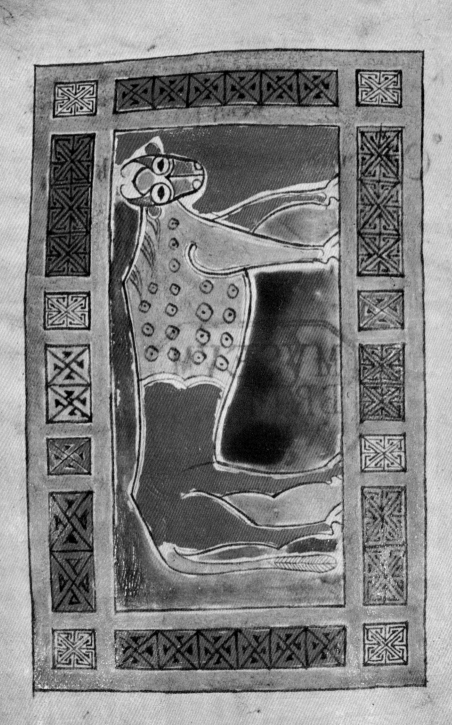

Secundum euangelium
... nomen ... pace
quoniam. lectio...
... que diu ...
... omnes ...
... Neque ...

Iohannes
qui non ...
grunt ...
Amo ...
diebuit no...
... xpm ...
nunc. Et nunc ...
... apparuit ...
ipsum ... Masy...
dilexit ex omni...
theopfile ut co...
o eorum euno...
in diebus ... herod...
... dor quondam no...
abie. iuxta illum ...
elisabeth. En an...
... ciolis ... mommbri...
mbz domini ... qui ...
eo quod esset ... helig...
cessarent in diebus...
... ux bilt sacerd...
et congruo mem p...
cenrum ponene...
Iohannis multitudo...
hora incens. Ap...
rtaur adex tr...
charias ... an bus...
meum. Et ka d...

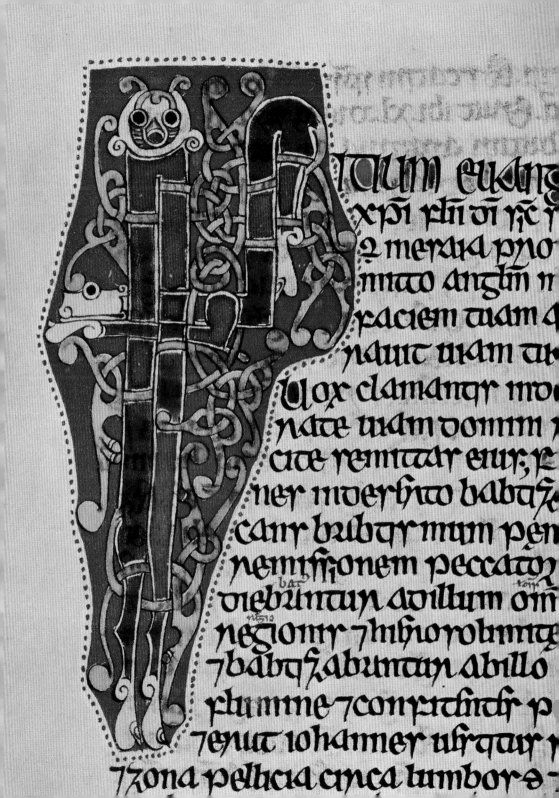

ITIUM euang
xpi filii di ihc
2 meraia pho
nuio angim n
raciem tuam q
nauit uiam tu
 Uox clamantir mo
nate uiam domini j
cite remittar eius; j
ner inderstio babtiz
catur babtiri mum pen
remissionem peccatoi
diebuntan ad illum om
negiomr 7 hiriorolimir
7 babtizabuntan abillo
flumine 7 confitentir p
7 enut iohannes uestitir 7
7 zona pellicia crnca lumbor

t. utr ho glins
or kt nob hec
anta confenat
2. Petndem. nc
onnemunfia
lata 7 beate
nagaingbz mha
qraurilium p
p. cõ Ernita
ta ienttn ece nex
luacton mundi.
7 pacttq rmm
mrtamet cr
amr humana
tatem. p. hõ
e fximkam
lbzfacttrqttr
nefoue crioll
ur pdommu.

uen natq no
dat 2 nob cri
in humeti dno
no-e magmorht
clutapticabrta.
once dequttou
or tidiorumftt
notta pctmetta
lbeitetqr rubr
ttgo uet2 trhtttd
pes mattgra
rte mattcttc tne
obtti or loctter
bz ttppptttr non
dtt dtttt ttqrto

called Dom Ealbrigte' (do maelbrigte) who, according to him, 'wrote at least eight hundred years ago' (that is to say in *c.* 900), in 'old Saxon characters'. By the time his book appeared, the manuscript had, in fact, disappeared from the Royal Library from which it had been abstracted, with several other volumes, by Jean Aymon who took them to Holland. There it was examined by John Toland, a native of Donegal, who recognized it as Irish and advised Robert Harley to buy it. It eventually passed with his collection to the British Museum. The 1808 *Catalogue of the Harleian Manuscripts in the British Museum* corrects Père Simon's errors, and since then the Irish texts in the manuscript have been studied by Robin Flower in his *Catalogue of the Irish Manuscripts in the British Museum*. These texts are numerous and varied in their nature, but only the colophons need be examined here. At the end of St Matthew's Gospel, one finds, in a mixture of Irish and Latin,: 'Pray for maelbrigte *qui* scribsit *hunc* librum. It is an awful deed cormac mac carthaig having been killed by tairdelbach hua briain'. The first sentence is repeated at the end of each Gospel, with the addition in St Luke's of: 'in XXo VIIIo anno aetatis suae (in his twenty-eighth year)'. The last colophon, much more elaborate, gives the full name: 'Máel Brigte Ua Máeluánaig' and adds 'who wrote this book in Armagh'. Then follows a long list of the kings who reigned then in the various parts of Ireland. It is a very important historical document. But all that matters to us here is that the dating elements concur to give 1138 as the date when the manuscript was copied.

This manuscript, like the other Gospel-book in the Harley collection, had originally an Evangelist's symbol at the beginning of each Gospel, though two only have survived, one in guise of St Luke's symbol, a fantastic ox, half yellow half orange, outlined on a background where purple, green, red and yellow succeed each other (Pl. F) and a much more elegant symbol of St Mark (Pl. D), one of these curious monsters with the profile of a Chinese dragon which occur occasionally in Irish manuscripts of that time. It is also outlined on a variegated background and its tail ends in a foliage motif similar to those in the *Liber Hymnorum*. However, the frames of these two symbols recall those of the pocket Gospel-books of the eighth and ninth centuries. In all the decoration of

65

the book, this juxtaposition of traditional motifs with much more up to date ones remains manifest, to the point of seeming a deliberate device. Two of the large capitals, in the beginning of the Gospels of St Mark and St John, and likewise the small capitals in other parts of the book are drawn in a thick black line ending in spirited little animal heads. They are exact parallels to the initials of the Harley 1023 and they have antecedents in most manuscripts of earlier centuries back to the Book of Armagh or the Book of Mulling. There are, however, capitals of an absolutely different type in the beginning of the text proper of St Matthew (XP) (Pl. 10) and the Gospel of St Luke (Pl. G): they consist of ribbon-shaped animals, with foliage and great flourishes of paws suggesting the shape of a griffin's wings, in other words, all the repertoire of the *Liber Hymnorum*. The similarity, in one special case, goes to the point of quasi-identity (Pl. 10 and Fig. 4). This complexity shows the extraordinary difficulties of this study of manuscript decoration, and the danger of drawing conclusions from fragments of incomplete books. Some motifs are carefully kept alive over centuries, and they are liable to reappear in the most incongruous juxtapositions with more recent inventions. In the case of Máel Brigte, we know from some marginal notes in the book that he was brought up in Armagh, but did he travel and visit other scriptoria in the course of his brief career? From his indignation about the death of Cormac Mac Carthy one may wonder if he had not met him. It could have been in Armagh where Cormac came in 1134 for the enthronement of St Malachy as primate. But it could also have been in Munster. As, unfortunately, we do not know which monastery fostered the development of the foliage capital, such speculations have to remain vague.

Nevertheless we get from these two manuscripts a picture of an Armagh scriptorium steeped in tradition, and only opening up to new styles in the later part of the second quarter of the twelfth century, a picture which will seem fairly puzzling when we come to examine the much bolder and more up to date decoration of the shrine of St Patrick's Bell, made for Armagh around 1100.

Several other manuscripts are connected with this milieu and show a

slightly later stage of its development. They seem to come from Bangor, from Down and from an Irish foundation in Scotland, and they all belong to the area where St Malachy's influence was strongly felt.

One of them, Ms. 122 of the Library of Corpus Christi College, Oxford, is a Gospel-book similar in size to Harley Ms. 1023 ($8\frac{1}{2}$ inches by $5\frac{1}{2}$ inches).[1] It is nearly complete, lacking only the beginning of the Gospel of St John. It is in a wonderful state of preservation, and here is at last a book which gives some idea of the original state of all the derelict volumes wrecked by damp and carelessness which we have examined so far. The vellum has kept its ivory whiteness, a clear and soft foil for the bright red escutcheons streaked by the blue and purple beast-letters and the golden knots around them. The presentation is so devoid of artifice that it might be brutal, were it not for the perfect accord of the colours which gives a poignancy to that harsh shriek.

Nothing is known of the manuscript before it was given, in 1619, to the Oxford College by one of its fellows, Henry Parry,[2] who had connections with Ireland. The Irish origin of the manuscript is obvious, and is sufficiently demonstrated by the type of minuscule used and by the presence of a gloss in Irish. But in addition, a very curious text, inserted between the canon-tables and the *Novem opus* preface connects it clearly with the monastery of Bangor. This is the 'Gospel Game' (*Alea Evangelii*, literally: Gospel dice), of which the gaming-board and gaming-pieces are drawn with great care, and which is described as having been brought back by 'Dubinnsi, bishop of Bangor, from the court of the king of the English, Aethelstan' where it was explained to Dubinnsi by 'a Frank and a Roman [i.e. Byzantine] scholar, who was an Israelite'. Dubinnsi, bishop of Bangor, died, according to the Annals, in 953. As we have seen,[3] his visit to the court of Aethelstan (924–939)

[1] H. O. Coxe, *Catalogus Codicum MSS qui in Collegiis Aulisque Oxoniensibus hodie adservantur*, II (Oxford, 1852), p. 52, Westwood, *Facsimiles*, p. 95; Kenney, *Sources*, pp. 647–8 (No. 481); *Illumination*, pp. 152 sqq.

[2] Glunz (*History of the Vulgate*, p. 65) says that the manuscript 'was written in Dublin in the eleventh century'. The mention of Dublin is pretty obviously deduced from the fact that members of the Parry family are buried in Dublin, a fact which has no real bearing on the origin of the manuscript.

[3] *Vol. II*, p. 103.

may be connected with the bringing to England of the Book of Mac Durnan. At this time, the monastery of Bangor may already have been abandoned, and Dubinnsi, bishop, and possibly abbot, in name only, may have lived in Armagh. So it is perhaps in Armagh that the *Alea Evangelii* was preserved as a precious possession, transmitted from one to the other of the nominal abbots of the destroyed monastery.[1] The manuscript in Corpus Christi College was probably written for Bangor after the restoration of the monastery by St Malachy. This can hardly have been during the short period (1124–1127) when Malachy erected on the old site a few wooden buildings which were destroyed during Conor Mac Loughlin's attack. Much more likely is the time when, shortly after his return from the Continent in 1140, St Malachy undertook vast constructions in Bangor. Such a date would explain some features of the manuscript: the text, much nearer to the Vulgate than those of the Harley manuscripts, the very regular appearance of the script, obviously trying to give the illusion of a Continental lay-out of pages, perhaps also the large red fields on which the capitals are outlined and the small human heads inserted in some parts of the ornament. The design of the arcadings of the canon-tables, very remote, in their sober lines, from the usual fantasies of the Irish canons, are fairly similar to those found in the first Citeaux manuscripts, and especially in the Bible of Stephen Harding written around 1109.[2]

If our manuscript dates, as is likely, from *c.* 1140, it is nearly contemporary with Harley Ms. 1802, copied in 1138. Like it, it has several very traditional small initials with animal heads. It has even a very surprising Chi-Rho, all surrounded with spirals (Pl. 11) which seems an imitation of a page of a manuscript of the type of the eighth-century Maihingen Gospels.[3] However, the three large capitals which have survived (Pls. E.I) are well-developed examples of the new style where the beast-letter is accompanied by foliage and even a few snakes, combining the styles of the Corpus Missal and the *Liber Hymnorum.*

[1] J. Armitage Robinson, *The Times of St Dunstan* (Oxford, 1923), pp. 69–71 and 171–81.

[2] Municipal Library, Dijon, Ms. 15; Charles Oursel, *La miniature cistercienne* (Mâcon, 1960).

[3] *Vol. I*, pp. 178 sqq.

Some features of this splendid Gospel-book re-appear in a manuscript which is, however, very far from its perfection, the Coupar-Angus Psalter (Pal. Ms. Lat. 65 in the Vatican Library).[1] It was planned on ambitious lines. In size, it competes with the large eighth-century Gospel-books (9 inches by 12¼ inches). Its script is also on a large scale, majuscule for the first page of each Fifty of the Psalter, minuscule for the rest. Each psalm is accompanied by a commentary taken from the *Maior Glossatura* of Peter the Lombard, the final text of which came out in 1143–5. Before reaching the Heidelberg Library, from which it was sent, during the Thirty Years War to the Vatican, it had belonged to the Scottish Cistercian Abbey of Coupar-Angus of which it bears a thirteenth century ex-libris. When going to the Continent in 1148, St Malachy crossed from Bangor to Scotland and stopped in Galloway to found the monastery of *Viride Stagnum* (Soulseat, Wigtownshire), where he left a few monks under an abbot who had been a monk at Bangor.[2] From the way St Bernard mentions it, this monastery seems to have followed the Cistercian rule.[3] It disappeared fairly soon and it would be only normal that another Cistercian monastery in Scotland inherited its books. Thus, we may assume that the Coupar-Angus Psalter was written in *Viride Stagnum*. It is a surprising book, and its decoration, impetuous, both in design and colour, seems at times a sort of caricature of the style of the Corpus Christi Gospel-book. It is handled with such uncouthness that it would hardly deserve notice were it not that it confirms the popularity of this style in the milieu where St Malachy laboured. This is especially notable, as it shows how much the reformer remained steeped in Irish tradition.

The Rosslyn Missal (Edinburgh, Advocates' Library, Ms. 18. 5. 19)

[1] *Codices Palatini Latini Bibliothecae Vaticanae* descripti Praesidi J. B. Cardinali Pitra, H. Stevenson Jr. et I. B. de Rossi, I (Rome, 1886), p. 11; H. M. Bannister, *Specimen Pages of two Manuscripts of the Abbey of Coupar-Angus in Scotland* (*Codices e Vaticanis selecti*, ser. min. II) (Rome, 1910); Id., 'Irish Psalters', *Journ. Theol. Studies*, 1910–11, p. 280; F. Ehrle, F. Liebart, *Specimina Codicum Latinorum Vaticanorum* (Bonn, 1912), Pl. XXIV; *Illumination*, pp. 157 sqq.

[2] Lawlor, *Vit. Mal.*, ch. 68.

[3] St Bernard does not say explicitly that the monks followed the Cistercian rule, but he refers to them as 'our brothers'.

may be of slightly later date.[1] It comes from Down, whose see St Malachy occupied from 1137 to 1148. Unlike the Coupar-Angus manuscript, its capitals are delicately drawn and full of fantasy, but the painter still relies on the same repertoire, with only slight variants (Fig. 5).

Fig. 5. Capitals from the Rosslyn Missal.

There remain to be examined two manuscripts very different from

[1] H. J. Lawlor, *The Rosslyn Missal* (London, 1889); A. Laurie, 'The Pigments used in painting the Rosslyn Missal in the Advocates' Library and the Celtic psalter D. p. 111.8 in the Library of the University of Edinburgh', *Proc. Soc. Ant. Scot.*, 1923, pp. 41 sqq; F. E. Warren, *The Manuscript Irish Missal belonging to the President and Fellows of Corpus Christi College, Oxford* (London, 1879), *passim*.

each other both in contents and text, though they have in common the fact of belonging to the second half of the twelfth century.

First, there is the famous Book of Leinster[1] (T.C.D., Ms. H. 2. 18; Francisc. Libr., Ms. A. 5),[2] celebrated for the various texts it contains, chiefly the *Táin Bó Cúailnge*, the Ulster epic. It was until recently considered as a book done for a patron, either Dermot Mac Murrough or even Turlough O'Brien. But William O'Sullivan has shown convincingly that the entries relative to Dermot are additions to the original manuscript, and sees in it 'the last fling of the learned ecclesiastics of the unreformed Irish church', and a later version of the type of monastic book already represented by the Book of the Dun Cow. It is the work of several scribes, but the chief ones seem to have been Áed Ua Crimthainn, abbot of Terryglass, and Find Ua Gormáin, bishop of Kildare and for a long time abbot of the old Patrician monastery of Newry. Áed died in 1160, leaving the manuscript incomplete, and it was added to for a number of years. The manuscript is in very poor condition and is no more now than a collection of unbound pages, darkened and stained by age.

The decoration consists of little capitals at the beginning of some sentences or some sections of the text. Exceptionally, the *Táin* starts with a larger ornamental letter whose colour-scheme includes a shade of 'shocking-pink' unknown in the usual range of colours of twelfth-century manuscripts. The small capitals include most of the types of ornament we have found in other manuscripts so far: beast with snakes, foliage, animal heads. To this are added little human heads of incisive, nearly caricatural drawing, which lend its peculiar character to the manuscript (Pl. 13). The schematic description of the banqueting-hall of Tara includes a little figure, vivid and slightly burlesque, which gives us

[1] Its real name is Book of Noughaval (Lebor na Nuachongbála), a name which comes from the fact that it was kept in the later Middle Ages at Oughavall (Co. Leix).

[2] T. K. Abbott, *Catalogue of the Manuscripts in the Library of Trinity College, Dublin* (Dublin, London, 1900), No. 1399, pp. 360–4; T. K. Abbott and E. G. Gwynn, *Catalogue of the Irish Manuscripts in the Library of Trinity College, Dublin* (Dublin, 1921), No. 1339, pp. 158–61; R. I. Best, O. Bergin and M. O'Brien, *The Book of Leinster, formerly Lebar na Nuachongbala* (Dublin, I, 1954, II, 1956, III, 1957); A. Gwynn, S.J., 'Some Notes on the History of the Book of Leinster', *Celtica*, 1957, pp. 1 sqq; *Illumination*, pp. 159 sqq; Gwynn-Gleeson, *Killaloe*, pp. 44 sqq; W. O'Sullivan, 'Notes on the Script and Make-up of the Book of Leinster', *Celtica*, 1967, pp. 1 sqq.

reason to regret that no other figured representation has survived in the manuscripts of this period (Pl. 16).

The other book is a small psalter (7 inches by 5½ inches), preserved in the British Museum (Add. Ms. 36.929).[1] From an artistic point of view it is infinitely more valuable than the Book of Leinster. It is in the same wonderful state of preservation as the Gospel-book of Corpus Christi College, but its decoration is much richer. Like it, it glows with intense shades of blue, purple, green and yellow, on red backgrounds, but the large initials at the beginning of each Fifty are of an extreme complexity and each covers most of the surface of the page (Pls. 14, 15, H). The opposite pages have ornamented frames, originally meant to surround figured scenes which were never drawn.[2] In addition to this lavish decoration at the beginning of the Fifties, every page of text is enlivened by coloured letters at the beginning of each verse and larger, very bright capitals introducing each psalm (Pls. A, B). There are also, as in the Book of Kells, animals which mark the end of verses written below the main line. It is a gay, vivacious decoration which adds a few unusual features to the main repertoire of the period, especially a very precisely drawn half-palmette and minute human heads forming the end of some interlacings.

An original feature of the book is a musical colophon where Cormac, the scribe, asks our prayers below four staves ruled in black and red: 'Cormacus scripsit hoc psalterium ora pro eo. Qui legit hec ora pro sese qualibet hora'. Apart from his Irish name, we do not know anything of the scribe's origin or history. The book was bought in Munich in 1904. It lacks, however, those Continental features which we noted in the work of both Marianuses, so that it must have been written in Ireland. The musical notations give, up to a point, a chronological landmark. The nearest parallels to them are found in manuscripts of the second half of

[1] *Catalogue of Additions to the Manuscripts in the British Museum in the years MDCCCC–MDCCCCV* (London, 1907), pp. 259–60; H. M. Bannister, 'Irish Psalters', *Journ. Theol. St.*, 1910–11, p. 282, Zimmermann, pp. 109 and 256, III, Pl. 216 *a*; *Illumination*, pp. 161 sqq.

[2] The frame of the first Fifty is filled by the 'absolutio' (see next page); the two other frames are empty except for a Dextra Dei appearing in the corner of that facing the 'Quid gloriaris'.

the twelfth century, dating from *c.* 1165–75 and having, most of them, Cistercian connections. For example, a manuscript in the Municipal Library in Douai (Nord) (Ms. 372), which comes from the Benedictine monastery at Anchin and contains a copy of the Office of St Malachy, taken probably from a Cistercian original around 1165; or the Breviary of Citeaux,[1] which dates between 1173 and 1191. These comparisons are especially remarkable as our manuscript has a definite indication of contact with a Cistercian milieu: one of the texts inserted in the frame on the page facing the first Fifty is headed: *absolutio bernarddi* [*sic.*]. It is a formula of absolution which has parallels, but no exact equivalent in other twelfth-century manuscripts. Its attribution to St Bernard comes to confirm both a date in the second half of the twelfth century and a connection with a Cistercian milieu. All this seems to place the book at a date very near that of the Norman invasion, and to make it possible that it could have been copied for one of the new Cistercian monasteries which grew up after 1148.[2]

It is strange that the work of the Irish monastic scribes should end as if in fireworks, with a manuscript whose brilliance and perfection has practically no equivalent amongst the Irish manuscripts of the Romanesque period. It gives the impression of heralding a new flowering of Irish illumination. Then, instead of the works one is entitled to expect, the Norman invasion brings a break without parallel. From that time all Irish liturgical manuscripts were either made in England or modelled slavishly on imported works. Of the other categories of manuscripts, a few of those written in monasteries in the thirteenth and fourteenth centuries still show the survival of an Irish tradition of initials.[3] But the main bulk of the manuscripts later than the Norman conquest are the work of professional scribes usually passing on from one generation to the next a fixed tradition of script and ornament. And thus, this manuscript which seems so full of promises marks in fact the end of an artistic era shortly to be brutally destroyed by the invasion.

[1] Dijon, Bibl., municip., Ms. 114. [2] See pp. 185 sqq.
[3] Such as for example the copy of the Annals of Tigernach made in Clonmacnois, which is in the Bodleian Library (Rawlinson Ms. B. 488).

4. Metalwork

A.D. 1020–1170

METALWORK OF the Romanesque period is represented in Ireland by a series of nearly complete objects, slightly battered and tarnished, but still giving a magnificent picture of the work of the craftsmen of that time, and much more gratifying to the historian than the disjointed fragments which are practically the only witnesses to ninth- and tenth-century craftsmanship.[1] Only a few decorative panels are missing from three croziers found, one in Clonmacnois, another near Killarney[2] and the third in Lismore Castle. The reliquary-cross of Cong is complete except for one bronze plaque and a few studs. The shrine of St Lachtin's arm is almost intact. Though St Manchan's shrine is not as well preserved, it is in sufficiently good condition to give a clear idea of the appearance of large shrines of which no earlier example has survived.

Around these pieces and adding to what they tell us, can be grouped all sorts of less well-preserved fragments: incomplete croziers or broken and repaired reliquaries and book-boxes. This does not mean that there are no gaps in our information. No decorated chalice, flabellum or pyx of this period has come down to us. Other objects very popular in earlier times seem to have gone out of fashion or not to have survived. For example no hanging-lamp later than the Ballinderry lamp[3] is known and it may be that they were not manufactured after the mid-ninth century.

[1] On these objects, see: G. Coffey, *Guide to the Celtic Antiquities of the Christian Period preserved in the National Museum, Dublin* (Dublin, 1909); H. S. Crawford, 'A Descriptive List of Irish Shrines and Reliquaries', *J.R.S.A.I.*, 1923, pp. 74 sqq; and 151 sqq; *Christian Art in Ancient Ireland* (quoted as *C.A.A.I.*), Vol. I, ed. by Adolf Mahr (1932), Vol. II, ed. by Joseph Raftery (Dublin, 1941) (to be consulted for all objects mentioned in this chapter); Margaret Stokes, *Early Christian Art in Ireland* (London, 1887, Dublin, 1911, 1928). For the inscriptions, see: G. Petrie, *Christian Inscriptions in the Irish Language* (publ. by M. Stokes) (Dublin, 1872, 77); R. A. S. Macalister, *Corpus Inscriptionum Insularum Celticarum, Vol. II* (Dublin, 1949).
[2] The so-called 'Inisfallen Crozier'.
[3] See *Vol. II*, pp. 112–14 and Pl. III, Fig. 14.

74

The same may be true of penannular brooches, of which no example can be definitely dated to the eleventh and twelfth centuries. In this case a change in clothes fashions may explain this disappearance. The way in which many objects have been transmitted to us might, however, account up to a point for these deficiencies. Though a few have been found by chance, most of them, whether croziers, book-boxes or shrines proper, were reliquaries, containers of an object believed to have belonged to a saint or of a manuscript relating his history, and as such they had their custodians. It is known, for example, that three of the great relics of Armagh, the 'Staff of Jesus', the Book of Armagh and St Patrick's Bell, had each its own keeper who watched over them, carried them in important functions and held on this account substantial land-endowments. When the monasteries were dissolved in the sixteenth century, the family of these keepers or that of the last abbot or steward generally kept these precious objects which were then transmitted from father to son for centuries. In many cases the hereditary custodians only parted with them in the nineteenth century.[1] There are countless examples of this but the most remarkable story is probably that which concerns St Patrick's Bell and its shrine.[2]

At the dissolution of the monastery of Armagh, the O'Mulchallan were its keepers. They went on looking after it from generation to generation. The last of them died childless at the beginning of the nineteenth century. He was a schoolmaster, and one of his pupils, Adam Mac Lean, had become an important merchant in Belfast; and was in 1798 in a position to save the life of O'Mulchallan who had taken part in the insurrection. A few years later, on his deathbed, O'Mulchallan told him to dig at a certain place in his garden where his most precious possessions, were hidden, which he wanted to give him. There, enclosed in an

[1] See some examples quoted in Gwynn-Gleeson, *Killaloe*, pp. 142–3: 'Just before the Famine, John O'Donovan found the O'Hagans of the Creggaun in Youghalarra parish in possession of the staff of St Coolaun'. . . . 'A little later, Thomas Lalor Cooke, the historian of Birr, got possession of the bell of St Molua of Clonfert-Molua (or Kyle), near Roscrea, from Father Egan, the parish priest of Dunkerrin, whose mother – a Deegan of Cloncoose – was the last representative of the coarb family there'.

[2] W. Reeves, *Memoir of the Clog an Edachta commonly known as St Patrick's Bell or the Bell of Armagh* (Dublin, 1877); see also: *T.R.I.A.*, 1877–86, pp. 1 sqq.

oak box, Mac Lean found St Patrick's bronze bell in its gilt shrine.

Some Irish churches had gathered treasuries well on a par with those of Continental monasteries of the same time. In 1129, the high altar of the cathedral of Clonmacnois was burgled. The Annals list the missing objects: a 'model of Solomon's Temple', a drinking horn and a cup, a silver chalice with gold insets, all gifts of kings or chieftains, a silver cup given by Cellach, archbishop of Armagh, a drinking horn with a golden mount, finally a chalice and a paten given by Turlough O'Conor a few years previously.[1]

Incidentally, an episode in the fighting which immediately followed the Norman invasion shows clearly to what hazards the metal objects were exposed as a result of the importance and power attached to them. In 1177, two of the Northern kings, accompanied by the 'successor of Patrick' (the archbishop-primate of Armagh), together with 'the shrines from the North and his clergy', tried to wrench Downpatrick from John de Courcy. But the army took flight, the clergy were massacred, the relics remained on the battlefield and the primate was taken a prisoner.[2] When the Normans released him they gave him back the Book of Armagh and a bell, but they kept the rest, the 'sweet-sounding bell of St Patrick', the crozier of St Mura of Fahan and several other croziers.

Some of the metal objects of Romanesque time have inscriptions which often help to fix their date or at least their origin. We saw that St Molaise's shrine was completely remodelled between 1001 and 1025.[3] This is the first chronological landmark. Then come:

[1] *A.F.M.*, 1129; *A.C.*, 1129; *A. Tig.*, 1129, 1130, The Annals of Boyle, 1196, give a similar indication: 'the altar of the great church of Derry was robbed by Mac Cienacht of 314 cups, which were esteemed the best of their kind in Ireland' (*R.C.*, 1925, pp. 284 sqq.).

[2] The most detailed account is in *A.U.*, 1177; see also *A.F.M.*, 1177; the Book of Mac Carthy is briefer: 'Patrick's coarb was captured, but was released by the English of their own accord and the Canóin Pádraig and the Ceolán Tighearnaigh (the Book of Armagh and the 'Lord's Bell') were brought back from the Galls, after they had been found in the slaughter, when their young keepers were killed [*A.U.*: when the clerical students were killed]. The Galls have all the other relics still' (*M.C.*, 1178). Most of the relics were probably finally restored to their monasteries, except some of the relics of Armagh which may have remained in the hands of de Courcy and finally reached the treasury of the cathedral of Sens.

[3] *Vol. II*, p. 120.

The cumdach (book-case) of the Stowe Missal wrought in Clonmacnois between 1045 and 1052.

The cumdach of the Cathach made in Kells in the last years of the eleventh century.

The shrine of St Patrick's bell made for Armagh between 1094 and 1105.

The Lismore crozier made for an abbot of Lismore between 1090 and 1113.

The shrine of St Lachtin's arm which dates between 1118 and 1121.

The cross of Cong begun around 1123 and finished between 1127 and 1136 in the neighbourhood of Roscommon or Elphin.

These few dates give a rather satisfactory chronological framework, as several other objects can be connected with the inscribed ones from a similarity of decoration or the use of similar technical processes. It is thus possible to group the Inisfallen crozier and the top knop of the British Museum crozier with the side panels of the Cathach shrine which have the same bands of niello and the same type of foliage patterns. The British Museum bell-shrine which comes from Glankeen (Tipperary) makes a transition between this group and two other objects, the shrine of the arm of St Lachtin and the Clonmacnois crozier whose decoration consists essentially of ribbons of silver inset in the bronze surface. Finally, the cross of Cong and St Manchan's shrine have in common a decoration of red and yellow enamels (found also on the Glankeen bell-shrine) and animal-interlacings in gilt bronze, often in openwork.

The inscriptions tell us also something about the craftsmen themselves. There were certainly families of lay workmen attached to some of the monasteries, such as the Mac Aedas in Kells, or Cúduilig and his sons in Armagh.[1] The workshops of the great monasteries seem to have been resorted to from afar for the execution of luxury objects. Two outstanding examples are the sending of the Stowe Missal, kept probably at the time in Terryglass or Lorrha, to the better equipped monastery of Clonmacnois, where it was enshrined in a cumdach,[2] and the dispatching to Kells for the same purpose of several objects belonging to the O'Donnells, a branch of the Northern Uí Néill reigning in Inishowen.[3]

The technical processes used by the eleventh- and twelfth-century

[1] See pp. 89 and 95. [2] Book-shrine. [3] See pp. 88 sqq.

metalworkers differ in many ways from those used in the eighth and ninth centuries. There are still bronze and silver panels of chip-carving, but instead of being gilt by fusion as in the eighth century they are generally covered with a thin sheet of gold or silver, a method which had come into use already on the ninth- and tenth-century croziers. This is far from being satisfactory, as the applied sheet of precious metal is inclined to blur the sharpness of the original design, and is also liable to be torn off either as a result of normal wear and tear or through the cupidity of a robber. This has happened repeatedly. A few outstanding examples of the old-style gilding are, however, to be found occasionally, as for example on the Inisfallen crozier, the cross of Cong and the shrine of St Manchan, showing that the actual process was still known, though it had lost its exclusive prestige.

The colours and textures of surfaces are varied by several methods. In the eighth century, the use of enamel, sometimes combined with millefiori glass, was the chief way of enlivening the appearance of an object. The practice of enamelling probably went on uninterrupted, though no example of it can be quoted to bridge the gap between the early ninth-century Ballinderry escutcheons[1] and Prosperous crozier[2] and the enamels which are found on many of the late eleventh- and twelfth-century objects. The technique remains in both cases so much the same that no interruption is likely, and this comes only as one more proof of the paucity of our information on the metalwork of the Viking period.

The only obvious difference between the red and yellow enamels found on late objects such as the British Museum bell-shrine, the cross of Cong or St Manchan's shrine and the earlier ones is the fact that the geometric patterns are red on a yellow background in the Romanesque objects whilst before they used to be the reverse. The base of the Breac Maodhóg has an enamel border where red and yellow champlevé alternates with millefiori chequer-patterns. There is also a millefiori decoration on the border of the crook of the Lismore crozier and thin sections of millefiori glass have been applied by fusion on some of the glass studs of the same crozier. A technique similar to cloisonné enamel, unknown so far in Ireland, appears on three objects of this time,

[1] *Vol. II*, pp. 113–14. [2] *Vol. II*, pp. 115–16.

and may show an attempt at imitating Byzantine models. On one of them, the shrine of St Patrick's bell,[1] there is on the upper part of the front side a blue disc, in which is inscribed a small flower whose red and white petals are circumscribed by tiny gold ribbons put on edge. As it is impossible to examine the back of the disc, one cannot be certain whether the technique is a real cloisonné or if it is of the same type as that used in some parts of the Ardagh chalice where a molten glass bead is applied to the back of a little enamelled panel decorated with metal ornaments or cloisons. This last process has probably been used for a blue rectangular stud on the base of the Breac Maodhóg,[2] obviously cast in a mould which gave it its swastika pattern, but where the remains of a tiny gold box made to contain another colour of enamel can also be seen. A fragment of crozier in Dublin Museum shows some discs with flower insets which may be a real cloisonné.[3]

There are a few other remarkable examples of enamel and of studs which were first cast and then enamelled, such as the bosses of the cross of Cong decorated with interlacings on a blue background, the blue glass which decorates the bodies of the animals on one of the panels of the shrine of the Stowe Missal (Pl. 28), and finally the small palmette with blue, green and white (or yellow) champlevé which is inserted at the end of the crook of the Clonmacnois crozier.

Niello is also very commonly used. This is not entirely a novelty in Irish metalwork, as the Steeple Bumpstead boss already showed bands of niello,[4] but it is found much more frequently from the middle of the eleventh century on. In some cases the paste of silver and sulphur is inserted in thin grooves such as those which run parallel to the silver ribbons on the Clonmacnois crozier, or it may occupy larger areas. In this case, probably to prevent scaling, a zigzagging silver band, put on edge, runs the whole length of the surface or folds itself so as to cover any widening of it. This method was used by the Romans and survived in Byzantine work. It was imitated by the Saxons in the sixth and seventh centuries, with a champlevé approximation of the silver inset. Irish craftsmen never seem to have resorted to this expedient. So Byzantine

[1] See p. 94; Pl. 22. [2] See p. 117; *C.A.A.I., Vol. I*, Pl. 62, 1b.
[3] *C.A.A.I.*, Vol. II, Pl. 86, 2. [4] *Vol. I*, Pl. 43.

models, once more, may have supplied the inspiration. This pattern is found already on two bell-shrines which probably go back to the tenth century, the Corp Naomh[1] and the Bann fragment which comes from Ahoghil.[2] It plays an important part in the decoration of the top knop of the British Museum crozier and the side plaques of the cumdach of the Cathach and it is found also on the Inisfallen crozier and in a few places on the Clonmacnois crozier. So it looks as if it was in the tenth and eleventh centuries that this technique became fashionable.

Filigree work of this period cannot compare for technical perfection or minuteness with that of the eighth century, and appears as no more than a coarse imitation of it, often made of thick and heavy threads. This decadence of the filigree was plain already at the beginning of the eleventh century on the shrine of St Molaise.[3] The Inisfallen crozier has, nevertheless, a few panels of comparatively fine filigree. At first sight the gold filigree of the cross of Cong and the silver work on St Lachtin's shrine seem tolerably good. A closer examination reveals that they are made of fairly heavy flattened notched threads put on edge. Those on the shrine of St Patrick's bell are due to a strange process where the patterns seem to have been made by thick brass wires embedded in mastic. A thin gold foil then seems to have been applied on each panel, wrapped over the brass threads, and may have carried a final pattern of gold threads. The whole arrangement is very rough (Pl. 27).

There are also some processes of metal incrustation which seem, in Ireland, to belong only to the Romanesque period. One of them consists of borders made by hammering into a groove twists or plaits of mixed red copper and silver wires. Once the threads have been completely inserted, the surface is polished and the result is a rope-pattern of two colours. This method had been used by Merovingian and Scandinavian metalworkers but was becoming obsolete by the time it was adopted in Ireland.[4] The oldest Irish example of it is a little plaque applied on one of the weights found at Kilmainham.[5] The fragments of jewellery which have been attached to these weights are of Irish original although they were probably mounted thus for use by a Viking. They go back to the

[1] *C.A.A.I.*, Vol. I, Pls. 68–9. [2] *Vol. II*, Pl. 56. [3] *Vol. II*, Pl. 59.
[4] Salin, *C.M.*, III, pp. 166 sqq. [5] *Vol. II*, p. 38; *V. Ant.*, III, pp. 50–1, Fig. 33a.

second half of the ninth century, a date which makes sense in relation to the chronology of the non-Irish examples of the technique. This type of ornament is found then, at a later date, on the long sides of the Cathach shrine, on the Glankeen bell-shrine (Pl. K) and the Clonmacnois crozier (late eleventh- and early twelfth-century).

The other inset technique is also based on hammering, this time to press silver ribbons into shallow grooves cut into the surface of a bronze object; they are usually accompanied on each side by thin bands of niello. The best examples of this method are found on the Clonmacnois crozier, the shrine of St Lachtin and the Glankeen bell. As the bronze was originally gilt, the resulting effect, very pleasing no doubt, was a silver tracery edged with black outlined on the gold background. Silver incrustations, often accompanied with niello, are found frequently on Continental objects of the seventh and eighth centuries, such as belt-buckles.[1] The eighth-century Tassilo chalice in Kremsmunster (Austria)[2] shows its application to a liturgical vessel. However, the peculiar aspect of the Irish insets, with their ribbon tracery, seems nearer to Byzantine work. The bronze gates of the sanctuary of Monte Gargano in Apulia,[3] made in Byzantium in 1076, show a magnificent example of drawing carried out in silver lines. We have already noted a few other examples of imitations of Byzantine techniques in Irish metalwork of the eleventh and twelfth centuries; this may be another example of contacts whose exact conditions escape us.[4]

During all this period casting is of a good quality and shows even a great skill in the handling of bronze or silver. Crozier crooks, for example, are usually cast in one piece, with a groove for the insertion of a crest. The openwork panels of the cross of Cong and the shrine of St Manchan, so finely wrought, are also examples of technical mastery.

[1] Salin, *C.M.*, III, pp. 197 sqq.

[2] G. Haseloff, *Der Tassilokelch* (Munich, 1951).

[3] H. Leisinger, *Romanische Bronzen* (Zurich, 1956), Pls. 124 sqq.

[4] They may, however, be indicated by a significant eleventh-century quatrain on an Irish fair:

> 'Three busy markets on the ground,
> A market of food, a market of livestock,
> The great market of the Greek strangers,
> Wherein is gold and fine raiment.'

If we come back to the chronological list given above, the first object we meet is the cumdach in which were enshrined the Stowe Missal and the fragment of St John's Gospel which accompanies it.[1] This is a fairly shallow box, $7\frac{1}{4}$ inches by $6\frac{1}{4}$ inches and $2\frac{1}{8}$ inches in height, made of wood covered with metal sheets. Its decoration has been altered repeatedly and several inscriptions, some of the eleventh, others of the fourteenth century, correspond to these different stages. The upper part of the box is entirely medieval, but the rest shows the eleventh-century ornament practically intact, except for the presence of a late stud and the absence of a few fragments. There was on the under part an openwork decorative plaque, and the sides show, alternately, figured scenes and ornament (Pls. 28–30, 32, 48). The eleventh-century inscription engraved on the under part says that it was made by Dunchad O'Taccain, a monk of Clonmacnois,[2] for Donagh, son of Brian Boru, who was king of Ireland ('with opposition') from 1023 to 1064, and Mac Raith O'Donoghue, king of Cashel from 1045 to 1052. In consequence, the cumdach was made between 1045 and 1052.[3] The fourteenth-century inscription makes mention of an abbot of Lorrha. From this the conclusion has been drawn that the manuscript and its box were already in the same region, in Lorrha or in Terryglass, at the time when a monk of the neighbouring monastery of Clonmacnois made the cumdach. Though this is only a probability, it is a likely one.

The 1045–52 date places this shrine sometime after the shrine of St Molaise, made between 1001 and 1023[4] which has also a figure decoration. The style, however, is very different, and seems almost more archaic. Certainly the little compact panel which shows two ecclesiastics, one with a bell, the other with a crozier, on both sides of a little harp player and an angel, recalls the heavy and massive style of the tenth-

[1] *Vol. I*, p. 201; G. F. Warner, *The Stowe Missal* (London, 1906); *C.A.A.I.*, I, Pls. 65–7.

[2] Macalister, *Corpus*, II, pp. 104 sqq. (No. 932); *C.A.A.I.*, II, pp. 154–5; for the entries relative to Donagh O'Brien and Mac Raith O'Donogue, see: M. Stokes, *Early Chr. Art in Ireland*, pp. 75–8. The inscription only mentions 'Cluain' which has always been assumed to refer to Clonmacnois.

[3] And not between 1023 and 1052 as has often been said.

[4] *Vol. II*, pp. 120 sqq., Pls. 58–9.

century crosses (Pl. 30); but the other panels are rather different: on one of them a little figure holding a dagger tightly is surrounded by four animals (Pl. 29), on others a warrior passes in profile, a spear in one hand, a shield in the other (Pl. 48), or a stag is attacked by dogs (Pl. 32);[1] in the middle of each of the narrow sides one finds the same motif of an angel surrounded by two beasts whose bodies make a perfectly circular frame (Pl. 28). All this shows a curious mixture of spontaneity and stylization. The subjects remain obscure, all the more so since half the panels are missing. Except for the harp-player panel, they are all in openwork, and the gilt bronze figures originally all stood in bold relief on a background of patterned gold foil of which only one fragment has survived. All the older part of the decoration is also treated in open-work, and consists of bronze plaques completely wrapped in silver foil backed by a thin sheet of gold applied on the red copper plaque which covers the wooden box. To these metallic contrasts enamel and glass added their bright tones, the blue of the angels' wings, the red spot on the chest of one of them and the now vanished enamel on the little bell.[2] The panels of chip-carving interlacings inserted in the inscription plaque on the under part recall the little panels on the ninth- and tenth-century croziers. Such survivals of an earlier style, often very dull in execution, occur on most of the objects which we are going to examine.

These two fairly archaic reliquaries, the Soiscél Molaise and the cumdach of the Stowe Missal, are followed by a series of objects which, although they do not wholly break with the old styles, show completely new patterns and a sense of decorative rhythm combined with bold design which comes as a novelty: the Inisfallen crozier, the upper knop of the British Museum crozier, the cumdach of the Cathach, and the Misach; as we have seen, the Glankeen bell-shrine is connected with this group.

The Inisfallen crozier, judging by its ornaments, is probably the older

[1] An arrow or the tip of a spear pointing at the neck of the stag shows that this is intended for a scene of hunting and not simply an animal fight.

[2] The surface of the bell (Pl. 30) is covered with irregular hatchings which are obviously a key for enamel.

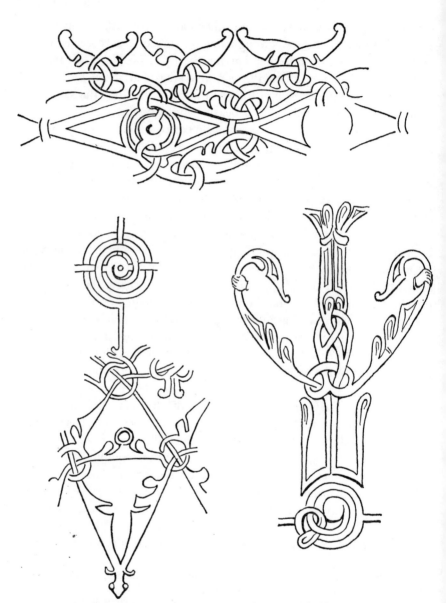

Fig. 6. Foliage: upper knop of the British Museum crozier, Inisfallen crozier, Breac Maodhóg.

84

of these objects, and the late part of the British Museum crozier is probably only very slightly more recent. As the cumdach of the Cathach is dated by its inscription to the last years of the eleventh century, the whole group seems to belong to the second half of the eleventh century.

The so-called Inisfallen crozier,[1] which is exhibited in the National Museum, Dublin, was found in the river Laune at Beaufort Bridge, near Killarney (Kerry). It may have belonged to an abbot of the monastery on Inisfallen, an island in the lower lake of Killarney, though the monastery of Aghadoe, on the shore of the lake, is closer to the find spot. There is also a possibility, even if it was looted from Inisfallen, that this crozier was brought there from afar, as the Annals of Inisfallen mention the death in 1075 at Inisfallen of Aicher Ua Domnalláin, bishop of Lorrha.[2] Though we use here the traditional name for convenience sake, it is essential to remember that its ultimate provenance remains problematic.

It must have been a magnificent object. Its appearance is now seriously altered by the oxydation of the silver surface which looks dull and black, though without obliterating completely the elegance and strength of the design (Pl. 21). It is 3 feet 8 inches long. It is built, like all Irish croziers, around a wooden core covered with metallic plaques – here plaques of silver.[3] It has four knops, one of which merges into the ferrule and another into the base of the crook. The two middle ones are divided into small compartments containing zoomorphic ornaments originally plated with gold and separated by silver frames. Technically these panels are treated like those of the lower knops of the British Museum crozier, but the animals are of a different type, and have often long jaws curled up at the end. This is the most traditional part of the crozier. The upper and lower knops have a splendid decoration of pliant

[1] *C.A.A.I.*, II, Pls. 87, 2 and 89, p. 159; Crawford, *List*, p. 168; *J.R.S.A.I.*, 1891, p. 607, 1918, p. 107.

[2] 'The bishop of Lothra, Aicher Ua Domnalláin died in Inis Faithlinn', *A.I.*, 1075, 5. The same Annals record at 1180 the plundering of Inisfallen by Máel Dúin, son of Domnall Ua Donnchada 'and the carrying off of all the worldly wealth therein', adding: 'but the mercy of God did not allow him to kill people or to strip this paradise-like place of church furnishings or books'. So, if the crozier was at Inisfallen then, it remained untouched.

[3] Examined at the cracks, the plaques seem to be solid silver, and not bronze coated with silver.

foliage crossed and knotted in a much more ambitious pattern than any of the little vegetable scrolls we have met so far. On the foot (Pl. 20, Fig. 6), the stems emerge from lozenges of niello with zigzag bands of silver similar to the niello work of the Ahoghill shrine and the Corp Naomh, form complex patterns standing out boldly on the background,[1] and sprout into leaf motifs of the *Liber Hymnorum* type. All this part of the crozier which is cast silver was originally gilt, so that the black and white lozenges stood out in bright contrast.

All the upper part, crook and knop (Pl. 21) is also made of gilt silver with insets of niello and gold filigree. The ornament on the crook is different from anything which we have found so far on Irish metal objects. Each side is punctuated by a series of lozenge-shaped and triangular frames holding the panels of filigree and connected by straight flat bands, the rest of the surface being occupied by a low-relief pattern of animal-interlacing. Both frames and animal-interlacing are without parallels in Irish metal decoration. The lozenges are reminiscent of those found on some of the late Scandinavian tortoise-brooches, and the animals (Fig. 41) have affinities in the same direction, as they have exact parallels on the Copenhagen horse-collars which may date from the early eleventh century[2] (Pl. II). They belong to what is usually described as the 'Jellinge style' and have the characteristic rolled-up hind quarters with no legs. They also can be compared with some of the *Liber Hymnorum* animals (Pl. 2).

The filigree on the crook and the knop attached to it, though definitely not as delicate as those on eighth-century objects, are of good quality considering the usual level of the period. The drawing is made everywhere by a combination of two wires, a plain gold wire being applied on a beaded wire flattened so as to become a dented ribbon. This gives an interesting texture to the interlacing as well as sufficient relief above the thin gold foil which constitutes its background. The motifs are either an interlacing or a combination of small snakes whose heads are usually accommodated in the corners of the frame.

[1] These knot-patterns are very similar to Scandinavian work; see for comparison a disc from Vorby in Stockholm Museum (M. Stenberger, *Die Schatzfunde Gotlands der Wikingerzeit*, Stockholm, 1958), I, Fig. 12.

[2] See p. 194.

These decorative elements conceived so as to vary the texture of the surface are disposed on a crook whose lower part has a remarkable robustness softened by the very clever play of opposed curves. Of all the Irish objects of the Romanesque period which have come down to us it is the most perfect both as to workmanship and structure.

The upper part of the British Museum crozier, which is a refection of later date than the rest of the object[1] is decorated with patterns of the same type as those on the Inisfallen crozier (Pl. 17). The lower part remains from a crozier of the ninth or tenth century whose crook was treated with the utmost brutality. Its panels of ornaments were scraped, possibly in order to tear off the gold foil applied onto them, and the wooden core was broken.[2] It seems likely that these damages were the consequence of a Viking incursion into the monastery where the crozier was preserved. When peaceful times came back in the eleventh century, the crozier was repaired as the Soiscél Molaise had been in similar circumstances. The broken fragment of wood and the erased bronze plaques were enclosed in a plain silver casing (Pl. L), whose sole ornaments are the openwork crest terminated at one end by a human head and at the other by an animal one, and the frame of the reliquary-box made of a series of triangles as on the Inisfallen crozier. A new knop was made to connect this restored crook with the straight part of the crozier (Pl. 17, Fig. 6). It differs sharply from the other knops, all divided into small panels filled with interlacings or animals, as its decoration consists essentially in a loose plait of foliage similar to the ornaments on the foot and upper part of the Inisfallen crozier. In some of the intervals between the leaves there are little panels of animals which tend, without much success, to imitate those of the lower knops; they are of the same belated style as those on the middle knops of the Inisfallen crozier or the under

[1] *Vol. II*, pp. 118–19; M. Mac Dermott, 'The Kells Crosier', *Archaeologia*, 1955, pp. 59 sqq.

[2] These facts, which are not mentioned in the early descriptions of the crozier, came out when, at my request, it was taken apart in the British Museum laboratory in 1934. Before it was remounted, drawings of the rubbed crook and its broken wooden core were made, and Sir Thomas Kendrick, then Assistant-Keeper of British Antiquities, wrote an elaborate description of them, whose substance will be found in the above-quoted paper by M. Mac Dermott.

part of the Stowe Missal cumdach. Foliage and stems are enhanced by patterns of niello with silver zigzags, which, combined with some gilding, contributed no doubt to the brilliant colouring of the object.

We have seen[1] that it is not possible to determine exactly the date and origin of this crozier which was found by chance, hidden behind a cupboard in a lawyer's office in London, and whose inscription mentioning Cúduilig and Máelfinnén, two very common names, without any indication of their social position, is of little chronological help. Two possible interpretations would give dates in the middle of the eleventh century and either Kells (Meath) or the monastery of Emly, between Cashel and Limerick, as the place of manufacture. But they are both open to criticism. And the fact that Cúduilig is the name of a member of a craftsman family working for Armagh around 1100 complicates the problem further. So it seems safer to accept our ignorance of the origin of the crozier and of its exact date. However, the similarity of its later part with the Inisfallen crozier, which shows a close imitation of some Scandinavian patterns of the first half of the eleventh century, permits us to place it in the middle of the century.

These two croziers may represent a style which flourished in several Irish monasteries in the eleventh century. The predominance of foliage motifs calls for a comparison with the foliage-initials of manuscripts which seem to have Meath or Leinster affinities and date from the second half of the eleventh century.[2] The cumdach of the Cathach, which nearly certainly originates from Kells towards the end of the eleventh century belongs to the same group. It is a reliquary-box which contained the fragment of psalter attributed to St Columba which is known by the name of 'Cathach' (the Battler).[3] Its history has been told in the first volume of this series,[4] as it is of importance in the study of the manuscript itself. It will suffice to mention here that several texts show that in the fifteenth and sixteenth centuries the manuscript and its box were treasured possessions of the O'Donnells, one of the royal families of

[1] *Vol. II*, pp. 118–19. [2] See pp. 53 sqq.

[3] Crawford, *List*, p. 152; *C.A.A.I.*, II, p. 155, Pls. 113–14; W. Betham, *Irish Antiquarian Research* (Dublin, 1826), pp. 109 sqq.; E. C. R. Armstrong, 'The Shrine of the Cathach', *P.R.I.A.*, 1916 (C) p. 243.

[4] *Vol. I*, pp. 58 sqq.

the north of Ireland whose most illustrious member had been St Columba. After many adventures the manuscript has now found a resting place in the Royal Irish Academy and the box is with the collections of the Royal Irish Academy in the National Museum, Dublin. The O'Donnell connections goes back at least as far as the time when the cumdach was made, as it bears the following inscription: '[OR]OIT DO [CH] ATHBARR UA DOMNAILL LAS INDERNAD IN CUMTACHS'A *ACUS* DO SITTRIUC MAC MEIC AEDA DO RIGNE *ACUS* DO DOMNALL MAC ROBARTAIG DO COMARBA CANANSA LAS INDERNAD – pray for Cathbarr Ua Domnaill who caused this shrine to be made; for Sitic Mac Meic Aeda who made it and for Domnall Mac Robartaig coarb of Kells who caused this shrine to be made.'[1]

These names allow a fairly precise dating of the object, as they are mentioned in the Annals and in charters of the monastery of Kells copied into the Book of Kells in the twelfth century: Domnall Mac Robartaig was abbot of Kells from *c.* 1062 to 1098;[2] Cathbarr died in 1106[3] aged at least 68 as his father, Gilla Christ O'Donnell, died in 1038;[4] Mac Aeda, father of Sitric the metalsmith is mentioned as a craftsman (ceard) in one of the Kells charters;[5] we may assume that he belonged to a craftsman family attached to the monastery. Sitric is a Scandinavian name, but at this date this has very little significance, and he may simply have had as a godfather a converted Scandinavian. What matters is that the link with the monastery of Kells is well established, and that the object can be dated between 1062 and 1098. According to the Annals of Ulster, the reliquaries of St Columba were brought from Donegal to Kells in 1090.[6] The Annals of Tigernach relate the event in more detail 'The reliquaries (mionna) of Columcille, viz. the Bell of the

[1] Petrie, *Chr. Inscr.*, II, p. 91; Armstrong, op. cit.; Macalister, *Corpus*, II, pp. 38–9 (No. 588a), Reeves, *St Columba*, p. 319 sqq.; M. Stokes, *E. Chr. Art*, p. 79; Kenney, *Sources*, p. 629 (No. 454).

[2] See Reeves, *St Columba*, pp. 400–2; his death is recorded in the *A.U.* in 1098; his name is mentioned in one of the charters copied in the Book of Kells, which dates between 1073 and 1084 (O'Donovan, 'The Irish Charters in the Book of Kells', *Irish Archaeological Society Miscelleany*, I (Dublin, 1846), pp. 127–58).

[3] *A.F.M.*, 1106. [4] *A.F.M.*, 1038. [5] O'Donovan, op. cit., pp. 140–1.

[6] *A.U.*, 1089 (*recte* 1090), 'The reliquaries of Colaimcille were brought from Tirconaill to Cenannus'.

Kings and the Cuillebaigh, came from Tirconnell, with 120 ounces of silver and Aongus O'Domnallain was the one who brought them from the north' [to Kells].[1] Aongus was an ecclesiastic of Kells who died in 1109.[2] It has been suggested that we have here a story of the coming to Kells of relics of St Columba whose possession seems to have been of great consequence for the kings of Tirconnell and which were sent to Kells with enough silver to enshrine them in reliquaries worthy of their importance. Though the only objects mentioned are a bell and perhaps a tunic,[3] it is not impossible that the psalter, later a venerated possession of the O'Donnells, and another relic enclosed in the reliquary called the Misach, were sent to Kells at the same time. Some of these relics are mentioned in a curious text, the 'Death of Muircertach Mac Erca', as having been given by a Donegal saint, Cairnech, to the Clans Conaill and Eoghain, the two chief branches of the Northern Uí Néill 'That when they should not be chiefs or kings of Erin, their influence should extend over every province around them and that the coarbship [right of succession] of Ailech, and Tara, and Ulster, should be with them; . . . and that they should have three standards, viz., the Cathach, and the Bell of Patrick, i.e. the Bell of the testament, and Cairnech's Miosach; and that the virtue of all these should be on any one reliquary of them in time of battle, as Cairnech bequeathed them'.[4] All these relics were associated later with St Columba, but the essential point is here their close association with the Clans Conaill and Eoghain which explains why the name of Cathbarr O'Donnell, chief at that time of Clan Conaill is mentioned on the Cathach shrine. The Cathach remained in the hands of the O'Donnells, and possibly the Misach also, and they were probably deposited, when the clan and its army did not need them, in monasteries of Inishowen, such as Fahan and perhaps Clonmany, close to Aileach, their chief fortress. As for the bell, it may be by a mistake that it is called 'the Bell of the testament', which makes it the bell of St Patrick, kept in Armagh. In fact it is more likely to have been the bell which, until the

[1] *A. Tig.*, 1090. [2] *A.U., A.F.M.*
[3] 'Cuilebadh', see: Reeves, *St Columba*, pp. 321–2.
[4] Reeves, op. cit., p. 329; W. Stokes, 'Aided Muirchertaig maic Erca', *R.C.*, XXIII, pp. 395 sqq., XXIV, pp. 349 sqq.; L. Nic Dhonnchadha, *Aided Muirchertaig Meic Erca*, 1964.

nineteenth century was kept in Fahan Mura.[1] So it is possible that all these precious objects were sent at the same time to Kells which would mean that the reliquary of the Cathach dates to *c.*1090. It may also have been made before the other shrines, on account of the outstanding importance of the manuscript and in this case it might be as early as 1062.[2]

The cumdach of the Cathach is a rectangular wooden box $9\frac{3}{4}$ inches by $7\frac{1}{2}$ inches and $2\frac{3}{8}$ inches thick. It is completely covered with metal sheets. That on the upper side dates from the fourteenth century,[3] but the other sides, except for some additions, belong to the shrine made in Kells in the eleventh century. The under side[4] has the openwork decoration found on so many reliquaries of that time: the wood is covered by a bronze plaque which was probably gilt or covered by a thin gold foil. On this background rests a thick sheet of bronze in which have been cut patterns of crosses and squares and which is completely wrapped in silver foil. The inscription is cut into the border of this openwork plaque. On the two long sides were small rectangular panels, probably fourteen on each side, now partly hidden under fourteenth-century additions. The bronze of these chip-carving panels was covered with gold foil which has partly survived. Each panel has a different motif: corded interlacings, palmettes, foliage scrolls or animals. The animals are mostly of the stunted type connected with the Jellinge style which is found also on the Inisfallen crozier. The two short sides were covered each by a single pattern; their ends are now unfortunately hidden by more recent ornaments, but it remains possible to form an idea of the general shape of the motif by what remains visible (Fig. 7): both sides are very similar versions of a bold pattern made of two animals folded in a figure of eight indicated by bands of niello and silver and accompanied by gilt foliage. Except for the suggestion of animal shape the motif is very close to that

[1] London, Wallace Collection. What remains of the early ornament of this bell (Pl. 81, 1, right hand lower corner) is not inconsistent with a date in the second half of the eleventh century; see p. 93.
[2] The earliest possible date from the inscription.
[3] *C.A.A.I.*, Pl. 113; the figure of the bishop and that of the blessing figure may be inspired by earlier representations; the bishop's mitre seems to be of twelfth-century type.
[4] *C.A.A.I.*, Pl. 114.

on the British Museum crozier (Pl. 17).[1] A few fragments of the original decoration of the upper side may still exist, judging from the confused glimpses one can get through a hole in the medieval plaque which now covers this side.

Another object mentioned in the 'Death of Muircertach Mac Erca' together with the Cathach, the Misach – whose exact nature remains unknown – was enshrined in a box very similar in size and shape to that of the Cathach.[2] It is known that its hereditary keepers were members of the O'Morison family (O'Muirgiussa), stewards of the monastery of Clonmany in Inishowen. One of them, in 1534, according to an inscription, added some ornament to the box. Another is mentioned in a text as

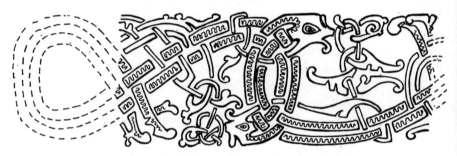

Fig. 7. Decoration of one of the short sides of the cumdach of the Cathach (the dotted lines show the probable ornament on that part covered by a more recent panel).

keeper of the reliquary. Around 1760, Thomas Barnard, who at that time lived in Fahan Mura (Donegal) became possessed of it. He was later Church of Ireland bishop of Killaloe, then of Limerick. When he died in 1806, the reliquary was sold with his books, and after a while

[1] It is even more closely similar to the design on a 'trial piece' found in the excavation of the Viking city of Dublin in the summer of 1967. I am greatly indebted to Brandán Ó Ríordáin who immediately informed me of the find and allowed me to mention it here. It is still too early to evaluate its dating, but the presence of such a pattern in this context points clearly to the possibility that some of these designs were elaborated in the Viking cities of Ireland.

[2] *C.A.A.I.*, II, p. 164 and Pls. 128–9; Crawford, *List*, p. 153; 'The Reliquary known as the Misach', (1) 'Description', by E. C. R. Armstrong and H. S. Crawford, (2) 'Historical Notes', by H. J. Lawlor, *J.R.S.A.I.*, 1922, pp. 105 sqq.; W. Betham, *Irish Antiquarien* Research (Dublin, 1826), pp. 213 sqq.; Petrie, *Chr. Inscr.*, II, pp. 102–3.

came into the hands of Sir William Betham, Ulster King at Arms, who seems to have prised the box open with a chisel in such a way as to break it. He never disclosed what he had found inside, and he seems to have had the box remade by using the unbroken plaques of bronze and getting copies of these made to replace the broken ones. He then presented the reconstituted object to the Duke of Sussex. It came later into the possession of Lord Dunraven, the archaeologist, who gave it to St Columba's College, Rathfarnham (near Dublin), where it is still kept.

The box is $10\frac{1}{4}$ inches by $9\frac{1}{8}$ inches and $2\frac{1}{2}$ inches in thickness. The original box was hollowed out of a piece of yew, but only one side of it remains now. It was covered with metal plaques. That on the upper part was remade in the sixteenth century, but the older part has more than a point in common with the decoration of the Cathach box. The under side has the same silvered bronze plaque with openwork cross-patterns. The two narrow sides were also decorated with animal and foliage patterns similar to those on the Cathach cumdach and probably originally enhanced with niello insets, judging by the deep grooves which are cut in most of the stems. But the pattern is more irregular, with a Baroque intensity of design and the animal bodies are so disarticulated as to be practically unrecognizable. H. S. Crawford, who examined them in 1922, thought that these two plaques were not part of the original decoration; but it seems that he was mistaken and this imaginative orgy is hardly likely to be a reconstruction (Pl. II). On the other hand the plaques on the two long sides are identical and one of them is likely to be a copy of the other. They are similar in composition to some of the motifs on the Inisfallen and British Museum croziers, with a decoration based eventually on zoomorphic patterns.

As for the 'bell of the kings' which was sent to Kells in 1090, and no doubt sent back to Cathbarr O'Donnell after having been enshrined, we have seen that it must probably be identified with a bell found in the mid-nineteenth century in the house of a fisherman of Fahan Mura,[1]

[1] *C.A.A.I.*, II, p. 157, Pl. 81; *Illustrated Catalogue of the Wallace Collection, Furniture*, etc. (London, 1920) (6th ed.), p. 74 sqq.; H. S. Crawford, 'Notes on the Irish Bell-Shrines in the British Museum and the Wallace Collection', *J.R.S.A.I.*, 1922, pp. 1 sqq.

which belonged for a while to a Mr MacClelland of Dungannon (Tyrone), and is now in the Wallace Collection in London. It is not exactly enclosed in a shrine, as the ornaments are affixed on the cast bronze bell itself and cover the wooden handle. Two rings, one on each side, were obviously meant to fasten the ends of a chain or leather strap passing around the neck of the keeper when he carried the bell in procession or battle. The front panel had a cruciform design, now partly hidden by more recent additions. The original decoration, which can still be seen on part of the frame and on the side of the handle-cover, was of gilt bronze with patterns of foliage and animal heads in relief, with some niello insets. The patterns are very similar to those on the narrow sides of the Cathach box, and are probably the work of the Mac Aedas at Kells.[1]

We are now coming to two objects which have many points in common, though they seem at first sight to come from two widely different parts of Ireland: the shrine of St Patrick's bell and the Lismore crozier.

The bell is made of iron and is considered traditionally to have been used by St Patrick and eventually buried in his tomb, out of which St Columba would have taken it to give it to Armagh where it was then kept.[2] At the end of the eleventh century a box was made to enshrine it,[3] perhaps in replacement of a destroyed one. The date is fixed by the inscription on the shrine: 'OR DO DOMNALL U LACHLAIND LAS IN DERNAD IN CLOCSA OCUS DO DOMNALL CHOMARBA PHATRAIC ICON DERNAD OCUS DOD CHATHALAN U MAELCHALLAND DO MAER IN CHLOIC OCUS DO CHON-DULIG U INMAINEN CONA MACCAIB ROCUMTAIG, pray for Domnall Ó Lachlaind who caused this bell to be made, and for Domnall

[1] Several other decorated bells or bell reliquaries of this period would need mention; the chief ones are the 'Clog-an-oir' or Clogán óir (bell of gold), from Scattery Island, in the N.M.D. (*C.A.A.I.*, II, p. 157, Pl. 82) and the Bearnan Chonaill (the decoration applied on the bell; the outer case is later), from Inishkeel (Donegal), in the British Museum (*C.A.A.I.*, II, p. 165, Pl. 124).

[2] *A.U.*, 552.

[3] *C.A.A.I.*, II, p. 156, I, Pls. 78–80; Crawford, *List*, p. 157; Petrie, *Chr. Inscr.*, II, p. 109; Macalister, *Corpus*, II, pp. 112–3 (No. 944); W. Reeves, 'On the Bell of St Patrick, called the Clog an Edachta', *T.R.I.A.*, 1877–86 (also separate issue, Dublin, 1877), pp. 1 sqq.; Coffey, *Guide*, pp. 47 sqq.

successor of Patrick in whose house it was made, and for Cathalán Ó Máelchalland steward of the bell, and for Cúduilig Ó Inmainen and his sons who enriched it'. Domnall Ó Lochlainn, according to the Annals[1] died in Derry in 1121, after being Árd-rí for twenty-seven years (so from 1094 to 1121). Domnall Mac Amhalgadha or Mac Auley became abbot of Armagh in 1091 and died in 1105.[2] So the reliquary was made between 1094 and 1105, probably in Armagh. The bell, enclosed in its shrine, remained in the monastery for centuries, an object of utmost veneration, witness to solemn oaths and entrusted to a keeper. At the dissolution of the monastery in the sixteenth century the family of its keeper, the Mulhollands (O'Mulchallan) kept it. We have seen how it passed, shortly after 1798 into the hands of Adam MacClean of Belfast. At his death it was sold to J. H. Todd whose heirs sold it to the Royal Irish Academy.

The shrine is a box $10\frac{1}{2}$ inches high and $5\frac{3}{4}$ inches by 4 inches at the base (Pl. 22) made of thick sheets of bronze held in position at the corners by thick, rounded joint-covers. These sheets carry an openwork decoration in strong relief. The ornaments are disposed as on a cumdach, the reverse being entirely occupied by a silver-plated bronze plaque bearing the inscription, in which have been cut a series of cruciform patterns.[3] The sides bear zoomorphic patterns. The front of the box which has not been covered up and is only torn off in places, can help us to imagine what the upper sides of the Stowe Missal and Cathach cumdachs were like. It also explains why that part of the box was so fragile as to have often to be replaced, as it is covered with filigree or imitation filigree, a type of ornament which easily gets broken. Indeed it is far from being complete and some of the panels are missing whilst others are in bad condition. The lithographs made in Belfast in 1850, which Margaret Stokes reproduced in her edition of Petrie's *Christian Inscriptions* show in their original state three panels which have now vanished. The handle-cover, of a beautiful design, ended on each side by heads of

[1] *A.F.M.*, 1121: 'died . . . after having been twenty-seven years in sovereignty over Ireland', so from 1094 to 1121, and not 1083 to 1121 as Macalister says; see also *A.U.*, *A.I.*, *A. Tig.*
[2] *A.F.M.*, 1091 and 1105. [3] *C.A.A.I.*, I, Pl. 80.

monsters which are now partly broken, but were intact in 1850.[1]

The openwork zoomorphic plaques are certainly the most original and interesting part of all this decoration. The treatment is new, thin, elongated shapes being the essential elements of these fine pieces of gilt silver casting. They differ from the usual openwork plaques by their subtle modelling and the way in which the various levels of relief of the interlacings are indicated. The design is of impressive boldness, an impatient network of diagonal lines and well-balanced curves. A thread-like animal is the basic element of all these compositions; it has a bulbous eye, sometimes made of glass, long, drawn-out jaws, and is made of no more than two long threads which knot and curl several times, but are generally devoid of all indications of paws or tail. Only two animals, above one of the suspension rings, are slightly better defined (Pl. 24); one of their legs ends in a foliage scroll, and they are accompanied by snakes whose heads, seen from above, have eyes in high relief. It is more or less the complex animal-foliage-snakes which is found in Harley Ms. 1802, illuminated in Armagh in 1138, though the virtuosity of design is infinitely greater on the shrine. One panel only has a different pattern, that on the reverse of the handle-cover, where two birds are shown face to face, caught in a desiccated and semi-zoomorphic vegetable scroll (Pl. 23).

The two suspension rings are mounted in little bronze cubes attached to the centre of a circular frame. There, all the panels are of chip-carved bronze, plated with silver, though the animals which fill them have the same supple rhythm as those of the openwork plaques.

As for the filigree work of the front of the shrine, we have seen its strange structure (Pl. 27).[2] There are however some small panels of ordinary filigree, comparatively fine, which have remained quite intact on the handle-cover, whilst the others are in a very poor condition. The decoration on this side had the same cruciform layout as that of the Fahan bell. It is now difficult to appreciate it because of two enormous intruded

[1] *Five Chromo-Lithographic Drawings representing an Irish Ecclesiastical Bell which is supposed to have belonged to St Patrick and the Several Sides of the Jewelled Shrine in which it is preserved* (Belfast, 1850), text by W. Reeves, drawings by James Murray; see Petrie, *Chr. Inscr.*, II, p. 110.

[2] See p. 80.

Colour plates between pages 96 and 97

K. Detail of Glankeen bell-shrine
L. Crook of British Museum crozier

M. Cross of Cong, end of arm
N. Cross of Cong, knop

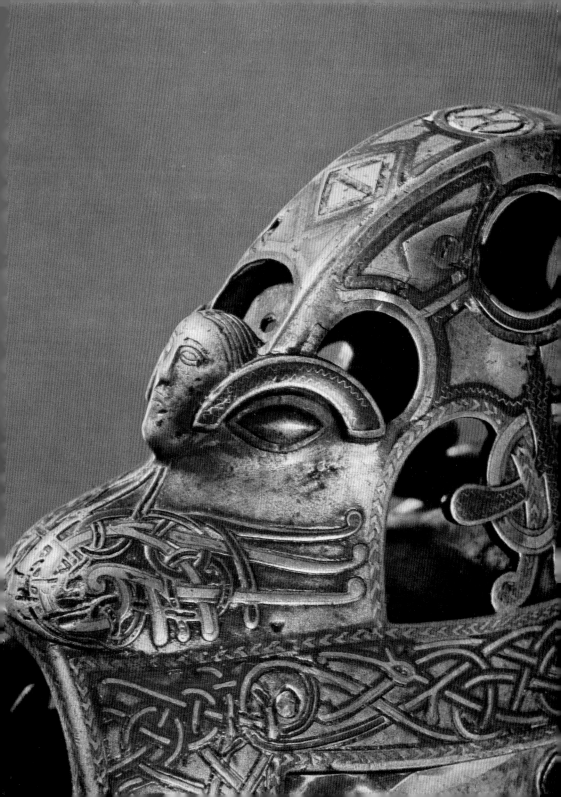

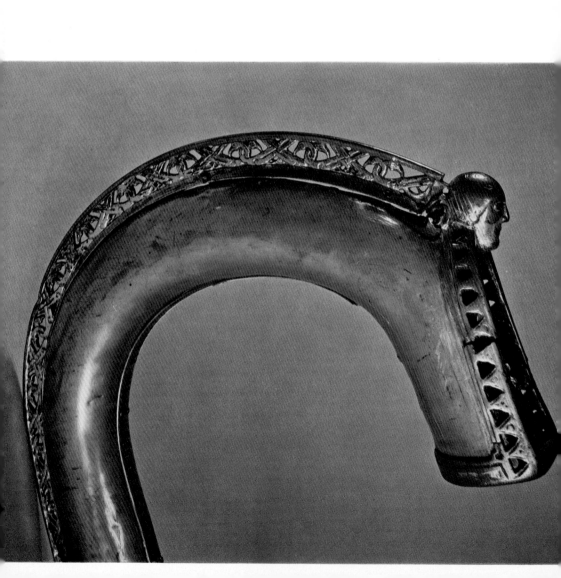

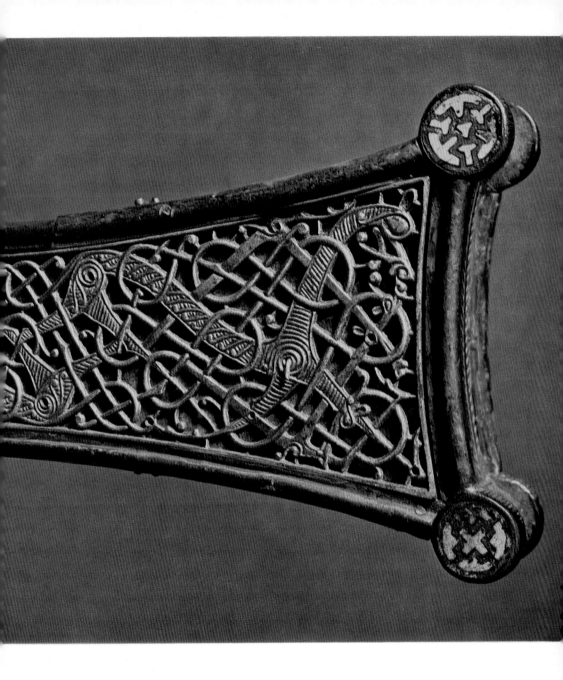

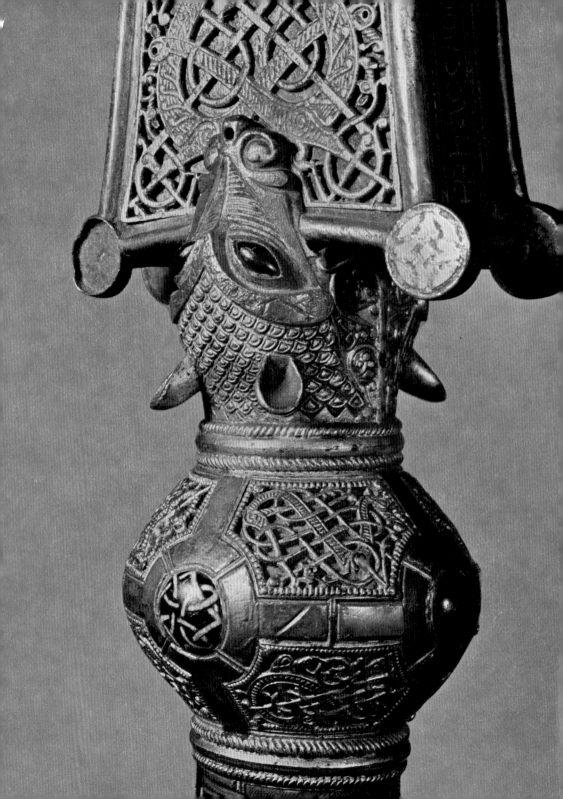

quartz settings and the disappearance of five of the filigree panels. Originally, it was an ornamentation very strictly kept on one level, with only eight oblong settings standing out of the general plane. There was a circular motif in the centre, but one may assume that it did not protrude as boldly and sharply as the quartz and its mount. As a result, the general effect was probably infinitely more pleasing than it is now. The awkward structure of the filigree remains all the same rather puzzling, though the animal patterns are so identical with those of the side panels that there can be little doubt as to the contemporaneity of all the work.

The craftsmen who made this shrine came probably from the Ossory monastery of Tullymaine, near Callan, from which they derived their name.[1] This is of importance when comparing the bell-shrine with another object, exactly contemporary, the Lismore crozier.

The crozier[2] was found in 1814 walled up in a tower of Lismore Castle,[3] whose most ancient part was the residence of the bishops of Lismore until the sixteenth century. It has an inscription engraved on the lower part of the crook and the top of the knop next to it. It reads: 'OR DO NIAL MC MEICC AEDUCAIN LAS AN[D]ERNAD IN GRESA. OR DO NEĊTAĪ ĊERD DO RIGNE Ī GRESA, pray for Niall Mac Meic Aeducáin who caused this object to be made, pray for Nectan, the craftsman, who made this object'. According to the Annals of Inisfallen, 'Mac Meic Áeducáin, bishop of Lismore, quievit in Christo' in 1113. He succeeded Máelduin whose death is recorded by the Four Masters in 1090, so that the crozier can belong to the last decade of the eleventh century or the beginning of the twelfth.

It is 3 feet 9½ inches long,[4] and in spite of the disappearance of some applied panels, it is in a wonderful state of preservation (Pls. 25, 26). It must have been at least as magnificent as the Inisfallen and Clonmacnois croziers which it resembles in general shape, but it was probably more colourful on account of its numerous glass studs. Like all the

[1] See *A.F.M.*, 1121, where the monastery is called Tealach-nInmainne; for a different spelling see: *A.F.M.*, 1026.

[2] *C.A.A.I.*, II, pp. 159–60, Pls. 93, 94; Crawford, *List*, p. 171; Petrie, *Chr. Ins.*, II, p. 118; Macalister, *Corpus*, II, p. 109 (No. 939); M. Stokes, *E. Chr. Art*, pp. 84–5.

[3] Together with the manuscript known as the 'Book of Lismore'.

[4] Crawford says 3 feet 4 inches.

other Irish croziers it is built on a wooden core which can be seen through a split in the bronze, and which is covered by sheets of bronze held by three cast bronze knops. As with the Inisfallen crozier, the lower knop forms nearly part of the foot, whilst the top knop merges into the crook. As a consequence, there is only one clearly defined knop as on the Clonmacnois crozier, and not two as in the case of the Inisfallen crozier and the earlier ones.[1] This middle knop and that near the foot are divided in an archaic fashion into a great number of panels containing each a zoomorphic pattern or an interlacing, but the relief is much less accentuated than on ninth- and tenth-century croziers, and the patterns are thinner. They are cast in bronze, and were originally covered by gold foil of which a few fragments have survived. Tiny panels of the same type surround the reliquary box at the end of the crook, showing clearly that this part of the object is contemporary with the rest. In all these panels the animal-interlacings are as different as possible from those on the early part of the British Museum crozier or on the crozier of St Mel.[2] Adapted to a different technique, they are combinations of the same thread-like and meandering beasts with long, thin jaws, as are found on the Armagh bell-shrine. On the lower knop, there are, in addition, wheel patterns of human figures similar to those found on several stone crosses of the eighth, ninth and tenth centuries,[3] and two human figures whose feet and outstretched arms are caught in the tangled knots of thread-like beasts (Pl. 26). These have close parallels on a small bronze cross found at Cloyne (Cork).[4] On the ferrule stretch long-drawn figures of diabolical appearance.

All the top part of the crozier, upper knop and crook, was covered with applied motifs inserted into frames left in relief on the bronze surface, and held by small bronze nails, which have survived in several places to the tearing off of the panel they were holding. One may suspect, from the care with which these panels have all been removed, that they were made of gold – probably gold filigree. It would have been interesting to know whether they were, technically, of better quality than those on St Patrick's bell shrine. They were separated by glass medal-

[1] *Vol. II*, pp. 115 sqq. [2] *Vol. II*, p. 116 sqq. [3] *Vol. II*, Fig. 9.
[4] *C.A.A.I.*, II, Pl. 106, 6.

lions of very remarkable type. Some of them are cast glass discs with enamelled grooves. Others are made of blue glass covered by a thin section of millefiori glass which has scaled off in a few places, leaving the blue core exposed. The frame of the reliquary-box has little panels of millefiori glass, fixed on the bronze by a thin layer of red enamel, as was the habit on Irish penannular brooches, and earlier, on Gallo-Roman objects.

The crest is a wonderful piece of bronze casting and is inserted in a slit left for that purpose in the crook. As in the other croziers of the same period, it ends by a monster head; then three fantastic animals with coarsely indicated fur constitute the crest proper; they stand out clearly on a background of openwork – thread-like legs, tails, jaws and tongues. This is another version of the animal of the Armagh bell-shrine which constitutes also obviously the chief element of the decoration of the crozier.

Two other fragments can be linked with this one. One of them, which has no locality (N.M.D.) consists of the upper part of a crozier whose crook is less curved but whose ornament must have been very similar, except for the crest more reminiscent of the cumdach of the Cathach with its rectangular panels and palmette-decorated monster head.[1] The rectangular panels are gold plated and amongst them appear the cloisonné discs which have been discussed earlier.[2] The other is the upper part of a Tau crozier (Pl. 19), the only example which has survived in Ireland where the Tau crozier is often represented in carvings from the eighth to the twelfth century.[3] The transverse member ends in two splendid animal heads cast in one piece and modelled with generous sensitiveness. The only surviving knop has, around the settings, zoomorphic patterns treated in the same jerky and elongated style as those of the Lismore crozier.

[1] *C.A.A.I.*, II, p. 159, Pl. 86; Crawford, *List*, p. 173; *Art roman*, No. 517, pp. 297–8 and plate.

[2] See p. 79.

[3] *Vol. I*, Fig. 15, *Vol. II*, Pl. 95, Tau croziers do occur on the Continent in the pre-Romanesque or early Romanesque period. Their significance, as opposed to the crook crozier has, to my knowledge, never been elucidated. The comparisons with the resting sticks used in some Oriental churches are very far-fetched.

A few other croziers, amongst them one from what must have been a very rich treasury at Fahan Mura (Donegal; N.M.D.), another from Dysert O'Dea (Clare; N.M.D.), have also some features in common with the Lismore crozier and help us to realize that it represents a much more current type than do the Clonmacnois crozier and even more such an archaic object as the Inisfallen crozier. The type of ornament connected with the Lismore crozier may belong to that part of the south-west of Ireland which stretches from south Ossory to the neighbourhood of Cork, if we rely on the scant indications at our disposal: the monastery from which came the craftsmen of the Armagh bell-shrine, the connection of the crozier with a bishop of Lismore and the discovery of a little bronze cross of the same style at Cloyne, to the east of Cork. It is necessary to remember, at the same time, that we know nothing of the origin of the two other crozier fragments (Tau crozier and crozier with cloisonné enamel), so that it is wiser not to be too definite about such a localization.[1]

Another series of objects, belonging to North Munster and Clonmacnois, has different characteristics; their most prominent feature is the use of a damascening technique consisting in the insertion into the bronze surface of patterns of silver ribbon edged on each side by thin lines of niello which have silver zigzags only where they widen too much for the safety of the niello. With this technique are combined others such as enamel or filigree.

The chief objects treated in this way are the Bearnan Cuilean – the bell of St Cuilean (Br.M.), the shrine of the arm of St Lachtin (N.M.D.), a complete crozier and a fragment from another one, both from Clonmacnois, and a few elements of other croziers including the foot of the British Museum crozier, which is probably a refection later than all the other parts of the object. An indication of the date of this group of objects is given by the inscription on St Lachtin's shrine which dates it as shortly before 1121; so we are now dealing with twelfth-century metalwork, more recent than the objects we have examined so far. The various circumstances of discovery and the inscription itself seem to point to a

[1] It is remarkable that this group of objects includes two examples of cloisonné or imitation cloisonné.

link between these objects and the kingdom of Munster and its various reigning dynasties, and also with the monastery of Clonmacnois. In fact one may wonder if Clonmacnois was not the centre from which they all came, some meant for use in the monastery itself, others ordered by Munster princes and kings for some churches of their kingdom. As a consequence it will be useful to examine first the croziers.

A nearly complete crozier and a fragment of another, both in the Dublin Museum, seem to have been found in Clonmacnois.[1] One of them is said to come from the tomb of St Ciaran, the founder of the monastery, in the diminutive 'St Ciaran's Church'. This is probably the fragment which was later taken to London, where it was bought in 1889 by Dr W. Frazer, from Dublin. It is decorated with inset bands of silver on a gilt bronze background. As for the crozier, it appears in the eighteenth century in the Dublin collection of the notorious Major Sirr, who might have obtained it directly or indirectly from the family of its hereditary keepers; it has always been refered to as 'the crozier of the abbots of Clonmacnois', a name which may have been transmitted from one of its keepers to the next and which there is no valid reason to question.

This crozier[2] is 3 feet 2 inches long and is built like all the others on a wooden core, which is covered by bronze plaques held up by cast bronze knops (Pls. 20, 33). The upper and lower knops are both divided into triangular panels whose ornaments were enlivened with an inset, probably niello. The crook and the middle knop are decorated with damascening of silver ribbons edged with niello. Below the upper knop an additional band has a frieze of four animals opposed in pairs. The ferrule, instead of ending as in other croziers with a sort of stand, has a long point similar to those of mountain walking-sticks.

Some of the triangular panels on this crozier are decorated with interlacings, but others have palmettes and other foliage motifs similar to those found on the voussoirs of several Irish church doors. It has been

[1] The evidence is very confused; see Margaret Stokes' Introduction to her edition of Petrie's *Chr. Inscr.*, Vol. I, p. 3, where the dates are inextricably mixed up. See also *C.A.A.I.*, II, p. 161, Pl. 95.

[2] *C.A.A.I.*, II, p. 159, Pls. 87, 88; Crawford, *List*, p. 169, Armstrong, *Catalogue*, p. 306; M. Stokes, *E. Chr. Art.* pp. 81, 85, 87.

101

mentioned already[1] that one of these panels, at the end of the crook, has blue, green and white enamel. The frames of these triangles are decorated with plait-like insets of silver and red copper. The most novel part of this ornamentation is, without doubt, the fluid and elegant pattern of silver lines edged with black niello which spreads over the whole crook. The technique used allows for a freedom of design unknown until then in Irish metal decoration. Hence this supple movement of lines which bend, cross each other, are knotted in a seemingly endless pattern. In fact, as nearly always in Irish art, there is organization and a reasoned arrangement under this apparent disorder. The pattern is made really by a combination of long snakes with well-defined heads, each bent in a figure of eight, though the addition of thin, curling threads confuses the eye at a first glance (Fig. 37).

Similar techniques have been used in the decoration of the Glankeen bell-shrine or 'Bearnan Cuileain'.[2] The bell itself is made of iron coated with bronze. The tradition is that it was found inside a hollow tree at Kilcuilawn (Cill Cuileain, the church of St Cuilean), near Glankeen (Tipperary). After belonging in the nineteenth century to T. L. Cooke, it went into the British Museum collections. The fact that it may have belonged to the church of St Cuilean, who lived in the late ninth century, is of especial interest, as he was the brother of the king of Cashel, Cormac Mac Cuilennáin, and he might have played the part of protector-saint of the kings of Cashel; this would explain the lavish decoration of the metal casing of his bell. It is now fairly difficult to assess the original appearance of the shrine which is partly broken and whose surviving fragments are now more or less affixed on the bell. It consisted probably of four sheets of bronze held at top and bottom by cast bronze mounts (Pl. 18). Only one of these plaques has survived; it bears an engraved cross with enlarged ends similar to those found on many funerary slabs of the same time (Pl. 79). The upper mount, which covered the now lost handle and the upper part of the bell, is in a wonderful state of preservation. It is a piece of cast bronze decorated with damascening and enamels.

[1] See p. 79.
[2] *C.A.A.I.*, II, p. 157, Pl. 83; Crawford, *List*, p. 162; Smith, *Guide Anglo-Saxon A.*, p. 141; M. Stokes, *E. Chr. Art*, p. 52.

On each side are two superposed monster heads with a human head in full relief above the upper one (Pl. K). Between the heads runs a loosely knotted pattern of animal-foliage and in the middle of each side there is a large openwork palmette with several kinds of insets: silver ribbon, niello and plaits of brass and silver. The foliage moustaches of the monster heads are one of the most florid motifs of all this art of the fantastic. Silver, niello and gilt bronze are mixed even more freely than on the crozier, and all shapes have a singular tendency to equivocal and deceptive appearances, as two lines issuing from the little human head suggest the shape of arms, whilst the head itself is firmly hemmed between the eyebrows of the monster.

The shrine of St Lachtin's arm[1] is one of the best preserved objects of that period. Its gilding is somewhat rubbed off and it may have been slightly shortened, but a good deal of the filigree work is intact and the general colour effect sought by the artist is still apparent. Apart from the much later reliquary of St Patrick's arm it is the only surviving example of a type of Irish shrine mentioned in several texts.[2] There was, for example, a silver shrine of St Ruadan's arm at Lorrha, and references to arms of St Comgall and St Ciaran certainly concerned relics mounted in the same way. Indeed the type was well-known on the Continent where a certain number of examples have survived.[3]

Lachtin, a sixth-century saint, was the patron both of Achad-Ur (Freshford; Kilkenny) and Donaghmore (Cork) and probably also of Lis Lachtin in Kerry and some Clare churches,[4] but it was Donaghmore which had been entrusted with the relic of his arm or hand for which kings and princes of Munster had a shrine made in the twelfth century. It seems to have remained there until the middle of the eighteenth century when

[1] C.A.A.I., II, p. 161 and Pl. 99; Crawford, *List*, p. 90; Coffey, *Guide*, pp. 53–4; Allen, *Celtic Art*, p. 210; Westwood, *Facsimiles*, p. 151; M. Stokes, *E. Chr. Art*, pp. 85–6.

[2] See: J. Huband Smith, 'The Shrine of St Patrick's Hand with notices of some similar reliquaries', *U.J.A.*, 1854, pp. 207 sqq.

[3] See for example a reliquary in Braunschweig (*c.* 1038), H. Swarzenski, *Monuments of Romanesque Art* (London, 1954), Pl. 27, Fig. 66.

[4] T. J. Westropp, 'The Churches of County Clare and the Origin of Ecclesiastical Divisions in that County', *P.R.I.A.*, 1900–1902 pp. 100 sqq.: 'Lauchteen of Kilnamona, Church and Well; the reliquary of his arm was preserved at Kilnamona for

it was taken away by the bishop of Cloyne.[1] One hears of it next in England where it belonged for some time to Sir Andrew Fountaine who described it in *Vetusta Monumenta*;[2] It belonged to his family, in Norfolk, until it came, in 1884, into the Royal Irish Academy collections (Pl. 38).

It is 1 foot and $3\frac{3}{4}$ inches high. It consists in a wooden cylinder covered with metal plaques into which the relic was inserted. Above this is a bronze hand with insets of filigree and sheets of silver. Inscriptions have been cut into the vertical bronze joint-cover of the arm. Several different readings have been given, a fact in no way surprising when one realizes the worn condition of the upper part of the reliquary as a consequence of constant rubbing from the hands of the keeper when it was carried in procession. However, Petrie, Macalister and Raftery[3] agree in their versions of the essential points, which are the giving of the shrine by the king of Desmond, Maelsechlainn O'Callachan who died in 1121[4] and by two princes of the Mac Carthy family, Tadg, who died in

some time, and thence sent to Lislachtin, Kerry.[1] He is most probably Lachtin, friend of S. Senan, *c*. 550, and gave his name to Autkeenlaughteen at Kilnamona. ([1] Bruodin's 'Propugnaculum Catholicae Veritatis [Prague, 1669])' (p. 109). The difficulty with all place-names including 'Lachtin' is that a diminutive of 'Lacht', slab, may be meant instead of the name of the saint.

[1] See the early accounts: *Ant. Journ.*, 1853, p. 241, and chiefly Todd in *P.R.I.A.*, 1853, pp. 461 sqq. It was still in Donaghmore in the first half of the eighteenth century (C. Smith, *The Ancient and Present State of the County of Cork*, I (Dublin, 1750), p. 184). Michael Herity drew my attention to an unpublished letter of Crofton Croker (15 Nov. 1830) in the *R.I.A.* collections which implies that Swift, who is known to have stayed in the neighbourhood, obtained possession of the shrine and that he handed it over to Sir Andrew Fountaine (1676–1753) for his 'Museum'. Sir Andrew died in 1753, unmarried, and his sister's grandson assumed the name of Fountaine. The family held the collection at Narford Hall, near Swaffham, Norfolk, until it was sold at Christie in 1884. The shrine was exhibited to the Society of Antiquaries of London in 1829, and in 1853 it was exhibited with the Academy collections at the great exhibition.

[2] *Vetusta Monumenta* (Soc. Ant. of London), vol. VI, Pl. XIX.

[3] Petrie, *Chr. Inscr.*, II, p. 104; Macalister, *Corpus*, II, pp. 94–5 (No. 909); *C.A.A.I.*, loc. cit.

[4] His death is recorded in *A.F.M.*, 1121: 'Maelseachlainn Ua Ceallachain, lord of Ui-Eathach Mumhan, the splendour of the South of Munster [died]'; *A.I.*, 1121: 'Death of Mael Sechnaill Ua Cellacháin, King of the South of Ireland (rig deisceirt Herenn) in Corcach Mór Muman' Cf. *A. Tig.*; he has sometimes been confused with Máelsechlainn Mac Ceallachan who was killed in 1162 (*A.F.M.*, 1162).

1124[1] and his brother, the famous Cormac, who at that time was only heir presumptive (rig-damna). This series of facts places the date of the reliquary between 1118 and 1121. The inscription mentions also the 'successor of Lachtin', Diarmait Mac Denisc of whom nothing is known otherwise.

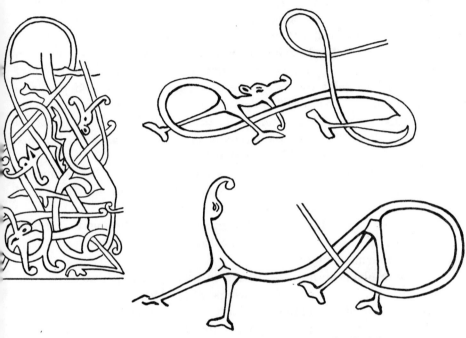

Fig. 8. Details of the ornament on the shrine of the arm of St Lachtin.

The decoration of the shrine (Pls. 39, 40) is based on the same principles as that of the croziers: sheets of bronze cover the wooden core and are held in position by cast-bronze rings. The eight plaques of the arm are inlaid with damascened motifs which vary for each of them, and are on the whole of the same type as those of the crook of the Clonmacnois

[1] *A. Tig.*, 1124, *A.L.C.*, 1124, *A.I.*, 1124, 2; according to *A.I.*, 1123, 6, and *M,C.*, 1123, 2, Cormac would have become king in 1123, before the death of Tadg, and Tadg would have died at Cashel in the same year (*M.C.*, 1123, 4) or in the following year (*A.I.*, 1124,2).

crozier, though the ribbons are thinner and the compositions, instead of being a bold pattern knotted across the surface, have a tendency to become a tight weaving either of knots as regular as knitting stitches, or of more fanciful patterns. They are all made of combinations of thread-like animal bodies which have sometimes two or three paws and always a little combative head, ready for biting or barking (Fig. 8). Part of the hand is covered with very worn interlacings; the nails are plain silver; under the fingers is a little strip engraved with a vegetable scroll and the hollow of the hand is inlaid with another sheet of silver, partly plain, partly decorated with a wind-blown foliage pattern; triangular frames on the hand and the wrist hold panels of filigree; others are inserted in the curves of palmettes which surround the lower part of the reliquary and in the disc which closes the underpart of it. The blue settings on the base are connected by chip-carved bronze panels which were probably gold-plated.

The decoration of the shrine has both unity and a nearly austere simplicity, partly due to the small number of different techniques used and their even distribution. Though every portion of the surface – except the nails – is covered with ornament, the main impression is of economy and balance, so that it is probably the most completely satisfying of these metal objects.

The drinking-horn in the Musée du Cinquantenaire[1] has at its wide end two bands of animal-interlacings edged by foliage, which are so strongly reminiscent of the lower part of St Lachtin's shrine that the two objects might well have come out of the same workshop (Pl. I).

An atelier with very different traditions must have produced the large metalwork cross which was for a long time at Cong (Mayo)[2] and is usually called in consequence the cross of Cong. It was bought there by Professor Mac Cullagh who gave it in 1839 to the Royal Irish Academy

[1] H. Shetelig, 'The Norse style of Ornamentation in the Viking Settlements', *Acta Archaeologica*, 1948, pp. 69 sqq. (see p. 112).

[2] On the discovery of the cross, see: Wilde, *Lough Corrib*, pp. 192 sqq. and notes in the *P.R.I.A.*, I, pp. 211 and 326, II, p. 113. The best descriptions are still that by Petrie in *P.R.I.A.*, IV (1847–50), p. 572, and the monograph by Margaret Stokes, *Notes on the Cross of Cong* (Dublin, 1895, for priv. circ.). See also: Crawford, *List*,

with whose collection it is now kept in the National Museum, Dublin.

From the inscriptions it bears and entries in the Annals, it is possible to arrive at a fairly complete reconstruction of its history. At 1119, the Chronicum Scottorum mentions 'The cross of Christ in Connacht this year'. The Annals of Tigernach (1119–1123) are more definite: 'Christ's cross in Ireland in this year, and a great tribute was given to it by the king of Ireland, Toirdelbach Húa Conchobáir, and he asked for some of it to keep in Ireland, and it was granted to him, and it was enshrined by him in Roscommon'. This fragment of the True Cross may have come enshrined inside a small cross on which was cut the Latin inscription repeated on each side of the Cross of Cong: 'HÁC CRUCE CRUX TEGITUR QUA PASUS CONDITOR ORBIS'. The other inscriptions quote the patrons who have commissioned the large reliquary-cross. First the king: 'OR DO THERRDEL[BUCH] U CONCHO[BAIR] DO RÍG EREND LAS DERRNAD IN GRESSA, pray for Therdelbuch U Chonchobair (Turlough O'Conor), for the king of Erin, for whom this shrine was made' then come two ecclesiastics belonging to the O'Duffy family; first: 'OR DO DOMNALL MAC FLANNACAN U DUB [THAIG] D EPSKUP CONNACHT DO CHOMARBA CHOMMAN ACUS CHIARÁN ICAN ERRNAD IN GRESSA, pray for Domnall Mac Flannacan U Dubthaig (O'Duffy), bishop of Connacht and comarb of Comman and Ciaran, under whose supervision the shrine was made'. This is the bishop of Elphin, one of the Connacht dioceses whose death is reported in 1136 or 1137;[1] he was at the same time abbot of Roscommon (coarb of Comman) and abbot of Clonmacnois (coarb of Ciaran). As the death of an abbot of Clonmacnois is mentioned in 1127,[2] it is only between 1127 and 1136 that he could have had all the titles enumerated in the inscription. In 1136 he was succeeded in the see of Elphin by the other member of the O'Duffy family mentioned in the inscription: 'OR DO MUREDACH U DUBTHAIG DO SENÓIR

p. 89, and the bibliography indicated there; E. P. Wright,' Notes on the Cross of Cong', J.R.S.A.I., 1901, p. 40 sqq.; C.A.A.I., II, p. 152, Pls. 97, 98. For the inscriptions, see, beside Petrie and Margaret Stokes, loc. cit.; Petrie, Chr. Inscr. II, p. 120 and Macalister, Corpus, II, p. 15–16 (No 552).

[1] A.F.M., A.L.C., AB.　　[2] A.F.M., 1127, A.I., 1127, 9.

ÉREND, pray for Muredach U Dubthaig, the Senior of Ireland'. In his obituary the Four Masters give him, beside the title of 'ard-epscop – great bishop or archbishop' that also of 'Senior' of Ireland, which must have had a definite significance.[1]

The end of the inscription deals with the artist: 'OR DO MAELISU MAC BRATDAN U ECHAN DO RIGNI IN GRESSA, pray for Maelisu Mac Bratdan U Echan, who made this object'. It has often been said that this name does not occur in any text. Only Sir William Wilde seems to have been of a different opinion, but he expressed it in such an elusive way that it has passed unnoticed. He says that the artist was 'successor of St Finnen of Cloncraff, in the county of Roscommon'.[2] If one looks up the Four Masters at the very year when the death of Domnall O'Duffy is mentioned,[3] one finds also mention of the death of 'Gilla Christ Ua hEchain, successor of Finnen'. Gilla Christ means Servant of Christ and can so easily be confused with Máel Isu which means Servant of Jesus, that both names are likely to refer to the same person.[4] Successor of Finnen, may not mean, as could be thought first, abbot of the monastery of Clonard (Meath), founded by St Finnian or Finnen, as there was also in Connacht a monastery of St Finnen, at Cloncraff, near Elphin.[5] This fits too neatly with the other data not to confirm the point in question. As a consequence, the sequence of events can be reconstructed thus: a fragment of the True cross was sent to Ireland temporarily in 1119, during the pontificate of Calixtus II. However, Turlough O'Conor, having obtained permission to keep a small portion of it, had it enshrined under the supervision of Domnall O'Duffy. Domnall, being bishop of Elphin, chose a craftsman from his own diocese who was or eventually became abbot of Cloncraff, near Elphin; though, being abbot of Roscommon and possibly living there,

[1] *A.F.M.*, 1150. [2] W. Wilde, op. cit., p. 195. [3] *A.F.M.*, 1136.

[4] The confusion could easily arise if the Four Masters were translating the name from Latin into Irish or vice-versa. See a similar confusion: Máel Muire Ua Fócarta (*A.I.* 1112, 2) is called in *Chr. Sc.* 1108 (*recte* 1112) Gilla Muire Ua Fógartaigh.

[5] St Finnen was originally from County Roscommon. See Myles Dillon, 'The Inauguration of O'Conor', *Medieval Studies A. Gwynn.*, pp. 186 sqq., where a 'comarb Finnéin ó Clúain Creamha' is quoted. On Cloncraff, see: *Onomasticon*, p. 259.

he had the reliquary-cross made in his own monastery as say the Annals of Tigernach. The inscription was engraved after the moment when Domnall O'Duffy became abbot of Clonmacnois (1127) and before 1136, date of his and the artist's death. As the work was probably started around 1122 or 1123, it may well have been finished shortly after 1127. In any case the cross seems to have been in use by 1136, judging from an entry in the Four Masters where it is said that Turlough O'Conor made prisoners two people (one his own son Rory), though they were 'under the protection . . . of the Bachall Buidhe (the yellow staff)'.

In this particular case the relic is not enclosed in the shrine but mounted on it, as happens to several more or less contemporary reliquaries of fragments of the True cross. The metal plaques are mounted on a large oaken cross, 2 feet 6 inches high (Pls. 41, 42, 43, 74, K, L). The reliquary proper is a sort of silver truncated cone affixed in the centre of the arms and holding a large half-sphere of rock crystal which acted as a magnifying glass for the tiny relic below it. This is exactly the arrangment which one finds on a Spanish reliquary-cross of the same time, that at Mansilla de la Sierra, near Burgos, made in 1109 to enshrine another fragment of the True cross.[1] The proportions of the two crosses are different, but the relic is in the same position in both cases, and the lower arm is held in the same way between two overlapping portions of the foot (Pl. I). This tends to show that the type was probably fairly common in the twelfth century.[2]

Like St Lachtin's shrine, the cross of Cong gives a singular feeling of sobriety and balance in spite of the fact that all its surface is covered with a network of ornament; here that impression is partly due to the firm way in which the wavy line of the arms is stressed by a large tubular silver edging, and partly to the emphasis put on the reliquary box. This lucidity of structure was probably even more striking when the now vanished settings on the arms of the cross were there to give them accent.

The basic patterns are gilt bronze animal-interlacings, where the

[1] W. L. Hildburgh, *Medieval Spanish Enamels* (Oxford–London 1936), Pl. III. 5a, 5b; also J. H. Perera 'Las Artes industriales españolas de la Epoca Romanica', *Goya*, Jul-Dec. 1961, pp. 98 sqq. (ill. p. 106).

[2] The shape may have derived from that of the original reliquary, probably kept in Rome, from which the various fragments were obtained.

animals are all of the same type but vary constantly in presentation. On the front of the cross they are cast in low relief and are enclosed in similar panels balancing each other on either side of the middle line. On the reverse there are four large openwork plaques where the lace-like patterns stand out on a dark background. The casting is everywhere of a great perfection, and the designs are remarkably precise and delicately finished. The animals have thin, ribbon-shaped bodies covered either with hatching or with the curves of their manes, whose regularity is only broken by the whorls of the spiral-articulations (Pl. K). They have nothing of the disjointed appearance of the snake-like fauna on the damascened objects. The firm definition of the legs and heads, and the clear though complex arrangements are reminiscent of eighth-century animal-decoration. The only difference is in a greater elasticity, a more supple aspect of the beasts. In fact the large animal-patterns on the reverse may well be an attempt at imitating foliage palmettes of the type of those found on the cross of Mansilla de la Sierra. But the feeling that this is a very traditional milieu is reinforced by the use of discs of yellow and red chamlevé enamel on the reverse of the cross.

There is something savage in the manner in which the cross is mounted on the foot: above a bulbous knop appear two monster-heads with scaly brows, large blue glass eyes and foliated moustaches picked out in niello and silver, which firmly hold the cross in their jaws (Pls. 74, L). When looking sideways at this part of the object, one discovers with surprise, springing up between the two heads, a beautiful, nearly naturalistic foliage pattern, very unexpected among all these creatures of the imagination.

The workshop which produced the cross of Cong was no doubt responsible also for the large shrine from the monastery of Lemanaghan, now preserved in the neighbouring church at Boher (Offaly).[1] It has the same red and yellow enamels, nearly the same animal-interlacings, and similar mannerisms such as the habit of interrupting the frames here and there by transverse lines. A few panels which are now empty may

[1] T. D. Kendrick and E. Senior, 'St Manchan's Shrine', *Archaeologia*, 1937, pp. 105 sqq.; *C.A.A.I.*, II, p. 162, Pl. 104; J. Graves, 'The Church and Shrine of St Manchan', *J.R.S.A.I.*, 1874–5, pp. 134 sqq.

have held niello and filigree ornaments which would have made the kinship of the two objects even more striking.

In its present state it has unfortunately no inscription, so that its date and origin remain uncertain. It has often been said that it was made in Clonmacnois. Lemanaghan, a small monastery lost in the middle of marshes, was given to Clonmacnois in 645 by king Diarmait, son of Aedh Slaine[1] and remained from that time attached to the great monastery of the Shannon to which it was quite near. We have seen that the cross was probably made in Roscommon and under the supervision of Domnall O'Duffy. As he was abbot of Clonmacnois as well as of Roscommon, there would be nothing extraordinary in his getting the shrine made for a monastery of the Clonmacnois obedience. When he became abbot of Clonmacnois in 1127, the cross was probably nearing completion, so that the workshop was soon able to undertake another large-scale enterprise. The goldsmith died in 1136, and the shrine is likely to have been executed before his death,[2] so that it would date to between 1128 and 1136. Lemanaghan was probably protected from looting by its marshes and the shrine was still there in the seventeenth century when it was described in the Martyrology of Donegal.[3] Sometime later it was transferred to a small chapel in the neighbourhood. This having been destroyed by fire it was kept in the house of the Moony family. Around 1838 it was placed in the church newly built at Boher, two or three miles from Lemanaghan.

It must have had originally the same finish and balance as the cross

[1] *A.F.M.*, 645; see p. 38, note 3.

[2] This, of course, assuming that Máel Isu did not train a workshop which went on working in a similar style for some time.

[3] Many points remain puzzling about this shrine. Was it the shrine of St Manchan of Lemanaghan? It is first quoted as such in the seventeenth-century Martyrology of Donegal: 'Manchan of Laith, son of Indagh. . . There is a church called Liath-Mancháin, or Leth-Mancháin, in Dealbhna-Mhec-Cochláin. His relics are at the same place in a shrine which is beautifully covered with boards on the inside and with bronze outside them, and very beautifully carved' (Jan. 24th; pp. 26–7). It could in fact have been one of the shrines of Clonmacnois brought for safety to Lemanaghan at a time of danger. There is also in the *A.F.M.*, 1166, an entry which probably refers to another shrine, made for another Manchan: 'The shrine of Manchan, of Maethail [Co. Leitrim], was covered by Ruaidhri Ua Conchobair, and an embroidery of gold (for bhrat óir) was carried over it by him, in as good a style as a relic was ever covered in Ireland'.

(Pls. 44, 45, 46, 89). Its slightly chaotic present appearance[1] is soon forgotten if one takes the trouble of examining it in detail, as it then becomes apparent that only one of the triangular sides, still intact, gives a full notion of the richness and variety of the decoration.

The shrine is in the shape of a roof whose gables are tapering slightly inwards, and is $19\frac{1}{4}$ inches high, with a maximum width of 14 inches, and a length of $23\frac{1}{2}$ inches at the bottom and $19\frac{1}{2}$ inches at the top. It was meant to be carried, and had for this purpose four large bronze rings at its four corners. It can also rest on four stout legs. It is made of five planks held by four uprights, all of yew wood. The wood was obviously everywhere covered by the metal decoration. Each side was very vigorously framed by relief borders decorated with openwork gilt bronze for the uprights, and with red and yellow enamel on the lower band. The upper crest has completely disappeared together with the finials by which it probably ended. On the triangular sides,[2] the borders stand out over a second frame which has an engraved decoration, whilst the centre of the triangle is filled by two magnificent zoomorphic panels separated by a relief mount, which is really the taut body of a snake whose whiskered head just touches the enamelled border. On each of the large sides there is an imposing cross punctuated by five semi-spherical bosses connected by enamel bands (Pl. 44). The central boss probably had a filigree decoration which has been ripped from the now empty frames. The other bosses are covered with the same network of animal patterns as are found on the borders. From a few fragments found inside the shrine it seems that the flat part of each of the long sides was originally covered with silver foil. All the workmanship is closely akin to that of the cross of Cong: both have the same zoomorphic patterns of gilt bronze either in openwork, outlined on a sheet of gilt bronze, or cast in one piece with the background; both have nearly identical patterns of red and yellow enamel, though they occupy a much more generous space on the shrine; on both also even the most exuberant patterns are kept in check and submitted to a pre-arranged plan.

The most surprising aspect of the shrine is the collection of little bronze figures affixed to the background by gilt nails. Many have dis-

[1] Pl. 44; C.A.A.I., II, Pl. 104. [2] Kendrick-Senior, Pl. XXVI.

appeared, but there are still five on each side of the cross on one of the sides (Pls. 44, 46). From the marks left by the nails, it appears that others filled all the flat spaces surrounding both crosses, and that they were originally outlined on the silver plate covering the wood. They are odd little figures, cast in one piece, dressed in little short skirts with decorated panels, and tunics with tight sleeves which seem to open in front in a scalloped line imitating the patterns of ribs on a naked chest. It seems likely that crucifix figures, awkwardly copied, are the origin of these singular statuettes.

It has been suggested[1] that the models were Rhenish and of a fairly late date. The types of faces, however, are closer to Spanish objects of the late eleventh century, such as the ivory crucifix in León Museum.[2] and the figures on the shrine from San Millán de la Cogolla.[3] The heads are like slightly roguish imitations of the high relief gilt bronze heads of the early twelfth-century enamelled shrine from Santo Domingo de Silos in Burgos Museum,[4] so that there is really no reason to date them as late as the end of the twelfth century, and they may well be contemporary with the shrine and have belonged to it from the start. There is, to reinforce this impression, a remarkable similarity between the treatment of the corrugated sleeves of the figures and that of the corded borders of the ornaments (Pl. 46).

Four similar figures have been found in Ireland. One, from Co. Roscommon, is now lost, but appears, from a drawing, to have been of the same type as those on the shrine.[5] Three, of slightly different type, were bought, one in 1850 by the Royal Irish Academy, another by the British Museum (it is reported to have been found on the site of the Augustinian monastery of St John, in Dublin) (Pl. 47), and a third in Athlone by the collector Robert Day. This last one seems to have belonged originally to the shrine and is now attached to it. The others come from similar shrines and are no doubt the product of the same workshop. The finding

[1] Kendrick-Senior, pp. 114 sqq.
[2] Third quarter of the eleventh century. Hildburgh, *Spanish Enamels*, pl. XIV (showing very clearly the pattern of the ribs).
[3] Late eleventh century. Id., Pl. XIV. [4] Id., Pls. IV–VI.
[5] For this figure and the following, see Kendrick-Senior, Pl. XXIX, Figs. 2–5. Also *C.A.A.I.*, I, Pl. 24, 6.

of one of them in Co. Roscommon brings us back to the region where the cross of Cong was made.

A few other objects have ornaments of the same type, though not always treated in the same way. One of them is a little heart-shaped openwork finial which probably fitted at the end of the ridge-pole of a shrine slightly smaller than the Lemanaghan one (N.M.D.).[1] Another is a bronze plaque with very low-relief ornament. It bears a cross covered with foliage pattern on a background of animal-interlacings. It was found in the Abbey of Holy Cross (Tipperary) which was probably founded around 1109 or 1110 as a Benedictine monastery by Murtough O'Brien to house a relic of the True Cross which he had just obtained.[2]

A third object is the ivory crozier crook found at Aghadoe (Kerry), which was bought around 1922 by Stockholm Museum (Pl. 85, Fig. 9). The crook has obviously been shortened and the crest is also partly broken. Otherwise it is in a very good state of preservation. The stem of the crook bears zoomorphic ornament which eventually turns into a foliage pattern; then it curves and becomes the forepart of a monster whose wide open jaws are making room for the exit of a small Jonah dressed like an acrobat in a tight-fitting jersey. The theme is the same as that which is found on the Irish crozier-head found at Ekerö (Sweden).[3] But the ornaments are of quite a different type. The sleeve of Jonah and the paw of the beast are corrugated in the same way as the arms of the little figures on the Lemanaghan shrine. When unrolled, the animal-interlacing on the stem of the crozier (Fig. 9) appears very close to those on cross and shrine, both in the use of hatchings on the animal bodies and the way of outlining them on a fine network of legs and serpents. As for the foliage scroll (Fig. 9), it is found also in the decoration of some Irish Romanesque portals. Finally the crest, with its crenellated pattern has parallels on some metal croziers such as that from Fahan Mura in the Dublin Museum, but it is even more striking to find the same crenella-

[1] C.A.A.I., II, Pl. 106.

[2] C.A.A.I., II, p. 141, I, Pl. 50, 1; M. Stokes, E. Chr. Art, p. 91; M. Mac Dermott 'An openwork Crucifixion Plaque from Clonmacnois', J.R.S.A.I., 1954, (pp. 36 sqq.) The object is ascribed to the ninth-tenth century in the first and last of these publications.

[3] Vol. I, Pl. 69.

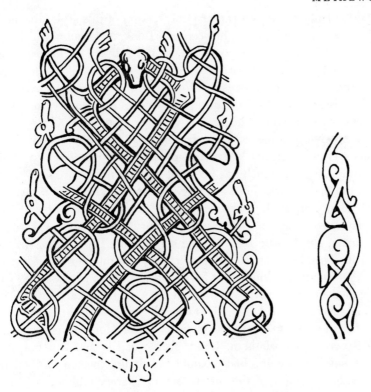

Fig. 9. Detail of the ivory crozier from Aghadoe.

tions carved on the jambs of the Romanesque portal in the ruined church at Aghadoe, the very place where the object was discovered.[1]

So it looks as if this type of animal ornament was not confined to the workshops supplying objects in Connacht for Turlough O'Conor. It may have been in fairly common use throughout Ireland.[2] What probably remains a characteristic of the Western smiths is the use of gilt bronze associated with enamel.

[1] It is found also on other doorways; see Pl. 84.
[2] Its best equivalent in stone is the Cashel sarcophagus (Pl. 89).

115

Another object gives a rather poor version of this style, the shrine in which was encased the eighth-century Book of Dimma which is now kept, together with the manuscript, in the Library of Trinity College, Dublin.[1] Only part of its original decoration has survived, inserted in a rather uncouth Medieval restoration. It is a box 7½ inches by 6½ inches and 2 inches thick. Pre-Romanesque elements may survive on one side. The under part seems to be a medieval copy of a twelfth-century decoration embodying some original fragments. The upper side certainly includes twelfth-century openwork plaques remounted in an ill-fitting frame (Pl. 48), on which has been cut a modern inscription.

On the under part, there is a slightly disconcerting Latin inscription, which is not in Irish characters, as is usual. It mentions a Tatheus O'Carroll, who had the shrine gilt (me ipsum deauravit), a Domnaldus O'Cuanáin, coarb, who restored the shrine, and Thomas the smith who made it. Thaddeus can be the equivalent of a number of Irish names: Tadg, Diarmait, Turlough, but hardly of Domnall, and the only O'Carroll mentioned in the Annals who would fit with the probable date of the original shrine is a Domnall O'Carroll whose death is recorded in 1152.[2] As for the O'Cuanáins, they have been for centuries associated with Roscrea. One of them, Isaac, bishop of Ely and Roscrea, died in 1161,[3] but here again, Isaac would be an unexpected equivalent for Domnaldus. In view of the unsatisfactory character of these identifications, one may prefer to think that the inscription belongs to a later date than the twelfth century and to the time when the shrine was remodelled (fourteenth or fifteenth century). This is all the more tempting since the Annals mention during that period several princes of Ely (the territory around Roscrea) called Tadg O'Carroll. However this removes any chronological import from the inscription. The decoration is a rather

[1] C.A.A.I., II, p. 163, Pls. 101–2; Crawford, List, p. 155; Petrie, Chr. Inscr., II, p. 100; Macalister, Corpus, II, pp. 103–4 (No. 931); Gwynn-Gleeson, Killaloe pp. 64 sqq. and 67 sqq.
[2] 'Domhnall, son of Righbhardan, lord of Eile, was slain by the son of the long-legged Ua Cearbhaill' (A.F.M., 1152; A. Tig.) also: 'Rory O'Carroll, lord of Ely, slain' (A.F.M., 1174).
[3] A.F.M., 1161.

coarsely engraved design of animal-interlacing, but its kinship with the animal patterns on the stone crosses at Roscrea and the neighbouring monastery of Mona Incha gives it some importance.

Consideration must now be given to a shrine which has practically nothing in common with any of those examined so far, the Breac Maodhóg, or 'speckled' of St Maodhóg (Pl. 34).[1] It was kept for a long time at Drumlane, in the County of Cavan, near the site of a monastery which is still marked by a rather curious round tower. In the nineteenth century it came into the possession of the archaeologist George Petrie, and passed then into the collections of the Royal Irish Academy (N.M.D.). It has nearly the same shape as the eighth century house-shrines, though in a somewhat flattened version and of larger size (9 inches by 7 inches and $3\frac{3}{8}$ inches of maximum thickness). Like them it was made to be carried by a strap passed around the neck of the keeper, and the rings to which that strap was fastened have survived. It could also be carried in a leather bag which still exists. It is made of wood covered by large sheets of bronze which were probably held in the corners by joint covers. These bronze sheets acted as a background for other plaques either cut in openwork or embossed in relief. On the reverse there was the usual plaque with an openwork pattern of crosses.[2] On the underside, other plaques with a regular pattern were held together by an enamelled frame.[3] Then the front was occupied by a series of applied figures probably grouped in panels each with its frame (Pls. 34–7). Only the lower row of figures seems to be in its original position; it consisted in three little bronze plaques, $2\frac{5}{8}$ inches by 2 inches, each bearing three low-relief figures in full face. These plaques were affixed onto the underlying bronze sheet by a few rivets. A space of $\frac{1}{4}$ of an inch indicates the width of the frame which encroached slightly over the sides of the embossed plaques. These have been cut at the top, as one of them shows the lower part of mutilated inscriptions[4] corresponding

[1] *C.A.A.I.*, I, pls. 60–2, II, pp. 152 sqq.; M. Stokes, 'On two works of Ancient Irish Art, the Breac Moedoc and the Soiscel Mólaise', *Archaeologia*, 1867, pp. 135 sqq.

[2] It has left an imprint on the plaque supporting it, which alone has survived.

[3] *C.A.A.I.*, I, Pl. 62. [4] They seem to be the names of the figures represented.

probably with each figure. Apart from this cutting, two of the plaques are intact; of the third, only the feet of the figures are left. The two figures above them are probably not in their original position. They were no doubt further to the right, just above the incomplete lower plaque. As for the other two pieces, a plaque with three female figures and a fragment now upside down where remains of the dresses of two figures can be seen on each side of an interlacing, they are mounted each on a separate sheet of bronze and do not correspond, either in size or in workmanship, with the rest of the decoration, so that it remains doubtful whether they were originally part of it. The narrow sides had also their decoration, of which there remains only the attachment of one of the rings with a cast bronze openwork figure of David playing the harp (Pl. 31).

In style the figures differ completely from those on the Cumdach of the Stowe Missal and the Lemanaghan shrine. If one was to try to find a parallel for them, it would have to be sought on St Molaise's shrine. Though this is earlier by at least a century, the fact that Drumlane is only some twenty-five miles from St Molaise's monastery at Devenish has to be borne in mind.[1] Except for the three female figures which are stiff and repetitive, all the other surviving figures are of a high quality and wonderfully varied. Though they cannot be said to be exact replicas of old models, the very spirit of their stylization and the way the garments' folds are turned into ornaments recall the evangelists' portraits in the early manuscripts. The exuberant, decorative and lyrical treatment of the hair is also a manuscript feature, as well as the constant interpenetration of ornament and figures. The patterns, however, except in the borders of the clothes, are foreign to the old Irish tradition. They are made by a supple plant which curls around the rivets in the lower part of the plaques, climbs between the figures, gets entangled in their hair, and is grabbed by their hands. It is of the same brand as the vegetation on the Aghadoe crozier (Figs. 6 and 9). But quite different

[1] The shrine is traditionally supposed to have contained relics given by St Maodhóg, the founder of the monastery of Ferns (Wexford), to St Molaise, the founder of Devenish (Fermanagh).

are the connections of the figures clasping foliage stems in their hands; these are Romanesque in origin and one would quote several examples of them, but the most striking parallels are on one of the voussoirs of the middle portal of the west front church of St Médard at Thouars (Deux-Sèvres).[1] The parallel is made more striking by the presence at St Médard of an eagle seen full face which has equivalents on the Breac Maodhóg. The superposed rows of figures on the shrine also recall fairly closely the stone saint's tomb in the church at St Junien (Haute-Vienne). The fragmentary state of the decoration of the metal shrine and the fact that the mutilated inscriptions have become illegible makes it impossible to discuss its iconographical programme. The figures have attributes, books, crosses, sword, vase, which might be those of apostles. But it is hard to see how the twelve figures could have been displayed when nine of them completely fill the lower row. The figure with his head bent on his hand could be St John at the foot of a Crucifixion which might have occupied the centre of the panel. This is the maximum of suggestions one might dare to make on this subject.

If we try now to sum up the results acquired so far by comparing the known dates of manuscripts, with those, much more numerous, of the metal objects, one can arrive at a broad classification of the different types of ornaments used, and this classification will be ultimately a convenient guide in the study of carvings where it will find its confirmation and sometimes useful additions. The list of dated objects on page 120 will give an idea of the results to which we have already been able to arrive.

This list shows at first glance that the vogue of foliage decoration is a phenomenon of the late eleventh century which lives on in manuscripts until perhaps 1110 and then falls to the level of vestigial survivals in the ornaments of initials. The Chronicle of Marianus Scottus of Mainz supplies a date at which it was fully developed, and this allows us to place the Inisfallen crozier and the upper part of the British Museum crozier fairly early also, perhaps as early as 1050–1060. Then come the

[1] See pl. VII

119

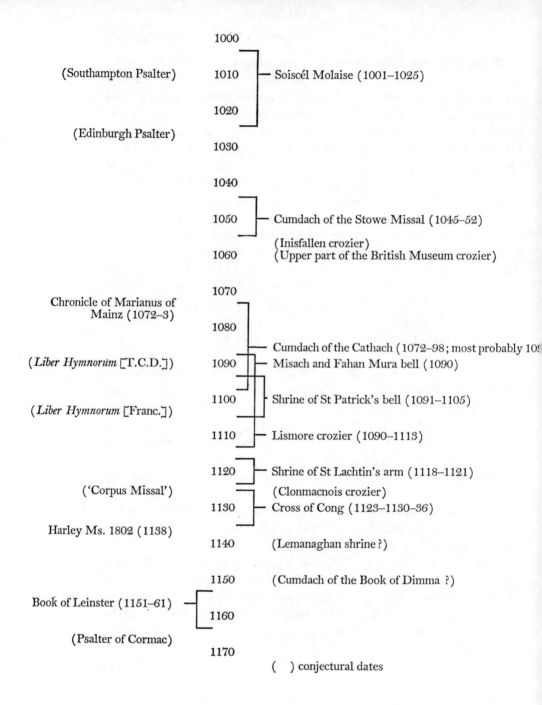

	1000	
(Southampton Psalter)	1010	— Soiscél Molaise (1001–1025)
	1020	
(Edinburgh Psalter)	1030	
	1040	
	1050	— Cumdach of the Stowe Missal (1045–52)
	1060	(Inisfallen crozier) (Upper part of the British Museum crozier)
Chronicle of Marianus of Mainz (1072–3)	1070	
	1080	
(*Liber Hymnorum* [T.C.D.])		— Cumdach of the Cathach (1072–98; most probably 109
	1090	— Misach and Fahan Mura bell (1090)
(*Liber Hymnorum* [Franc.])	1100	⊢ Shrine of St Patrick's bell (1091–1105)
	1110	— Lismore crozier (1090–1113)
	1120	— Shrine of St Lachtin's arm (1118–1121)
('Corpus Missal')		(Clonmacnois crozier)
	1130	— Cross of Cong (1123–1130–36)
Harley Ms. 1802 (1138)	1140	(Lemanaghan shrine?)
	1150	(Cumdach of the Book of Dimma ?)
Book of Leinster (1151–61)	1160	
(Psalter of Cormac)	1170	
		() conjectural dates

two versions of the *Liber Hymnorum* and Rawlinson Ms. B.502, which are usually ascribed to the late eleventh or early twelfth century for linguistic and paleographical reasons, and which are paralleled in metal by such works as the Cumdach of the Cathach, the Misach and probably the Fahan Mura bell. We must not forget, however, that the metalsmiths have probably used foliage motifs, mostly simple scrolls, during all the ninth and tenth centuries. They appear on the Ballinderry lamp (ninth century?), on the crest of the Ahoghill shrine, on the Crucifixion plaque from Clonmacnois and on the little applied cross on the British Museum crozier. Though illuminators were slower in adopting them, they occasionally betray the fact that they do not ignore them. In a few of the initials of the Edinburgh Psalter, a manuscript which probably goes back to the early eleventh century, the wide curve of an interlacing is sometimes notched in such a way as to turn it into a sort of half palmette. It seems also that the Welsh scribe Sulien who studied in Ireland *c*. 1045–1055 had got to know it then, as one of his sons and pupils uses it in a border of the Psalter of Ricemarcus.[1] The motif, thus, was not an absolute novelty in the middle of the eleventh century, but it seems to have become suddenly very popular in the second half of the century, for reasons which we shall have to examine later.

The serpentine animals with elongated jaws become fashionable at a slightly later date. They spread in their full exuberance around 1100 on the shrine of St Patrick's bell and the Lismore crozier and inspire also the decoration of damascened objects, such as the shrine of the arm of St Lachtin, the Bearnan Cuileain, the crozier of the abbots of Clonmacnois, etc. Manuscripts parallels are supplied up to a point by the two versions of the *Liber Hymnorum*, Harley Ms. 1802, and the Book of Leinster, though the illuminators keep their own counsel and, as far as this motif is concerned, never imitate very closely the metal objects. On the contrary, the very characteristic decoration of the 'Corpus Missal' with its coherent and firmly drawn animals corresponds exactly to that of the Cross of Cong, the Lemanaghan shrine and the Aghadoe crozier. On the whole, illuminators during this period are inclined to be more

[1] Vol. II, pl. 47

archaic and traditional than metalworkers, and once they adopt a motif, they keep repeating it for a long time. It is important to remember also that beside the manuscripts indicated on page 120, which are the out-standing milestones of the evolution of the new styles, there are others, such as the Book of the Dun Cow (*c.* 1100) or Harley Ms. 1023 (early twelfth century?) which are a continuation of the earlier tradition and show no influence of the new fashions.

5. The Crosses

<div align="right">A.D. 1020–1170</div>

F o r t w o centuries before the Romanesque period, large carved stone crosses had been the chief ornament of Irish monasteries where they stood here and there between the principal buildings.[1] Their development had not been interrupted by the first Scandinavian raids of the ninth century. However, it seems to have been cut short when, in 915, after a prolonged lull, the attacks started again with renewed violence and intensified looting activities. For a whole century, as far as we know, no crosses were erected. They only reappear late in the eleventh century, and then under a very different aspect. The break, in fact, had been so sharp that there are few points in common between the two groups, except the shape of the monument and its purpose. Only a few crosses, at Drumcliff (Sligo), Boho (Fermanagh) and Durrow (Offaly) constitute a sort of transitional group and maintain a link between the two series.

The chronological landmarks[2] are poor and consist only of three inscriptions, but stylistic considerations confirm the dates thus indicated. The earliest inscription-bearing cross is at Inis Cealtra (Clare),[3] in the island monastery where St Caimin's Psalter was kept for centuries (Pl. 50). It bears two inscriptions, cut on the sides of the monument. One of them, now very worn, gives the name of the sculptor, probably TORNOC; the other, in better condition, reads: 'O̅R̅ DO ARDSENOIR ERENN .I. DO CATHASACH – pray for the Chief Senior of Ireland, i.e. for Cathasach'. The Annals of Inisfallen, at 1111, mention the death of 'Cathasach,

[1] Vol. I, pp. 134 sqq., Vol. II, pp. 133 sqq. See for the crosses: H. O'Neill, *Illustrations of the Most Interesting of the Sculptured Crosses of Ancient Ireland* (London, 1857); F. Henry, *La sculpture irlandaise pendant les douze premiers siècles de l'ère chretienne* (Paris, 1932); E. H. L. Sexton, *A Descriptive and Bibliographical List of Irish Figure Sculpture in the Early Christian Period* (Portland, Maine, 1946); F. Henry, *Irish High Crosses* (Dublin, 1964) (short bibliography).

[2] Petrie, *Chr. Inscr.*, Macalister, *Corpus*, II.

[3] Macalister, *Corpus*, II, p. 89 (No 889).

<div align="right">123</div>

the most pious man in Ireland (cend crábuid Érénd)' at Inis Cealtra, and
the Four Masters and the Annals of Ulster add that he was an ecclesiastic
from Armagh so that he was probably at Inis Cealtra 'in his pilgrimage',
that is to say in that retirement away from their original monastery which
seems to have been the rule in Ireland for elderly monks who had been
invested with important charges. As was usual, the cross was most prob-
ably erected while Cathasach was alive, and not as a funerary monument.
This puts its date in the late eleventh or early twelfth century.

The two other inscriptions are on fragments of crosses at Tuam
(Galway). Both mention the same donors, King Turlough O'Conor and
the abbot of the monastery of Tuam, Áed O' Oissín. As we have seen,
Turlough reigned from 1106 to 1156.[1] Áed was abbot of Tuam from
1126, became archbishop after the synod of Kells in 1152, and died in
1167. On one of the fragments, that which is kept in the Church of
Ireland cathedral, he is described as 'comarba Jarlaithe' – successor of St
Jarlath (the founder of the monastery of Tuam).[2] He may have been
similarly described on the cross on the market-place,[3] but this part of the
inscription is badly worn; it is clear, however, that he is described there
as 'abbot'. These titles give the impression that the inscriptions go back
to a time earlier than the date when Áed became archbishop, so that the
two crosses would date between 1126, when Áed became abbot, and
1152, when he became archbishop. In any case, they cannot be later than
1156, the date of the death of Turlough. The three inscribed monuments
appear in consequence to be clearly dated between the late eleventh
century and the middle of the twelfth.

The shape of these crosses varies, some having a circle linking the
arms of the cross, like the older crosses, the others having simply a sort
of massive disc, or affecting the general shape of a Latin cross whose
arms are connected by a curve. In contrast with the earlier ones, most of
them bear figures in high relief, sometime even in full ronde bosse.
Some of the elements of these figures or of the cross itself are independ-
ent pieces fixed by mortice and tenon. Such was the head of Christ on the
Dysert O'Dea cross, now made fast by cement, but originally simply
inserted into the cross. On the same cross, the arm of the ecclesiastic

[1] See p. 22 [2] Macalister, *Corpus*, II, p. 2 (No. 522) [3] Id., pp. 2–3 (No. 523)

carved on the lower part of the shaft was fixed into a mortice and has now disappeared, as have the two ornamental pieces which used to decorate the ends of the arms of the cross. The market cross at Tuam, the cross on the Rock of Cashel, that at Roscrea and those at Drumcliff and Boho, show also the gaping openings of mortices deprived of the additional pieces they used to hold.[1] This is probably a consequence of the greater importance given to relief and of the difficulty of giving it its full value when using a single block of stone which often comes out of the sedimented layers of the quarry as a thick slab.

Including transition types and fragments, the remains of about twenty crosses of this period have survived. They are found on a much more limited territory than the earlier crosses, a fact probably related to historical conditions (See map p. 129). A group of crosses in Connacht is obviously connected with the royal patronage of Turlough O'Conor. They consist of fragments of two or three crosses in Tuam and a fragment at Cong. Another group is due to the munificence of some kings of the Munster dynasties. It includes crosses at Cashel, Roscrea, Mona Incha and Dysert O'Dea. It is more difficult to explain in the same way another series of crosses whose existence is possibly simply due to the presence of an excellent quality of stone. It has its chief centres at Kilfenora (Clare) and on the great island of Aran (Galway). An isolated cross belongs to the monastery of Glendalough (Wicklow). No cross which could be ascribed to this time has survived in Armagh. Kells, Clonard, Clonmacnois, Lismore, to quote only a few of the important monasteries of the Romanesque period, are just as devoid of remains of late crosses. Once more, we have to assume that only some fragments have survived of what was no doubt an important series of monuments.

The only crosses which to a certain extent constitute a kind of transition between the tenth-century high crosses and the twelfth-century ones are two closely related crosses, one in the Columban monastery of Drumcliff on the Sligo coast the other at Boho (Fermanagh), some distance to

[1] For undecorated crosses built of separate pieces, see the so-called Tau cross on Tory Island (mortice for the now missing upper limb) and the cross found in excavations at Peakaun, made of pieces of different kinds of stone. I am indebted to Michael Duignan for this last information (on the excavation, see: *J.R.S.A.I.*, 1944, p. 226).

the east, and a partly disfigured fragment at Durrow (Offaly). All three probably belonged to the ninth–tenth-century type with arms connected by the segments of a circle. The Drumcliff cross (Pls. 49, 51)[1] is the only one which is nearly intact. It is cut out of two blocks of glittering white sandstone and stands out as a limpid apparition against the sea-sky or the slopes of Ben Bulban, the table-mountain which dominates all the Sligo countryside. It has some figured scenes: Adam and Eve, the sacrifice of Abraham, Daniel in the Lions' den, etc. But they are treated with great freedom, sometimes bordering on absurdity. Adam and Eve stand in precarious balance on wheels of interlacings under a tree which ends in decorative knots. Abraham is partly hidden by a great, lanky, lion-like creature carved in high relief on the shaft. Another beast, curiously hunch-backed and contorted stands out on the other side in the same contrast of relief with the flat carvings behind it. Other full relief animals come down the sides of the cross (Pl. 49). Square holes in each side of the cross were probably the attachments of carvings in even more pronounced relief. It is an art full of movement and surprises.

The cross at Boho[2] is now reduced to part of the shaft and a fragment of arm. It is probably the work of the same sculptor, though what has survived does not show great effects of relief.

The Durrow fragment (Pl. 50)[3] has only recently come down to eye level. It comes from a fairly small cross which, in the eighteenth century, when the church at Durrow was re-built, was severely trimmed on the sides so as to turn it into a gable finial. A storm which knocked down a few stones at the top of the gable brought it down forcibly in 1959 or 1960. It has the same fine interlacings as the Drumcliff cross on part of the arms. On one side it bears a Crucifixion and on the other the figure of an ecclesiastic holding a crozier. This last is its most significant feature,

[1] M. Stokes, 'Notes on The High Crosses of Moone, Drumcliff, Termonfechin and Killamery', *T.R.I.A.*, 1896–1901, pp. 542 sqq. W. G. Wood-Martin, *History of Sligo* (Dublin, 1882), pp. 173–4; Henry, *Sc. irl.*, pl. 88; Sexton, *Fig. Sc.*, pp. 124 sqq. Henry, *Irish High Crosses*, pp. 28, 32, 34, pl. 60.

[2] *Belfast Field Club*, 1901–7, p. 83; Henry, *Sc. irl.*, pl. 89; Sexton, *Fig. Sc.*, pp. 71–2 Henry, *Irish High Crosses*, p. 64.

[3] F. Henry, 'A cross at Durrow (Offaly)', *J.R.S.A.I.*, 1963, pp. 83–4; Id., *Irish High Crosses*, pl. 61; S. de Courcy Williams, 'The Old Graveyards in Durrow Parish', *J.R. S.A.I.*, 1897, p. 128 sqq. The cross must have been originally a ringed cross.

as it represents the beginning of a new iconography on a cross which conforms otherwise to the tenth-century style. The High cross at Durrow, a few yards (in their present positions) from this fragment, may be the latest of the crosses of the School of Monasterboice and dates probably from the second quarter of the tenth century.[1] The gable cross is a slightly later work of the same workshop which may have remained active for a while in Durrow. Though it is connected with the style of the High cross, it adapts itself to new fashions.

As their dates remain rather problematic, it will be better to ignore all chronological considerations in a first review of the Romanesque crosses. The connections between the various groups will then appear as they are studied.

The Southern crosses seem to be closely linked with Munster dynasties, O'Brien, Mac Carthy, or O'Carroll Ely. The last named are probably responsible for the erection of the crosses at Roscrea and Mona Incha. It would be hard to say whether the cross at Cashel was presented by an O'Brien or a Mac Carthy. Since Cashel, the old capital of the Munster kings, had become an archiepiscopal city, it had witnessed in 1134 the dedication of a chapel built by a Desmond king, Cormac Mac Carthy. Why should not the same family be also responsible for a cross? As for the Dysert O'Dea cross, it stands in the present County of Clare, to the north of the territory directly controlled by the O'Briens and, like the door of the neighbouring church, it was probably erected by a member of that family.[2]

The three Tipperary crosses, at Cashel, Roscrea and Mona Incha all had a large relief figure of Christ crucified covered by a long dress, which recalls the famous Lucca crucifix attributed by legend to Nicodemus, which was often visited by pilgrims on their way to Rome.[3] In the eleventh and twelfth centuries, pilgrims brought back lead medals

[1] Vol. II, pp. 139–40.

[2] This even more if one accepts the hypothesis suggested on p. 169, note 1.

[3] Even if the statue at present in Lucca only dates from the twelfth century, it probably replaced another of earlier date and similar iconography. See Mâle, *XIIe siècle*, p. 253; P. Thoby *Le Crucifix des origines au Concile de Trente* (Nantes, 1959), p. 109; Porter, *Crosses and Culture*, p. 56.

bearing the Lucca crucifix and thus caused the spreading of this representation of Christ in a long garment. Some of these medals were found in the harbour of Wissant, near Calais, one of the chief harbours used in the traffic between England and the Continent. The devotion to the Lucca crucifix (the 'Saint-Vou') in England in the late eleventh century is attested by the fact that William Rufus, the Conqueror's son, used to make it a witness of his oaths. This type of crucifix is found everywhere in western Europe, from Catalonia to Germany. England has a remarkable example at Langford (Oxfordshire).[1] Its introduction into Ireland is only to be expected, given all we know of Roman pilgrimages of Irish kings and ecclesiastics in the eleventh century.[2]

Only a fragment of the upper part of the Mona Incha cross has survived,[3] now mounted on a modern shaft, so that it is impossible to know whether it carried another figure as well as that of Christ. On the Roscrea monument,[4] on the other hand, (Pls. 58, 59) there is on the reverse a large erect figure, now broken off at the knees, corresponding to the crucifix in front. As the carving is worn, its details are not clear, though it seems to be holding something. Lower down, there are, on the narrow sides of the cross, two long and slender statues in such strong relief that they modify the outline of the monument. The Roscrea and Mona Incha crosses are covered with ornament which seems to be mostly animal-interlacing arranged on diagonal lines. In addition, on the lower part of the Roscrea cross, there is probably a representation of the Fall. The Cashel cross[5] (Pls. 61, 62), on the contrary, has only a few

[1] D. Talbot Rice, *English Art, 871–1100* (London, 1952), Pl. 17.

[2] See p. 21.

[3] H. S. Crawford, 'Mona Incha Cross', *J.R.S.A.I.*, 1920, p. 81; C. Mac Neill, 'Mona Incha, Co. Tipperary, Historical Notes', *J.R.S.A.I.*, 1920, pp. 10–24; H. G. Leask, 'Mona Incha Church, Architectural Notes', Id., pp. 24–35; Carrigan, *Ossory*, IV, pp. 50–1; Henry, *Sc. irl.*, Pl. 105; Sexton, *Fig. Sc.*, p. 17; Henry, *Irish High Crosses*, p. 33.

[4] Dunraven, II, p. 8, Pl. CXXI; T. L. Cooke, *The early History of the Town of Birr or Parsonstown* (Dublin, 1875), pp. 132–9; Henry, *Sc. irl.*, Pl. 107; Sexton, *Fig. Sc.*, pp. 262–3; Henry, *Irish High Crosses*, p. 33.

[5] H. G. Leask, 'St Patrick's Cross, Cashel, Co. Tipperary' *J.R.S.A.I.*, 1951, pp. 14 sqq. Porter, *Crosses and Culture*, p. 113 and *passim*, Henry, *Sc. irl.*, Pl. 108; Sexton, *Fig. Sc.*, pp. 87–8; Henry, *Irish High Crosses*, p. 33, Pl. 64.

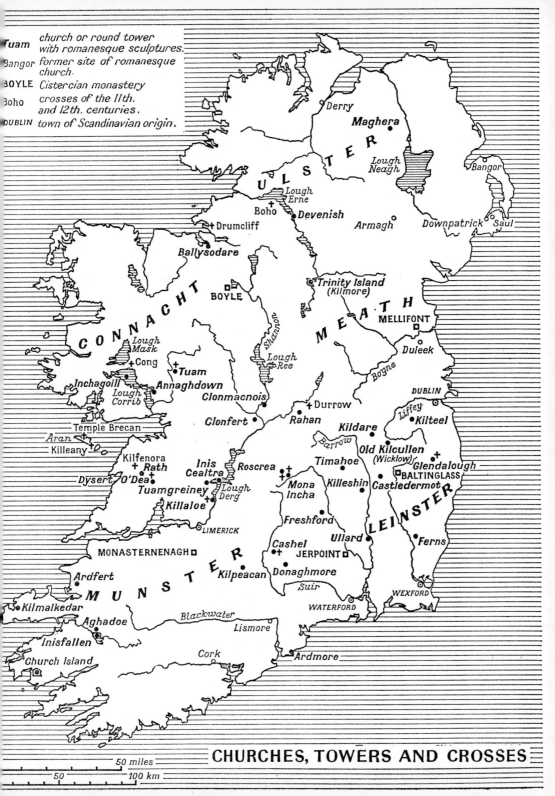

Tuam	church or round tower with romanesque sculptures.
Bangor	former site of romanesque church.
BOYLE	Cistercian monastery
Boho	crosses of the 11th. and 12th. centuries.
DUBLIN	town of Scandinavian origin.

Derry

Maghera

U L S T E R

Lough Neagh

Bangor

Lough Erne

Boho

Devenish

Armagh

Downpatrick Saul

Drumcliff

Ballysodare

Trinity Island (Kilmore)

C O N N A C H T

M E A T H

BOYLE

MELLIFONT

Shannon

Duleek

Lough Mask

Cong

Lough Ree

Boyne

Tuam

Annaghdown

Clonmacnois

Durrow

DUBLIN

Inchagoill

Lough Corrib

Clonfert

Rahan

Kildare

Liffey

Kilteel

Temple Brecan

Aran

Killeany

Kilfenora

Rath

Inis Cealtra

Roscrea

Timahoe

Old Kilcullen (Wicklow)

Glendalough

BALTINGLASS

Dysert O'Dea

Tuamgreiney

Lough Derg

Mona Incha

Killeshin

Castledermot

Killaloe

Freshford

Ullard

L E I N S T E R

LIMERICK

MONASTERNENAGH

Cashel JERPOINT

Ferns

Ardfert

Kilpeacan

Donaghmore

M U N S T E R

Suir

WEXFORD

Kilmalkedar

WATERFORD

Aghadoe

Blackwater

Lismore

Inisfallen

Church Island

Cork

Ardmore

50 miles

50 100 km

CHURCHES, TOWERS AND CROSSES

decorative panels on the base – a lamb in the middle of a great frame of concentric circles, a cross-pattern similar to those found on the reverse of so many reliquaries, and animal-interlacings.[1] It is in a category by itself as far as its general outline is concerned: the Roscrea and Mona Incha crosses are circle-crosses of traditional type and are both cut in a step-pattern opposite the segments of the connecting circle; not so the Cashel cross, which is a Latin cross with arms supported by two thin stone stems representing probably the thieves' crosses.[2] H. G. Leask has shown that mortice holes cut into the upper part of the horizontal arms of the cross and into the top of the shaft were probably provided for maintaining in position two small figures of angels, one on each side of the head of Christ. A similar arrangement may have existed at Roscrea, where the only surviving arm has a square cavity at the end. Apart from this, what connects the three Tipperary crosses is the presence on all of them of the crucifix with the long garment. On the Cashel cross the belt seems to have been indicated in the same way as on the English carving at Langford. On that cross, the figure of an ecclesiastic stands in relief on the reverse of the cross; it is very worn, but it is possible to see that the left hand held a crozier with a curled volute and that the right hand was raised in blessing.

The Dysert O'Dea cross[3] (Pl. 60), cut in the beautiful grey Clare limestone, is in much better condition than the three other crosses. It has also a monumental quality which the complicated Cashel cross certainly lacks. Base not included, it is a little more than 9 feet high. It stands in a field near the ruin of a church. Inscriptions on the base show that it was

[1] The pattern is very worn, but seems to be animal-interlacing on diagonal lines, and not foliage with birds, as would appear at a first glance.

[2] One of these side crosses has disappeared; the other is partly broken (Pl. 62); but they seem to represent the thieves' crosses in the same simplified way as on a small openwork bronze plaque of slightly earlier date in Dublin Museum (Vol. II, Pl. 8).

[3] G. V. Macnamara, 'The Ancient Stone crosses of Ui-Fairmaic, County Clare', *J.R.S.A.I.*, 1899, pp. 246 sqq.; W. Fitzgerald, 'The Dysart O'Dea High Cross, Parish of Dysart (Tola)', *Journ. Ass. for the Preservation of the Memorials of the Dead in Ireland*, 1913–6, p. 21; L. de Paor, 'The Limestone Crosses of Clare and Aran', *J. Galway H.A.S.*, 1955–6, pp. 53 sqq. (p. 60, pl. V); *Art roman*, No 1, p. 3 and plate; Henry, *Sc. irl.*, Pls. 99, 100; Sexton, *Fig. Sc.*, pp. 143, 6; Henry, *Irish High Crosses*, p. 32, Pl. 62.

repaired in 1683 and again re-erected in 1871 after lying in a field for a number of years. The two reconstructions, and the accidents which made them necessary, have caused some changes to the original appearance of the monument. The lower part of the shaft has been shortened by 2 to 4 inches,[1] movable pieces at the ends of the arms have disappeared, and so has the arm of the statue. The base has been cut to make room for the inscription, and has been put on an additional plinth which completely alters the proportions. To picture the original cross, one has to ignore the lower base, imagine the shaft as higher than it is now and the arms as longer.

On the front, one above the other, are two high-relief figures corresponding to those which are on opposite sides at Roscrea and Cashel: above, Christ on the cross, below, an ecclesiastic wearing a conical mitre[2] and holding a crozier with spiral volute in his left hand. The right arm, which is lost, was probably raised in blessing. Both are treated in simplified and rounded volumes which have an extraordinarily compelling presence when enhanced by a good light. This effect is emphasized by the plain background and the thin engraved lines of the frame. It must have been even more satisfying when the arms of the cross were slightly longer and when there was some space between the two figures. Christ is shown in a somewhat different way from the other crosses: instead of a long dress held by a belt, he wears a long-sleeved garment with a sort of pleated skirt. As on other Clare crosses, the head is quite erect and probably beardless.[3] The arms are stretched horizontally and there is no indication of nails. In fact, it seems more a representation of Christ triumphant than a crucifix. The face of the ecclesiastic, long, with hollow cheeks and prominent chin, has parallels in some of the faces on the voussoirs of the near-by church's portal which seems to date, on account of its Continental equivalents, from the second quarter of the twelfth century. Though at first glance the statue suggests a parallel with column-statues

[1] The cut is at the top of the lower block (Pl. 60) and is very noticeable in the decorative panels of the sides and back.

[2] This head-dress was higher before the block was shortened.

[3] One may wonder, however, if the present head is the original one. If the back of the Mongolian-looking head with long moustaches on the portal was examined it might be found to have been the original head, (Pl. 75, to the right of the eagle head).

of the Chartres type, it is in fact probably nearer to the elongated statues found on the western façades of so many churches of Saintonge and Poitou, and the Cashel ecclesiastic suggests a similar origin: he is standing on a monster head, exactly as some of these western French statues are standing on an animated corbel. Parallels to Irish portals with rows of heads are also to be sought in the same region, so that the portal and cross at Dysert O'Dea are linked by common sources of inspiration. As the Cashel and Dysert ecclesiastics have many similarities, it is possible to accept the benediction gesture of the Cashel figure as an indication of the position of the lost arm at Dysert.

All the rest of the cross is covered with ornament kept in such low relief as to be hardly more than an embroidery on the surface of the stone, and forming a strong contrast with the magnificent ronde-bosse and the Romanesque feeling of the front part. Though they are lightly cut, the designs which fill the various panels on the reverse and sides remain very legible. On the reverse, there is a regular pattern of crosses, similar to those on the underside of so many metal shrines, and a panel of animal-interlacing built on a diagonal grille like the panels on the cross of Tuam. The upper part (Fig. 15b) is built of a series of relief lozenges bearing marigold patterns alternating with simplified spirals of the type found on the Boho cross. The sides are divided into framed panels containing key-patterns and some very clear combinations of two animals. The base carries a pattern of woven snakes on one side and figured scenes on the others. The style of these scenes departs completely from what we have seen on the tenth-century crosses. Adam and Eve are surrounded by exuberant foliage; Daniel in the Lions' den has been brought up to date, the lions being contorted animals caught in snake knots (Fig. 10). Another scene is more puzzling: there are four figures, one of them holding a crozier and two others holding a large post in their joined hands.[1] It has been suggested that the ceremonies connected with the foundation of a church may be depicted here; in any case, there is a kinship between this carving and a panel on the cross of the Scriptures at Clonmacnois[2] and both have probably the same significance.

[1] See Crawford, *Handbook of Carved Ornament* (Dublin, 1926), Fig. 147.
[2] Vol. II, Pl. 92, p. 191.

It is slightly disconcerting to find that a cross of such monumental quality as that at Dysert O'Dea has neighbours, a short distance further north in Clare, which are no more than cut out thin slabs with low-relief ornament and flattened figures, recalling up to a point the very first crosses of the seventh century. Some of them have no more than a decoration of interlacings, such as the cross of Cathasach at Inis Cealtra[1] (Clare; Pl. 50) and two small crosses at Kilfenora (Clare).[2] Others are imposing monuments, 9 or 12 feet high, with a very wide shaft and a

Fig. 10. Daniel in the Lions' den, base of the cross at Dysert O'Dea.

cross in circle, sometimes in openwork. There are two, and a fragment of another, at Kilfenora, and the remains of several others on the great island of Aran (Galway).

Kilfenora, which is hardly mentioned in the Annals, must have been a monastery of some importance in the twelfth century, as in 1152, at the Synod of Kells, it became the seat of a bishopric. On the great island of Aran, the oldest of all Irish monasteries was still alive at Killeany, where it had been founded by St Enda to become in the sixth century the training ground from which Irish saints scattered towards their respective foundations.[3] Close by also survived the monastery founded by St

[1] See p. 123; Macalister, *Inis Cealtra*, pl. xvii; Henry, *Sc. irl.*, Pl. 101 Sexton, *Fig. Sc.*, pp. 169–70.

[2] See *North Munster A. J.*, 1910, pp. 91 sqq.; L., de Paor, *Crosses of Clare and Aran*, pp. 58–9.

[3] Kenney, *Sources*, pp. 373–4.

Brecan, disciple of St Enda. There are in the Annals, in the eleventh and twelfth centuries, mentions of two 'successors of St Enda'. The monastery was destroyed by fire in 1020 and was plundered by the Vikings in 1081. It may well be that some of its importance at that time is due to the fact that St Brecan was of Dalcassian origin, and could thus be looked upon as an illustration of the family from which stemmed Brian Boru. An O'Brien family took charge of the island in the thirteenth century and it is possible that already in the eleventh century the patronage of Brian's family brought a new life to the ancient monasteries on the island. Nevertheless Kilfenora and Aran remained slightly off the beaten track and the crosses which were fashioned out of a beautiful grey-golden limestone in these far-away monasteries retain an archaic and wild flavour which has no equivalent in other contemporary monasteries. The work of the sculptors was both fostered and conditioned by the existence of this excellent stone, which comes out in thin slabs and is still quarried at Liscannor, some 8 miles from Kilfenora. It lends itself only to the fashioning of very thin monuments, generally decorated by engraved lines.

The cross which stands in the middle of a field, a short distance from the ruins of the cathedral of Kilfenora (Pls. 52, 54),[1] is the most elaborately finished of all these monuments. It is about 15 feet high, though nearly 2 feet ought to disappear into a base or in the ground, which would make it squatter in appearance. The back is covered with finely engraved ornaments, but on the other side a greater play has been given to such various types of modelling as could be used on a thin piece of stone.

The figure of the Crucified, smooth and flattened, stands out on a background of incised ornament from which it takes, by contrast, an appearance of relief and volume. The double-corded stem which comes to support the suppedaneum breaks the monotony of all these engravings which, anyway, stop halfway, leaving in the lower part of the stone plank two great unworked areas. Right at the top, the engraving turns into a

[1] James Frost, *The History and Topography of the County Clare, from the earliest Times to the beginning of the eighteenth century* (Dublin, 1893), pp. 98 sqq.; T. J. Westropp, 'Notes on the Antiquities around Kilfenora and Lehinch, Co. Clare', *North Munster A.J.*, 1910, pp. 91 sqq.; L. de Paor, *Crosses of Clare and Aran*, pp. 54–5; Henry, *Sc. irl.*, Pl. 103; Sexton, *Fig. Sc.*, p. 192.

sort of chip carving in order to give its full impact to the fierce monster which pretends to be the Lamb. It is a very subtle treatment which lends itself beautifully to effects of light. The ornaments are very simple: a series of key and fret patterns, one of them circular and similar to the patterns on the terminals of some of the tenth–eleventh-century silver brooches, and interlacings which sometimes give an amusing parody of square key-patterns. There is nothing else, and this repertoire is so traditional that, taken apart from the whole group, the cross would be difficult to date.

Fig. 11. Cross near Temple Brecan (Aran) (after M. Stokes).

A cross which was moved from Kilfenora to Killaloe in the eighteenth century (Pl. 53)[1] appears as a rougher version of the same type, with more awkward ornaments and a heavier outline because of the absence of openwork spaces isolating the ring. To the patterns on the other cross is added a sort of helix ending in monster heads. On both crosses Christ wears a long dress, slightly different, however, from that depicted on the Tipperary crosses.

The Aran crosses are similar in type. There remains near Temple Brecan (the church of St Brecan) a very flat shaft of a cross and a few

[1] T. J. Westropp, 'Killaloe, its ancient Palaces and Cathedral', *J.R.S.A.I.*, 1892, p. 398 sqq.; L. de Paor, *Crosses of Clare and Aran*, p. 58; Henry, *Sc. irl.*, Pl. 102; Sexton, *Fig. Sc.*, p. 197.

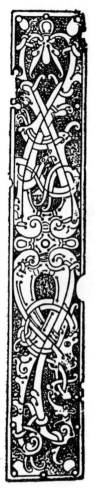

fragments of the arms linked by a circle (Fig. 11).[1] The ornaments there are also square labyrinths, interlacings and a few curled up monsters. There may also have been on that cross a Crucifixion in which Christ did not wear a long dress and was accompanied by the two thieves, but that part of the cross is so badly broken that nothing more is certain than the presence of legs and the top of a head. Another cross, now prostrate on the rocks[2] is covered with interlacings and key patterns. It is broken in several pieces and it is impossible to ascertain whether the other side was also carved. There are fragments of one or two more crosses at Temple Brecan.

The old monastery of Killeany (Cill Eanda, the church of Enda),[3] some 6 miles to the east of Temple Brecan, at the other end of the island, had also been adorned at that time with at least one carved cross. It was built on the slope of a hill and the ruins of six churches were still to be seen there in the seventeenth century. Four of them supplied the stones for a Cromwellian fortress. There remains the foundations of a round tower which was knocked down by a gale in the nineteenth century. A short distance from it stood the base of a cross. John O'Donovan, when examining the antiquities of the island for the Ordnance Survey in 1843[4] found the lower part of the shaft and had it put back into the base. Another fragment, heavily whitewashed, was for a long time the ornament of a dry-stone wall in front of a cottage below the ruins.[5] It has now been moved, together with several other fragments recovered from the wall of the fortress, into one of the ruined churches. Though some parts of the cross are still missing, its general shape and decoration can be gathered from these various pieces (Fig. 13). The centre consisted

Fig. 12. Fragment of a Scandinavian weather-vane from Winchester (after T. D. Kendrick).

[1] Cochrane, *Guide Islands and Coast*, pp. 69 sqq.; H. S. Crawford, 'Carvings from Aran Churches', *J.R.S.A.I.*, 1923, pp. 99–100; Henry, *Sc. irl.*, Pl. 104; Sexton, *Fig. Sc.*, p. 274.

[2] Cochrane and Crawford, op. cit. above; Henry, *Sc. irl.*, Pl. 104; M. Stokes, *Early Christian Arch.*, Pl. IX; Sexton, *Fig. Sc.*, p. 275.

[3] Cochrane, *Guide Islands and Coasts*, p. 84; *J.R.S.A.I.*,1897, p. 267 (Proceedings); J. Romilly Allen, 'On some points of Ressemblance between the Art of the early sculptured stones of Scotland and of Ireland', *P.S.A.Sc.*, 1896–7 p. 313; Henry, *Sc. irl.* Pl. 105; Sexton, *Fig. Sc.*, p. 205.

[4] Ordnance Survey Letters, Galway. [5] Henry, *Sc. irl.*, Pl. 105, 1.

Fig. 13. Reconstruction of the Killeany cross (Aran): *a,* west side of a
fragment inserted in the base; *b, c, d,* fragments coming from Arkin
Castle, now in the Church of Teglach Enda (the position
of *b* is doubtful).

of a large disc with a figure framed by a band of interlacing; only the top of the head and the feet and hem of a long dress remain. Below the disc, a small horseman with a short cape climbs a step. On the other side of the cross stood a figure in a long dress which seems to hold a crozier. The ornament on the shaft is the usual square labyrinth with interlacings, curled-up monsters similar to those of the Temple Brecan cross, a panel of spirals – a rare feature at this time – and a very strange pattern made of two opposed animals, head below, on each side of a large triangular knot.[1] They form an animal-interlacing on a figure of eight and they are accompanied by foliage of the type of that on the Cathach shrine. This composition has a parallel, more awkward in style, on a slab from Bibury (Gloucestershire)[2] which has also the two beasts heads downwards and much more developed foliage. The general pattern is also reminiscent of the slab at Vang, in Norway[3] or the fragment of Scandinavian weather-vane from Winchester (Fig. 12), though in these two objects there are no animals as a fundamental element of the ornament. These varied parallels have the advantage of dispelling the chronological vagueness which has surrounded this group of crosses so far, as they all belong to the eleventh or early twelfth century.

The last cross to be examined gives another version of a similar design. It is the strangest of the whole lot; incoherent, awkward here and there, close to popular art, its impetuous style makes it nevertheless a remarkable monument. For a long time it was overlooked, as it was lying in two fragments in the ruins of the cathedral of Kilfenora.[4] Since it was re-erected in the graveyard, it has taken its place as one of the most disconcerting problems of Irish Romanesque art. On one of its sides, a small figure sitting sideways on a horse which seems to be climbing like the horse of the Killeany cross, passes behind a small tiled monument. The man holds the end threads of a strange interlacing which in its general structure is like the animal-interlacing on the Killeany

[1] Henry, *Sc. irl.*, Pl. 105, 2, 3.

[2] Kendrick, *Late Saxon*, Pl. LXX, 2.

[3] *Osebergfundet*, III, fig. 333.

[4] L. Kaftannikoff, 'Discovery of a High Cross at Kilfenora', *North Munster A. J.*, 1946, pp. 33 sqq.; Id., 'The High Crosses of Kilfenora', *N.M.A.J.*, 1956, pp. 29–30. L. de Paor, *Crosses of Clare and Aran* (Dourty Cross).

cross, but is devoid, it seems, of any beast heads. The upper part, which is in very bad condition, seems to have had a figure of Christ crucified surrounded by birds. On the other side the upper part is completely filled by a large figure with conical headgear, holding a crozier with rolled-up crook. His blessing hand is directed towards the lower part where two figures are depicted walking arm in arm, one holding a Tau crozier, the other a crozier of the usual Irish type, and thrusting their ferrules into a large bird; the bird stands on the head of another figure shown in bust and attacks violently his companion. This scene is probably an allusion to an event or a situation known to all contemporaries, but now unintelligible for us. The costume of the upper figure is rather puzzling. His straight dress has nothing in common with the cope-like vestments of the crozier-bearing ecclesiastics shown on the Cashel and Dysert O'Dea crosses. The conical cap with infulae suggests, rather than a mitre, a tiara as it was worn by eleventh- and twelfth-century popes.[1] The two winged creatures, birds or angels, perched on his shoulders, are no less disconcerting.

Here, as on the other crosses, the question arises of who is meant by the ecclesiastic holding a crozier of a type unusual in Ireland who almost always accompanies the representation of Christ on the cross in monuments of this group. He can hardly be meant for a local saint, as he appears in widely different places. Any attempt at associating him with the establishment of new bishoprics in 1111 and 1152 would be discouraged by the fact that he appears at Dysert O'Dea and Killeany, two monasteries which did not become episcopal sees. One may wonder if what is meant is not a representation of Christ as Abbot of the World, a title given to him in some Irish texts. Comparisons may also come to mind with the Continental late twelfth-century enamelled crucifixes which often bear a figure of St Peter below the Crucifixion,[2] an iconography which may be older than the actual surviving enamelled crosses. In

[1] E. W. Anthony, *Romanesque Frescoes* (Princeton, 1951), fig. 74 and p. 73 (fresco in the Roman church of S. Clemente, executed between 1084 and the early twelfth century); also fig. 76 and p. 74.

[2] Thoby, *Crucifix*, Pl. LXIII and p. 104 (Crucifix in Cleveland Museum, twelfth cent.) See also: P. Thoby, *Les croix limousines de la fin du XIIe siècle au début du XIVe siècle* (Paris, 1933).

Ireland the figure never holds keys, but the Kilfenora tiara, so similar to a pope's tiara, could give some weight to this hypothesis.

As for the date of the Aran and Kilfenora crosses, it is difficult to assess. Nearly all the elements of decoration belong to Irish tradition. The only aberrant motif, the plant or animal pattern of the Killeany and Kilfenora crosses, has late eleventh-century connections. The rolled up crozier of the Kilfenora cross would not be anachronistic at such a date if one accepts the figuration as borrowed from a foreign model. The whole group may thus belong to the second half of the eleventh century, but is more likely to be an archaic production of the twelfth century.

There remains to examine a fairly well dated group of crosses, those erected in Tuam by Turlough O'Conor and Abbot Áed O'Oissín, and the related Glendalough cross. As we have seen,[1] the Tuam crosses can be dated between 1126, date of the installation of the abbot and 1156, year of Turlough's death. Turlough and Áed seem to have completely remodelled the abbatial city of Tuam in 1127.[2] It may be at that time that they erected stone crosses marking, as in Armagh, the chief divisions of the city, and this is a more likely time than the other period of building activity which may have followed the erection of the see into an archbishopric in 1152, as Áed is not described as archbishop in either of the two inscriptions.

There are remains of two, or perhaps three crosses: a very high shaft on the market-place, more than 9 feet high, erected on a carved base, is surmounted by a cross-head of very much smaller width,[3] and a fragment, now in the Church of Ireland cathedral, was originally discovered in the graveyard.[4] The mouldings on this fragment do not correspond with those on the market cross, so that it is likely to come from a different

[1] See p. 124. [2] See p. 35.

[3] H. T. Knox, *Notes on the early History of the Dioceses of Tuam, Killala and Achonry* (Dublin, 1904); R. J. Kelly, 'The Cross of Tuam', *Dublin Penny Journ.*, 1902–3 p. 154; Id., 'Antiquities of Tuam and District', *J.R.S.A.I.*, 1904, pp. 257–60; L. S. Gogan, 'The Famed High Cross of Tuam', *The Standard*, Aug. 9, 1930. Petrie, *Chr. Inscr.*, II, pp. 74 sqq.; Macalister, *Corpus*, II, p. 2 (No. 523); Henry, *Sc. irl.*, Pls. 109 and 110, 2; Sexton, *Fig. Sc.*, pp. 283–5, Henry, *Irish High Crosses*, p. 34.

[4] See references above; also: Henry, *Sc. irl.*, Pl. 110, 13; G. Petrie in *P.R.I.A.*, 1850–3, pp. 470 sqq.

cross, a fact made even more obvious by the inscription it bears, a nearly exact repetition of those on the base and shaft of the market cross.[1] So it seems that there was a large cross of which base and shaft remain in the market place. The two other fragments, the other shaft and the small head may come from the same monument, but may also have belonged to two different crosses.

The larger cross (Pls. 63, 64) has a monumental base with high-relief figures on either side. There may also have been two statues standing on both sides of the cross on little stone brackets, held up by a piece of stone fitting into a mortice which exists in the side of the stem; they would have been in the same position as the high-relief figures on the Roscrea cross. All the remainder of the surface is covered by a network of interlacings and animal-interlacings carved in very low relief. At first glance their patterns are confusing. The stone is worn, and many details which were lightly engraved are now hardly visible. A careful examination shows however that the arrangements of the patterns were very regular and were built on two diagonal lines. In one case there is only a series of knots; elsewhere a large interlacing cross spreads over the whole surface. Most patterns are made of ribbon-shaped animal bodies. The heads are small and sometimes difficult to spot, but, whenever the carvings are clear enough they can be seen and the structure of the interlacing is then quite clear (Fig. 30). The cross was probably nearly 20 feet high. The shaft may not have been much higher than it is now. The widening for the cross-head probably started immediately after the last surviving panel and one may assume that it bore a figure in high-relief of Christ crucified which was partly or totally a separate piece of stone, as the rectangular hole in the centre of an undecorated panel on one of the wide sides was probably for the attachment of the feet. The Dysert O'Dea cross and the cross in the field at Kilfenora supply obvious parallels for a high-relief crucified figure whose legs encroach on the stem of the cross.

A fragment of cross which was in private possession at Cong (Galway) at the time when Sir William Wilde was engaged in writing his book on Lough Corrib, that is to say around 1867, and of which he

[1] Macalister, *Corpus*, II, p. 2 (No. 522).

published a drawing (Fig. 14)[1] seems to have been decorated in the same style as the market cross at Tuam. The Augustinian monastery which replaced the old monastery of St Fechin at Cong, between Lough Corrib and Lough Mask, was founded by Turlough O'Conor in the first half of the twelfth century,[2] so that the similarity of the cross there with that at Tuam need not surprise us.

The other cross at Tuam was smaller and rather different in treatment. What remains of the shaft shows a greater variety of ornaments: knot interlacing, key-patterns and thickly modelled animal-interlacings are the staple patterns. It is a more traditional repertoire, nearer to that

Fig. 14. Fragment of a cross at one time at Cong (after W. Wilde).

of the Aran-Kilfenora crosses. The cross-head bears on one side a figure of Christ in high relief, torso naked, ribs strongly marked, wearing a kind of skirt and probably a crown. This is a very common type in the twelfth century on the Continent, much more common in fact than the 'Sacro Volto' type. On the other side there is, in the centre, a squat figure wearing a kind of hood, surrounded by four smaller figures, rectangular in shape, whose general appearance is reminiscent of the

[1] Sir William Wilde, *Lough Corrib, its Shores and Islands, with Notices of Lough Mask* (Dublin, 1867); re-published: *Wilde's Loch Coirib, its Shores and Islands, with Notices of Loch Measga*, ed. by Colm O Lochlainn (Dublin, 1936), p. 178; the fragment was then 'in the pleasure-ground at Moytura'.

[2] In any case before 1138, latest possible date of the foundation of Gill Abbey in Cork. See the Charter p. 157.

small figures on the upper part of the west front of the Abbey church of St Jouin-de-Marnes (Deux Sèvres).[1]

The inscription mentions the name of the artist: 'O̅R DON THAER DO GILLU CRIST U THUATHAIL – pray for the craftsman, for Gilla Christ O Thuathail (O'Toole)'. The name is rather unexpected. It belongs to Leinster and was at that time closely associated with Glendalough. Turlough, in 1127, made a successful foray against the king of Leinster and the 'Foreigners of Dublin' and for a few months his son Conor ruled Dublin. This was obviously a good occasion to hear about an artist working in Leinster. There remains in Glendalough a carved cross which has this remarkable feature of having also a figuration of Christ with the torso naked and dressed in a short skirt. So it may be that one at least of the artists working in Tuam came originally from the monastery of the Wicklow Mountains. Because of this we might usefully consider the Glendalough cross at this point.[2]

It is barely 6 feet high without the base, and the high-relief figures are all on the same side: an ecclesiastic, rather squat, blessing and holding a crozier, is carved immediately below Christ crucified and above shapeless remains of figures or animals on the base. Christ is shown with head bent, as on the Tuam fragment. At the back, there is an elegant pattern of flowers and snake-interlacings. On the two narrow sides and the base there are animal-interlacings (Figs. 15a and 30b). Those on the sides are made of combinations of well-drawn little beasts and of snakes. The structure and appearance of the interlacings are the same as on the large Tuam cross, being organized on diagonals, so that at first glance the elongated bodies with small heads give the illusion of an ordinary interlacing. The cross is now housed in 'St Kevin's Kitchen'. It is usually described as the 'market cross' and it is supposed to have been originally beyond the bridge, outside the 'City' proper. In actual fact, the documents do not agree, and it may well have stood near the cathedral.

[1] See: R. Crozet, *L'art roman en Poitou* (Paris, 1948), Pl. XXX; also: E. Maillard, 'La façade de l'église romane de Saint-Jouin-de-Marnes en Poitou', *G.B.A.*, 1924. pp. 137 sqq.
[2] Leask, *Glendalough*, Fig. 21 and p. 49; Henry, *Sc. irl.*, Pl. 107; Sexton, *Fig. Sc.*, p. 161.

a

Fig. 15. Floral motifs on crosses: *a*, Glendalough; *b*, Dysert O'Dea.

b

Other equally traditional aspects of Irish sculpture can be studied to-gether with the crosses, which are themselves a continuation of the monuments of the preceding centuries. During the eleventh and twelfth centuries the workshops which had been cutting and engraving funerary

144

slabs[1] go on making the same monotonous types of monuments. They produced a great number of slabs for the graveyard of Clonmacnois (Pl. 79) and for a few neighbouring monasteries such as Cloonburren (Galway), on the other side of the Shannon, Inis Cleraun (Longford) in Lough Ree, and Ballynakill, near Longford. Other stonecutters were active at Inis Cealtra (Clare) and at Glendalough (Wicklow). There are, on these late Inis Cealtra slabs, several types of crosses already in use in the eighth and ninth centuries, whilst the Clonmacnois and Glendalough ones nearly always have crosses of a later type, ending in semicircular terminals. The treatment is remarkably subtle, a slight modelling being combined with the engraved work, and the inscriptions, still as in earlier time placed above and below the cross, show a great feeling for the decorative value of script. A fairly common type has the cross defined by a continuous ribbon lightly knotted in the corners (Pl. 79). The slightly rounded modelling of the ribbon gives a great elegance to this motif. The ornaments are very simple, mostly interlacings and key-patterns, with only a few rare cases of zoomorphs. In this the slabs have a good deal in common with the Kilfenora crosses, and the similarity is such that one may wonder if the same workshop is not responsible for the crosses and the slabs.

The Glendalough funerary slabs are nearly of the same pattern, except for the fact that the cross is generally enclosed in a frame. They are cut out of local stone, granite or micaschist, which does not yield as easily to the chisel, so that the designs are not as elegant and the ornament is not as finely cut. One of them, however, has a pattern unknown on other Irish slabs, a vigorous plant motif with a central stem and symmetrical shoots curving back on both sides of it.[2] This is almost the same design as that on the narrow sides of the bronze cross of Cong.[3]

A certain number of names mentioned in the inscriptions are to be found in the obits of the Annals, though the identifications are not as

[1] Lionard, *Grave-Slabs*.

[2] Leask, *Glendalough*, Fig. 11, Memorial slabs *b*; Cochrane, *Glendalough*, Fig. 100.

[3] This pattern is found fairly frequently, for example on the doorway at Clonfert (Pl. 68) and on the doorway at Maghera (Pl. V). It appears also on some of the column bases at St Saviour's Priory, Glendalough (Pl. 108).

obvious as in the preceding periods because of the constant repetition of the same names. Nevertheless there are enough well-dated slabs to show that the traditional type of slab lived on until the Norman invasion, and this is confirmed by a sketch of the slab on Turlough O'Conor's tomb at Clonmacnois found in the margin of his obit in the Oxford manuscript of the Annals of Tigernach;[1] the cross with semi-circular endings is perfectly clear in spite of the simplified drawing.

Turlough's obit says that he was buried 'near St Ciaran's altar', so probably in the cathedral of Clonmacnois. But no untouched tombs with their slabs *in situ* have remained in Clonmacnois. In Glendalough, on the other hand, several are to be found near the church of Reefert. In several cases the box of slabs which does as a coffin can be seen clearly under the recumbent slab which is sometimes decorated;[2] a small cross or an erect stone is often to be found at the head of the tomb. The same arrangements are found at Inis Cealtra.

There must also have been burials in cut stone sarcophagi, but the only surviving example is that at Cashel, which is now in Cormac's Chapel (Pl. 89) but whose exact find-place in the complex of ruins which cover the Rock of Cashel remains unknown.[3] It is a great trough of stone 7 feet 4 inches long, carved only on one of its long sides. The carving is unfortunately partly broken, but it is possible, nevertheless to restore the original pattern which was obviously perfectly symmetrical; it was made of the combination of two elongated monsters whose bodies crossed exactly in the centre of the panel. This is a very ancient motif in Irish decoration; there are examples of it in eighth- and ninth-century manuscripts and metalwork. The treatment, however, is new in that there is an effort to give the impression of an openwork plaque on a dark background. So, this is a stone equivalent on a large scale of the panels of the cross of Cong and the borders of St Manchan's shrine (Pls. 89, 43). The addition to the elongated animals of a network of snakes holding them in complicated knots seems to indicate a date in the second

[1] Rawlinson Ms. B. 488, Fol. 23v; Lionard, *Grave-Slabs*, p. 169.

[2] Lionard, op. cit., Pl. XXVI, 2.

[3] It is too long to have originally fitted, as has been suggested, into the recess near the north portal.

146

quarter of the twelfth century, rather than the eleventh century date which has sometimes been proposed.[1]

Very little is known also of Irish eleventh- and twelfth-century altars and of their decoration. Many of them were probably made of wood, as a certain number of stone tablets inscribed with five crosses have been found, which are obviously altar-stones made to be inserted in wooden altars.[2] Five of these have been discovered at Clonmacnois, others come from Gallen (Offaly), Kilpeacan (Tipperary), Ardmore (Waterford) and Downpatrick (Down). A large rectangular stone decorated with saltires is said to have been found in Reefert church, in Glendalough, and is now preserved in St Kevin's Kitchen;[3] it has been suggested that it might be an altarfront, and this seems the only likely explanation of the regular design and the large size of the stone, which measures 5 feet 10 inches by 3 feet 1½ inches. It may be also that the lower part of the base of the Dysert O'Dea cross contains some fragments from a stone altar; this would be the only likely use of two large rectangular slabs decorated with several crosses inserted at present between four blocks which were probably part of the decoration of the church.

[1] Kendrick, *Late Saxon*, p. 114. [2] Lionard, *Grave-Slabs*, pp. 137 sqq.
[3] Cochrane, *Glendalough*, Fig. 102, p. 37.

6. The Churches

A.D. 1020–1170

IRISH ARCHITECTURE of the period which corresponds roughly to the development of Romanesque art elsewhere shows a surprizing lack of novel features.[1] The standard plan still consists of a square or rectangular choir. Except for the Cistercian churches, no surviving church anterior to the Norman conquest has a division of the nave by arcadings resting on pillars or columns; transepts are unknown; choirs still end in a straight wall. We have already noticed this lack of interest in the functional aspect of architecture. But it seems disconcerting still to be faced with such indifference to the articulation of the various parts of a building and the play of masses at a time when architects of Romanesque churches were ceaselessly experimenting with new formulae, at the very time when ogive vaults were being tried at Durham and in the north of France and when the consequences of this innovation were making themselves felt in the structure and disposition of the buildings.[2]

This attitude represents an archaism which has to be admitted as such and can perhaps be considered as the outcome of a deep-rooted tendency, remembering that the two original creations of the Irish masons are the round tower and the high cross, both typically non-functional monuments. The description given by St Bernard of the building of the church of Bangor by St Malachy on his return from the Continent clearly shows

[1] On these churches see: George Petrie, *The Ecclesiastical Architecture of Ireland anterior to the Norman Invasion* (Dublin, 1845); R. R. Brash, *The Ecclesiastical Architecture of Ireland to the close of the Twelfth Century* (Dublin, 1875); the Earl of Dunraven, *Notes on Irish Architecture* (ed. by Margaret Stokes; vol. II, London, 1877); A. Champneys, *Irish Ecclesiastical Architecture* (London, 1910); F. Henry, *La sculpture irlandaise pendant les douze premiers siècles de notre ère* (Paris, 1932); H. G. Leask, *Irish Churches* (Dundalk, vol. I, 1955, vol. II, 1958); Máire and Liam de Paor, *Early Christian Ireland* (London, 1958).

[2] Though there is an ogive vault in the choir of Cormac's Chapel, it is inert and non-functional.

148

the antagonism of the average twelfth-century Irishman to the novelties from abroad. During his journey St Malachy had seen all the new buildings which were surging out of the ground in the north of France, in Burgundy and in Italy around 1140; he had visited Clairvaux in course of re-building and probably Citeaux; even if he saw neither Vézelay nor Cluny, he certainly saw churches erected under their influence. On his return he laid the foundations of a church 'like those which he had seen constructed in other regions'.[1] From the start, says St Bernard, it startled the people of the neighbourhood as there were no churches built in this way and they said to him: 'Why have you thought good to introduce this novelty in our regions? We are Irish (Scotti), not French (Galli)', and they asked him how he was going to be able to bring such an ambitious plan to completion. It seems obvious that this novelty, which appeared so startling, from the early stages of construction, consisted in the use of pillars, transepts and chapels.

A careful study, however, shows a few attempts at transforming and up to a point adapting the methods of construction used so far. Vaults appear and various ways of inserting round towers into the fabric of the church are attempted.

The Irish experiments in vaulting have often been attributed to an earlier period, but they probably start only in the eleventh century, and a few of the most typical examples of vaulted churches are dated to the late eleventh or twelfth century either by carvings which are part of the original construction or by texts. This is the case for the oratory at Devenish,[2] the church of St Flannan at Killaloe,[3] Cormac's Chapel at Cashel,[4]

[1] Lawlor, *Vit. Mal.*, 61: 'It seemed good to Malachy that a stone oratory (oratorium lapideum) should be erected at Bangor like those which he had seen constructed in other regions. And when he began to lay the foundations, the natives wondered, because in that land no such buildings were yet to be found'.

[2] See p. 151; the carved corner stones may date from the late eleventh century; see; Lady Dorothy Lowry-Corry, 'St Molaise's House at Devenish, Lough Erne, and its sculptured Stones', *J.R.S.A.I.*, 1936, pp. 270 sqq.; Leask, *Ir. Churches*, I, pp. 37–8.

[3] It has a Romanesque doorway which the fairly recent cutting of the ivy has revealed as obviously part of the original structure; Dunraven, II, pp. 67 sqq. and Pl. CIII; Leask, *Ir. Churches*, I, pp. 36–7 and Fig. 13.

[4] See pp. 169 sqq.

the choir of the large church at Rahan,[1] St Saviour's priory at Glenda-
lough,[2] the church of Donaghmore (Tipperary),[3] the Priory of Ferns,[4]
and so on. There is no reason why St Columba's House at Kells[5] and
St Kevin's Kitchen at Glendalough[6] (Pl. 67), which are identical in
structure, would be of much earlier date. The development is probably
not a purely local one deriving from boat-shaped dry-stone oratories[7]
but an effort to imitate Continental vaults while still using some features
of the corbelled dry-stone vault. In these buildings the vault is made of
stones laid like the voussoirs of an arch and embedded in mortar; only
the roof is made of stones laid horizontally, which form the covering
proper. The originality of these constructions lies in the fact that the
vault is not covered by the wooden carpentry of a roof but is part of the
same complex of masonry as the roof itself. The masonry of the roof,
however, goes on in a straight course at the point where the vault
curves, so that a sort of room, triangular in section, is formed above the
vault (Fig. 23). This disposition is identical in St Kevin's Kitchen, in
St Columba's House, and in the Oratory of St Flannan at Killaloe. At
Kells and Glendalough, there were transverse beams at the level of the
roots of the vault, possibly because they were considered necessary to the
safety of the building or in order to support a floor dividing in two the
space under the vault. The Glendalough oratory was altered sometime
after its erection by the addition of a choir and a sacristy both vaulted
in the same way as the original part. St Flannan's oratory had a choir
which may have been built at the same time as the nave. In size, there
are no considerable variations between the three structures: St Columba's

[1] See p. 152; the chancel arch and choir seem to be contemporary. Though I proposed
at one time an early date for them (*Sc. irl.*, pp. 176–8; *Irish Art* (1940), pp. 94 sqq),
a more thorough investigation has convinced me that they were both of twelfth-century
date.

 [2] See pp. 152 and 182. [3] Leask, *Ir. Churches*, I, pp. 136–7.

 [4] See p. 182; this church had a Romanesque door of which the bases still survive.
To these churches could be added one of the churches at Liathmore (Tipperary), though
later alterations have confused its original appearance. For later examples of this type
of vaulting, see: Leask, *Ir. Churches*, I, pp. 40–1.

 [5] Leask, *Ir. Churches*, I, pp. 33–4 and Fig. 12.

 [6] Leask, *Glendalough*, pp. 22 sqq.; Id., *Ir. Churches*, I, pp. 34–6.

 [7] Vol. I, pp. 51 sqq.

House is the smallest and measures 19 feet by 15 feet 6 inches;[1] St Kevin's Kitchen is 22 feet 8 inches by 14 feet 7 inches, and St Flannan's Church 28 feet 10 inches by 17 feet 6 inches. The Kells and Glendalough oratories may be the oldest of the three and may date from the eleventh century. At Glendalough, the door has a flat lintel with relieving arch, an arrangement which is found in the awkward and late reconstruction of the upper part of the eighth-century doorway of the cathedral of Glendalough. The Killaloe doorway has mouldings which indicate clearly the twelfth century.

There was, at Devenish (Fermanagh), another oratory of this type. It is now completely ruined, but early nineteenth-century drawings show it intact, with its steep stone roof (Pl. IV). Part of the corner pilasters have survived in the ruins, and their carved bases have elegant palmettes which may go back to the late eleventh century. The oratory was slightly smaller than St Columba's House (19 feet 3 inches by 11 feet 2 inches).

This system where the vault directly carries a stone roof is found occasionally in parts of Europe where beams were hard to come by. It existed in the late tenth century in some Pyrenean churches and in Catalonia.[2] Somewhat later it was fairly common in Provence.[3] It was probably much more frequently used than appears now when the heavy stone roofing of Romanesque churches has nearly always been replaced by tiles or slates. These stone roofs were often made of large slabs slanting like slates, though resting directly on the vaulting masonry. In some cases, however, a corbelling system seems to have been used when a suitable type of stone was available.

Several monuments of this type seem to have had living quarters included in the general bulk of the church. They are often one or two adjacent rooms, sometimes vaulted, sometimes not, sometimes opening into the choir and thus probably used as sacristies. This is the case with St Kevin's Kitchen where a room was built on the north side of the choir. The same thing occurs in the Ferns priory, though in this case the room

[1] All the measurements given here are inside measurements taken at ground level.
[2] Mgr. E. Junyent, *Catalogne romane* (Zodiaque, 1960).
[3] M. Thibout – Père M. A. Dimier, *Senanque* (Paris, n.d.), Pls. 5, 16.

opens onto the nave (Fig. 27). In both cases the room is vaulted. At Rahan, there were two rooms, one to the north, one to the south of the choir.[1] In St Saviour's Priory at Glendalough, there were two rooms, both parallel to the nave (Fig. 27). There, as in Rahan and Ferns, a small staircase led from one of the rooms to a sort of loft which occupied the space between the vault and the roof of the choir. Thus in St Saviour's, if there was a floor above the two north rooms, the whole building included a five-room apartment closely aggregated to the church. In Cormac's Chapel, a ladder or stairs in one of the towers led to two large rooms above the nave and choir, each probably divided by a floor.[2] Most of these arrangements are meant to allow a few people to live in a compact building which can be easily defended. The idea may have been borrowed from Continental buildings. The Augustinian Priory of Serrabone (Pyrénées Or.), built in the twelfth century on a slope of Mont Canigou, is a good surviving example of such a building, and the earliest monastery at Clairvaux, built in the beginning of the twelfth century, seems to have been of a similar type.[3] One may wonder also if in some cases these rooms did not constitute a treasury adjoining the church. The 'Staff of Jesus', the most precious relic of Armagh, was kept in the twelfth century in a 'cave' or crypt[4] which could perfectly well be a vaulted room.

The idea of incorporating a round tower into the fabric of a church may also have been influenced by what Irishmen had seen abroad. The result is always slightly awkward in its execution, but the effect was nevertheless impressive in some cases. Sometimes the tower was built at the same time as the church, sometimes it was added later. This may be the case with the tower of St Kevin's Kitchen which is possibly one of the modifications to the original structure.[5] It occupies a rather cumbersome

[1] Leask, *Ir. Churches*, I, Fig. 46. They are now ruined, but their general shape can still be traced. A round-headed door opened from each of them into the choir.

[2] The stairs in the south tower are probably of fairly recent construction as is shown by the existence of a door on the east side of the tower, now blocked and partly obstructed by the stairs.

[3] Archdale King, *Citeaux and her Elder Daughters* (London, 1954), p. 5.

[4] 'Fochla', *A.F.M.*, 1135.

[5] Leask, *Ir. Churches*, I, p. 36.

position on the roof where it looks like a chimney-pipe, hence the nick-name of the church. Another Glendalough church, that dedicated to the Trinity, had been altered in a similar way, probably in the eleventh century.[1] In this case, the tower, built on a square foundation which tapered to a circular shape, had been added to the west front of the church, so that the doorway had to be transferred to the south wall. This tower was knocked down by a gale in 1818, but a late eighteenth-century drawing shows it still standing, probably some 60 feet high.[2] The Ferns priory has also a round tower on a square base, which is placed at the north corner of the west front and seems to be part of the original construction dating from 1140–50.[3] A curious tower standing on a vault or a block of masonry which existed in Derry is known from drawings.[4]

Elsewhere, the tower was near the choir. This was the case in the church on Ireland's Eye, a small island north of Dublin. The tower has now disappeared, but is also known from drawings.[5] A much more substantial tower, that of Temple Finghin at Clonmacnois, was also beside the choir (Pl. 66). It seems to belong to the original structure and to have been erected together with the carved chancel arch which dates from the middle twelfth century.[6] It is on the south side of the choir and is entered from it, at ground level.

All these combinations of churches and towers seem to belong to the eleventh or twelfth century. At the same time some of the old isolated round towers were being repaired, such, for example as the Conmacnois round tower, originally built in the tenth century. Others were being built. The Devenish round tower, which does not seem to

[1] See p. 44.

[2] Dunraven, I, p. 99; see in Leask, *Ir. Churches*, I, Fig. 41, a plan and conjectural restoration of the church.

[3] One may wonder if there was not another tower at the south corner, which would give a very Continental appearance to the west front. Excavations might give an answer to this problem.

[4] R.I.A. drawings.

[5] Amongst them a watercolour which was among the notes of Margaret Stokes and is now, through the kindness of her nephew, Dr. Henry Stokes, in the Department of Archaeology, University College, Dublin. See Dunraven, II, p. 154.

[6] Leask, *Ir. Churches*, I, p. 149.

have been altered, has a carved cornice, just below the roof, which is
obviously twelfth century (Pl. IV).[1] The tower at Ardmore (Water-
ford), which is very high, and where each floor is marked by a slight
recession is likely to have been erected at the same time as the church
beside it, that is to say at the very end of the twelfth century.[2] The
tower at Dysert O'Dea (Clare), built in the same way, dates also
probably from the twelfth century.[3] Two towers, at Timahoe (Leix)[4]
and at Kildare,[5] have carved doorways which are hardly likely to be
insertions, as the decoration affects the whole depth of the door in each
case. The much more superficial ornaments of the doors at Kells (Meath)
and Donaghmore (Meath) seem on the contrary to be additions to
already existing towers.[6]

These decorated doorways are an adaptation to the towers of con-
temporary fashions. In the same way, the one novelty which is found in
the very traditional churches of that time is the presence of a lavish
carved decoration consisting in portals, chancel-arches, sometimes even
arcadings and engaged pilasters. At first glance all this decoration
seems divorced from that of the manuscripts, metalwork and even of the
carvings on the crosses. The very structure of the doorways, with their
recessed arches and jambs, is borrowed exactly from Romanesque
churches in England and on the Continent. There does not seem to have
been either transition or progressive adaptation. Suddenly, the Roman-
esque doorway is there, in full flower, and it remains without important
alteration up to the time of the Norman invasion.

Its decoration shows a remarkable eclecticism and reveals unexpected

[1] *Devenish, Lough Erne, its History, Antiquities and Traditions* (An.; Enniskillen,
1897).

[2] Dunraven, II, pp. 39 sqq.; T. J. Westropp, 'Notes on the Antiquities of Ardmore',
J.R.S.A.I., 1903, pp. 353 sqq.

[3] T. J. Westropp, 'Churches with Round Towers in northern Clare', *J.R.S.A.I.*,
1894, pp. 150 sqq.

[4] Dunraven, II, pp. 29 sqq.; H. S. Crawford, 'The Round Tower and Castle of
Timahoe' *J.R.S.A.I.*, 1924, pp. 31 sqq.

[5] Brash, pp. 35–6; S. Ferguson, 'On the Doorway of the Round Tower, Kildare',
P.R.I.A., 1879–88, pp. 91 sqq.

[6] It is hard to date the decoration of the towers of Roscrea and Antrim.

154

contacts. As could be expected, there are English and Norman elements. The chevrons, dog-teeth and chains of lozenges can only come from that direction, and the same is true of scalloped capitals. But other motifs are curiously alien to English fashions. One of them, especially, the arch with human and animal heads,[1] is fairly common in Ireland. It probably developed in the Near East and appeared early in French Romanesque art. From there, around 1135–40, it passed into England, where almost at once it took on a new form, the near realistic heads of French monuments turning into 'beak-heads' – monstrous shapes where tongue or beak become almost an independent ornament. In Ireland, the beak-head proper is practically unknown,[2] whilst everywhere are found heads modelled in high relief similar to those of French churches between Loire and Garonne. There are also rows of large, high relief animal heads biting a moulding for which parallels can be found in churches immediately to the north of the Gironde, St Fort-sur-Gironde, Pérignac, St Quentin-de-Rançanne, St Germain-du-Saudre (Charente Maritime) (Pl. VI). It would be difficult to avoid the impression that there have been contacts and that the Irish heads are imitations, in a fiercer tone, of the horses' heads of the Saintonge churches.

Pilgrimages to Rome and Compostela most probably explain these borrowings. Some of the journeys were probably made partly by sea. At a time when the coast of Saintonge was not yet silted up, it had numerous harbours. Saintes, the capital of Saintonge, was one of the important secondary pilgrimages on the road to Compostela, and Irish pilgrims, whichever road they took, were bound to call there. The effect of such journeys is clearly shown by a well-documented itinerary which shows an English pilgrim, Oliver de Merlemond, going to the sanctuary of St James around 1140 and, as a result of what he had seen, building on his return, at Shobdon (Herefordshire), a church with three portals and carved tympana obviously inspired by a façade like that of the church

[1] F. Henry – G. Zarnecki, 'Romanesque arches decorated with human and animal heads', *Journ. British Arch. Assoc.*, 1957–8, pp. 1 sqq. To the early examples of the motif quoted in the paper can be added another carved Byzantine arch, a fresco of Bawit and the chancel arch of Santa Sabina (Rome).

[2] One of the few examples is found on a window of the church at Dysert O'Dea (Fig. 19).

at Parthenay-le-vieux (Deux-Sèvres).[1] This was the starting-point of a school of carving whose decoration is as eclectic as that of the Irish doorways, albeit made of slightly different elements. Though there is no Irish document of the same precision as that which survived by a stroke of luck for Shobdon, one can assume that similar journeys are responsible for much of the importations of Continental elements which are such a distinctive feature of Irish Romanesque.

However, pure Irish elements survive beside the borrowings, some traditional, some close to Scandinavian art. There are panels of inter-lacings, animal-interlacings and the heads on capitals and voussoirs often have hair and beards made of large inter-crossing ribbons occasionally ending in animal-interlacing. Even borrowings are treated in a peculiar way: scrolls or roses are flattened on the surface of the stone, become a sort of embroidery, even an engraving. The result is a complex and strange art whose attraction comes from the very contradictions and juxtapositions it offers.

The chronology of these decorated portals remains rather vague. No light can be drawn from inscriptions, as those which have survived – at Killeshin[2] and Freshford[3] – do not supply any name which could be identified with certainty. A few entries in the Annals give some land-marks, and these can be partly completed by comparisons with the models imitated in the decoration or by evidence deriving from the structure of the monument. Nevertheless there is not enough to allow for a formal description of the development of Irish Romanesque art, which anyway would be of necessity vitiated by the disappearance of essential buildings such as the Priory of SS. Peter and Paul at Armagh, consecrated in 1126,[4] the two churches built at Lismore around 1127 by Cormac Mac Carthy[5]

[1] G. Zarnecki, *Later English Romanesque Sculpture, 1140–1210* (London, 1953), pp. 9 sqq.

[2] Macalister, *Corpus*, II, pp. 26 sqq. (No. 574).

[3] Id., p.24 (No. 569).

[4] *A.F.M.*, 1126: 'The church called the Regles of Paul and Peter, at Ard-Macha, which had been erected by Imhar Ua Aedhagain, was consecrated by Ceallach, successor of Patrick, on the 12th of the Calends of November'.

[5] The Dublin Annals of Inisfallen say: 'two churches'; *M.C.*, possibly through a copist's error says of Cormac (1126, 5): 'He built a church at Cashel and twelve churches (da teampall dég) at Lismore' (repeated in the obit of Cormac, 1138).

and that which he erected in Cork,[1] as well as the church built at Bangor by St Malachy shortly after 1140. The only practical method then, is to study local groups of monuments, concentrating on the well-preserved buildings which can help us to imagine all that has disappeared.

It seems logical to start with the two regions which were politically the most important during that period, Munster and Connacht, where the reigning dynasties fostered and helped to finance the erection of new churches or the embellishment of old ones. Amongst the monasteries of this part of Ireland, those which are directly on the Shannon, together with some monuments of Clare and Connacht, form a somewhat distinct group in which contacts with western France are especially close, so that its study will help to outline some of the problems involved.

Clonmacnois, given its outstanding importance and its connections with several kingdoms, has pride of place, all the more since the Nuns' Church and Temple Finghin have carvings which will at once raise important problems.

The Nuns' Church, which was erected before 1167[2] is a small building, about 58 feet long, consisting of a nave with a rectangular choir. There is a carved doorway in the middle of the west wall and the choir opens on the nave by a large decorated arch (Pls. 76, 77, 78). Both had partly collapsed and were re-erected fairly satisfactorily during the restorations effected at Clonmacnois by James Graves in 1865. Though the ornaments of portal and arch are rather different, the treatment is the same and

[1] The original charter of Dermot Mac Carthy, Cormac's son is lost, but there is a Latin transcript by Sir James Ware in the British Museum (Add. Ms. 4793, fol. 65); see: C. B. Gibson, *History of the County and City of Cork*, II (London, 1861), p. 348, M. J. Blake, 'King Dermot Mac Carthy's Charter, A.D. 1174, to the Church of Cork, afterwards called Gill-Abbey', *J. Cork H.A.S.* 1904, pp. 145 sqq.; T. J. Walsh—D. O'Sullivan, 'Saint Malachy, the Gill Abbey of Cork, and the Rule of Arrouaise', *J. Cork H.A.S.*, 1949, pp. 41 sqq.; the abbey was founded as a result of a peace treaty between Cormac and Turlough O'Conor in 1134. Cormac in a raid on Connacht had destroyed St Mary's Abbey, Cong, an Augustinian abbey founded by Turlough *c.* 1120. So Cormac was made to build and endow a church for Canons regular of St Augustine on the site of the 'cave of St Finbarr' in Cork (St Finbarr's father was from Connacht) 'for the pilgrims from Connacht, compatriots of St Barri'. The abbey seems to have been dependent on St Mary's, Cong; its construction was probably only started in 1137, a year before Cormac's death.

[2] For all the Clonmacnois churches, see p. 36, note 2.

there is no reason to think that they were built at different times.

The portal presents us immediately with the combinations of various elements typical of the decoration of Irish churches at that time. There are examples of chevrons on the voussoirs and jambs, those on the arch carved in high relief, their points facing the onlooker, those on the jambs hardly more than engraved in the stone, covering it with a series of flash-like markings. The other jambs have fake columns, suggested by a rounded edge and a clever use of mouldings. Columns and zig-zags end at the top in monster-heads; at that level it suddenly becomes obvious that the zig-zags are really the bodies of snakes engaged in fierce battle with the monsters. One of the voussoirs was occupied by thirteen animal heads in high relief[1] whose foreheads and cheeks are covered with lightly engraved palmettes, whose upper and lower jaws, sharp teeth and half protruding tongues are described with a sort of controlled ferocity; each beast bites into a round moulding which underlines firmly the curvature of the arch.

The voussoirs of the chancel arch are also carved in bold openwork. The theme there is the chevron: facing triangles, triangles and lozenges, zig-zags all give the same patterns of broken lines. The outlines of the chevron is in clear relief, whilst each of the triangles they frame has a lightly worked border of pearls and various ornaments, keys, marigolds, foliage, etc. There is constantly a passage from finely incised work to violently contrasted plays of light and shadow. The jambs are in a drier vein; the capitals, squarely geometrical, are covered with a light chip-carving of key-patterns animal-interlacings and foliage, the vegetable patterns extend to the bulbous bases of the feint columns.[2]

Temple Finghin was a small rectangular church with a square choir and, as we have seen, a large round tower incorporated into the building, beside the choir. Its doorway was on the south side instead of the centre of the west front (Pl. 66). Not much is left of this door, only enough to show that, like the door of the Nuns' Church it had feint columns and

[1] Several of them have disappeared and were replaced in the restoration by plain blocks of stone.

[2] These bases, of Oriental origin, which are found occasionally in Continental Romanesque, occur in some Irish portals and arches, such, for example, as the chancel arch of the large church at Rahan (Offaly) (Pl. 71).

jambs with zig-zags. The chancel arch was simpler than that of the Nuns' Church; its arch was made of a series of triangles resting on a rounded moulding; on the jambs reappear animal heads biting a torus; though these heads are in very poor condition, it can be seen that they are of the same type as those of the Nuns' Church.[1]

As far as their date can be ascertained, the churches of Saintonge which have rows of horses' heads similar to the monster heads of the two Clonmacnois churches (Pl. VI) go back to the second quarter of the twelfth century[2] so that a date around 1150 or slightly later would be likely for the two arches with animal heads at Clonmacnois. If pilgrimages to St James' tomb were the occasion of these exchanges, they were no doubt pilgrimages of important persons taking with them a numerous retinue of friends and clients including some artists. Whether an O'Conor, an O'Brien, a king of Meath or an O'Kelly, we may never know. But the resulting introduction of a motif used originally near the Gironde remains to testify to these contacts. They have left other traces in the same part of Ireland.

A short distance to the south of Clonmacnois, on the other side of the Shannon, and so in Connacht, an absurd and charming portal decorates the west front of the cathedral of Clonfert (Cluain Ferta Brenainn; Galway).[3] This was originally the church of one of the chief monasteries founded by St Brendan the Navigator; it has antae and its main structure probably goes back to the ninth or tenth century and is obviously the 'stone church' (daimhliag) mentioned in 1045 in the Annals.[4] It was modified at various periods in the Middle Ages and the portal is the only remaining vestige of the re-modelling done in Romanesque times.[5] The position of the monastery on the Shannon gave it a good deal of

[1] A carved arch which was found in Clonmacnois has been remounted in a wall of Temple Finghin; it may have belonged to the portal of that church.

[2] Henry-Zarnecki, p. 11.

[3] H. S. Crawford, 'The Romanesque Doorway at Clonfert', *J.R.S.A.I.*, 1912, pp. 17 sqq.; Leask, *Ir. Churches*, I, pp. 137–42; Dunraven, II, pp. 106 sqq.; Henry, *Sc. irl.*, Pl. 162; Macalister, *Arch. Ireland*, pp. 256, 260 sqq.

[4] *A.I.*, 1045 (Cf. *A.F.M.*, 1045, *Chr. Sc.*, 1043).

[5] The very handsome windows in the east wall of the choir are of slightly later date (Leask. *Ir. Churches*, II, p. 71).

importance but led also to much trouble. The Vikings plundered it. Then, in the eleventh century, neighbouring chieftains, the O'Kellys of Uí Maine and the O'Rourkes of Breifne came down the Shannon in their boats and wasted the place. So much so that in 1068 'Cluain Ferta Brénainn was vacated and its seniors came into Iarmumu' (West Munster),[1] obviously to Ardfert, the other important foundation of St Brendan. However it was inhabited again in the last years of the eleventh century and in the twelfth century it prospered, possibly because of the protection of Turlough O'Conor. It is at Clonfert that died in 1136 the 'bishop of Connacht', Domnall O'Duffy, abbot of Roscommon and Clonmacnois, for whom the Cross of Cong was made.[2]

The Clonfert portal is infinitely more complex than those at Clonmacnois, though it reveals the same curious mixture of imported and native elements, more striking there perhaps, as each of them has its maximum of individuality. The doorway is deeply recessed, lending itself to much more subtle plays of light and shade than the three-jamb portal of the Nuns' Church. It also has columns only partly disengaged from the block, but far from being a smooth, restful surface in the general composition, they are completely wrapped in carvings which give them an agitated, glittering appearance which extends to the jambs themselves, also thickly coated with patterns. The columns of the portals of the cathedral of Lincoln, which date shortly after 1140[3] are similarly covered with a sort of carved embroidery. But the analogy ends there, as the dry engravings on the Lincoln columns belong to a different world from the gay fantasy at Clonfert; also the Lincoln doorways are full of zig-zags while chevrons are not found in the main work of the Clonfert portal, nor are the grim beak-heads of Lincoln, which are replaced by good-humoured dog-like beasts biting a wide torus (Pl. 82). This exuberance of decoration in the jambs of the portal is alien to most of the Saintonge doorways and calls much more for comparison with some north Italian doorways which were the inspiration of Lincoln,[4] as

[1] *A.I.*, 1068, 3. [2] See p. 107.
[3] Between 1141 and 1148; G. Zarnecki, *Later English Romanesque Sculpture 1140–1210* (London, 1954), pp. 20 sqq.
[4] Such as the doorways of St Michael of Pavia, if one accepts for them the date

light-hearted and full of imagination as that at Clonfert, though using very different ornaments.

At Clonfert there are interlacings treated as a flat network, like those on the large cross at Kilfenora (Pls. 68, 69) and animal-interlacings similar to those on the cross of Cong or some capitals of the Nuns' Church. But there are also discs and a symmetrical vegetal pattern closely related to that on the sides of the cross of Cong and on the large funerary slab at Glendalough.[1] Some of the capitals are even more an inherent part of the column than those at Clonmacnois and the head seems to bite the shaft with open jaws. This is not necessarily a local form, as there are numerous parallels on the Continent. Some of the other Clonfert capitals are stranger: they bear heads which seem to be applied onto them flat, some in profile, others full face, grinning or grimacing. Then the voussoirs are all irregular relief and openwork, with discs, bosses, lozenges, and an arch of animal-heads fully modelled, nearer even than the Clonmacnois ones to the horses of Pérignac and St Fort (Pls. 82, VI).

Fig. 16. Portal of Dysert O'Dea, detail (drawing E. Waldron).

Above all this is the famous gable with its gallery of small columns and arcadings and the great triangle of marigolds and human heads (Pl. 81). The arcadings have a Continental flavour. If, as is likely, they framed figures with the body painted and the head in full relief, the similarity would be even greater with some churches of western France where such arcading frame rows of figures. One might even think of a comparison with metalwork objects such as the Silos altarfront in Burgos Museum,[2] where the bodies of figures under arcadings are flat and enamelled whilst their heads are cast-bronze pieces in relief. As for the marigolds, they are not greatly different from those on the reverse of the

proposed by Kingsley Porter, *c.* 1130 (Porter, *Lombard Architecture*, III, pp. 213–4); see G. H. Crichton, *Romanesque Sculpture in Italy* (London, 1954), Pls. 24–5.

[1] See pp. 110 and 145. [2] See p. 113 note.

Dysert O'Dea cross (Fig. 15b). They are found also on the part of the doorway which is inside the church. These duplications of doorways in the interior of the building are also frequent on the Continent. They are occasionally found in Normandy,[1] and much more often in Poitou and Saintonge.[2] The heads inserted in niches like trophies are nearly reminiscent of some Gaulish monuments of the south of France, and the likeness may not be wholly fortuitous.

Thus this doorway represents an extraordinary mixture of borrowed elements, adapted, mixed with traditional Irish motifs and often treated in a way which calls to mind the appearance of the stone crosses in the neighbouring county of Clare. This is made even more striking by the complete absence of chevrons on the portal proper.[3] That complex series of carvings is a meeting point of Continental Romanesque and Irish art, with a complete absence of any element belonging to Norman art.

It is often assumed, on account of its great lavishness, that it is of late date. The vigour, however, and the number of models imitated may well explain this exuberance. No text gives an indication of dating, but H. G. Leask has pointed out rightly that Petrus O'More who was bishop of Clonfert from 1166 to 1171,[4] after having been a member of the Cistercian community of Boyle, would be an unexpected patron for a work so completely out of tune with what we know of the Irish Cistercian decoration of the time. The entry about a fire in Clonfert in 1164 is of little significance, as it may have affected quite another part of the monastery. It is thus possible to put back the date of the portal to the middle of the century, so that it would form a transition between the arches with horses heads of Saintonge and the fiercer and more unreal monsters on the Clonmacnois doorways.

Another doorway, that of Dysert O'Dea in County Clare,[5] supplies

[1] For example at Bretteville l'Orgueilleux (Calvados).

[2] See Melle, Church of St Hilaire (Deux Sèvres).

[3] The only chevrons are on the inside door.

[4] Leask, *Ir. Churches*, I, p. 138; *A.U.*, *A.I.*, 1166; *A.U.*, *A.I.*, 1171.

[5] Dunraven, II, pp. 111 sqq.; Brash pp. 58 sqq.; Champneys, p. 73; T. J. Westropp, 'Churches with round towers in northern Clare', *J.R.S.A.I.*, 1894, pp. 150 sqq.; Id., 'The Churches of County Clare and the origin of ecclesiastical divisions in that County', *P.R.I.A.*, 1900–1902, p. 141; Henry, *Sc. irl.*, Pls. 1153–4; Leask, *Ir. Churches*, I, p. 151.

further variations of this strange synthesis of influences. Not much is known about Dysert O'Dea at that time. The monastery was called Disert Tola, from an eighth century saint to whom is also ascribed a foundation of the same name near Clonard (Meath). It was situated in the north part of the Dalcassion territory, so in a region under O'Brien influence, though its immediate lords were another branch of the descendants of Cas, the O'Dea. Nothing in the surviving texts explains the sudden spate of activity which brought about the carved decoration of the church and of the cross nearby as well probably as the building of the round tower.

The church has been remodelled to such an extent that it is hard to visualize its original appearance. There is a doorway, obviously re-built, and badly re-built, in the south wall, a decorated window, possibly made of the remains of two or three, in the west gable, and some fragments inserted in the lower base of the cross. The portal was certainly higher than it is now and may also have had one more order though, except for some details such as the wrong placing of some of the voussoirs and of two stones in the jamb, what is left is roughly in its original state. Its jambs and columns are covered with ornament as at Clonfert. The capitals are more functional than the Clonfert ones. But in one of the arches appear the facing chevrons of the Nuns' Church. They accompany the famous motif of festoons or scallops, possibly Arab in its ultimate origin, which has been sometimes considered as a sort of symbolical pattern employed in the churches situated on the roads to Compostela, and is certainly very common in the north of Spain and the west of France. This is practically its only occurence in Ireland.[1] Then there is an arch decorated with human and animal heads. The human heads, all remarkably individual, have the same modelling, both smooth and vital as the head of the ecclesiastic on the stone cross nearby. Only one is different,

Fig. 17. Portal of Dysert O'Dea, detail.

[1] Except for the door inserted in the church at Wicklow (Leask, *Ir. Churches*, I, p. 160) and the jambs of the doorway at Killaloe (Id., Pl. XVII).

and its long moustaches gives it an extraordinary Mongolian appearance. Some of the animals hold a section of torus in their teeth. This does not necessarily mean that they belonged originally to another arch with a continuous torus, similar to those at Clonfert and Clonmacnois. They may also be figurations of three of the evangelical symbols each holding the roll of his Gospel. From a purely formal point of view, their closest parallels are some corbels of the west front of Notre-Dame-la-Grande in Poitiers which, though isolated, also bite a rounded piece of moulding (Fig. 18 *b*). One of these animals, an eagle with a scaly forehead and pointed beak, has strange connections: it has a very close parallel on the tower of the Abbey of St Aubin in Angers, begun in 1130 (Fig. 18 *c*) and on the other hand it is remarkably similar to the heads

a b c d

Fig. 18. Carved heads *a* and *d*, Dysert O'Dea; *b* west front of Notre-Dame-la-Grande, Poitiers; *c*, tower of St Aubin, Angers.

which hold the cross of Cong at the upper part of its foot (Pl. 74). We have seen that the cross was made between 1123 and 1136. Though one might accept a fairly long delay in the transmission of a Continental model, the Irish parallel points to about the same date and seems to indicate 1125–35 as the most likely date for the carvings of the portal and of the cross. It is interesting to note another similarity, though devoid of chronological value: the inside jambs of the door are both decorated with a wide zig-zag combined with animal motifs (Pl. 75, Fig. 16). On one side these motifs are very flattened heads which are also found, in a similar context, on the arch inserted in the north wall of the church at Beaumont-sur-Sarthe (Sarthe) (Pl. VI). The window in the west gable at Dysert O'Dea has foliage patterns of the type of those on the reverse of the cross, some animal-interlacings and three animal

164

heads with interlaced manes (Fig. 19). These heads, very flattened and stylized, are much closer to some heads on churches in Normandy and to English beak-heads than the heads above the doorway.

A remarkable little doorway, whose carvings are unfortunately very corroded by the elements, is on the west front of a small church on the island of Inchagoill in Lough Corrib.[1] The island may have been inhabited from the time of St Patrick and has a monument which may go back to that time. Its renewed occupation in the twelfth century is indicated by the mention at the date of 1128 in the Annals of Ulster of the death, at Inchagoill, of a steward of the monastery of Tuam.[2] It has also an arch with heads in full relief together with facing chevrons. The capitals (Fig. 22), with their arrangement of two heads and the mock columns only indicated by mouldings belong to another group of monuments which we shall study later.

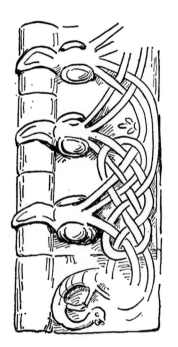

Fig. 19. Detail from the window of the church at Dysert O'Dea.

The church of St Caimin at Inis Cealtra (Clare)[3] built by Brian Boru in the early eleventh century, received, in the twelfth century, the addition of a choir with triumphal arch and of a portal inserted in the old wall. The door has chevrons and probably had an arch with human heads of

[1] Petrie, *Chr. Inscr.*, II, pp. 10 sqq.; Brash, pp. 55–6; Wilde, *Lough Corrib*, pp. 133 sqq.; J. Fahey, 'The shrine of Inis-an-Ghoill, Lough Corrib', *J.R.S.A.I.*, 1901, pp. 236 sqq.

[2] 'Muirghis Ua Nioic, herenach of Tuaim-da-ghualann for [a long] space, died in Inis-in-Ghaill', *A.U.*, 1128 bis.

[3] Dunraven, II, pp. 55 sqq.; M. Lenihan, 'A Visit to Iniscaltra', *J.R.S.A.I.*, 1889, pp. 162 sqq.; T. J. Westropp, 'The Churches of County Clare and the Origin of Ecclesiastical Divisions in that County', *P.R.I.A.*, 1900–02, pp. 156–7; Macalister, *Inis Cealtra*; Henry, *Sc. irl.*, Pls. 22, 101; Leask, *Ir. Churches*, I, pp. 92–4; for the early constructions, see Vol. II, pp. 47–8.

which six remain, some inserted in the wall of the church, the others awkwardly fitted in the arches of the door. The triumphal arch has plain voussoirs, capitals with large ovoid leaves at the corners and bases with rows of pearls.

The very peculiar capitals of this arch are also found, together with columns covered with zig-zag mouldings, on the portals of two churches, that at Clonkeen (Limerick) (Pl. 72)[1] and that at Aghadoe (Kerry)[2] on the shore of Lough Lein, the great lake of Killarney. The Aghadoe church seems well dated by an entry of 1158 in the Book of Mac Carthy which relates first that 'The great church of Achadh Dá Eó was completed by Amhlaoibh, son of Aonghus Ó Donnchadha'[3] and then mentions the death of Aongus in the same year, adding : 'His own family and his people took the body of Amhlaoibh to Achadh Dá Eó, and he was honourably buried by them with hymns and psalms and Masses on the right side of the church which he himself had built in honour of the Trinity and Mary'.[4] This gives a general indication for the approximate dating of these three arches to the middle of the twelfth century. That of Inis Cealtra, much more ambitious than the two others and most probably their model may have been the result of an effort of Turlough O'Brien to boost his prestige in the period which preceded the disastrous battle of Móin Mhór (1151). As for Killaloe, the royal monastery of the O'Briens, where one would expect to find imposing monuments,

Fig. 20. Tuam portal, detail.

[1] Dunraven, II, pp. 113 sqq. and Pl. CXIX; Brash, pp. 60 sqq.; T. J. Westropp, 'A Survey of the Ancient Churches in the County of Limerick', *P.R.I.A.*, 1904–5, pp. 439–40; Henry, *Sc. irl.*, Pl. 138; Leask, *Ir. Churches*, I, pp. 127 sqq.

[2] J. Windele, *Historical and descriptive Notice of the City of Cork and its Vicinity* (Cork, etc., 1839), pp. 334 sqq.; Dunraven, II, p. 36; Brash, pp. 103 sqq.; *J.R.S.A.I.*, 1890–1, p. 611; 1892, pp. 158 sqq.; 1906, pp. 336–7; Henry, *Sc. irl.*, Pl. 138; Leask, *Ir. Churches*, I, p. 145.

[3] *M.C.*, 1158, 6.

[4] *M.C.*, 1158, 7; Lanigan (*An Ecclesiastical History of Ireland*) quotes a similar text, ascribing it to *A.I.*; as *A.I.* has a gap for this period, Dunraven was puzzled by the quotation (op. cit., p. 36); in fact it is from the less reliable *D.A.I.*; but the facts are confirmed by the similar entry in *M.C.* which had escaped them both.

it has in fact very little to show. Wars and plunderings are probably responsible for the destructions. Beside the stone-roofed church of St Flannan,[1] there remain only scattered fragments of the decoration of a church, obviously the cathedral which preceded the present one (built in the thirteenth century).[2] It differs deeply from the austere sobriety of the Inis Cealtra arch and its carvings have an almost Baroque exuberance.

These fragments consist of a door, now inserted in the wall of the thirteenth century cathedral, three windows re-used in the church at Tuamgreiney, and pieces of a triumphal arch scattered between Killaloe and Tuamgreiney. From these remains it appears that the church was of the usual twelfth-century type with rectangular nave and square choir, though the decorated windows are an unusual feature. The elements of the decoration are the same as those of the chancel arch of the Nuns' Church at Clonmacnois: complicated

Fig. 21. Killaloe portal, detail.

arrangements of triangles and lozenges covered with foliage and pearl borders, to which is added a great flourish of festoons in the jambs. The door is framed by fluted pilasters partly made by the bodies of great beasts which bite some of the mouldings and hold on to them with their claws (Fig. 21). In 1168 Domnall Mór O'Brien began a reign which was to last some twenty years. He certainly tried to enhance the family prestige. To the time of his accession can be ascribed a *Life of St Flannan*, the patron of Killaloe, which he commissioned from an ecclesiastic of Continental origin and is conceived as a perpetual praise of the O'Briens. It may well be at the same time, just before the coming of the Normans, that he built a new cathedral in Killaloe. The analogies with the decoration of the Nuns' Church, finished shortly before 1167, would confirm such a date.

[1] See pp. 149 sqq. [2] Leask, *Ir. Churches, I*, pp. 151–2.

Another royal cathedral, that of the O'Conors of Connacht at Tuam is of an even more surprising style.[1] Most of the building proper has disappeared. All that is left is the chancel arch and the east windows of the choir. The arch is of an unusual width, without parallel in other Irish churches of traditional type.[2] The decoration, however, does not depart much from the normal repertoire of Irish churches: on the arches, there is the usual play of zig-zags and the capitals have animal-interlacing similar to that on the crosses offered to the monastery by Turlough O'Conor and Abbot O' Oissín (Fig. 20). On some of them amazing human faces are applied as on the Clonfert capitals, though treated in a very different style. One has a rectangular face with spiral nostrils, hatched eyebrows, elongated eyes above a widely slit mouth (Pl. 86). Another, crowned with foliage, has an elaborate beard (Pl. 87). There is something bewildering in these near-metallic oddities which have kept all their sharpness of line amidst rather worn carvings. The frieze around the windows which is hardly more than a low chip-carving is also remarkably well preserved. It includes all sorts of fantastic monsters (Pl. 88) and one figured scene difficult of interpretation in which there is a head as weird as those on the capitals.

It does not seem possible to fix exactly the time of construction of the cathedral. Ware and Archdall suggest a date *c* 1152, but this is in fact only a way of saying that it was built by Áed O' Oissín shortly after he became archbishop. It is certainly a likely time for such an undertaking, but in no way certain, and this date remains a conjecture.

This review of the churches of the Shannon valley and the west of Ireland leads us to appreciate the fact that they are distributed over a long period, extending possibly from 1125 to 1170 and that most of them, chiefly the older ones, reflect nearly contemporary phases of Continental art as well as some elements of English art, always intimately mixed with more typically native ornament.

[1] Dunraven, II, pp. 88 sqq.; Brash, pp. 45–6; Henry, *Sc. irl.*, Pl. 163; T. B. Costello, 'Temple Jarlath, Tuam, County Galway', *J.R.S.A.I.*, 1902, p. 414; R. J. Kelly, 'Antiquities of Tuam and District', *J.R.S.A.I.*, 1904, pp. 257 sqq.; Leask, *Ir. Churches*, I, pp. 153–4, Pl. XVI.

[2] There are wider arches over the transepts of the Cistercian abbey-church of Baltinglass.

Their development would probably be easier to understand if we knew the cathedral of Limerick in its twelfth century shape. Gillebertus in the first years after being raised to the episcopate around 1107 may have had only a wooden church. But it does not seem likely that between the Synod of Rathbreasail in 1111 and his retirement in 1140 he did not try to endow Limerick with a church of the same type as those he had seen during his travels. In 1107 he was in Rouen. Did he journey farther and did he keep in contact with some of the places through which he had passed? We have no means of knowing. In 1176, Limerick was deliberately set on fire to prevent the Anglo-Normans from entrenching themselves in the town. Shortly afterwards, Domnall Mór O'Brien built the cathedral church of St Mary, probably on the site of the earlier church of which nothing has survived. This has meant the loss of a key building whose influence must have made itself felt over a wide area.[1]

Fig. 22. Capital from the portal at Incha-goill.

Different influences, however, were at work in another series of churches which are connected by one feature or another with the chapel built in Cashel by Cormac Mac Carthy and consecrated in 1134.[2] In many ways this

[1] I have sometimes been tempted to wonder if the carvings at Dysert O'Dea do not come from Limerick. The doorway was obviously not made for its present position and the window is made of miscellaneous fragments, as if somebody had picked up the few surviving ornaments of a ruined building. Limerick in the time of Gillebertus would certainly provide a more suitable background than Dysert O'Dea for such a striking ensemble of carvings. Their very Continental flavour would also be a suitable parallel to the Continental origin of the *De Statu Ecclesiae*. It would then take its place normally as the head of the series of carvings of the Shannon valley.

[2] Petrie, *Round towers*, pp. 283 sqq.; Dunraven, II, pp. 71 sqq. Brash, pp. 85 sqq.; Macalister, *Arch. Ireland*, pp. 255 sqq.; A. Hill, *A Monograph of Cormac's Chapel, Cashel, County Tipperary* (Cork, 1874); J. Gleeson, *Cashel of the Kings*, (Dublin, 1927); Henry, *Sc. irl.*, pp. 104, 137, 161, Pls. 118, 167, 168, 169; Sexton, *Fig. Sc.*, pp. 89–90; Leask, *Ir. Churches*, pp. 113 sqq.; Paor, *E. Chr. Ireland*, p. 180;

is an unusual building, though maybe it would appear less exceptional had the churches survived which were built in Lismore and Cork by Cormac.

At the date of 1134, the Annals of Tigernach mention 'The consecration of the church of Cormac in Cashel, by the nobles of Ireland, both laymen and clerics'. Similar entries are found in the Annals of the Four Masters (1134), the Book of Mac Carthy (1134), and the Annals of Loch Cé (1135). There is a gap for this period in most of the other Annals, though the Dublin Annals of Inisfallen have an entry at 1127 on the building by Cormac of two churches at Lismore and the beginning of the building of the Cashel Chapel whose consecration they record in 1134.

To replace this church in the historical circumstances which form the background to its erection, it is necessary to remember first that Malchus, the bishop of Lismore-Waterford who had been Cormac's master in Lismore,[1] had spent a long time as a monk in the Benedictine monastery attached to the cathedral of Winchester and that he had probably kept close ties with England. The churches which Cormac built in Lismore may have felt the impact of this connection and the Cashel monument is certainly revealing from this point of view, though here one must remember also the links between Cashel and the monastery of St James at Ratisbon.[2] Abbot Denis (1098–1121), a native of the south of Ireland, re-built the monastery there from 1111 until his death. Whilst the work was in progress, he sent two Irish monks to gather money in Ireland who were accompanied by two craftsmen, also Irish. When they came, Cormac was only heir apparent, but he may have learnt a good deal from what they told him about the new church at Ratisbon.

This strange building is one of the most surprising anthologies of Romanesque art. When first glimpsed from the east, it has a strong Germanic flavour (Pl. 99): this series of similar blocks, one above the

L. de Paor, 'Cormac's Chapel, The Beginnings of Irish Romanesque', in: *Munster Studies, Essays in commemoration of Monsignor Michael Moloney* (Limerick, 1967), pp. 133 sqq.

[1] See p. 13.
[2] C. Mac Neill, 'Affinities of Irish Romanesque Architecture,' *J.R.S.A.I.*, 1912, p. 140.

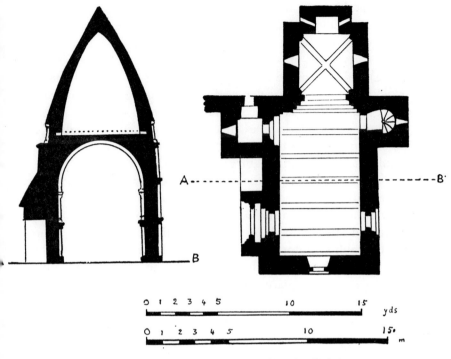

Fig. 23. Section and plan of Cormac's Chapel at Cashel.

other, built on a system of rectangle-triangle, and the two towers on each side of the choir are features calling for comparison with German Romanesque churches. The two square towers did in fact exist in the church of St James built in Ratisbon from 1111 to 1122 and they have survived, incorporated in the more recent building. However, when one turns to the south façade (Pl. 98), things look very different. The affinities there are with Normandy. The north side of the church at Mouen, near Caen, may be the closest parallel.[1]

The two portals (Pls. 98 and 102), with their elaborate play of zig-zags, their scalloped capitals and carved tympana, offer closer

[1] V. Ruprich-Robert, *L'Architecture normande aux XIe et XIIe siècles* (Paris, 1884–9), II, Pl. CIII.

comparisons this time with English work especially of the south-west, than with Normandy. As for the nave, with its barrel vault resting on flat arches supported by short columns on a cornice (Pl. 106), it calls to mind the former nave (the present choir) of St Eutrope at Saintes (Charente maritime)[1] which has the same type of arching on short columns. The choir, with its ogive of circular section brings us back towards England where ogive vaulting had become fairly common by 1130. Following the example of the Durham architects, those of Peterborough in 1120, of Romsey in 1125 had used it.[2] Romsey, close to Winchester, gives a good indication of how this feature came to be borrowed.

To complete this extraordinary conglomeration of varied elements the church has stone roofs under which are accommodated one large room over the nave and a smaller one over the choir, forming an appartment reached by stairs or ladders in one of the towers.[3] This brings us back to the vaulted oratories of the type of St Flannan of Killaloe, though the original idea has been elaborated. In fact, together with the plan of rectangular nave and square choir, it is the only nearly native feature in the whole building.

The problem of lighting seems to have worried the architect. The small apse which held the altar has slit windows cut on the slant so as to reach outside the choir wall. In the choir itself, there is a window on each side. As for the nave, it had a window in the west wall, and that may well have been all. The general effect must have been a rather dim nave opening onto a brightly lighted choir.

The great number of doors and their positions have also to be considered. The Irish churches usually have only one portal, set in the middle of the west front. There are only a few cases of doors in the south wall, usually explainable by the presence of an obstacle on the west side.[4] This seems to be what occured at Cashel. Everything there indicates that space was limited and that the Chapel was inserted willy

[1] Conant, *Carolingian and Romanesque A.*, Pl. 61 (A).

[2] T. S. R. Boase, *English Art, 1100–1216* (Oxford, 1953), p. 18.

[3] See p. 152, note 2.

[4] This is the case for Trinity church, Glendalough (see p. 153), possibly for Temple Finghin, Clonmacnois (see p. 158). St Saviour, at Glendalough has a somewhat similar disposition to that at Cashel.

nilly in the midst of already existing buildings; this would explain all the singularities of the plan, the side doors, the different sizes of the two towers and the off-centre position of the choir. The main façade was obviously on the north side which has the most elaborate of the two portals.[1] It may be that the east wall of the north tower continued beyond the tower itself. This would explain the existence of a decorated doorway leading from the nave into that tower from which one could pass by another door beyond the east wall of the tower, and thus probably into another enclosure than the one to which the great portal belonged. Though the chief entrance was on the north side, it was deemed necessary to cover all the south wall with arcadings, a fact which shows that on that side the Chapel was visible from a certain distance; there may have been there a courtyard corresponding to the cloisters in a more developed monastery.

The north portal appears as a sort of porch and one might have wondered if this was not the result of an early remodelling of other Irish portals such as those at Freshford (Kilkenny) and Timahoe (Leix) did not have the same appearance.

The tympana of the two portals belong to the same type as a series of low relief tympana often found in England and in Denmark, which may eventually be of Lombardic origin.[2] They are all in very low relief, with an animal or a subject including an animal as the chief decorative element. Amongst the English tympana studied by Kayser, several would lend themselves to comparison with the north portal tympanum at Cashel: that at Ribbesford (Worcestershire), with its archer shooting at a large fowl (Fig. 24) and those at Stoke-sub-Handon (Somerset) and Kencott (Oxfordshire), which have both a centaur (identified as 'sagit[t]arius' by an inscription) shooting an arrow at a monster (Fig. 24). At Stoke, the centaur turns back to shoot as at Cashel. But the similarity ends

[1] The old cathedral (which preceded that built by Domnall O'Brien) must have been on part of the site of the present choir of the cathedral, with the round tower nearly level with its west front. The entrance of Cormac's Chapel would then have been on the same square as that of the cathedral – probably the centre of the chief buildings on the Rock. The Chapel may have been quite close at its west end to another building, possibly low enough to enable light to get freely into its west window.

[2] C. E. Keyser, *A List of Norman Tympana and Lintels* (London, 1927).

173

SA
GI
TA
IVS

a

b

Fig. 24. Tympana of English churches: *a*, Stoke-sub-Hamdon (Somerset); *b*, Ribbesford (Worcestershire).

there. The theme is the same – the fight of Good and Evil, no doubt – but there is a world of difference between the awkward and scattered compositions of the English tympana and the fastidious arrangement of subtle curves of the Cashel tympanum.

Though the chancel arch has mouldings of a slightly different type and more elongated proportions than the doors, this does not seem to indicate a later date. We have seen elsewhere similar differences between chancel

174

arch and portal.[1] The arch, however, has an important feature, the presence of human heads as decoration on one of the orders. These heads are of a very individual character, standing out in 'ronde bosse', and they have a definite kinship with those at Dysert O'Dea, though they are not closely pressed together, each on a voussoir. A few, at the apex of the arch, are in a radial position (Pl. 104); then, their orientation changes suddenly (Pl. 105) and the next ones are in the axis of the arch. To this there is a close parallel in the west front of the church at Bellegarde-du-Loiret,[2] a church which, in spite of its geographical situation east of Orléans, is of Aquitanian type, except for the presence of chevrons (Pl. VI).[3] It may well be a now isolated survivor of a type once more common which was seen by a travelling craftsman.

Cormac's Chapel, this church of so unusual a type, certainly impressed the Irish architects and sculptors, so that here and there are found reflections of some of its most original features. The most obvious example is found fairly near, at Roscrea (Tipperary) (Pl. 65).[4] Only the west front of the church remains. Though the effect is now partly obliterated, it originally had the same play of parallel gables as the apse of Cormac's Chapel. The original shape of the roof is still indicated by lines which cut into the upper part of the antae. Its angle corresponded exactly with that of the very prominent gable over the door. On each side of the figure in the centre of that gable there are roses exactly similar to those on the gable of the north portal at Cashel (Pls. 96, 97). The little arcadings on each side of the door are the same as those on the south side of the door at Cashel. This is simply a different composition of the same elements. In this façade one is surprised to find antae, obviously contemporary with the portal, but manifesting the survival of the eighth–tenth-century façades right into the twelfth century.

[1] For example at the Nuns' Church, Clonmacnois.

[2] Loiret; formerly Choisy-aux-Loges.

[3] The aberrant type of this portal may be explained by the fact that the abbey depended on St Martial-de-Limoges (Joan Evans, *Romanesque Architecture of the Order of Cluny* (Cambridge, 1938), p. 31).

[4] Dunraven, II, p. 8, Pl. CXXI; M. Stokes, *E. Chr. Art*, 2nd part, pp. 19, 69; T. L. Cooke, *The Early History of the Town of Birr* (Dublin, 1875), pp. 132 sqq.; Leask, *Ir. Churches*, I, p. 125; Gwynn-Gleeson, *Killaloe*, pp. 60 sqq.

There is at Ferns (Wexford) a very strange ruin, the remains of a small Augustinian monastery built by Dermot Mac Murrough between 1140 and 1154.[1] The choir of the church shows a system of vaulting supported by parallel arches which is the same as that of the nave of Cormac's Chapel. There must have been a very high room above that, reached by a narrow staircase from a vaulted room to the north of the choir. As we have seen, on the north side of the west front, the church has a round tower on a square base beside which opened, in the centre of the façade, a doorway now reduced to some fragments of carved bases (Fig. 27b; Pl. VIII).

Another church, at Kilmalkedar, in Kerry,[2] has a nave which is practically of the same size as that of Cashel (Pl. 107) and the squat columns resting on a cornice on the two side walls are similar to the columns at Cashel though they do not carry arches. There was a stone vault, now so completely ruined that it is not possible to know anything about its structure. The original choir was very much smaller than the present one and probably no larger than the apsidial chapel at Cashel on which it may have been modelled. The west front has a portal with a blank tympanum, which may originally have been painted, and it is framed by antae. In the same neighbourhood, the cathedral of Ardfert (Kerry) has on its west façade a series of arches reminiscent of Cashel and Roscrea.[3]

A series of portals and triumphal arches can be studied together, though they belong to churches of very different types. Their common feature is the presence of large human or animal heads marking the corners of the jambs. This arrangement we have already found at Inchagoill

[1] See a copy of a charter of Dermot Mac Murrough donating land to the Priory of Ferns (R. Dodsworth – G. Dugdale, *Monasticon Anglicanum*, II (London, 1661), pp. 1040–41). From the indications given by the names of the witnesses, it seems to date *c.* 1154; the wording seems to indicate that the priory existed at that date; it may have gone back to *c.* 1140, a time when St Malachy established a great number of communities of Augustinian canons in Ireland. See Leask, *Ir. Churches*, I, pp. 163–4; Archdall, p. 743 sqq. For Ferns, see: *J.R.S.A.I.*, 1895, pp. 403 sqq. and Id., 1910, pp. 297 sqq.

[2] Dunraven, II, pp. 52–3; Brash, pp. 98 sqq.; A. Hill, *Kilmalkedar, County Kerry* (Cork, 1870), Leask, *Ir. Churches*, I, pp. 121 sqq.

[3] Leask, *Ir. Churches*, I, pp. 124–5.

and to a certain extent on the door of the Nuns' Church at Clonmacnois, associated in both cases with arches with heads. This use of a head to accentuate the corner of a capital is frequent in Romanesque art, but it has taken on in Ireland a character of its own through the nature of the modelling and the treatment of the background of these heads. One of the most outstanding examples of this type of portal is that at Killeshin (Glen Uissen; Leix).[1] The church is built on the slope of a hill above a wide stretch of countryside (Pl. 91). The monastery is mentioned fairly often in the Annals. One of the last entries relates the plundering of the monastery in 1041 by the king of Leinster who carried away 700 prisoners and destroyed the church.[2] The buildings seem to have been re-built as, in 1077, we are told that 'Glen Uissen and its yew-trees were burnt'.[3] The church whose walls have survived to our time is obviously a reconstruction of later date than the eleventh century destructions. According to tradition, the monastery was of a certain importance, and the large number of prisoners taken there in 1042 seems to confirm this fact. Near the church there was a round tower which was knocked down in 1703.

Only the west and north walls of the church have survived. The west front is framed by antae; in the middle, the sharply pointed gable of a door stands out boldly (Pl. 91), below a small window with pointed top. The wall was obviously very much higher than it stands at present, and its gable may have been, as at Roscrea, parallel with the gable of the portal. This portal looks very odd, as it is made of stones of different texture and colour used without any symmetry, some of a shiny white, the others

Fig. 25. Foliage from the portal at Killeshin.

[1] For the inscription see p. 156; Dunraven, II, pp. 81 sqq.; Brash, pp. 57–8; J. O'Hanlon—E. O'Leary, *History of the Queen's County* (Dublin, 1907), I, pp. 257 sqq.; H. S. Crawford, 'Carvings from the Doorway of Killeshin Church, near Carlow', *J.R.S.A.I.*, 1925, pp. 83 sqq.; Henry, *Sc. irl.*, pls. 130–32.

[2] *A.F.M.*, 1041; *A.U.*, 1042 (mention of 400 prisoners and 100 killed).

[3] *A.F.M.*, 1077.

dark brown and coarse. This makes it pretty obvious that the whole door was coated with paint which covered up these disparities. This is made even more likely by the fact that much of the ornament is lightly engraved and would be seen at a distance only if picked out with paint. In the jambs, the shape of the smooth columns resting on bulbous bases is simply suggested by a play of mouldings; between them, scrolls of foliage in very low relief emerge from human or animal heads – a motif probably of North Italian origin.[1] The ornaments on the voussoirs are so finely incised as to suggest a close imitation of a piece of metalwork, possibly much older than the portal itself. One may wonder if the model was a shrine or a crozier belonging to the monastery, as there is on one of the arches that pattern of endlessly repeated crosses which we have found on the reverse of so many shrines and cumdachs of the eleventh and twelfth centuries; also in the triangles framed by the zig-zags in one of the arches are found the hounds, stags and birds which decorate several of the ninth and tenth century croziers (Fig. 26). The key of the arch has a full face head in relief with a background of finely wrought ornament (Pl. 74). The most remarkable feature remains, however, the heads which mark the corners of the jambs above the feint columns. They are powerfully modelled in simplified volumes which, worn as they are now, are still remarkably impressive. The same arrangement is found at Inchagoill (Galway), at Annaghdown (Galway),[2] and we shall find it at Kilteel (Kildare) and on the tower of Timahoe (Leix). Still nowhere, except perhaps at Rahan (Offaly) does it have this impassive serenity retaining perhaps a memory of some carvings of Byzantine inspiration.[3] In violent contrast, though, the wavy, classical hair is transmuted on the flat part of the capital into a weaving of straps ending in foliage and inter-mingled with animals similar to those in the Oxford Missal (Pl. 92).

[1] See G. Zarnecki, *The Early Sculpture of Ely Cathedral* (London, 1958), pl.78 (Verona cath.); see also the detailed comparisons between the doorway at Ely where this detail occurs and S. Michele at Pavia (pp. 28–30).

[2] Dunraven, II, p. 125; Wilde, *Lough Corrib*, pp. 66 sqq.; Henry, *Sc. irl.*, Pl. 124; J. Fahey, 'The Diocese of Annaghdown', *J. Galway H.A.S.*, 1903–4, pp. 102 sqq.

[3] Of which the angel heads on an arch at Monopoli (Pr. of Bari) are an example; see: A. Kingsley Porter, *Romanesque Sculpture of the Pilgrimage Roads* (Boston, 1923), III, Pls. 158–62.

Of all the paradoxes we have found so far, this may be the strangest.

It ought to have been possible to date this beautiful doorway, had not the inscription on the labels of the capitals been systematically hammered out. A few letters have kept their elegant design, but most of them have vanished. Even the optimistic readings of Graves and Macalister[1] do not give secure indications, so that it is better to resign ourselves to leaving the portal undated.

There are similar heads on other monuments. On the round tower of Devenish (Fermanagh)[2] they have been placed to the four cardinal points, above the upper windows. They have imposing faces framed by the interlacings of their ribbon-like hair (Pl. IV). On the Timahoe tower[3] the doorway, perched nearly 20 feet above ground level, is carved like a

Fig. 26. Killeshin portal, detail.

church portal, with fake columns and haughty human heads as capitals.

The most handsome of these heads are certainly those on the chancel arch of the larger church at Rahan (Offaly),[4] a short distance from Clonmacnois. They crown plain mock-columns. Their presentation is not quite the same as at Killeshin: instead of stressing the corner of the jamb by a smooth volume, they accentuate the upper part of the column through a great insistence on the oblique lines of moustache and beard. The nave of the church has been re-built comparatively recently. The barrel-vaulted choir originally carried a stone roof which formed a room above

[1] Macalister, *Corpus*, II, pp. 26 sqq. (No. 574).

[2] They are part of the frieze immediately below the conical roof (Pl. IV).

[3] Dunraven, II, pp. 29–32, Brash, pp. 34 sqq.; H. S. Crawford, 'The Round Tower and Castle of Timahoe', *J.R.S.A.I.*, 1924, pp. 31 sqq.; Henry, *Sc. irl.*, Pls. 125–7.

[4] See p. 152.

the vault; the stairs leading up to that room can still be seen in the north wall, though the upper part of the building has now disappeared. On each side of the choir, round-headed doors led into rooms to the north and south of the choir.

A choir arch at Kilteel (Kildare),[1] which shows a more agitated version of the motif of heads with elongated animals intermingled in their hair, brings a new element to the study of Irish Romanesque art, that of figured representations. The church at Kilteel was built on one of the last shelves of the Wicklow Mountains, above the plain of Kildare. It seems to have had a rectangular door of a type common in the eighth and ninth centuries. A choir was added in the twelfth century, with the usual chancel arch framing it. The church was partly destroyed in Norman times and treated as a quarry. A certain number of carved blocks taken from the arch were retrieved in 1934 from outbuildings of a nearby castle. Excavations revealed the lower courses of the arch *in situ* in the ruins of the church. The stones from the castle were then built onto them so as to restore part of the piers of the chancel arch. Much is still missing and the piers must have been at least a foot higher than they are now, but, even so, the general structure has become obvious. The carvings are of an unexpected type. The jambs had three orders, one of which was decorated with zig-zags and the two others with figured scenes. Some of these were in superposed panels, as on the tenth-century crosses, whilst the others are separated by large marigolds. The bases are all scalloped and the capitals are magnificent examples of corner heads with interlaced hair (Pl. 93). Two of the figured scenes, Adam and Eve and Samson and the Lion, are treated in a sort of impressionistic style where light and shade are violently contrasted. The others are modelled with a greater sense of volume and of smooth, rounded surfaces (Pls. 94, 95). One of the most striking shows a small figure of David bringing back the head of Goliath (Pl. 94); on others are seen two figures fighting in the traditional posture of Jacob and the angel, an ecclesiastic holding a crozier, a figure taking an enormous drinking-horn to his mouth. One of the strangest is

[1] H. G. Leask, 'Carved Stones discovered at Kilteel, Co. Kildare', *J.R.S.A.I.*, 1935, pp. 1 sqq.; Henry, *Irish Art* (1940), p. 184, Pl. 80*b*; Leask, *Ir. Churches*, I, p. 165, Pl. XX.

a little acrobatic figure which invites comparison with the dancing Salome of the French Romanesque doorway at Avallon (Yonne). As it is now impossible to reconstruct the original order of the panels, it would be vain to try to argue about its iconographical programme.

The doorway at Freshford (Kilkenny)[1] also had figured carvings, now very worn. It is a very deep, porch-like portal (Pl. 84) of the same type as the north door at Cashel with which it shares also the feature of a pointed gable. On each side, at the root of the oblique lines of the gable, there are carved panels, one with a little horseman, the other with two figures. On the inner sides of the door there are a series of high relief frames one of which holds also two very battered carved figures. This door has a fairly well-preserved inscription, but it is unfortunately impossible to identify the donors which it mentions.[2]

Carvings were made in Glendalough in the twelfth century[3] in the same spirit as those with corner heads at Killeshin, Timahoe and Kilteel, though on a more minute scale, with a sort of dryness reminiscent of metalwork and a rather poverty-striken repertoire where dessicated zig-zag patterns are the chief motif. Neither in the additions to the old cathedral nor in the cemetery chapel is anything found which could be compared with the inventiveness of the carvings at Killeshin and though St Saviour's Priory has a more energetic style, its decoration remains on a small scale.

This priory is, as we have seen a curious complex of church and adjacent rooms whose compactness aims probably at an easier defence, as it is far away from the main group of buildings of the monastery. Like Cormac's Chapel, the church had no door to the west and the entrance was probably by the door at the west end of the south wall (Fig. 27). Another door, at the east end of the same wall seems to have opened into a small square or rectangular construction whose foundations were uncovered in 1875 and which might have been a small tower. Another door, in the north wall, led into two rooms, probably meant as living quarters; from

[1] Petrie, *Round Towers*, pp. 281–3; Brash, pp. 101 sqq.; Dunraven, II, pp. 91 sqq.; Henry, *Sc. irl.*, Pls. 155–6; Leask, *Ir. Churches*, I, pp. 154 sqq.; Carrigan, *Ossory*, II, pp. 253 sqq.
[2] See p. 156. [3] For Glendalough, see Vol. II, pp. 44–46.

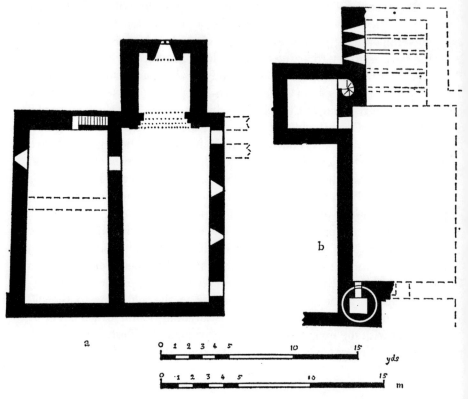

Fig. 27. a, Plan of St Saviour's Priory, Glendalough; *b*, Plan of Ferns Priory.

there, as in Ferns, it was possible, by a small staircase to reach a room above the vaulted choir.

The church is longer and slightly wider than Cormac's Chapel, though the choir is practically the same size as that at Cashel, and like it slightly off-centre in regard to the axis of the nave. The nave does not seem to have had any decoration, but the chancel arch and the window in the east wall of the choir are covered with carvings. The arch had collapsed and was re-built in 1875 with stones found between the piers (Pls. 108, 109). It is robust, even slightly squat. The inside arch is supported by two heavy semi-columns similar to those found in the same position at the

182

cathedral of Tuam. Some of the bases are scalloped like those at Kilteel and the others show a variety of motifs so totally inadequate as to be rather attractive from their very absurdity (Pl. 109). A special mention should be made, however, of some powerfully drawn scrolls of foliage of the same type as those on a slab in the cathedral. The capitals of the semi-columns have a slightly modified version of the corner-head motif which loses something of its effectiveness because of the rounded shape of the columns. The other capitals have a scalloped form or key-patterns. A striking feature of this arch is the absence of ornament on the jambs, in great contrast to the lavish decoration between the mock-columns at Killeshin.

Another arch, now in the south wall of the Church of Ireland church at Wicklow was probably brought at a fairly late date from Old Kilcullen (Kildare)[1] which had become the seat of a bishopric at the Synod of Rathbreasail. It has features in common with the Romanesque decoration at Glendalough and is probably of the same date.

One small carving in Glendalough is still worth considering.[2] It is inserted as a tympanum over the door of the small cemetery chapel, near the cathedral (the so-called 'Priest's house'). It is badly broken, but there are old drawings which show it complete. It was probably a version of the *Traditio Legis* as it is found on a few Romanesque monuments such as one of the tympana of the church at Champagne (Ardèche); on either side of a frontal figure are shown two others slightly bent in reverence, one holding a bell, the other a crozier. The poor state of this fragment does not allow for any remarks on its style.

Several other monuments would also deserve study, such as the church at Mona Incha near Roscrea (Tipperary),[3] an old eremitic settlement

[1] For Wicklow, see Leask, *Ir. Churches*, I, pp. 160–1; the Old Kilcullen arch is illustrated in Grose, *The Antiquities of Ireland* (Dublin, 1791–5), II, pl. 124, cf. Henry, *Sc. irl.* pl. 122, 2; making allowances for the awkward drawing, there can be little doubt that it is the greatest part of the same arch. The church at Old Kilcullen was excavated in 1939 (*J.R.S.A.I.*, 1941, 'Miscelanea') and only a few broken fragments of the arch were found then.

[2] Petrie, *Round Towers*, p. 251; this drawing is reproduced in: Cochrane, *Glendalough*, Fig. 18*a* and Leask, *Glendalough*, Fig. 6.

[3] C. Mac Neill, 'Mona Incha, Co. Tipperary, Historical Notes', *J.R.S.A.I.*, 1920, pp. 19–24; H. G. Leask, 'Mona Incha Church, Architectural Notes', Id., pp. 24–35; Brash, pp. 46 sqq.; Carrigan, *Ossory*, IV, pp. 50–1; Henry, *Sc. irl.*, Pls. 159–60.

which had a renewal of popularity in the twelfth century, that at Donaghmore, near Cashel,[1] the churches on the island of Inisfallen (Kerry),[2] or a doorway taken from a church on Trinity Island in Lough Outer, which was inserted in the Church of Ireland cathedral at Kilmore (Cavan)[3] and shows animal motifs with a strong Scandinavian flavour. We have had to limit ourselves to the most characteristic monuments and those which show best the various aspects of the sculptured work.

This review of Irish Romanesque art has taken us into all the important kingdoms of Ireland except those of Ulster. Further north than the Trinity Island door, the tower at Devenish and a late portal on White Island (Fermanagh), nothing has survived of the same type as the doorways in other parts of Ireland. One may wonder if wooden churches had not remained more popular in that part of Ireland. Still, there are mentions of stone churches at Armagh, and others such as the cathedral of Down, the church built at Derry in 1155 and that revolutionary church of St Malachy's at Bangor.[4]

There is only one exception to this lack of carvings in the north: the very strange doorway at Maghera (Derry),[5] some 25 miles east of Derry. It probably goes back to the eleventh or twelfth century. It is different from all the portals we have seen in being rectangular in shape, with a boldly protruding frame, like the door of the neighbouring church at Banagher (Derry) and that of the church at Aghowle (Wicklow).[6] As in these two other doors there is an arch above a blank tympanum on the inside of the door. We have seen[7] that several fragments of rectangular tympana have survived and that those at Dunshaughlin (Meath), Raphoe (Donegal) and Clonca (Donegal) seem to go back to the ninth or

[1] H. S. Crawford, 'Donaghmore Church, Co. Tipperary', *J.R.S.A.I.*, 1909, pp. 261 sqq.; Henry, *Sc. irl.*, Pls. 143–4.

[2] *J.R.S.A.I.*, 1890–1, pp. 609 sqq., 1892, pp. 158 sqq., 1906, pp. 337 sqq.

[3] O. Davies, 'The Churches of County Cavan', *J.R.S.A.I.*, 1948, pp. 73 sqq.; Henry, *Sc. irl.*, Pls. 135, 146–9, 152.

[4] See pp. 148–9.

[5] Dunraven, I, pp. 116 sqq.; M. Stokes, *Early Christian Arch.*, pp. 130 sqq. and Pl. XIX; A. K. Morrison – S. D. Lytle, 'Some Notes on the Parish of Maghera and neighbouring district in the County of Derry', *U.J.A.*, 1902, pp. 128 sqq.; Champneys, pp. 100 sqq.; Henry, *Sc. irl.*, Pls. 112–3; Sexton, *Fig. Sc.* pp. 116 sqq.

[6] *Vol. II*, Pls. 5 and 6; Henry, *Sc. irl.*, Pl. III, 3, 6. [7] *Vol. II*, p. 189.

tenth centuries. That at Maghera would come as a very normal continua-
tion of this series (Pl. V). It has an elaborate figuration of the Crucifixion
in low relief where Christ wears a long dress and the two thieves are
perhaps shown behind the arms of the cross; angels occupy all the free
space above the cross. Below, there are several people standing on each
side of the lance and sponge bearers. The sides of the door and the frame are
covered with ornament amongst which is foliage of a type we have already
met several times in Irish Romanesque carvings, interlacings, probably
animal-interlacings and chequer patterns. On the side of the frame to the
right of the Crucifixion, there is a small figure with conical cap, crozier in
hand, similar to some of the figures on high crosses of this time (Pl. V).

At the same time when this partly native decorative style was flourish-
ing leisurely on the walls of churches with very traditional plans, build-
ings of a new type were appearing here and there. Nothing is left of the
oldest, the church erected by Malachy in Bangor shortly after his return
from the Continent in 1140, but we can assume that it had a nave with
side aisles. About the same time he had founded at Mellifont (Louth) on
ground given by a local chieftain, Donagh O'Carroll, a short distance
from the bridge which had recently replaced a ford at the mouth of the
Boyne (Droicheat átha, the bridge of the ford: Drogheda), a new monas-
tery which was to follow the rule of Citeaux.[1] St Bernard sent him an
architect named Robert, who was to establish the plan, a difficult task on a
patch of flat ground compressed between the river Mattock and a steep
slope. The building must have been far advanced in 1152, if the *pallia*, as
seems likely, were given to the archbishops at Mellifont at that date. In
any case the church was consecrated with great solemnity in 1157, in the
presence of King Murtough Mac Loughlin, of the donor, O'Carroll, and
of Devorgilla who, as the daughter of a king of Meath played an import-
ant part in the ceremony. All lavished gifts on the new foundation. It
needed them badly, as the influx of novices had been such that some ten
daughter-houses had already had to be built.[2]

[1] Father Colmcille, O.C.S.O., *The Story of Mellifont* (Dublin, 1958).
[2] Id., p. 16, Leask, 'Cistercian Monasteries, Pedigree and Distribution Map',
J.R.S.A.I., 1948, p. 63. Id., *Ir. Churches*, II, pp. 1 sqq.

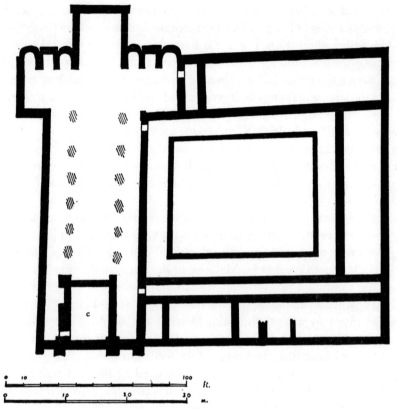

Fig. 28 Plan of the Cistercian monastery at Mellifont (from data supplied by the National Monuments Branch, O.P.W.); *c*, crypt.

Few of these Cistercian abbeys have preserved their early buildings. Only the foundations have been discovered in Mellifont, where excavations made in 1953 have revealed the lay-out of practically all the first constructions (Fig. 28). At Boyle (Roscommon), the earliest parts of the church seem to go back to 1161–2, the date at which the community, after looking for a suitable site from 1148 on, settled on the present one.[1] At Baltinglass (Wicklow) the church, which has been recently cleared,

[1] *A.F.M.*, 1162; see also *A.U.*, 1174 and footnote pp. 181–1; Leask, *Ir. Churches*, II, pp. 32–5.

probably dates from a few years after 1148, the official foundation date. Monasternenagh (Limerick)[1] and Jerpoint (Kilkenny)[2] also have substantial early portions.

Mellifont must have been nearly finished in 1157; Baltinglass, endowed by Dermot Mac Murrough must have been finished or at least very far advanced at the time of his flight to England in 1167. So we have here two monasteries erected in the middle of the century, thus contemporary with the second monastery at Clairvaux which was being built at the time of St Malachy's first visit and of which they may reflect some features.[3] It is noteworthy that in both cases the chapels on the transept do not conform to the usual Cistercian plan. At Mellifont they are alternately square and round (Fig. 28), a plan which has equivalents only amongst Cisterican churches at Fontfroide (Aude),[4] but can also be compared with the transepts with semi-circular chapels of Les Vaux-de-Cernay (Yvelines) and Reigny (Yonne).[5] At Baltinglass, instead of forming a continuous block, the chapels are separate. In all this there are obvious echoes of the experiments which eventually led to the standard Cistercian plan.

Fig. 29. Detail of Dysert O'Dea portal.

The church at Mellifont (Fig. 28) was certainly very surprising when compared with the average Irish church of the time. It was 150 feet long, the nave was divided by rows of pillars and it had a transept. Because of the nearness of the river it even had a small crypt to the west, which was meant to prevent flooding. The general plan of the monastery was already the Cistercian plan as it will be found, with only a few modifications, in most Irish abbeys of the order. The foundations of the cloisters have been cleared and a few fragments of its arcadings have been found (Pls. 110,

[1] Or Maigue, P. Power, 'The Cistercian Abbeys of Munster', *J. Cork H.A.S.*, 1930, pp. 43 sqq.

[2] H. G. Leask, *Jerpoint Abbey* (O.P.W., no date).

[3] Aubert, *Arch. cisterc.*, I, p. 15. [4] Id., I, Fig. 29. [5] Id., I, Figs. 48 and 33.

111) and are now re-erected near the slightly more recent lavabo. These arcadings with scalloped capitals are not Burgundian in style and reveal an aspect of the foundation of Mellifont about which the texts remain mute. They are practically identical with those of the porch of the church at Fountains Abbey (Pl. VIII), the great Cistercian monastery of the north of England, and are also very close to the arcadings of the cloisters at Rievaulx (Yorkshire) which probably date from the building campaign corresponding more or less with the installation of St Ailred as abbot (1147).[1] So it seems possible that Malachy, beside the help of an architect from Clairvaux who laid out the plans of the monastery and then left, availed himself of the service of masons sent by the abbot of one of the Cistercian monasteries with which he had come in contact on his journey through England. In the same way the similarities between the nave of Boyle with its powerful columns and scalloped capitals (Pl. 112) and that of the church at Fountains (Pl. VIII) have often been pointed out.

On the other hand, what is remarkable at Baltinglass is the survival of elements of native decoration. The door which opens in the north wall of the nave has chevrons which would be normal in any of the churches of the neighbourhood (Pl. VII); the ornaments on the column bases in the transept crossing and the bulbous shape of some of them have parallels in Killeshin and St Saviour's Priory at Glendalough (Pl. VII). A study of the oldest part of the choir and the crossing of the church at Monasternenagh, founded between 1148 and 1151 by Turlough O'Brien is made very difficult by later transformation but it seems to yield some features of Burgundian Romanesque. At Jerpoint – probably a construction of the late twelfth century with adaptation of earlier elements – some features of the decoration are oddly traditional (Pl. III).[2]

This represents in Ireland the end of an art with a true native flavour. As everywhere else the novelty of Gothic art swept everything before it, though in some parts of Ireland its adaptation was remarkably slow as shows, for example, in the building at Ardmore (Waterford), in the last

[1] Sir Charles Peers, *Rievaulx Abbey, Yorkshire* (London, 1948).
[2] Compare for example the capital on Pl. 111 with one of the capitals at St Saviour, Glendalough, Pl. 108.

years of the twelfth century, of a perfectly traditional church accompanied by a round tower.[1]

[1] *A.I.*, 1203, 5, 'Mael Étaín Ua Duib Rátha, noble priest of Ard Mór died after finishing the building of the church of Ard Mór', A series of low relief carvings inserted in the West wall of this church may not have belonged to it originally; T. J. Westropp, 'Notes on the Antiquities of Ardmore', *J.R.S.A.I.*, 1903, pp. 353 sqq.

7. Conclusions

THE PERIOD, covering hardly two centuries, which we have just reviewed, has revealed an extraordinary wealth of works of art of all kinds. The moment has come now to try and understand the way in which they are connected and the various tendencies which manifest themselves in their decoration, not always successively but often side by side and at the same time. We are lucky in having for this period what was lacking for the earlier ones, dating elements for many of the objects and some of the monuments; other objects can be connected with the dated ones. The table given on p. 120 has indicated a first analysis in time of portable objects, metalwork and manuscripts. When the stone monuments are added to this, one can get a general picture whose main features become fairly clear. Its study, however, raises a series of problems deserving special study which will only be mentioned as we proceed to outline this picture, and will be examined later in detail.

It is necessary to point out first that very few objects can be ascribed to the first half of the eleventh century. This period was probably devoted to restoration and attempts at regaining balance after the violent upheavals of the second half of the tenth century. The great monasteries concentrate their efforts on picking up the threads of tradition and reviving it. Several of them, as late as the end of the century, seem thus to confine themselves to continuing the past in a strictly conservative spirit. This is probably the case for Clonmacnois, as far as we can judge from the style of the shrine of the Stowe Missal and the initials of the Book of the Dun Cow and Rawlinson Ms. B. 502 (first part); it is the case also for the scriptorium of Glendalough as we know it from the Drummond Missal, and of that of Armagh at the time when the Gospelbook Harley 1023 was copied.

Elsewhere there was more curiosity about new patterns and methods.

190

Since the ninth and tenth centuries, vegetable elements had appeared in Irish decoration. Though they are not found in any of the works enumerated above, they spread abundantly, taking a very distinctive flavour, on a series of objects of the second half of the eleventh century: upper knop of the British Museum crozier, Inisfallen crozier, cumdach of the Cathach, initials of the *Liber Hymnorum* of Marianus' Chronicle and of Rawlinson Ms. B. 502 (second part) (Pls. 17, 20, 21, 2, 3, 8, 9). It is difficult to pin down this style to a definite region of Ireland, though one may venture the hypothesis that it belongs chiefly to Leinster and Meath. The cumdach of the Cathach was made in Kells as was probably also the Misach, the Rawlinson manuscript seems to originate from Leinster, the scribe working for Marianus may have come from Meath or Leinster. One can hardly go further, though it is rather striking that only in Leinster can survivals of this style into Romanesque carvings be detected (Pl. 92). It was already developed in all its exuberance in 1072 when the Chronicle of Marianus was copied, and one can assume that it had then been in existence for some time. It seems to disappear in metalwork around 1120–30. It lives on later in illumination, nearly always a conservative art, and we have just seen that there are echoes of it in carvings belonging to the middle or the second half of the twelfth century. But on the whole it flourished mostly in the period 1050–1110. Its origin and affinities will have to be examined in detail.

Around 1100, a few metalwork objects show striking examples of a decorative style based on elegant and flowing combinations of fantastically elongated animals; this is chiefly found on the shrine of St Patrick's bell (Pls. 23, 24), the Lismore crozier (Pls. 25, 26) and the crozier of the abbots of Clonmacnois (Pl. 20). Such a style is hardly found elsewhere in Irish decoration, while it has close parallels in Scandinavian art. This problem also will deserve attention.

However, on the same objects, besides these new ornaments, small panels of animal-interlacing are found, which are in many ways connected with an old Irish tradition. They may have helped the development of the art which appears around 1100–1120. This is a decorative style whose chief element is a ribbon-shaped animal, often arranged in rectangular panels according to diagonal construction lines and generally caught in

191

the knots of long, meandering snakes. In spite of the affinities with the 'Urnes style' which have been ascribed to it, it is really based on traditional Irish motifs, ribbon-shaped animals and snakes combined according to rhythms which are already found in the eighth century, for example in the St Gall manuscripts. Its apparent affinities with Scandinavian patterns only comes from a sort of exotic colour which it sometimes affects, whilst the very structure of the ornament remains essentially Irish. There are, however, some border cases, such as the Oxford Missal initials (Pls. 4, 5) and the panel of Daniel in the Lions' den on the base of the Dysert O'Dea cross (Fig. 10).

These ornaments are found in manuscripts, usually associated with the foliage style, and also on the stone crosses of Dysert O'Dea, Roscrea, Mona Incha, Tuam and Glendalough. In the decorations of churches they creep between the imported Romanesque elements and occupy much space on the jambs and capitals of the portals of Dysert O'Dea and Clonfert, of the chancel arches of the Nuns' church at Clonmacnois and of the cathedral of Tuam; they appear beside the corner heads on the jambs of the Killeshin doorway; the Cashel sarcophagus is a sort of dogmatic demonstration of their most outstanding features (Pl. 89); in metalwork, they are chiefly found on the cross of Cong, the Lemanaghan shrine and a few related objects. It would be difficult to decide whether this style represents a deliberate and conscious return to some of the staple motifs of Irish art of the best period or simply a nearly instinctive survival.

If we look in more detail at some of the problems which have been mentioned in the course of this review of the various Irish styles, it becomes obvious that they may be reduced to the question of the relationship of Irish decoration to Scandinavian art and English art of the same period.

One of the great difficulties which has to be faced at once when dealing with the connections between Irish art and Germanic arts is the fact that they are close relations, being descended from motifs of animal-interlacings which they had in common since the seventh century. Then, they have occasionally influenced each other. The Vikings took home with them a quantity of Irish objects which have had a much greater influence

a

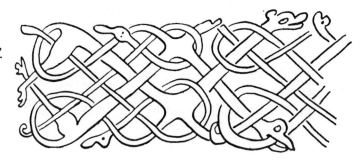

Fig. 30. Animal-interlacings,
a, Roscrea cross; *b,* Glenda-
lough cross; *c,* Tuam cross.

b

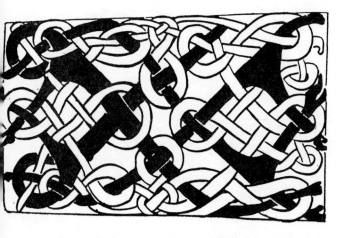

c

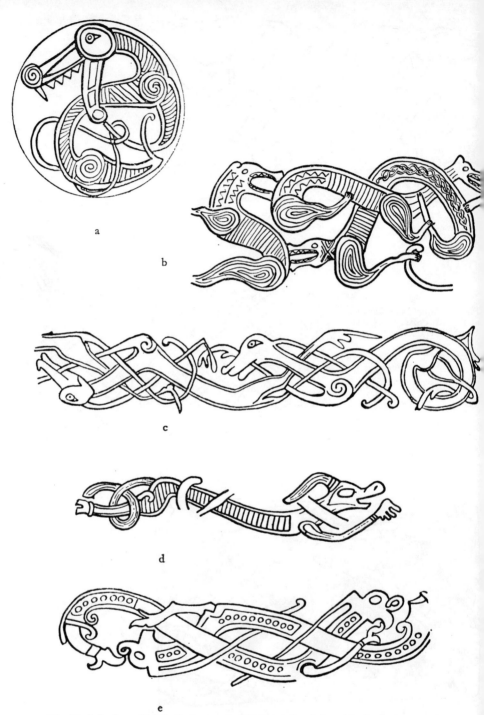

a

b

c

d

e

Fig. 31. Animals, *a*, Detail of a fragment of Irish metalwork found in the Oseberg tomb (Norway); *b*, Oseberg chariot, detail; *c*, animal border from the Lindisfarne Gospels; *d*, detail of one of the Copenhagen Museum horse-collars; *e* decoration on a silver cup found in the Jellinge grave (Denmark).

194

on Scandinavian art than is generally admitted. Traces of this already appear in the objects from the Oseberg tomb (Fig. 31*b*). We shall meet other examples. When, finally, Irish craftsmen imitate Scandinavian patterns, it is often their own art, subtly altered, which becomes their source of inspiration. How then can we discriminate between what is imitation and what is not?

There is also the fact that, so far, part of the answer to these problems was confused by the generally accepted chronology of Scandinavian works of the eleventh century. It seemed difficult to reconcile the known dates of Irish objects with the traditionally accepted landmarks of Scandinavian art:[1] 'Jellinge style' around 930 (represented chiefly by the silver cup found in one of the mounds at Jellinge (Denmark) and by the horse-collars in Copenhagen Museum); the carved rune-stone at Jellinge around 980; Swedish rune-stones scattered over most of the eleventh century; wood carvings on the church at Urnes (Norway) around 1060 or 1070; 'Ringerike style' somewhere in the eleventh century. These dates are based to a great extent on the historical conclusions deduced from an inscription at Jellinge which said that the mound with the silver cup had been erected by King Gorm (who died *c.* 940) for his wife Tyre. This monument, associated with a pagan sanctuary, antedated the introduction of Christianity in the middle of the tenth century, which did result in the establishment of three Danish dioceses depending on Hamburg, and the conversion in 960 of King Harald Blue-Tooth, who then governed Norway and Denmark. Harald, sometime between his conversion and his death, abolished the pagan sanctuary of Jellinge and raised to the memory of his parents a stone decorated with a carving of the Crucifixion on one side and a great beast on the other.

For a long time I have felt this chronology to be incompatible with the well-established dates of numerous Irish objects. I raised the question at the Congress of Celtic Studies held in Dublin in 1962,[2] hoping for some answer to my queries. It came in the shape of a long post-script to

[1] *Osebergfundet*, III (H. Shetelig) (Oslo, 1920); S. Lindqvist, 'Nordisk Kultur', *Konst*, 1931.

[2] F. Henry, 'The Effects of the Viking Invasions on Irish Art', *Proc. int. Congress of Celtic Studies* (Dublin, 1962), pp. 61 sqq.

an article of W. Holmqvist[1] where he quoted a paper published by S. Anjou in 1932 demonstrating that the objects found in the Jellinge mound cannot be those of Tyre's tomb, as they form a group of clearly Christian flavour, where the cup may well be a chalice. Differing with many Scandinavian scholars, Holmqvist subscribes to Anjou's conclusions. If this position be accepted, all the datings of Scandinavian works later than the cup have to be revised, especially that of the Swedish rune-stones and of the Urnes carvings. It is to be hoped that this question will be re-examined in detail by Scandinavian archaeologists and runologists, the only people really qualified to establish a new chronology. Meanwhile I feel less misgivings in allowing a certain play to the dates hitherto admitted.

In the same article, Holmqvist proposes an extreme solution to which I cannot subscribe entirely. He refuses to admit any influence from Scandinavian art on Irish art, and suggests that the forms which appear in Scandinavia have been invented first in Ireland. This goes certainly much too far, and we shall see that the problems have to be defined in a different way and considered in relation to a much wider geographical area. There are also some motifs characteristically Scandinavian which had a great vogue in Ireland. To quote only one, which will be a sufficient demonstration, there are, going back to the ninth century, and the wooden objects from the tombs at Oseberg and Gokstad, examples of animal heads whose whiskers and hair are made of large ribbons, usually interwoven.[2] This mannerism reappears on the bronze heads at the ends of one of the Copenhagen horse-collars, which the revised chronology allows us to place in the first half of the eleventh century. When we observe it – a motif with no antecedents in Ireland – towards the end of the century on the shrine of St Patrick's bell and the shrine of the Glankeen bell (Pls. 23, 18), we have to accept it as a manifestation of Scandinavian influence. In the twelfth century the same motif reappears in carvings applied to human heads (Pl. IV). It is then fairly obvious that

[1] W. Holmqvist, 'Övergangstidens metalkonst', *Kung. Vitterbets Hist. och Ant. Akademiens Handlingar*, 1963.

[2] *Osebergfundet*, III, Fig. 208.

after the battle of Clontarf[1] a wave of Scandinavian fashions made itself felt in Ireland, fashion which is just as explicable as the Irish fashion which arose in Norway soon after the first Viking conquests out of an imitation of the loot taken from Ireland. It would also be a strange paradox to try to derive the ornament found on innumerable Swedish rune-stones from the unique pattern on the Clonmacnois crozier – the only Irish object whose decoration can be compared to theirs (Figs. 36, 37), whilst the opposite position, which consists of seeing in the decoration of the crozier a fleeting curiosity for a foreign motif, is perfectly satisfying.

On this basis we can now try to take the study of the various motifs common to both arts. Let us first examine the 'Jellinge style' – if the word 'style' is not too ambitious for such a small collection of objects, as may well be. It can be summed up in the use, as a decorative element, of a small elongated animal, similar to those found in Irish manuscripts of the ninth and tenth centuries, but whose hind legs are replaced by a sort of spiral or a pattern of leaves. The Jellinge cup (Fig. 31, e) and the horse-collars found at Sollested and Möllemosegaard (Denmark; Copenhagen Museum) are always quoted when trying to define this style.[2] The horse-collars are not dated. But the similarity both of patterns and associated objects with the Jellinge tomb objects shows that both series are contemporary. If the Jellinge tomb dates from the late tenth century, as Anjou argues, or the early eleventh, as W. Holmqvist suggests, the horse-collars have to be put at the same date. I have shown at one time[3] that they may well include fragments of Irish gilt bronze strips with perfectly coherent animals of common Irish type, which seem

[1] In the present – very incomplete – state of our knowledge, it seems that Scandinavian patterns, with a few exceptions (Vol. II, Pl. 60), were chiefly imitated in Ireland after the complete defeat of the Vikings (see: Henry, *Effects of the Viking Inv.*).

[2] *Osebergfundet*, III, pp. 303 sqq.; Brøndsted, pp. 161 sqq.; Kendrick, *Late Saxon*, pp. 87 sqq.

[3] Henry, *Sc. irl.*, p. 76 (where the horse-collars are dated much too early (850–70). Sophus Muller gave an essential role in the elaboration of the Jellinge style to Irish models ('Dyreornamentiken i Norden', *Aarb. j. nord. Oldk. og Hist.*, 1880), while Shetelig tried for a long time to minimise the Irish element in favour of a local evolution.

to serve as models for the rest of the decoration. This is of Scandinavian workmanship, and includes 'Jellinge' animals (Pl. II). Some of them are near-faithful copies, others have that rolled-up spiral replacing the hind legs which is characteristic of the style and is found also on the Jellinge cup. There are some examples of such monsters in England, especially some rather coarse carvings from Yorkshire,[1] but in Ireland they are very rare. The only really convincing examples are on the Inisfallen crozier (Fig. 41), and the cumdach of the Cathach, when complete, may also have had them (Fig. 7). This is all, so that it is unlikely that the motif was invented in Ireland, whilst it can be a Scandinavian distortion of an Irish pattern which, in its turn, did influence a few Irish objects. Dated c. 1000 in Scandinavia, its impact in Ireland becomes much easier to understand, as a few objects of this style can have been amongst the trophies picked up in 1014 on the battlefield of Clontarf and imitated by Irish craftsmen during the next half-century.

Let us now turn to the Irish foliage patterns. It has become a habit to connect them with monuments of the 'Ringerike style', such as the slab from Vang (Norway). Since the classic work of Brøndsted on early English ornament, published in 1924,[2] it is usual to derive the Ringerike foliage patterns from the windblown acanthus of English manuscripts of the 'Winchester style' (early eleventh century). I must confess that I have always found this derivation perplexing. The lobed foliage of the Ringerike style may have acanthus as its ancestor, but acanthus at a more advanced stage of disintegration than those of the English illuminations. More recently it has been suggested that they might be adaptations of the foliage of Ottonian manuscripts,[3] which is exactly at that stage once removed from the Carolingian acanthus which would be so satisfactory. Given the essential part played by Germany in the conversion of Denmark and Norway, this theory would have history in its favour and it would be acceptable as an explanation of the origin of the Ringerike style. But it becomes much less convincing when Irish objects are also taken into

[1] Kendrick, *Late Saxon*, Pl. LXVI.

[2] J. Brøndsted, *Early English Ornament* (London-Copenhagen, 1924).

[3] R. Hauglid, *Akantus* (Oslo, 1950); H. Christiansson, 'Jellingestenens bildvörld', *Kuml*, 1953; E. M. MagERöy, 'Flatatunga Problems', *Acta Archaeologica*, 1961.

consideration. In the Irish foliage, each little bunch of leaves flows directly from the next, so that they form a continuous vegetable chain without a separate stem. This treatment is very seldom found in Ottonian art, whilst it is frequent in eleventh century manuscripts of the south of France, such as the Albi Graduel or the Sacramentary of Figeac (Fig. 32). This may be only a coincidence, but it would be a

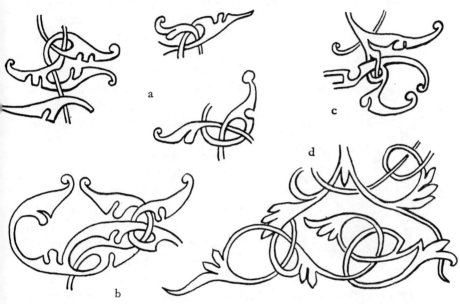

Fig. 32. Foliage: *a*, Cathach shrine; *b*, upper knop of the British Museum crozier; *c*, capital from the Marianus Chronicle; *d*, page, *Te igitur*, Sacramentary of Figeac (Paris, B.N. Ms. Lat. 2293).

strange one. The vegetable motifs we have met up to now in Irish art were simple scrolls where leaves grew to the right and left of a central stem.[1] From these only the shape of the leaf has been transmitted to later patterns. The elaborate compositions of the late eleventh century are of a completely different order (Figs. 6 and 32). The pattern on the end plaques of the Cathach cumdach may here give a useful indication of their origin: it has animals drawn in two thick, parallel lines, with a

[1] *Vol. II*, Pl. 56.

head blossoming into a foliage pattern (Fig. 7). This may be a re-
miniscence of animal heads mounted on two thick lines of ink or colour
which are found as terminals in so many initials of Carolingian and post-
Carolingian manuscripts. They derive originally from an Irish motif
borrowed on the Continent in Carolingian times, which, after endless
adventures may have its effect in Ireland again. They are found in all
Ottonian manuscripts (Pl. III), but have also passed from Carolingian
manuscripts into some French post-
Carolingian books. In the Albi-Figeac
group of some manuscripts of the north
of France they take, in the late eleventh
and early twelfth centuries, the most
varied shapes (Figs. 33, 38). It is in no
way a far-fetched hypothesis to admit
that some elements from Continental
manuscripts served as models in the ela-
boration of this Irish vegetable style. Let
us remember those manuscripts from
'beyond the sea and the great ocean'[1]
imported by Brian Boru in the early ele-
venth century and think of the influence
these importations and, no doubt, others
later in the century, may have had in the

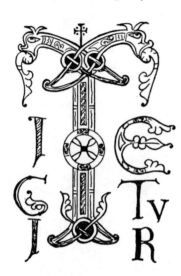

Fig. 33. Capital, Ms. *155,*
Municipal Library,
Amiens (Somme).

Irish monasteries. But what then of the
Ringerike style? The analogies between
Irish metal and manuscript work and the
Vang slab cannot be overlooked, and the slab is also connected with
another Irish monument, the Killeany cross (Fig. 13). W. Holmqvist
would probably suggest that the Scandinavian monuments derive from
the Irish ones. I would be more inclined to see here parallel phenomena
and varying aspects of a fashion which takes slightly different forms in
the various countries where it occurs, countries in constant contact with
each other, having in common not so much fully evolved patterns as
certain tastes and trends. The part played in these exchanges by the

[1] *War*, pp. 138–9.

Scandinavian cities in Ireland may have been tremendous, but its modalities escape us nearly completely so far.[1]

The connections of Irish art with what is usually called the 'Urnes style' are of a different order. There, it is essential to define first what Irish objects are concerned and also, as much as possible, the characteristics of the corresponding Scandinavian style. The Irish objects are few in number and consist only in the shrine of St Patrick's bell, the Lismore crozier, the Clonmacnois crozier and, up to a point, the shrine of St Lachtin's arm. The two first give examples of a decoration made of

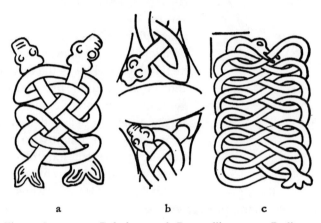

a b c

Fig. 34. Serpents: *a*, Duleek cross; *b*, Drumcullin cross; *c*, Bealin cross.

combinations of thread-like animals, whose joints are sometimes marked with spirals and which are treated with the same sinuous and plastic modelling as the carvings of the church at Urnes (Norway). The animals represented on the Clonmacnois crozier have no legs and have knotted upper jaws (Fig. 37), two features which belong to some of the animals on the Swedish rune-stones (Fig. 36). St Lachtin's shrine is more disconcerting. At first sight, the animals in its ornament, inlaid with silver and niello like those on the Clonmacnois crozier, seem to be of the same

[1] The discovery of the bone trial-piece quoted on p. 92, note 1, gives some hope that the excavations on the site of the old city of Dublin may eventually throw some light on this problem.

family. But when isolated they appear very un-Scandinavian, and give that feeling of a metal spring ready to be released which is essentially Irish (Fig. 8).

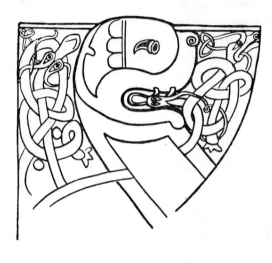

Fig. 35. Detail, Book of Kells.

The similarity between the ornament on the bell-shrine of St Patrick and the high-relief carvings at Urnes are all the more striking as they are both isolated each in its own milieu.[1] The flat carvings at Urnes, on the door and the gable, are closely related to the decoration of several runestones, while the fierce violence of the high-relief carvings is only paralleled in Scandinavia on a few small metal objects. This is the magnification and intensification, by a sculptor of genius, of a decorative theme common at the time. At least, this is the construction we are tempted to put on the facts in the present state of our knowledge. Were there many other carvings of the same type as the high-relief ones at Urnes? One may wonder. Carrying hypotheses further, one may even wonder whether this sculptor who lends so much energy to a motif usually more sluggish did not come from one of the Irish-Scandinavian cities in Ireland, Waterford, for example.[2] What do we know of monumental wood-carvings in Ireland at that time? Absolutely nothing. This leaves the field open to all sorts of speculations. The date of the Urnes carvings remains completely hypothetical. It is generally put at *c.* 1060–80. In fact its only limit is set by the date – obviously full in the twelfth century – of the capitals in the church which has partly replaced the original monument. A date similar to those of the bell-shrine and the Lismore crozier, that is to say around

[1] On the Urnes style, see: O. H. Möe, 'Urnes and the British Isles', *Acta Archaeologica*, 1955.

[2] I suggest Waterford because the metalwork group (Lismore crozier, St Patrick's bell-shrine, etc.) seems to have its roots in the region around Lismore-Waterford; see p. 100.

1100, is consequently perfectly possible. In that case, instead of worrying about influences, we could simply deal with several contemporary works, all having the same origin. This might help in a re-evaluation of the dating of the Swedish rune-stones, taking as a basis for chronology those which are akin to the flat carvings at Urnes, which would then be dated *c.* 1100.

Fig. 36. Animal from a Gotland rune-stone.

As for the last group of objects, those where a maze of snakes plays an essential part in the ornament, it has been indicated already that their relation to the Scandinavian decoration is limited to some details of the treatment inspired by a current fashion. There are snakes in Scandinavian art before the advent of the 'great beast', for example on the Vendel horse-trappings. Ireland, this snakeless country, uses them constantly as an art motif. They crawl through all the pages of the Book of Kells, where they are often engaged in a fight with monsters or monster heads (Fig. 35). They are found also in the ninth and tenth century crosses (Fig. 34) and in the metalwork as well. There may have existed in the Northern arts – Celtic and Germanic – a theme of the great beast fighting with reptiles, a pagan theme easily susceptible of taking a Christian meaning, and, consequently, of keeping its place as a decorative pattern in Christian art.

In Scandinavian art, its clearest formulation is on the Jellinge stone (Pl. III), where a monster with foliage tail and crest has a serpent wrapped like a muffler around its neck. Then the beasts on the Swedish rune-stones and the Urnes carvings are all tied up in the multiple knots of snakes. Those which appear in Irish decoration, whether carved, painted or wrought in metal, are not necessarily servile imitations of Scandinavian motifs, as their heads are quite different from those found on the rune-stones. Thus again both series may simply be affected by a general fashion.

In conclusion this is how the relations between Irish and Scandinavian art during that period can be summed up: in the eleventh century, after the defeat of the Vikings and at the time when the cities of Scandinavian origin were being incorporated into Ireland, there was a great interest in Scandinavian objects amongst Irish craftsmen. They certainly imitated some features of these objects which they thought interesting or which appealed to them because of some fanciful or imaginative twist. This gave

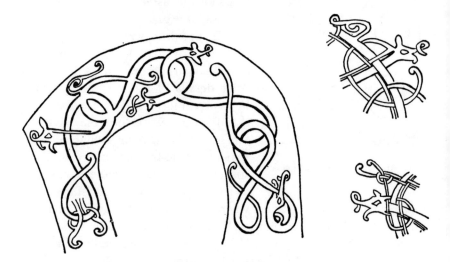

Fig. 37. Crozier of the abbots of Clonmacnois, details.

some of its distinctive flavour to eleventh century Irish art, though other influences, mostly from illumination, combined with this one, and the native tradition remained very much alive. The impetus of that Scandinavian fashion wanes fairly early in the twelfth century, leaving behind only a vague similarity in the general appearance of patterns and a common trend pervading these so closely related arts.

As for English art prior to the Norman invasion, it seems even more remote from Irish art. The Winchester manuscript style has hardly left any traces in Irish art, and when some motifs are found in both arts, it seems to be also by the dictates of a general fashion equally affecting two

neighbouring countries. It is only in the twelfth century that one can notice a strong influx of English Romanesque motifs into Irish art.

What now of Continental Romanesque? We have seen that it is the source of many features of Irish art: the composition of portals, part of their decoration, the attitude of the figures on the Breac Maodhóg and probably the foliage patterns used in the decoration of metalwork and manuscripts. These borrowings are quite understandable, as Continental Romanesque art was arresting enough to provoke imitation, and we have seen the numerous contacts which fostered them.

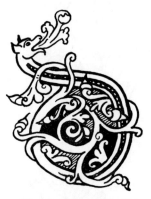

Fig. 38. Capital, Ms. 228, Municipal Library, Le Mans (Sarthe).

However, is this all, or did influences also work the other way round? Many times, when mentioning borrowings from Continental art, it has been necessary to point out the equivocal aspect of the problem caused by the fact that some elements of the model imitated went back to a faraway Insular origin. It is obvious that, through Carolingian art, motifs such as initials with animal terminals, interlacings, compositions of interlocked animals, were handed over to Romanesque illumination.

This happened everywhere, but in a few cases, transmission is especially clear. Let us examine for example the manuscripts decorated in Tours when Alcuin was living there (796–804). We have seen that he had Irish scribes around him,[1] so that we need not be surprised if manuscripts decorated in Tours have canon-tables whose arches are filled with devouring monsters (Fig. 39, *a*). It is known that one of them, Ms. Lat. 260 of the Paris Bibliothèque nationale, was already in the region of Limoges in the tenth century.[2] Others may also have been there, as there were constant contacts between Limousin and Tours. The first great Limoges Bible (Paris, B.N., Ms. Lat. 5), dating from the eleventh century, shows amazing similarities to that style, animals alternating in

[1] *Vol. II*, p. 29. [2] Micheli, *Enluminure*, p. 173.

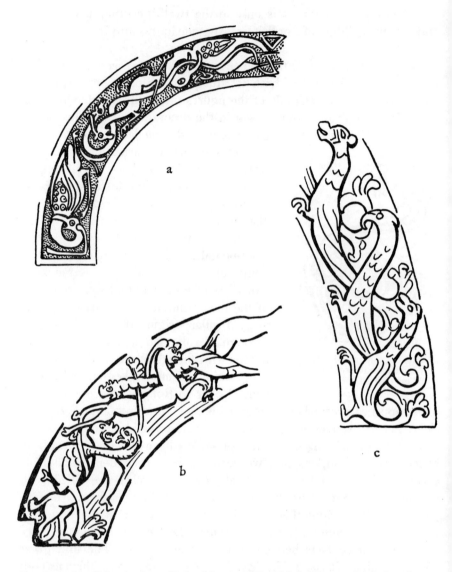

Fig. 39. Arches with animals: *a*, Harley Ms. 2790 (Br. M.) (of Tours origin); *b*, and *c*, voussoirs, portal of Ruffec (Charente).

206

the arches with acanthus leaves, monsters fighting on the pillars sup-
porting them, and inside the outlines of monumental letters.[1]

This Touraine-Limousin element certainly played an important part
in the elaboration of the Romanesque ornament of Poitou and Saintonge.
The Abbey of St Cybard of Angoulême, daughter of St Martial of
Limoges, may have been an active agent of transmission, though
Limousin manuscripts may have spread through that region simply
because of their outstanding quality. The voussoirs of the cathedral of
Angoulême,[2] even more those of Ruffec (Charente) (Fig. 39), show
complex fights of animals organized in the same way as the animal-
interlacings in the borders of Irish manuscripts. At St Pierre-de-Melle
and Aulnay (Fig. 40), there are processions of small quadrupeds which
remind us forcibly of the frieze of monsters in the animal page of the
Book of Durrow.[3] The long drawn-out animals on some of the arches of
Ms. Lat. 260 reappear on an arch at Corme-Royal (Charente maritime)
(Fig. 40). These are only a few examples, but many others could be
quoted. The pillar at Souillac (Lot), some capitals at Carennac (Lot)
would have a claim to be included also. In other regions these motifs
are less common. J. Vallery-Radot has however published a very striking
example from St Martin-d' Ainay in Lyons.[4] The monsters on the jambs
of the portals of San Michele in Pavia (Italy), may, through a series of
manuscripts, have a similar origin.

When one has realized how much Romanesque art was open to sug-
gestions of Irish origin transmitted by manuscripts, one wonders if it
did not in fact borrow more than these obvious patterns. Marie-
Madeleine S. Gauthier has shown convincingly the geometrical frame-
work or the associations of curves on which were built or combined the
figures drawn by the Limoges illuminators.[5] This system has so much in
common with what we have seen in Ireland[6] that it could well have its

[1] J. Porcher, *French Miniatures from Illuminated Manuscripts* (London, 1960),
fig. 25; *L'art roman à St Martial de Limoges*, Pl. IX.

[2] C. Daras, *Angoumois roman* (Zodiaque, 1961). [3] *Vol. I*, Pl. 60.

[4] J. Vallery-Radot, 'La sculpture française du XIIe siècle et les influences irlan-
daises', *Revue de l'art ancien et moderne*, 1924.

[5] *Art roman à St Martial*, pp. 51, 53, Fig. 19–27.

[6] *Vol. I*, Conclusions.

origin there. The method is, in fact, so similar, that it produces nearly identical results in Ireland and on the Continent at about the same date. What could better lend itself to comparisons than the angel on the cumdach of the Stowe Missal accompanied by two animals which form a perfect circle round him (Pl. 28) and the figure between two birds, each inscribed in a perfect circle, of the Tropaire-prosier of St Martial (Paris, B.N., Lat. 1121)?[1] Later, some of Villard de Honnecourt's

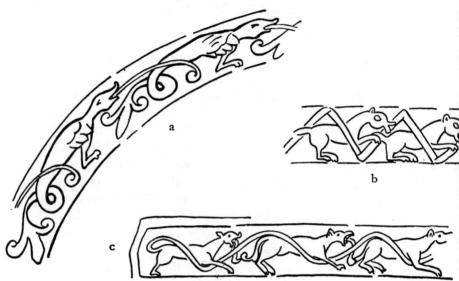

Fig. 40. Friezes of animals: *a*, Corme Royale (Charente-Maritime); *b*, Aulnay-de-Saintonge (Charente Maritime); *c*, Saint-Pierre, Melle (Deux-Sevres).

drawings[2] could be mistaken for construction-patterns for some ornaments in Irish manuscripts. The method which consists in building up compositions on geometrical schemes is indeed universal. However, there is a certain way of bending humans or animals along the main lines of a geometric figure or a combination of curves which belongs most especially to the Irish artists and whose progression can be followed on some of the Irish trial-pieces. And this is precisely the method which is

[1] *Art roman à St Martial,* Fig. 19, p. 51.
[2] J. B. A. Lassus, *Album de Villard de Honnecourt* (Paris, 1858).

applied by Romanesque artists and survives in Villard's sketches.[1] As the manuscripts show clearly what the method of transmission might have been, one has to accept the fact that the Irish masters who came to the Continent did more than teach their pupils the routine of a few combinations of patterns, but taught also to some privileged students the very principles which would enable them to bring to life these fantastic combinations and give them a rhythm. If this be admitted, it means that the Irish teachers played an essential part in the elaboration of the discipline which is the core of the structure of Romanesque carvings.

Fig. 41. Inisfallen crozier, detail of the crook.

In this way they contributed to the elaboration of Romanesque art, whilst, as we have seen, they had little or no part in the formation of its iconography[2] and probably none in its immediate development.

Still, here again, these currents and counter-currents can be very confusing. What for example are we to think of the strange portal of Avy-en-Pons (Charente maritime)? On one of its arches little figures follow each other, all with one knee on the ground; they are in the same position as several of the figures in the wheel-patterns so common in Irish art.[3] In the next arch, the Elders of the Apocalyptic Vision are shown with spiral hair and crossed legs folding over the edge of the voussoir. They also have an obvious Irish flavour. But their nearest parallels are the figures on the Breac Maodhóg, which in their turn seem to have a

[1] Cf. J. Baltrusaitis, *La stylistique ornementale dans la sculpture romane* (Paris, 1931).
[2] Vol. II, Conclusions. [3] *Vol. II*, Fig. 9.

very obvious Romanesque inspiration (Pl. VII). And that same region of Saintonge has arches with horses' heads (Pl. VI) which are most probably the inspiration of the arches with monsters' heads of several Irish doorways.

It may be wiser, finally, not to put too precise construction on these so complex relationships. As in the case of Scandinavian art, there is a kind of shuttle movement and there are echoes sounding in both directions. It is a test of the strangeness of these exchanges that Irish Romanesque portals show very few of the combinations of human figures or of animals which one tends, probably rightly, to attribute to Irish influence when they occur on the Continent.

Bibliographical Abbreviations

A.C. – *Annals of Clonmacnoise, being Annals of Ireland from the earliest period to A.D. 1408. Translated into English A.D. 1627 by Conell Mageoghagan*, ed. D. Murphy, Dublin (*J.R.S.A.I.*), 1896.

A.F.M. – *Annals of the Kingdom of Ireland by the Four Masters, from the earliest period to the year 1616*, ed. John O'Donovan, Dublin, 1851.

A.I. – *The Annals of Inisfallen* (*Ms. Rawlinson B.503*), ed. Seán Mac Airt, Dublin, 1951.

A.L.C. – *The Annals of Loch Cé*, ed. William M. Hennessy, London (R.S.), 1871.

Allen, *Celtic Art* – J. Romilly Allen, *Celtic Art in Pagan and Christian Times*, London, 1904.

An. Boll. – *Analecta Bollandiana*

Ant. J. – *The Antiquaries Journal* (Journal of the Society of Antiquaries of London).

Archdall – Merwyn Archdall, *Monasticon Hibernicum*, Dublin, 1786.

Armstrong, *Catalogue* – E. C. R. Armstrong, 'Catalogue of the Silver and Ecclesiastical Antiquities in the Collection of the Royal Irish Academy' *P.R.I.A.* 1941–6 (C), pp. 287 sqq.

Art roman – *L'art roman*, catalogue exhib., Barcelona, 1961.

Art roman à St Martial – *L'Art roman à Saint-Martial de Limoges*, catalogue de l'exposition, Limoges, 1950.

A.Tig. – 'Annals of Tigernach', ed. Whitley Stokes, *R.C.*, 1895, pp. 175 sqq.; 1896, pp. 6 sqq., 118 sqq., 336 sqq.

A.U. – *Annals of Ulster, otherwise Annals of Senat, A Chronicle of Irish Affairs from A.D. 431 to A.D. 1540*, ed. William M. Hennessey, Dublin, 1887.

Aubert, *Arch. cisterc.* – Marcel Aubert, *L'architecture cistercienne en France*, avec la collaboration de la Marquise de Maillé, Paris, 1947.

Brash – R. R. Brash, *The Ecclesiastical Architecture of Ireland to the close of the Twelfth Century*, Dublin, 1875.

Brøndsted – J. Brøndsted, *Early English Ornament*, London–Copenhagen, 1924.

C.A.A.I. – *Christian Art in Ancient Ireland*, Dublin, vol. I, ed. by Adolf Mahr, 1932, vol. II, ed. by Joseph Raftery, 1941.

Carrigan, *Ossory* – William Carrigan, *TheHistory and Antiquities of the Diocese of Ossory*, Dublin, 1905.

Champneys – Arthur Charles Champneys, *Irish Ecclesiastical Architecture, with some notice of similar or related Work in England, Scotland and elsewhere*, London, 1910.

Chr. Sc. – *Chronicum Scottorum, A Chronicle of Irish Affairs from the earliest Times to A.D. 1135, with a Supplement containing the Events from 1141 to 1150*, ed. William M. Hennessey, London (R.S.), 1866.

Cochrane, *Glendalough* – R. Cochrane, *Glendalough, Co. Wicklow* (Extr. from the 80th Report of the Commissioners of Public Works in Ireland), Dublin, 1911-12.

Cochrane, *Guide Islands and Coast* – R. Cochrane, *Programme of Excursion and illustrated descriptive Guide to the places to be visited in the northern, western and southern Islands, and Coast of Ireland, June 21st to 29th, 1904*, Dublin (*J.R.S.A.I.*), 1904.

Coffey, *Guide* – George Coffey, *Guide to the Celtic Antiquities of the Christian period preserved in the National Museum, Dublin*, Dublin, 1909, 1910 (this last edition is the one quoted).

Conant, *Carolingian and Romanesque A.* – Kenneth J. Conant, *Carolingian and Romanesque Architecture, 800 to 1200*, Pelican History of Art, Harmondsworth, 1959.

Course of Irish History – *The Course of Irish History*, ed. by T. W. Moody and F. X. Martin, O.S.A., Cork, 1967.

Crawford, *List* – H. S. Crawford, 'A descriptive List of Irish Shrines and Reliquaries', *J.R.S.A.I.*, 1923, pp. 74 sqq.

D.A.I. – So-called *Dublin Annals of Inisfallen*, eighteenth-century compilation in T.C.D. Ms. H.I.7; excerpts in Charles O'Conor, *Rerum Hibernicarum Scriptores Veteres*, London, 1814, II, pp. 1 sqq.

Dugdale, *Mon. Angl.* – R. Dodsworth – G. Dugdale, *Monasticum*

Anglicanum, London, 1655, 1661 (this last edition is the one quoted).

Dunraven – The Earl of Dunraven, *Notes on Irish Architecture* (ed. by Margaret Stokes), 2 vols., London, 1875, 1877.

G.B.A. – *Gazette des Beaux Arts*

Gleeson – See: Gwynn-Gleeson.

Gwynn, *The First Bishops of Dublin* – Aubrey Gwynn, S.J., 'The First Bishops of Dublin', *Repertorium Novum*, 1955, pp. 1 sqq.

Gwynn-Gleeson, *Killaloe* – *A History of the Diocese of Killaloe, The Early Period*, by Rev. Aubrey Gwynn, S.J.; *The Middle Ages*, by Dermot F. Gleeson, Dublin, 1963.

Henry, *Irish High Crosses* – F. Henry, *Irish High Crosses*, Dublin, 1964.

Henry, *Sc. irl.* – F. Henry, *La sculpture irlandaise pendant les douze premiers siècles de l'ère chrétienne*, Paris, 1932.

Henry – Marsh-Micheli, *Illumination* – F. Henry – G. L. Marsh-Micheli, 'A Century of Irish Illumination (1070–1170)', *P.R.I.A.*, 1932 (C), pp. 101 sqq.

Henry – Zarnecki – F. Henry – G. Zarnecki, 'Romanesque Arches decorated with Human and Animal Heads', *Journal of the British Archaeological Association*, 1957–8, pp. 1 sqq.

Hildburgh, *Spanish enamels* – W. L. Hildburgh, *Medieval Spanish Enamels*, Oxford. U.P., 1936.

I.E.R. – *Irish Ecclesiastical Record.*

I.H.S. – *Irish Historical Studies.*

Illumination – See: Henry – Marsh-Micheli.

J. Cork H.A.S. – *Journal of the Cork Historical and Archaeological Society.*

J.Galway H.A.S. – *Journal of the Galway Historical and Archaeological Society.*

J.R.S.A.I. – *Journal of the Royal Society of Antiquaries of Ireland.*

Kendrick, *Late Saxon* – T. D. Kendrick, *Late Saxon and Viking Art*, London, 1949.

Kendrick – Senior – T. D. Kendrick – E. Senior, 'St Manchan's Shrine', *Archaeologia*, 1937, pp. 105 sqq.

Kenney, *Sources* – James F. Kenney, *The Sources of the Early History of Ireland An Introduction and Guide*, vol. I: *Ecclesiastical* (the only volume published), New York, 1929.

Lawlor, *Ricemarch* – H. J. Lawlor, *The Psalter and Martyrology of Rice-march*, London, 1914.

Lawlor, *Vit. Mal.* – H. J. Lawlor, *St Bernard of Clairvaux's Life of St Malachy of Armagh*, London, 1920.

Leask, *Glendalough* – H. G. Leask, *Glendalough, Co. Wicklow*, Dublin, n.d.

Leask, *Ir. Churches* – Harold G. Leask, *Irish Churches and Monastic Buildings*, I: *The First Phase and the Romanesque Period*, Dundalk, 1955; II: *Gothic Architecture to A.D. 1400*, Dundalk, 1958.

Lionard, *Grave-Slabs* – Pádraig Lionard, C.S.Sp., 'Early Irish Grave-Slabs', *P.R.I.A.*, 1961(C), pp. 95 sqq.

Macalister, *Arch. Ireland* – R. A. S. Macalister, *The Archaeology of Ireland*, 1st ed., London, 1928.

Macalister, *Corpus* – R. A. S. Macalister, *Corpus Inscriptionum Insularum Celticarum*, 2 vols., Dublin, 1945, 1949.

Mahr – See: *C.A.A.I.*

M.C. – *Miscellaneous Irish Annals* (*A.D. 1114–1437*), ed. Séamus O'hInnse, Dublin, 1947, *Fragment I* (*Mac Carthaigh's Book – 1114–1137*), pp. 2 sqq.

Micheli, *Enluminure* – G. L. Micheli, *L'enluminure du Haut Moyen Age et les influences irlandaises*, Brussels, 1939.

Micheli – See: Marsh-Micheli

Medieval Studies A. Gwynn – *Medieval Studies presented to Aubrey Gwynn, S. J.*, ed. by J. A. Watt, J. B. Morrall, F. X. Martin, O.S.A., Dublin, 1961.

North Munster A. J., or: *N.M.A.J.*, – *North Munster Archaeological Journal*.

Onomasticon – E. I. Hogan, *Onomasticon Goedelicum locorum et tribuum Hiberniae et Scotiae*, Dublin, 1910.

Osebergfundet – A. W. Brögger, Hj. Falk, Haakon Shetelig, *Oseberg-fundet*, Christiania, 1917.

L. de Paor, *Crosses of Clare and Aran* – Liam de Paor, 'The Limestone Crosses of Clare and Aran', *J. Galway H. A. S.*, 1955–6, pp. 53 sqq.

Paor, *E. Chr. Ireland* – Máire and Liam de Paor, *Early Christian Ireland*, London, 1958.

Petrie, *Chr. Inscr.* – George Petrie, *Christian Inscriptions in the Irish Language* (ed. by Margaret Stokes), 2 vols., Dublin, 1972, 1878.

Petrie, *Round Towers* – G. Petrie, *The Ecclesiastical Architecture of Ireland anterior to the Norman Invasion, comprising an Essay on the Origin and Uses of the Round Towers of Ireland*, Dublin, 1845.

Plummer, *St Laurent* – Charles Plummer, 'Vie et Miracles de St Laurent, archevêque de Dublin', *An. Boll.*, 1914, pp. 121 sqq.

Plummer, *VV.SS.Hib.* – C. Plummer, *Vitae Sanctorum Hiberniae*, Oxford, 1910.

Porter, *Crosses and Culture* – Arthur Kingsley Porter, *The Crosses and Culture of Ireland*, New Haven, 1951.

Porter, *Lombard Architecture* – A. K. Porter, *Lombard Architecture*, New Haven, 1917.

P.R.I.A. – *Proceedings of the Royal Irish Academy.*

Raftery – See: *C.A.A.I.*

R.C. – *Revue celtique.*

R.S. – Rolls Series.

Salin, *C.M.* – Edouard Salin, *La civilisation mérovingienne d'après les sépultures, les textes et le laboratoire*, Paris, 4 vols., 1950–9.

Sexton, *Fig. Sc.* – E. H. L. Sexton, *Irish Figure Sculpture of the Early Christian Period*, Portland (Maine), 1946.

Smith, *Guide Anglo-Saxon A.* – Reginald Smith, *British Museum Guide to Anglo-Saxon Antiquities*, London, 1923.

M. Stokes, *Early Christian Arch.* – Margaret Stokes, *Early Christian Architecture in Ireland*, London, 1878.

M. Stokes, *E. Chr. Art.* – M. Stokes, *Early Christian Art in Ireland*, London, 1887, Dublin, 1911, 1928 (this last edition is the one quoted).

T.R.I.A. – *Transactions of the Royal Irish Academy.*

Thoby, *Crucifix* – Paul Thoby, *Le crucifix des origines au Concile de Trente*, Nantes, 1959.

U.J.A. – *Ulster Journal of Archaeology.*

V. Ant. – *Viking Antiquities in Great Britain and Ireland*, Oslo, 1940, vol. III, J. Bøe, *Norse Antiquities in Ireland*.

Vit. Mal. – See: Lawlor.

Vol. I – First volume of *Irish Art* (London, 1965).

Vol. II – Second volume of *Irish Art* (London, 1967).

War – *Cogadh Gaedhel re Gallaibh, The War of the Gaedhil with the Gaill, or the Invasion of Ireland by the Danes and other Norsemen*, ed. J. H. Todd, London (R.S.), 1867.

Westwood, *Facsimiles* – J. O. Westwood, *Facsimiles of the Miniatures and Ornaments of Anglo-Saxon and Irish Manuscripts*, London, 1866–8.

Wilde, *Lough Corrib* – Sir William Wilde, *Lough Corrib, its Shores and Islands, with Notices of Lough Mask*, Dublin, 1867; re-published: *Wilde's Loch Coirib, its Shores and Islands, with Notices of Loch Measga*, ed. by Colm O Lochlainn, Dublin, 1936 (this edition is the one quoted).

Zarnecki – See: Henry – Zarnecki.

Zimmerman – E. Heinrich Zimmerman, *Vorkarolingische Miniaturen* (1 vol text, 4 vols. plates), Berlin, 1916).

General Index

Figures in brackets refer to footnotes (pages).
Figures in square brackets refer to relevant
pages where the word is not mentioned.
Figures in italics refer to line illustrations (pages)

217

List of Monochrome Plates

All monochrome photographs without indication of origin are by Belzeaux-Zodiaque. The others are from the photographic Archives of the Department of Archaeology, University College, Dublin, and for these the origin of each negative has been indicated.

1. Corpus Missal (B.L.), with its satchel
2. *Liber Hymnorum* (T.C.D.), initial
3. *Liber Hymnorum* (T.C.D.), initial
4. Corpus Missal (B.L.), initial
5. Corpus Missal (B.L.), initial
6. Harley Ms 1023 (Br.M.), beginning of St John's Gospel
7. Harley Ms 1023 (Br.M.), symbol of St Mark
8. Rawlinson Ms. B. 502 (B.L.), initial
9. Palat. Ms. 830 (V.L.), initials (*Ph.V.L.*)
10. Harley Ms. 1802 (Br.M.), Chi-Rho
11. Corpus Gospels (B.L.), Chi-Rho
12. Rawlinson Ms. B.502 (B.L.), Psalter of Cormac (Br.M.): drawings in the text
13. Book of Leinster (T.C.D.), drawing in text
14. Psalter of Cormac (Br.M.), initial
15. Psalter of Cormac (Br.M.), initial
16. Book of Leinster (T.C.D.), plan of banqueting hall at Tara
17. British Museum crozier (Br.M.), upper knop
18. Glankeen bell-shrine (Br.M.)
19. Tau Crozier (N.M.D.)
20. Clonmacnois crozier (N.M.D.), crook; Inisfallen crozier (N.M.D.), foot (*Ph. F. Henry*)
21. Inisfallen crozier (N.M.D.), crook

54. Cross at Kilfenora (Clare), detail
55. Cross in graveyard of Kilfenora (Clare), detail
56. Cross in graveyard of Kilfenora (Clare), details
57. Cross in graveyard of Kilfenora (Clare), detail
58. Cross at Roscrea (Tipperary), detail
59. Cross at Roscrea (Tipperary)
60. Cross at Dysert O'Dea (Clare)
61. Cross at Cashel (Tipperary); cross at Drumcliff (Sligo), detail (*Ph.F.Henry*)
62. Cross at Cashel (Tipperary), reverse
63. Cross on Market Place, Tuam (Galway), detail
64. Cross on Market place, Tuam (Galway), base
65. Roscrea (Tipperary), façade of church
66. Clonmacnois (Offaly), Temple Finghin, choir and tower
67. Glendalough (Wicklow), St Kevin's kitchen and round tower
68. Clonfert (Galway), detail of doorway
69. Kilfenora (Clare), detail of cross
70. Rahan (Offaly), capital; Inis Cealtra (Clare), chancel arch of St Caimin's church
71. Rahan (Offaly), pier of chancel arch
72. Clonkeen (Limerick), portal (*Ph.F.Henry*); Dysert O'Dea (Clare), detail of portal
73. Dysert O'Dea (Clare), portal
74. Cross of Cong (N.M.D.), detail; Killeshin (Leix), detail of portal; Dysert O'Dea (Clare), voussoir of portal (*Ph.F.Henry*)
75. Dysert O'Dea (Clare), voussoir of portal
76. Clonmacnois (Offaly), Nuns' church, detail of portal
77. Clonmacnois (Offaly), Nuns' church, general view; chancel arch
78. Clonmacnois (Offaly), Nuns' church, detail of chancel arch
79. Clonmacnois (Offaly), funerary slab
80. Clonfert (Galway), portal
81. Clonfert (Galway), detail of portal
82. Clonfert (Galway), details of portal
83. Clonfert (Galway), detail of portal
84. Freshford (Kilkenny), detail of portal

85. Ivory crozier from Aghadoe (Stockholm Museum) (*Ph.St.M.*)
86. Tuam (Galway), detail of chancel arch
87. Tuam (Galway), detail of chancel arch
88. Tuam (Galway), detail of chancel arch
89. Lemanaghan shrine (Boher church, Offaly), detail; Cashel (Tipperary), sarcophagus
90. Killeshin (Leix), detail of doorway
91. Killeshin (Leix), doorway
92. Killeshin (Leix), details of doorway
93. Kilteel (Kildare), chancel arch, capital
94. Kilteel (Kildare), details of chancel arch (*Ph.F.Henry*)
95. Kilteel (Kildare), details of chancel arch (*Ph.F.Henry*)
96. Cashel (Tipperary), detail of the portal of Cormac's Chapel
97. Roscrea (Tipperary), detail of portal
98. Cashel (Tipperary), Cormac's Chapel
99. Cashel (Tipperary), Cormac's Chapel
100. Cashel (Tipperary), loft in Cormac's Chapel
101. Cashel (Tipperary), Cormac's Chapel, vault of choir
102. Cashel (Tipperary), Cormac's Chapel, doorway
103. Cashel (Tipperary), Cormac's Chapel, tympanum of doorway
104. Cashel (Tipperary), Cormac's Chapel, detail of chancel arch; capital
105. Cashel (Tipperary), Cormac's Chapel, choir and chancel arch
106. Cashel (Tipperary), Cormac's Chapel, vault of nave
107. Kilmalkedar (Kerry), choir of church
108. Glendalough (Wicklow), St Saviour's Priory, pier of chancel arch
109. Glendalough (Wicklow), St Saviour's Priory, choir; detail of base of column
110. Clonmacnois (Offaly), cathedral, portal; Mellifont (Louth), cloisters (*Ph.F.Henry*)
111. Mellifont (Louth), cloisters, capital (*Ph.F.Henry*); Jerpoint (Kilkenny), capital
112. Boyle (Roscommon), nave of church (*Ph.F.Henry*)

Documentary Plates

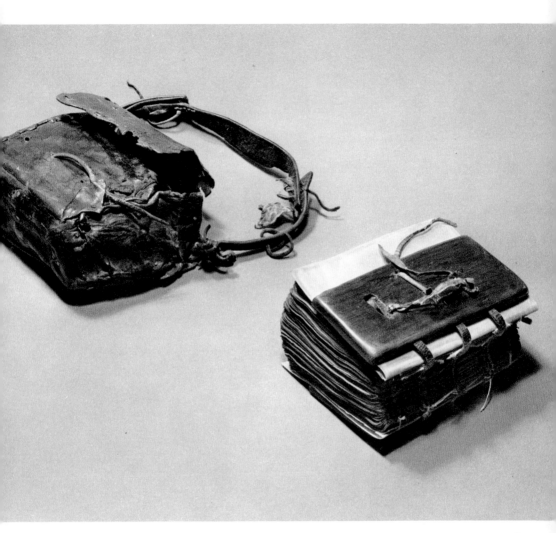

Onsit pnonc
facnmr nr
caqonsn rcn
ahr am; momn oie. Cuchr
meiec ostizra.pao amu
oiponoco annonoch bf
comm oonschrzuo nsm
nr lo cmman; oe.
chmllecha. Cuchr
allsm nsle cna
iexchens; m p
onccm;
oclaman
bis pcho
nuor vulse
anicoetn
oportman

ecclesiam dñi. i.oplu

cuic ad fina. zuz

ponaz anc aib a

none annts

naxeall atcu

éauu agen u

chouison crap

ol rrron

Cuord

ploñsam

it.ron

nume m

it se doylin

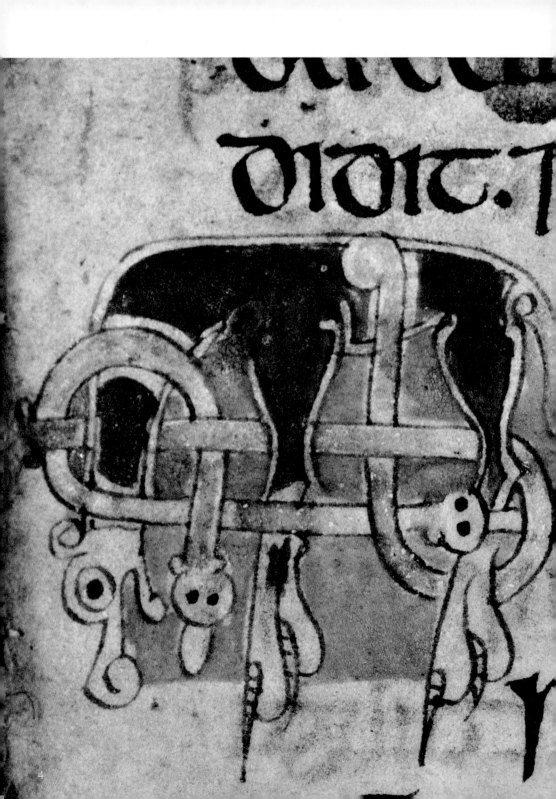

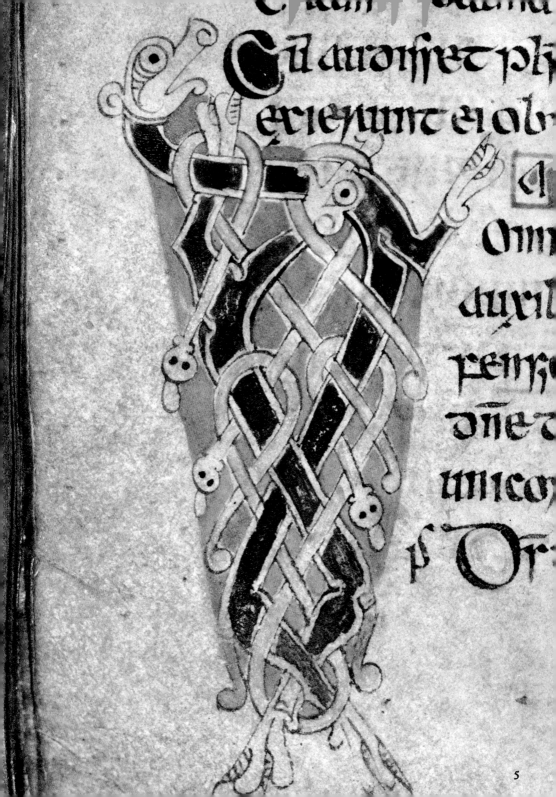

cu audisset ph[

exierunt ei ob[

omni

auxil

petr[

dñe t[

unico[

p Or[

eh umgin debebat. eyu tu uel repton inchispo
ne offpofgo b libuoz oponne nago 1olo pzigu
lly ano b non expont. yt reshidi d'chohuo collo
exto 7qushbtibz pmieti laboup. 7do magrdi
doctruia rhuanetun.. pmit angutuell iohannut.;

iohes

nchcur · isti

uccdomu m

dm combiam

.i. sd

ubne

i. voletch

duilch

bomon

macab

.i. bab

aibuslia

ita 7 bathsē

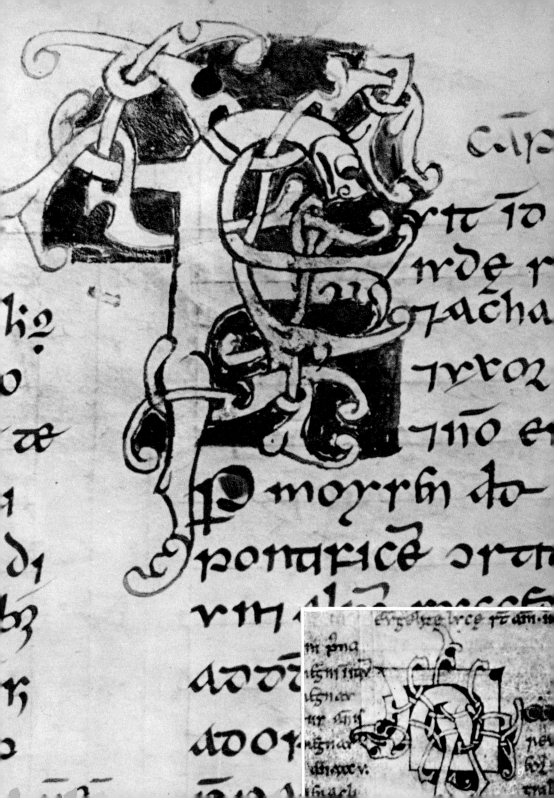

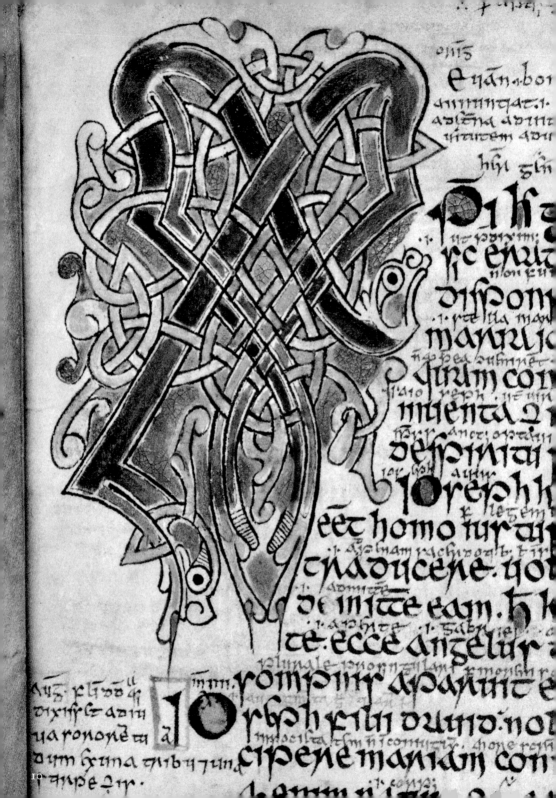

ħ: genuit ioseph uir

omner q̃ gfihiat
ouno generat
urẹ aomatyu
nepucquoner ri
bu biloniy uř aox

Ƿ auu
eyric cu
ma ioyep
q̃ muten
um ꝺ cui
ꞇiaoucene uoluiꞇ
eo cogiꞇanꞇe· ecce a
ꞇ ei ꝺiciꞇuꞃ: Ioyep
mariam coniugfii

Runid c coun̄
f alid c ordna
Sand c coffed
epp̄t c cor ogain
Thgete c cocypet
Caid etc̄eoltachur
Socnaid c ṡona
Docnaid con̄danet
Milr̄ caldccaurgd
Milr̄ censol
ceol indomet.
Milr̄ cotacoua
acfudeoz

campindtul unhad mrin

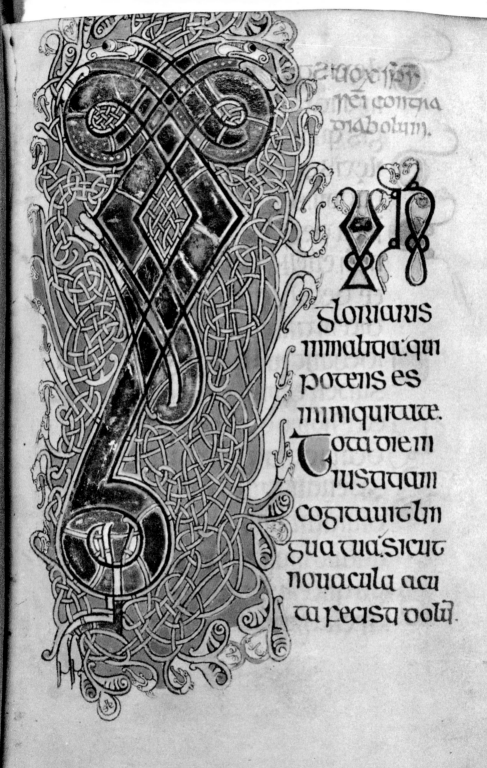

...tortuus
p̄i contra
diabolum.

Q

gloriaris
inmalitia qui
potens es
ininiquitate.
Tota diem
iustitiam
cogitauit lin
gua tua. sicut
nouacula acu
ta fecista dolū.

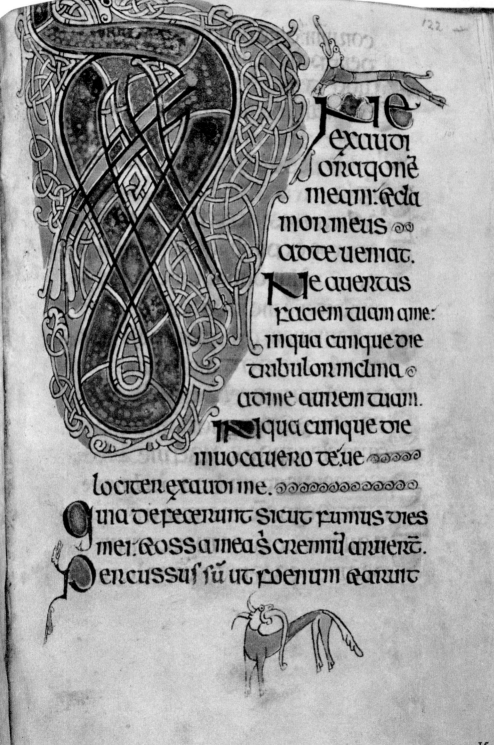

Ne
exaudi
oraqoné
meam. & cla
mor meus
ad te ueniat.
Ne auertus
faciem tuam a me:
in qua cunque die
tribulor inclina
ad me aurem tuam.
In qua cunque die
inuocauero de ue
lociter exaudi me.
Quia defecerunt sicut fumus dies
mei. & ossa mea s cremiñ aruerūt.
Percussus sū ut foenum & aruit

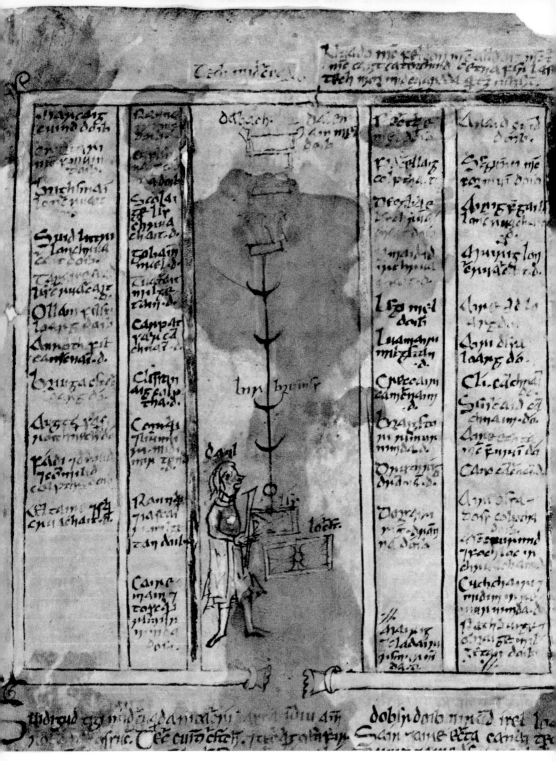

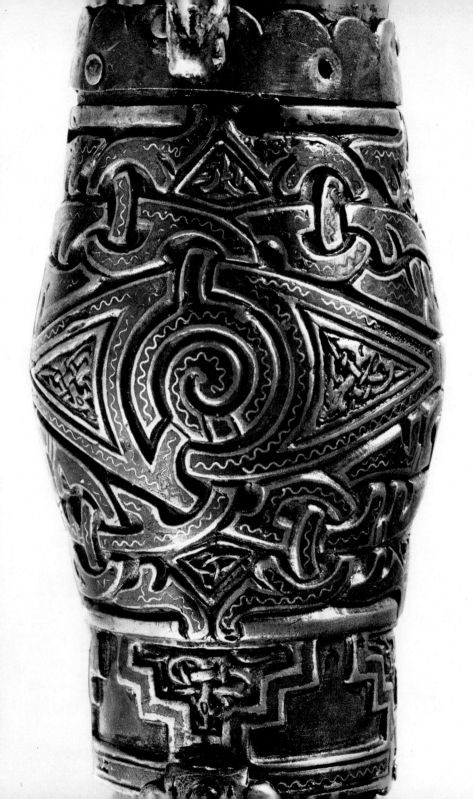

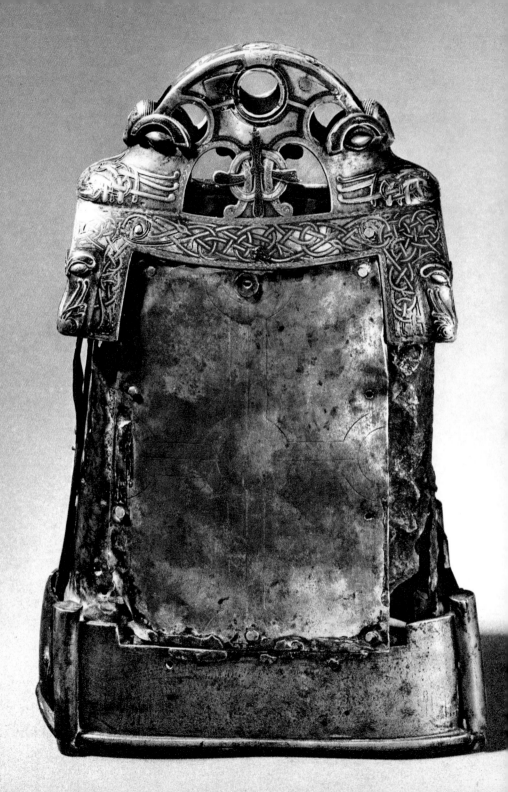

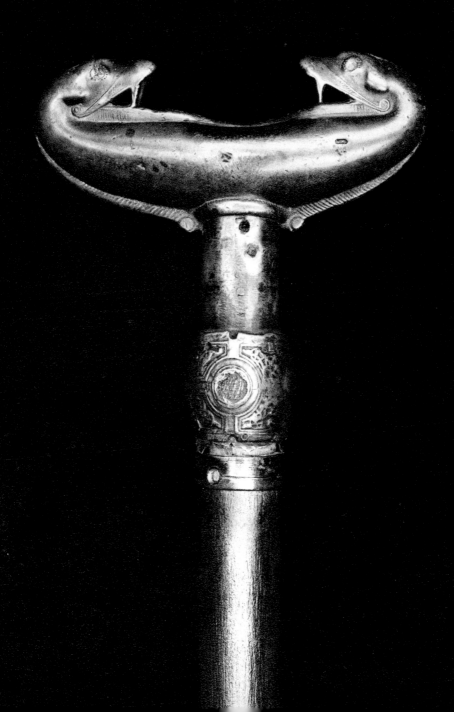

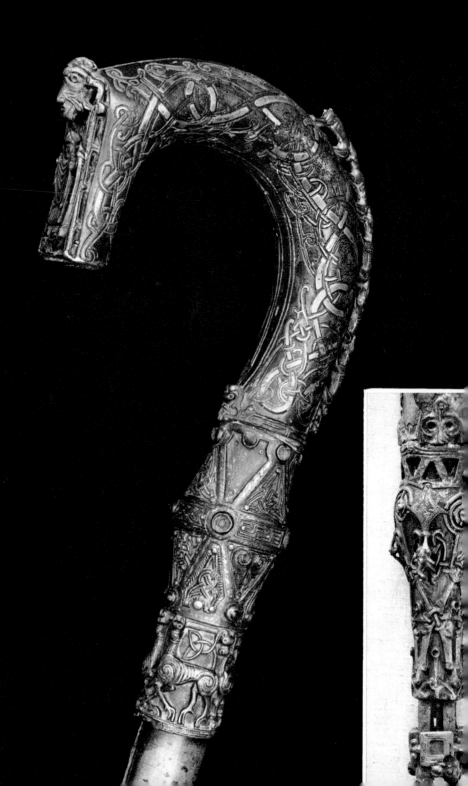

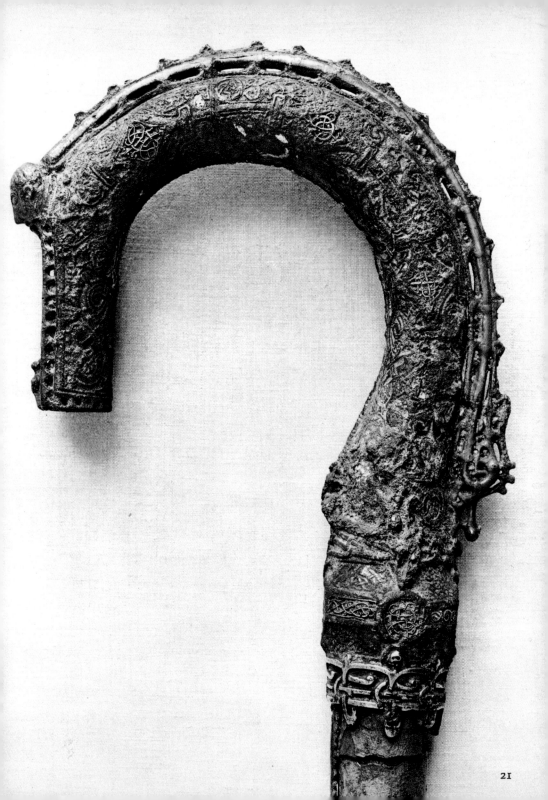

21

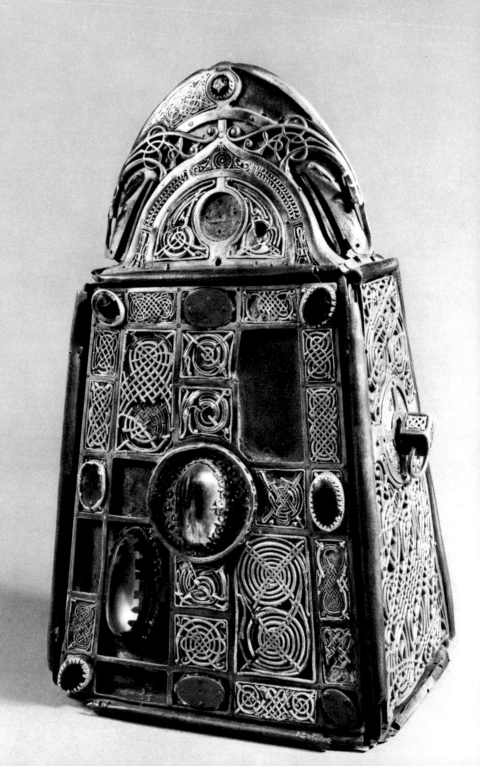

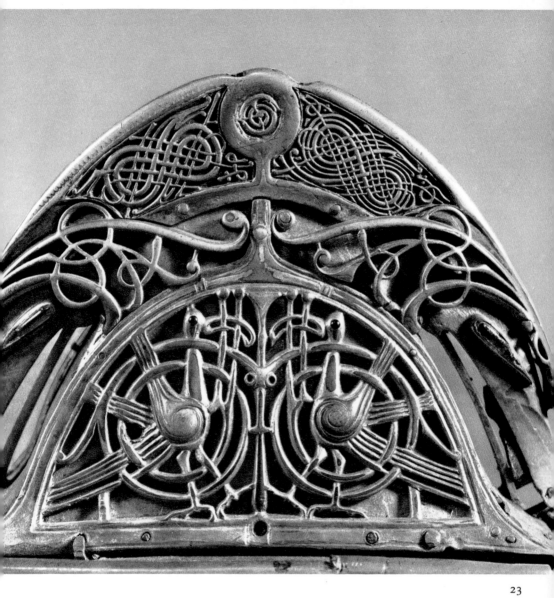

23

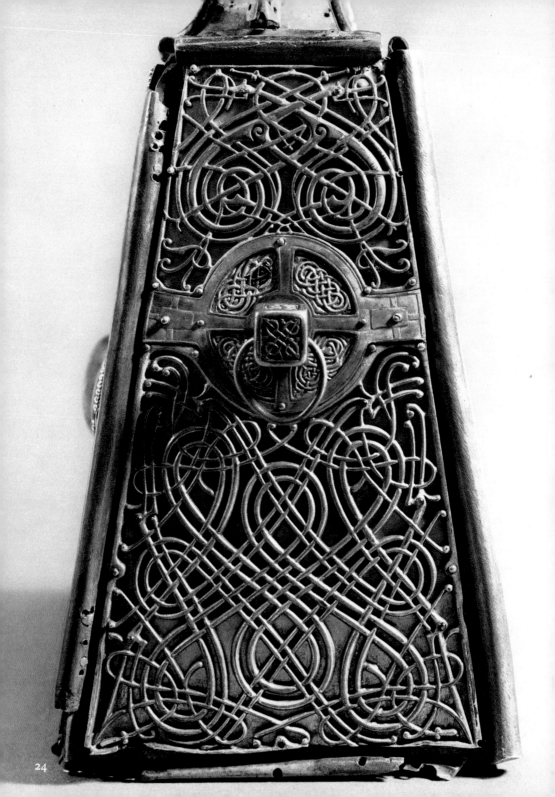

24

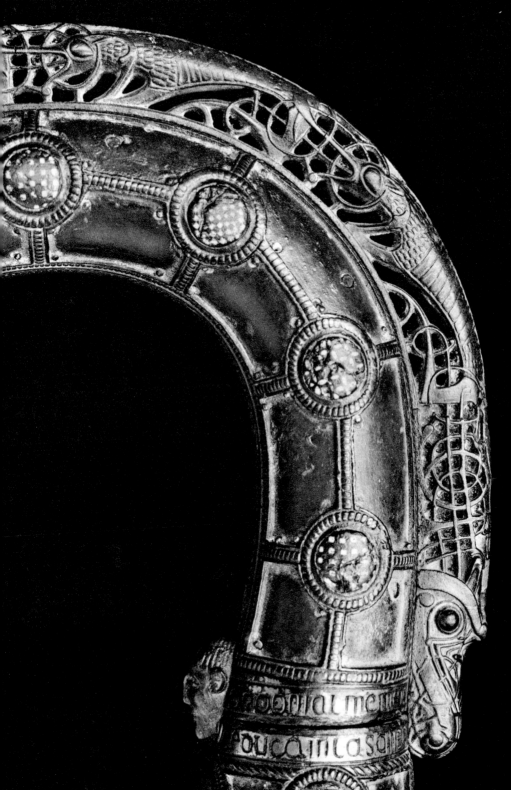

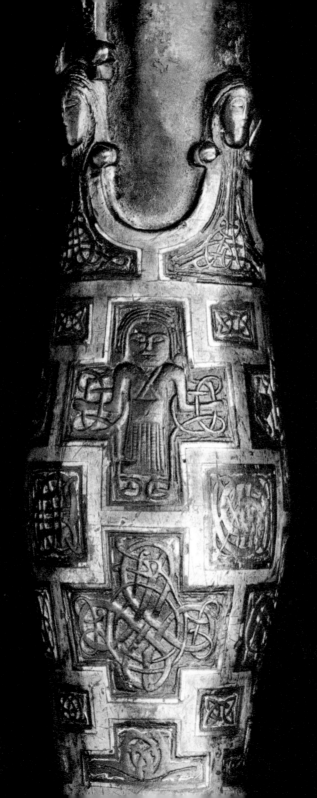

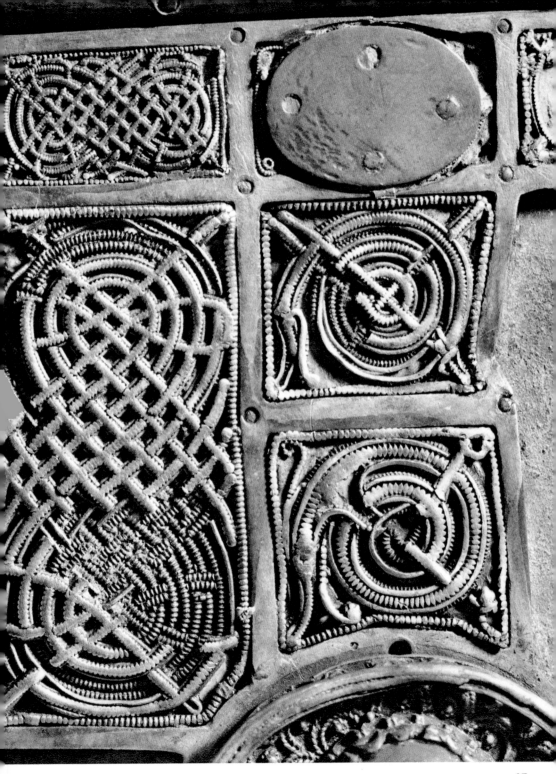

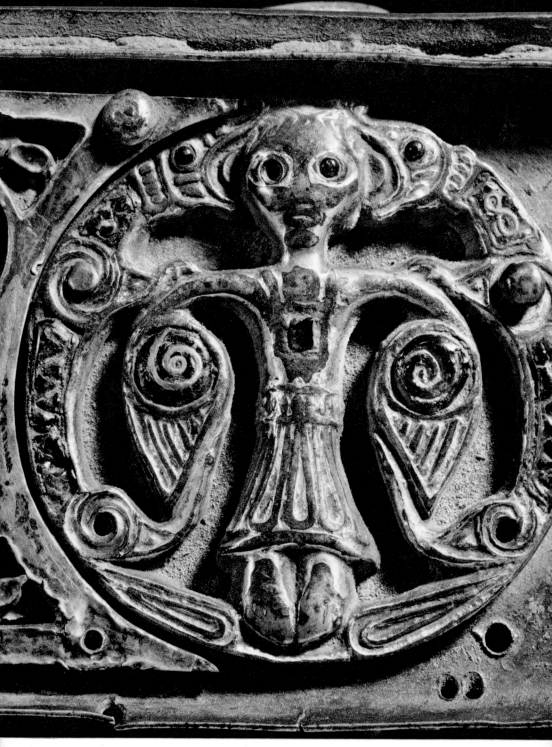

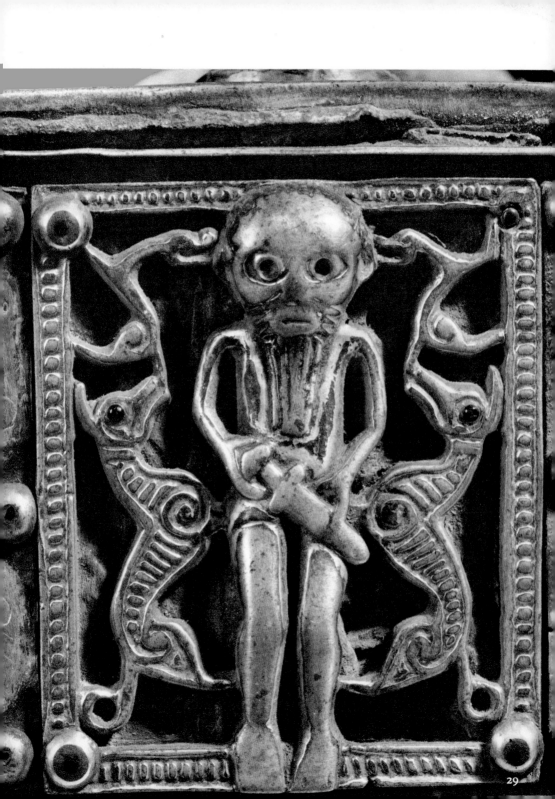

29

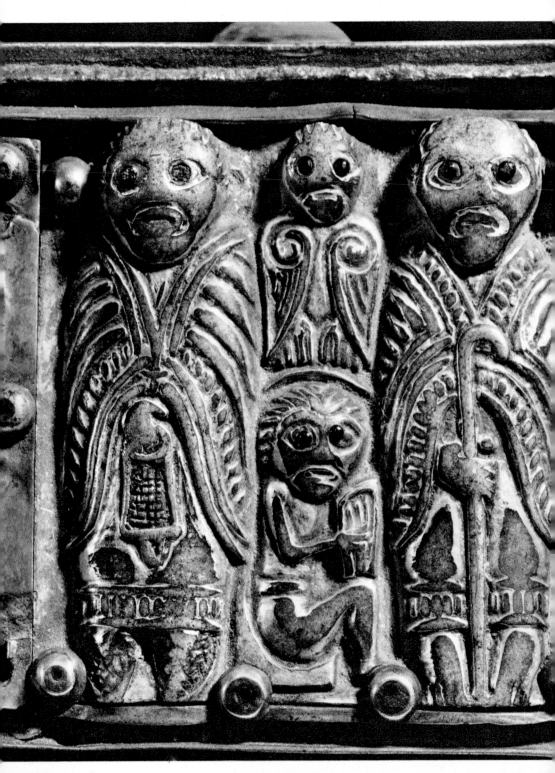

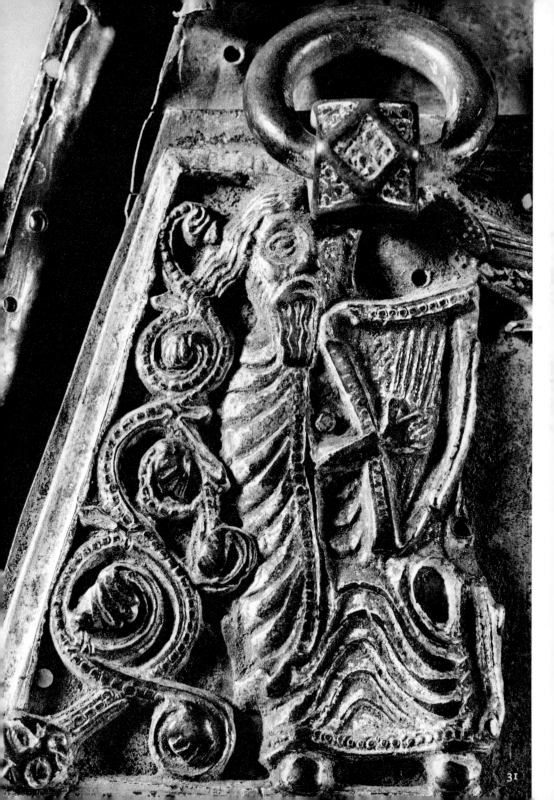

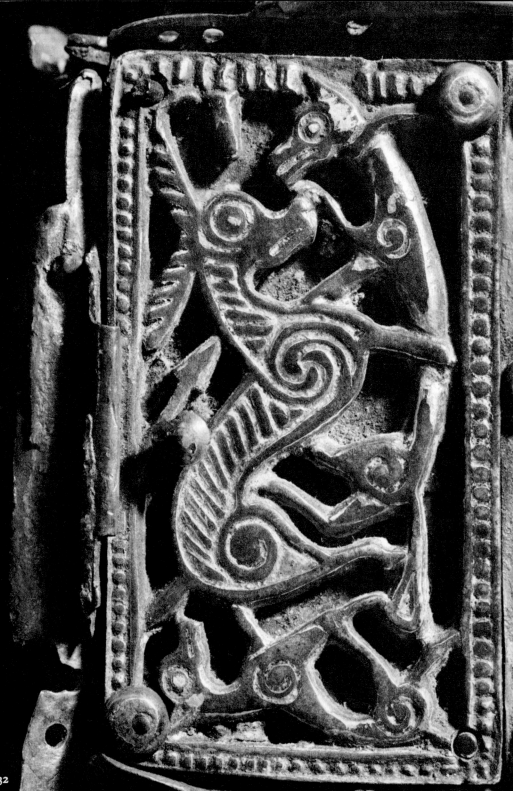

32

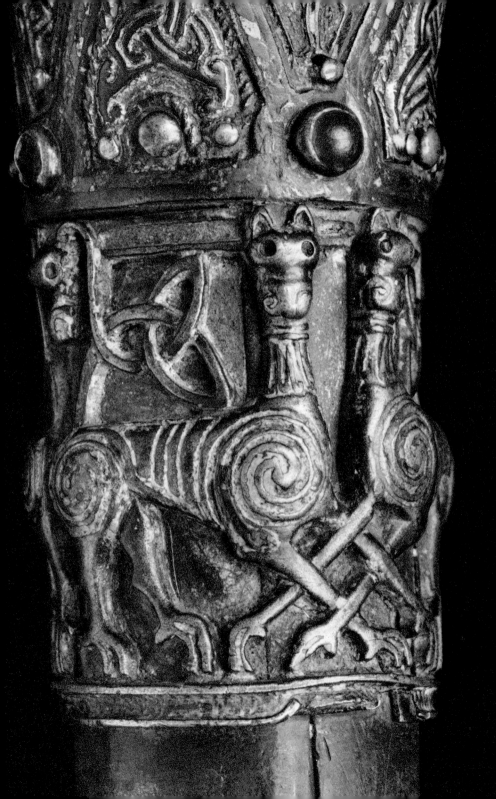

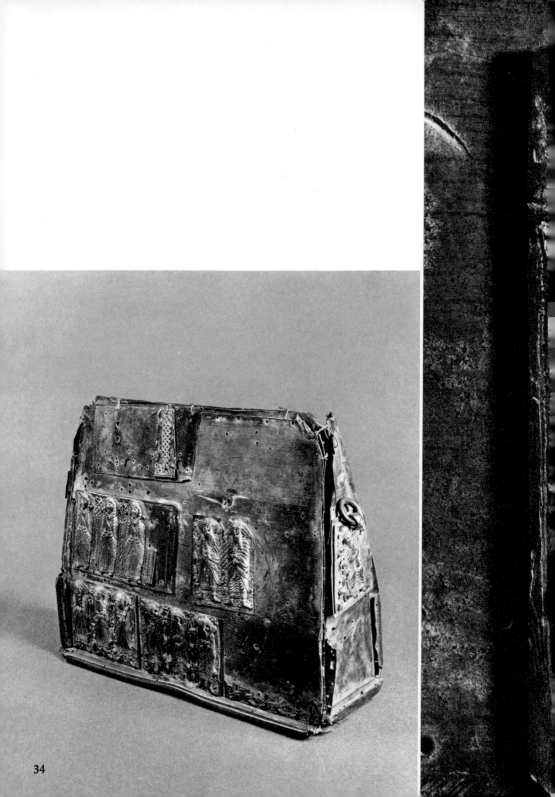

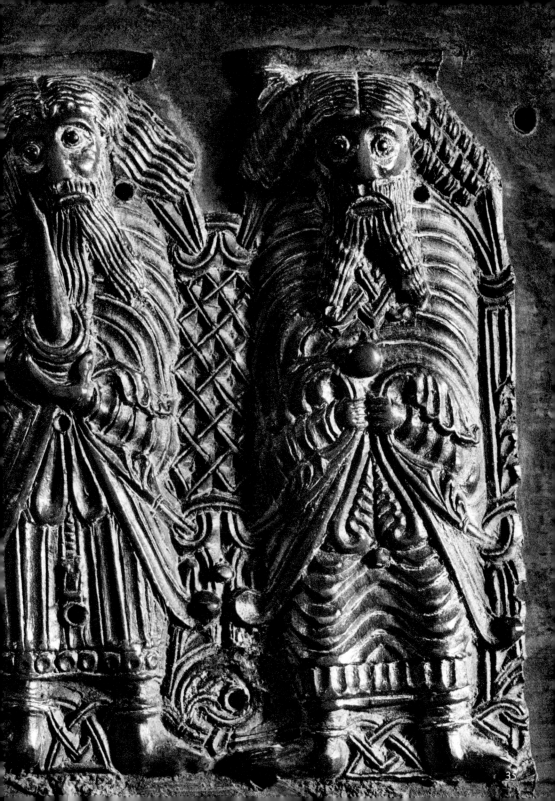

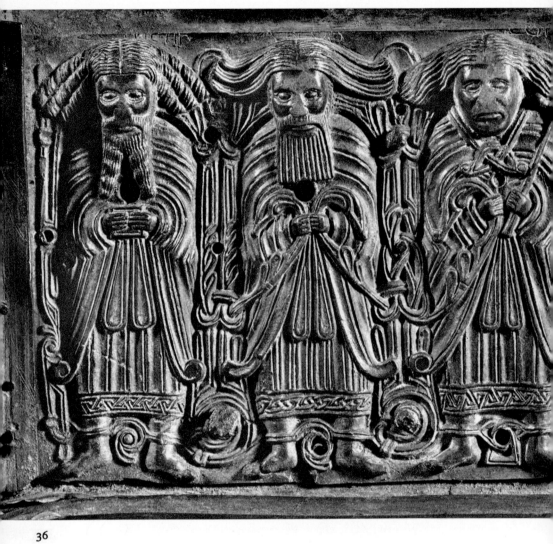

36

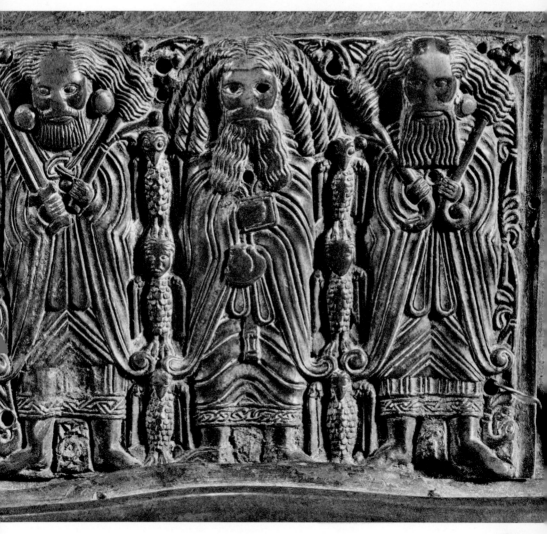

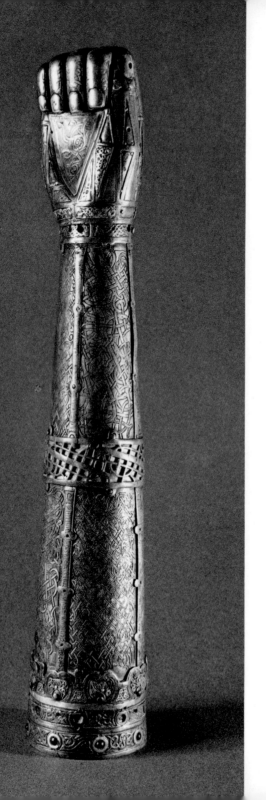

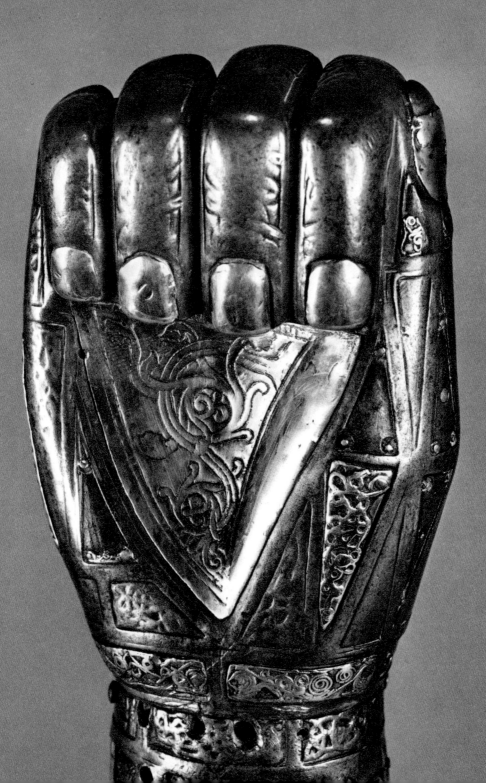

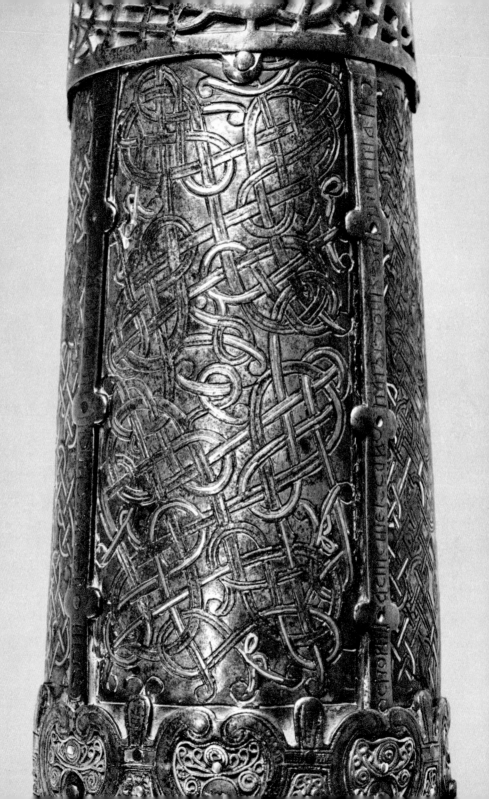

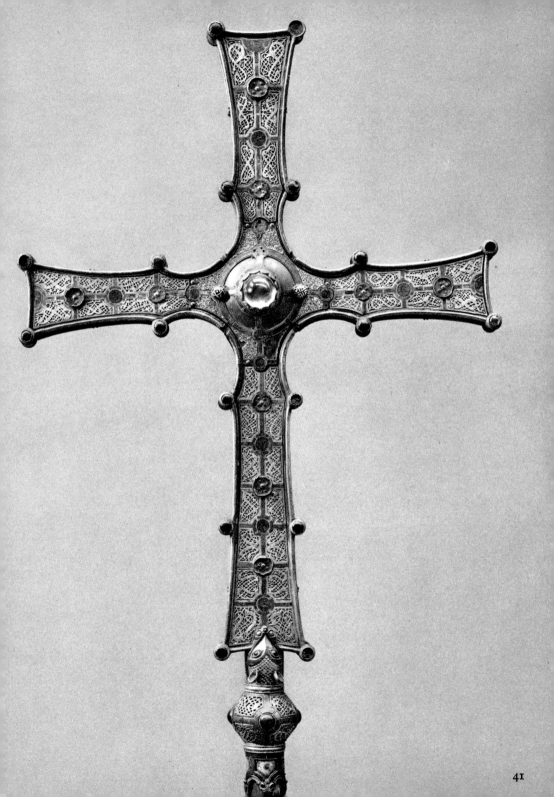

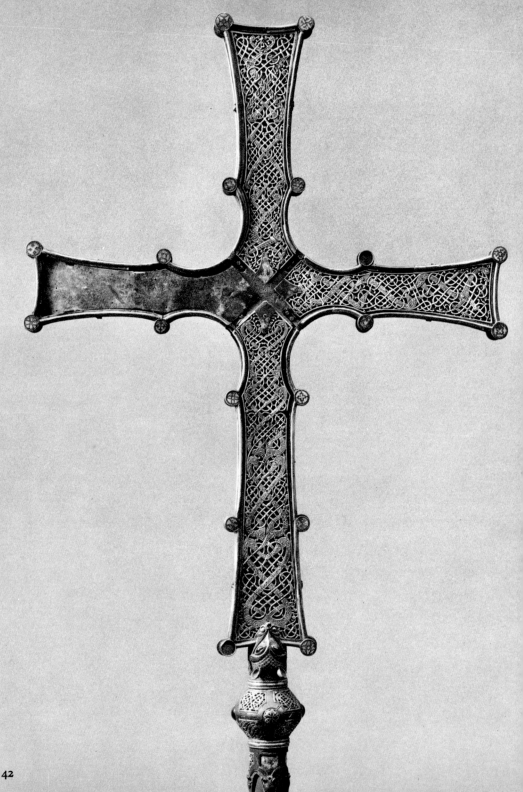

42

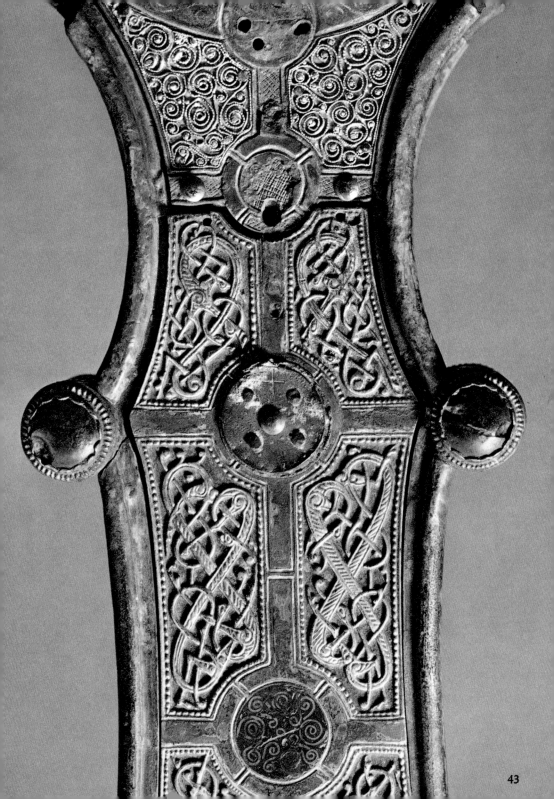

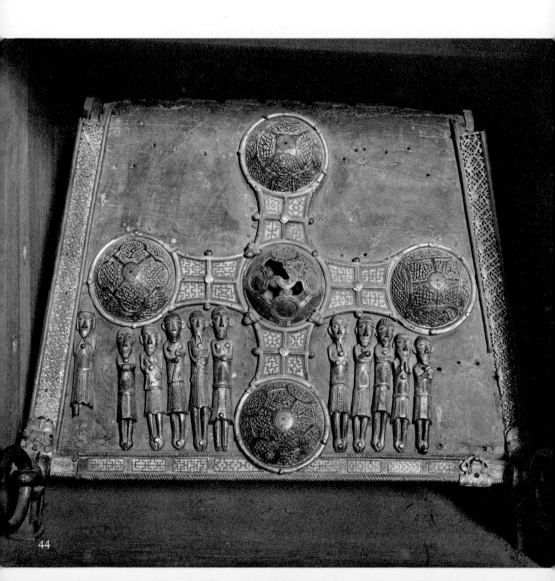

44

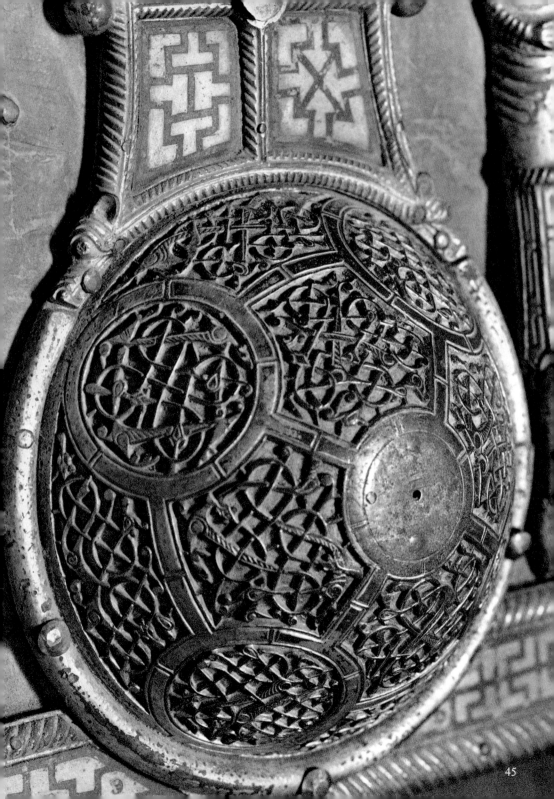

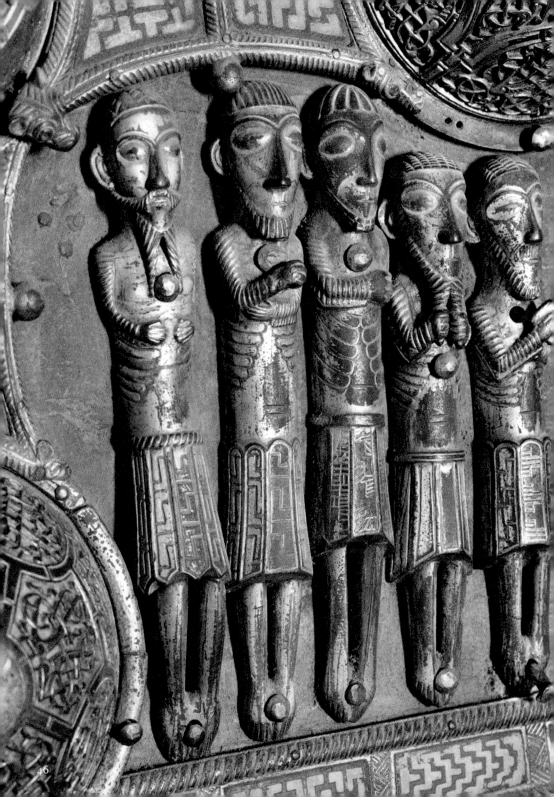

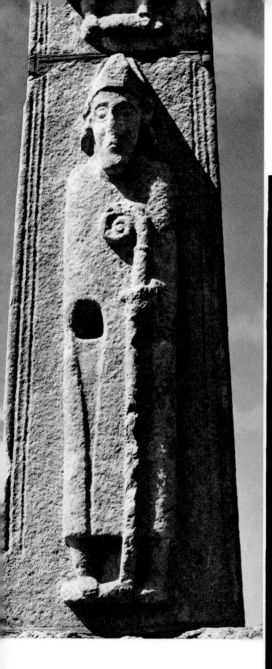

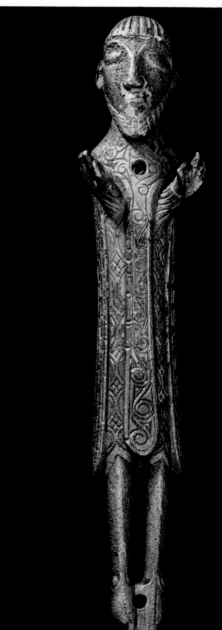

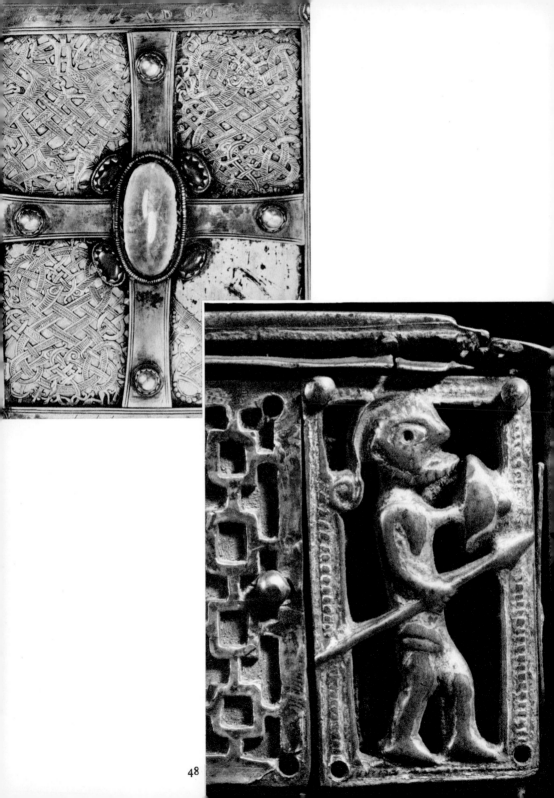

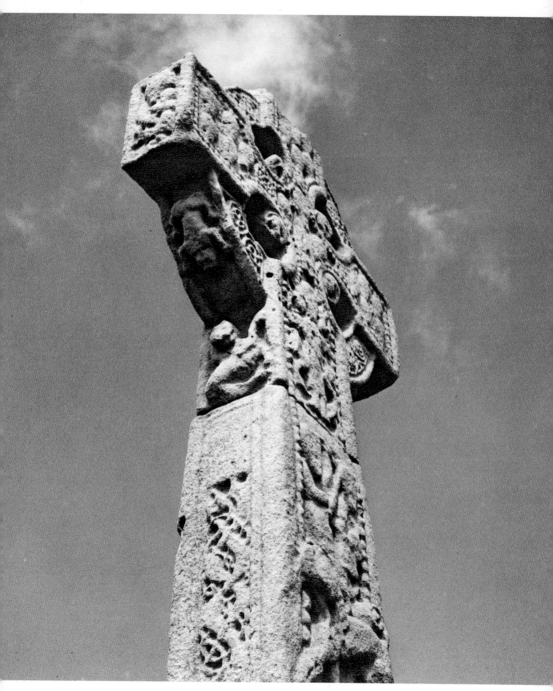

50

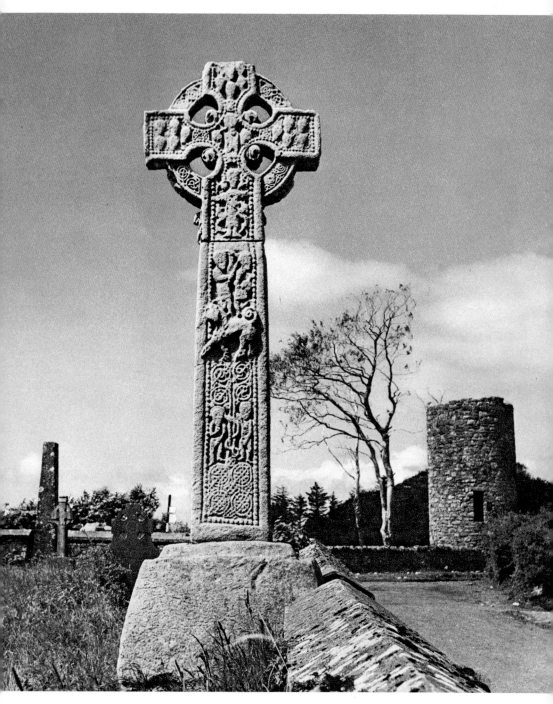

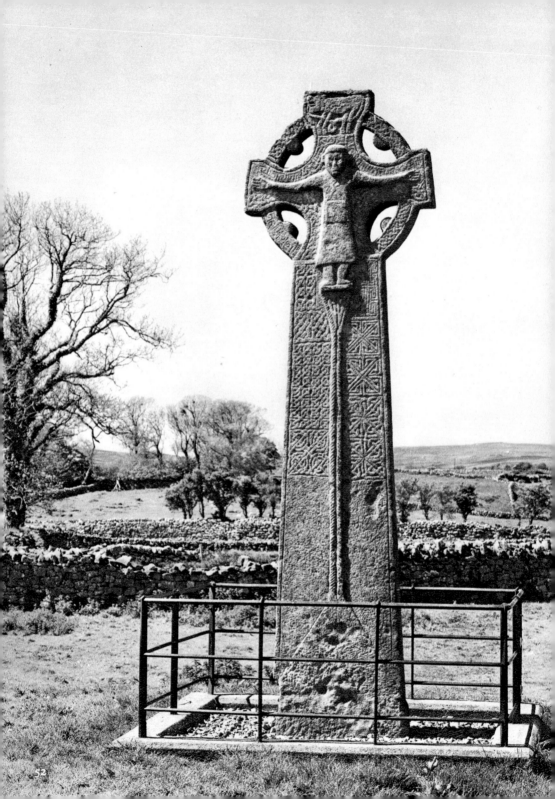

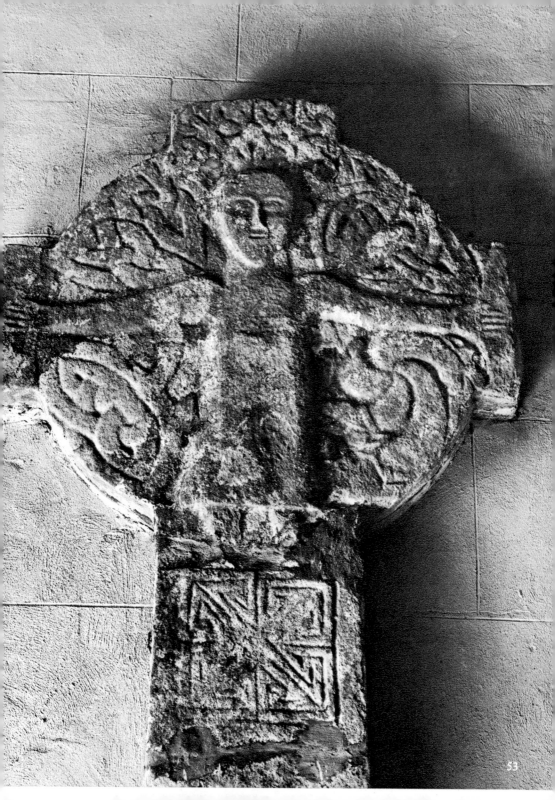

53

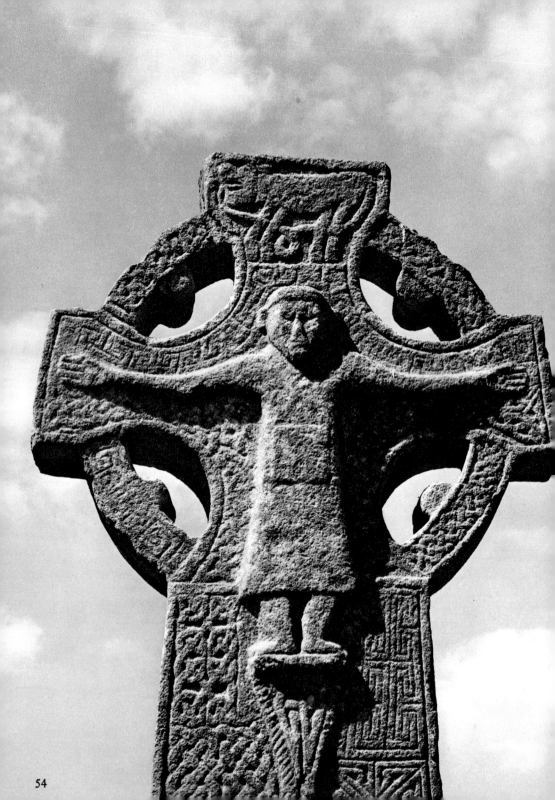

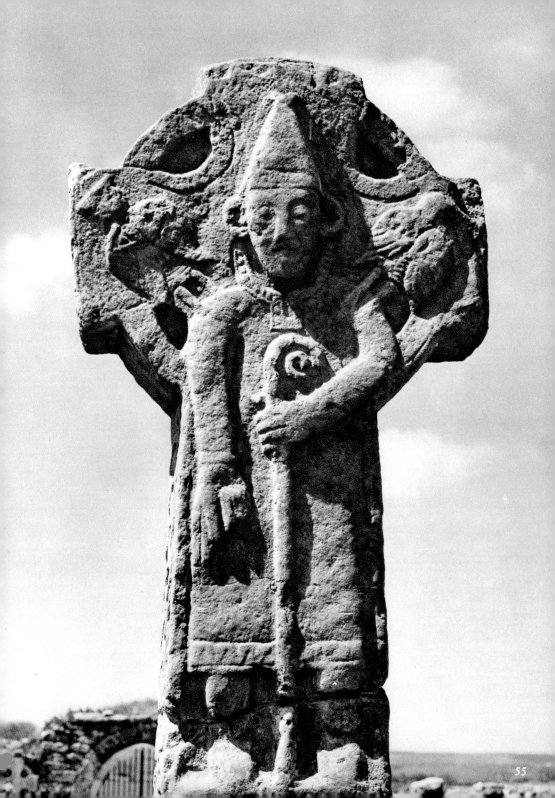

55

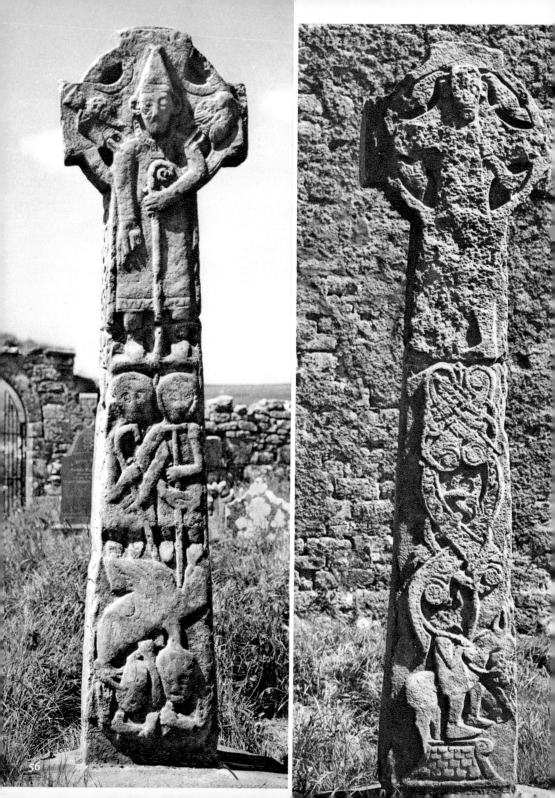

56

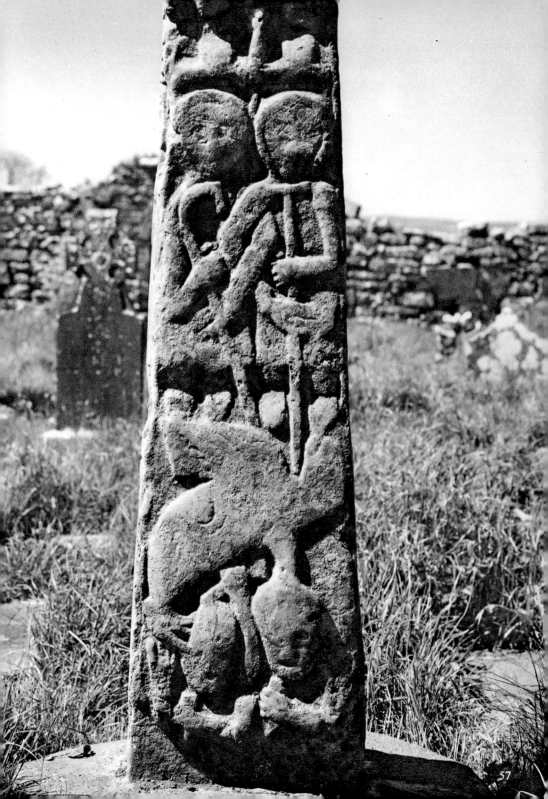

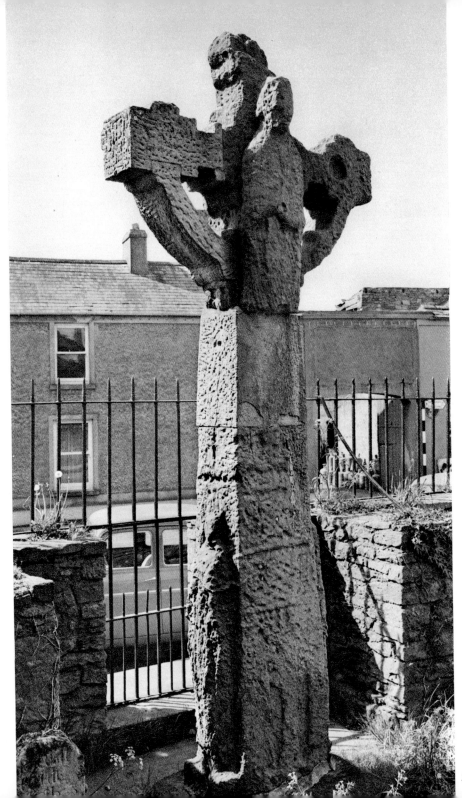

59

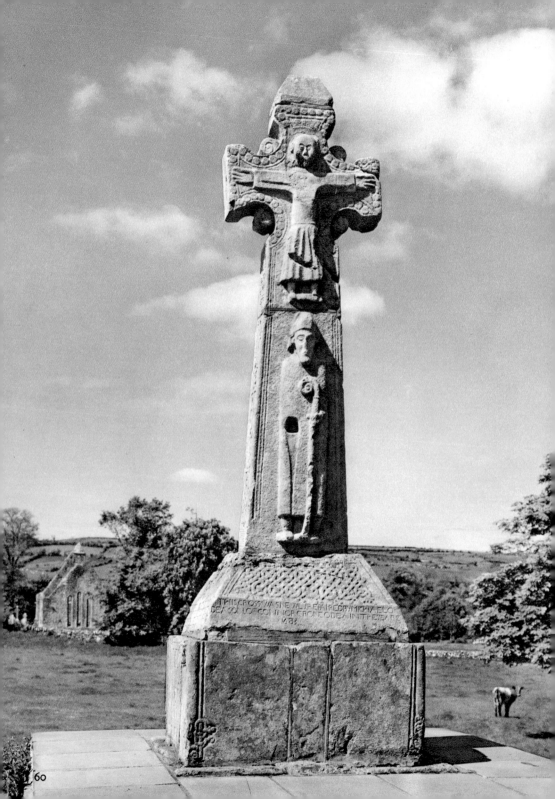

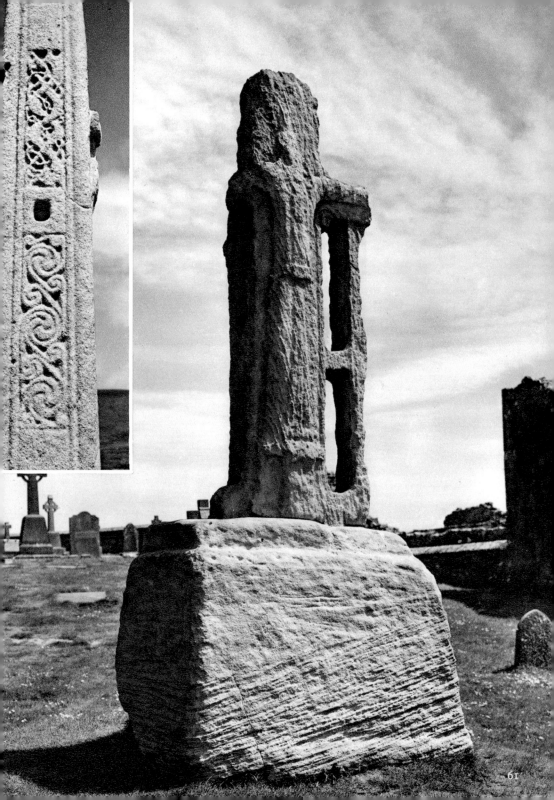

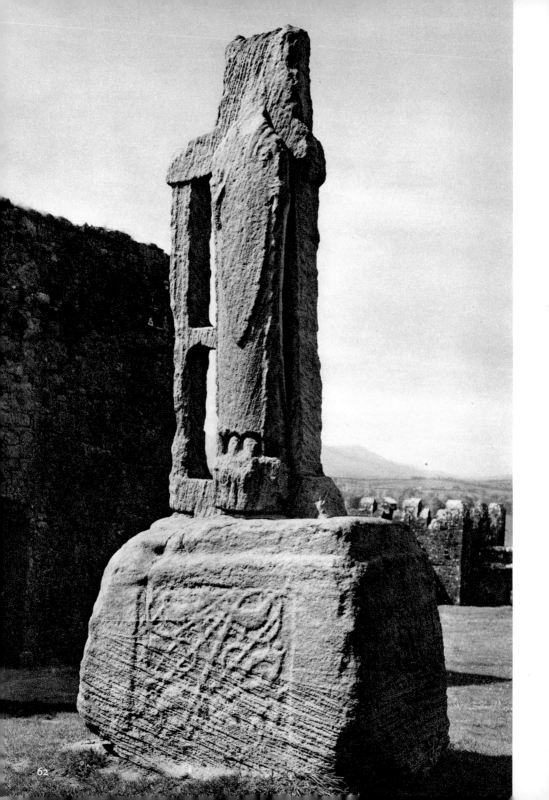

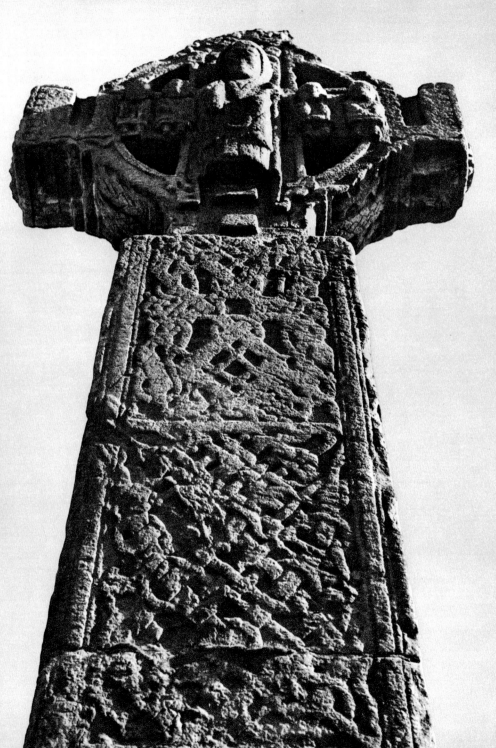

63

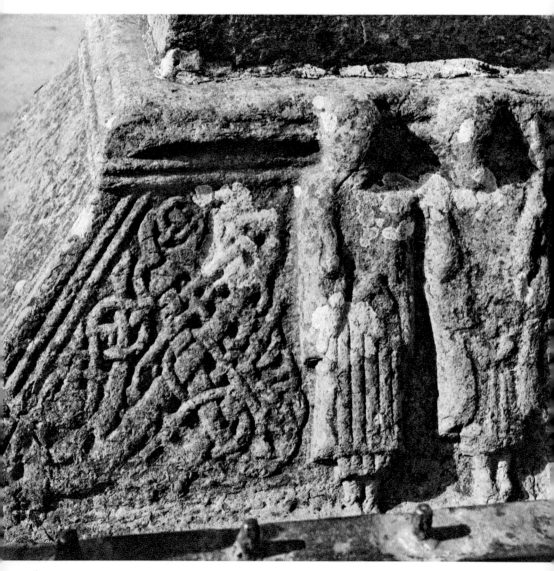

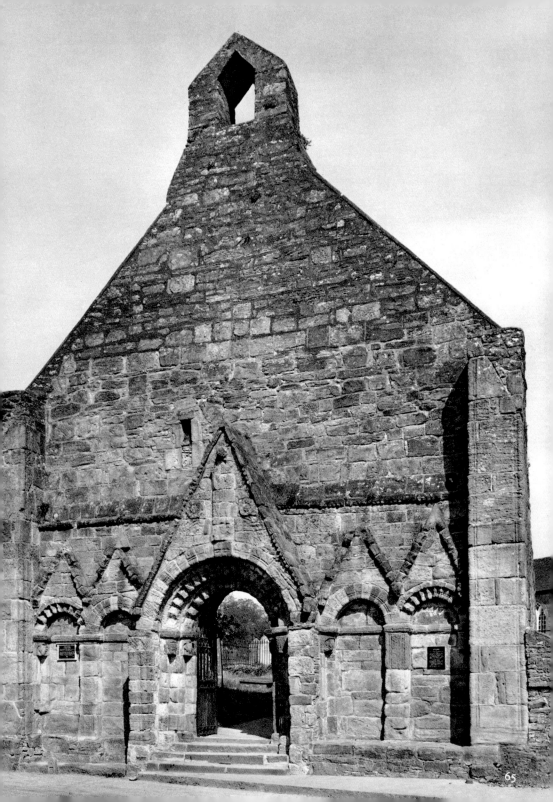

65

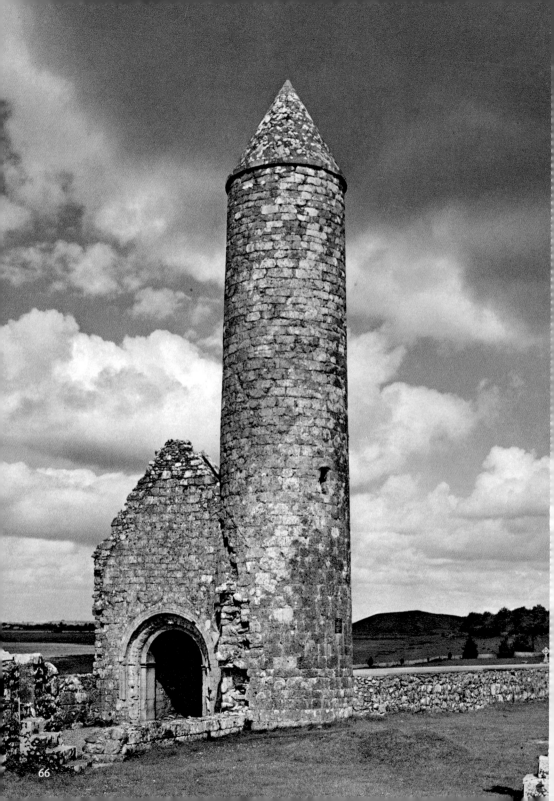

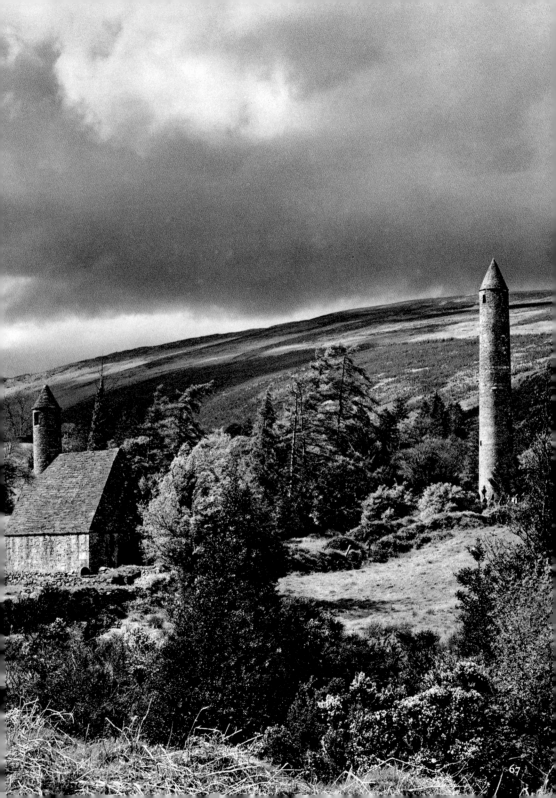

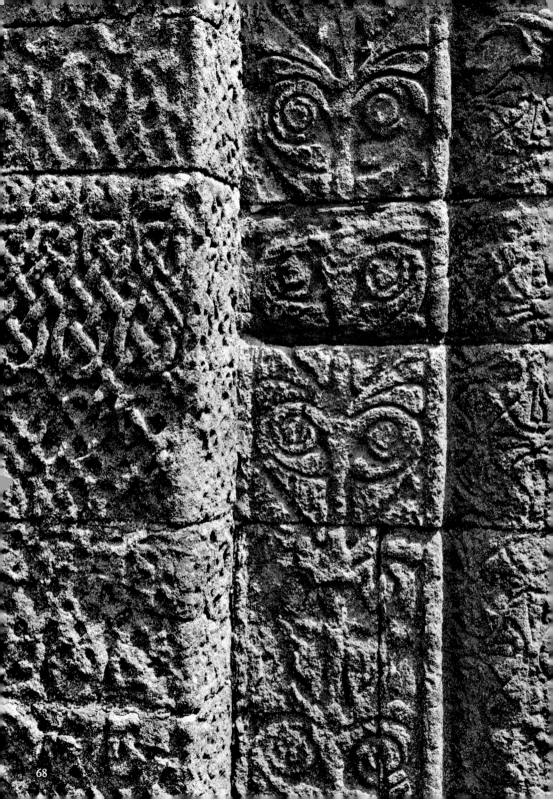

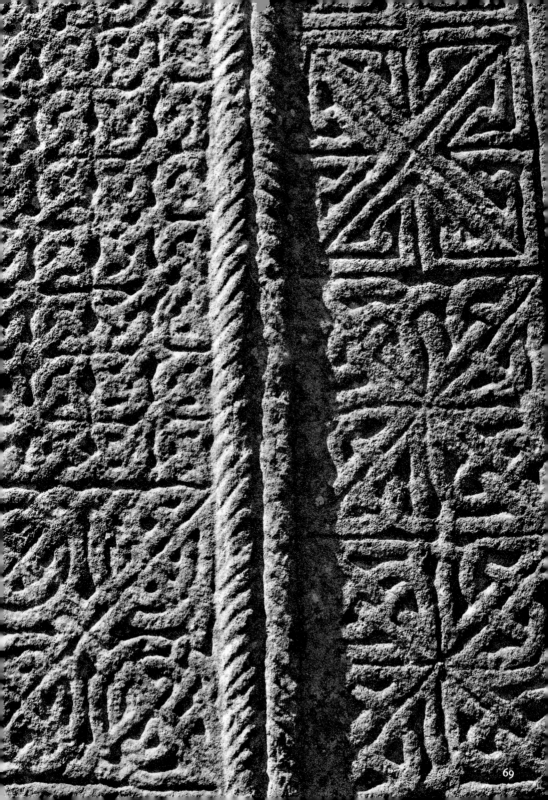

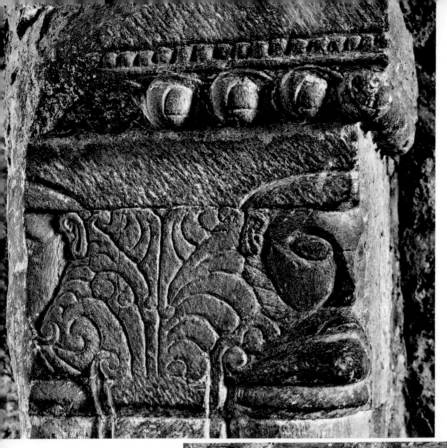

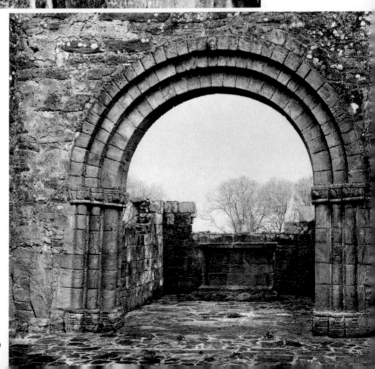

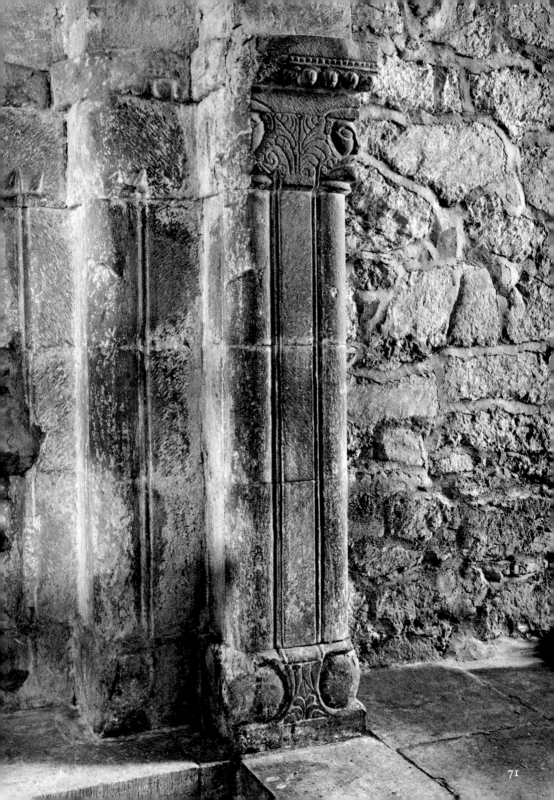

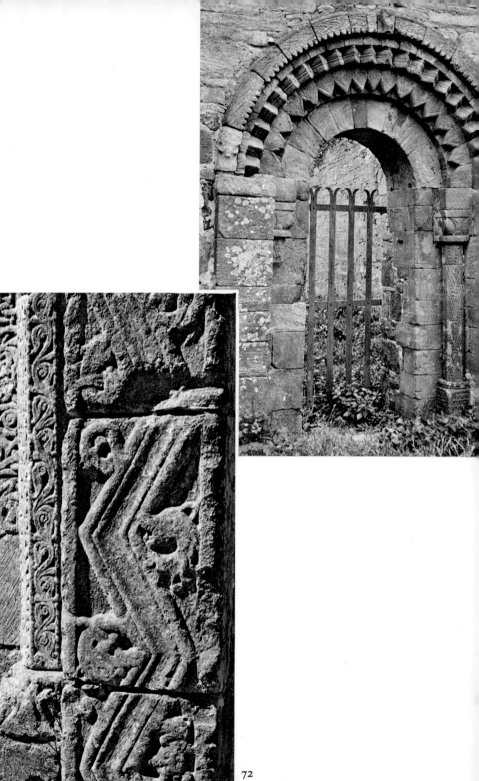

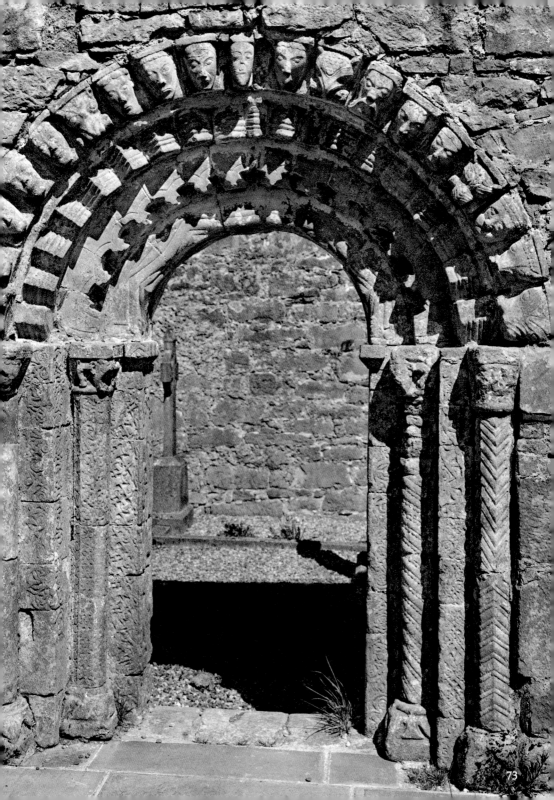

73

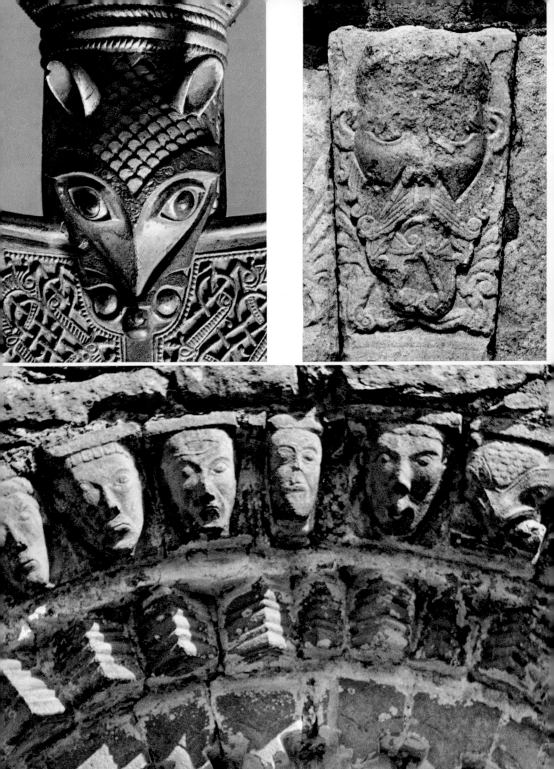

74

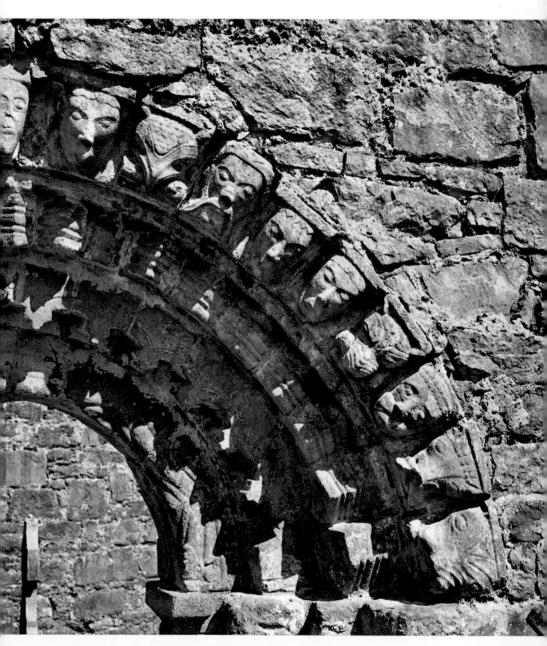

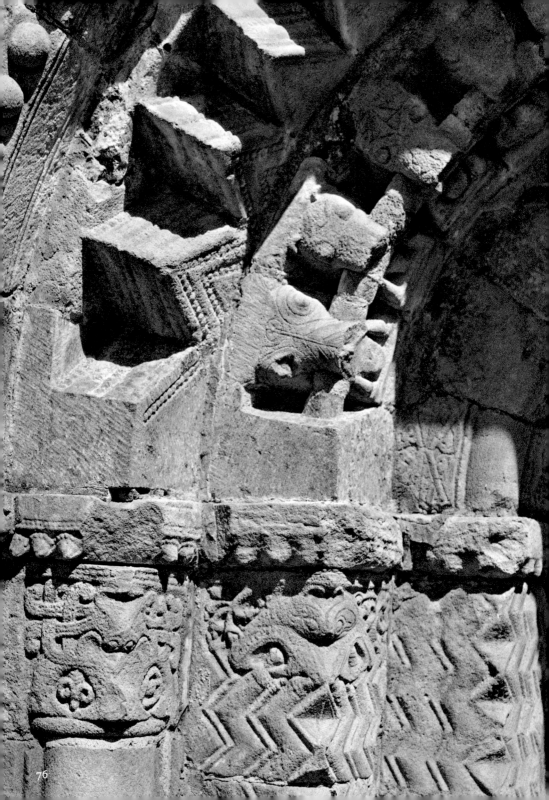

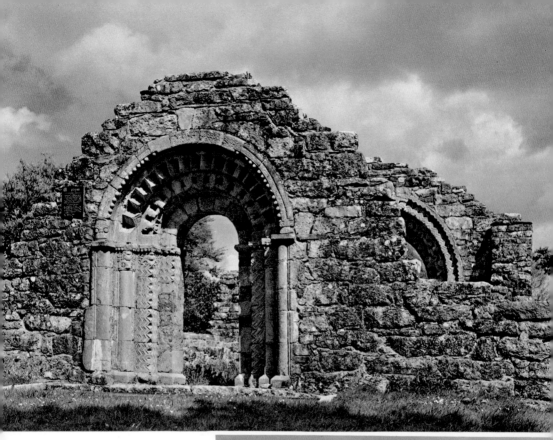

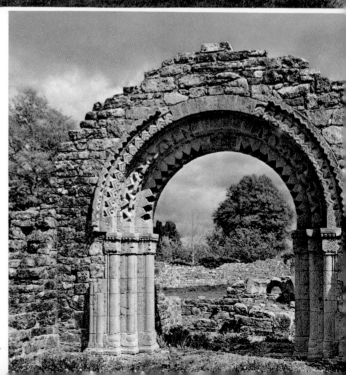

77

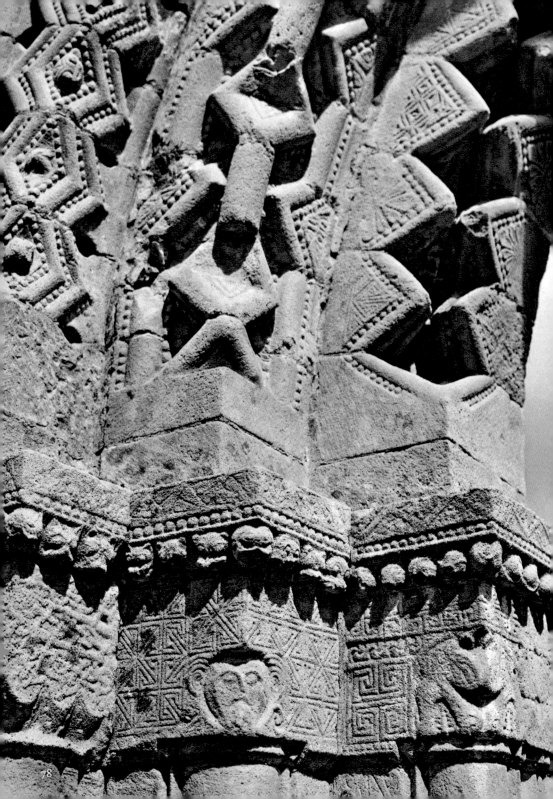

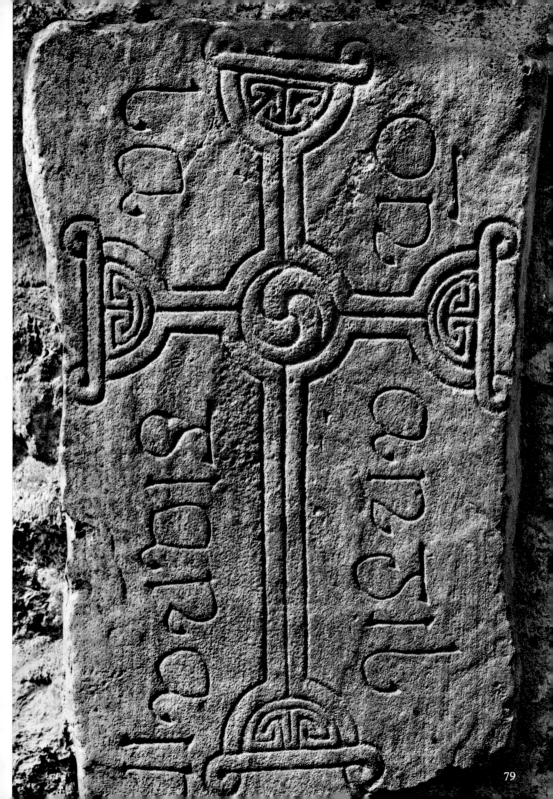

79

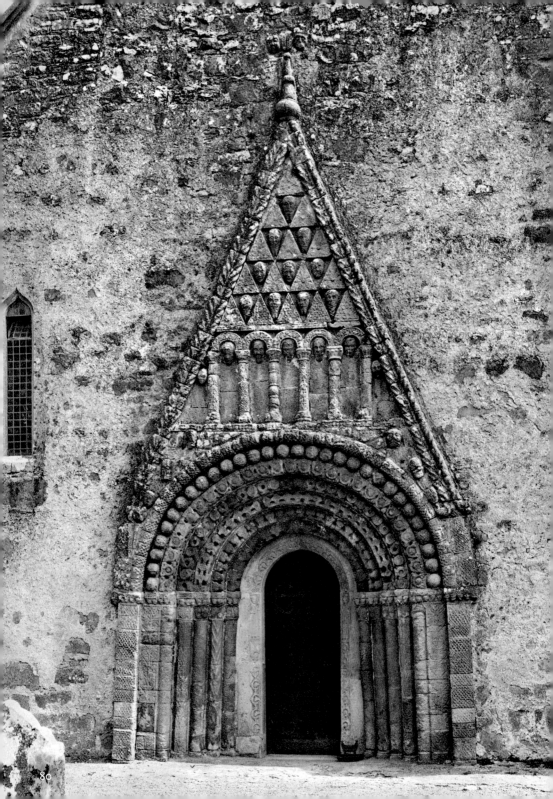

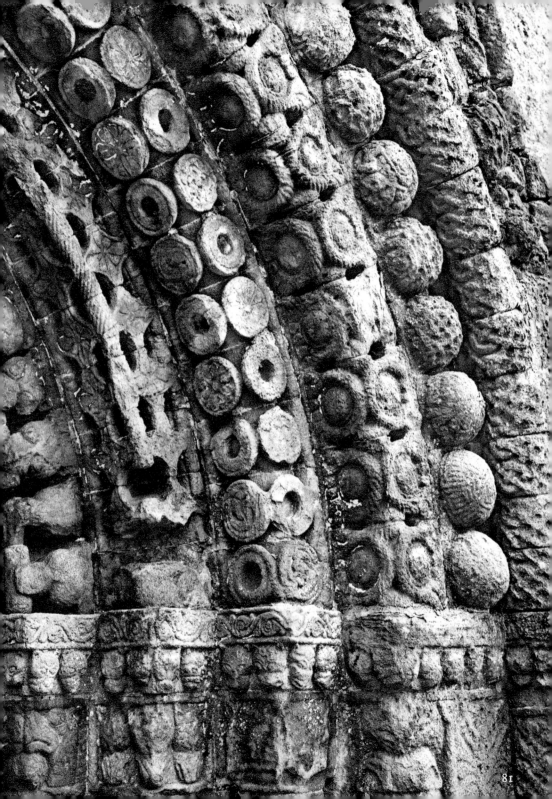

81

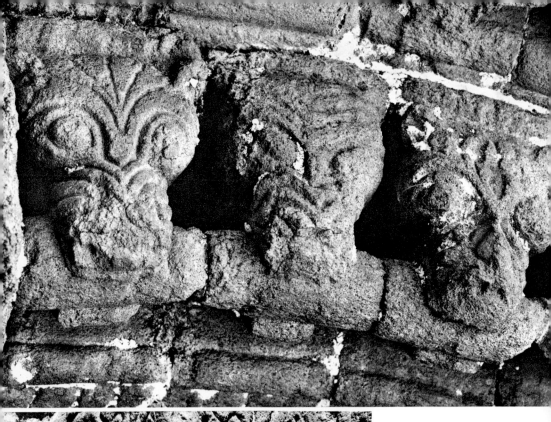

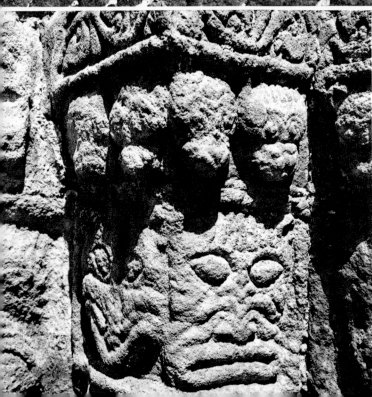

82

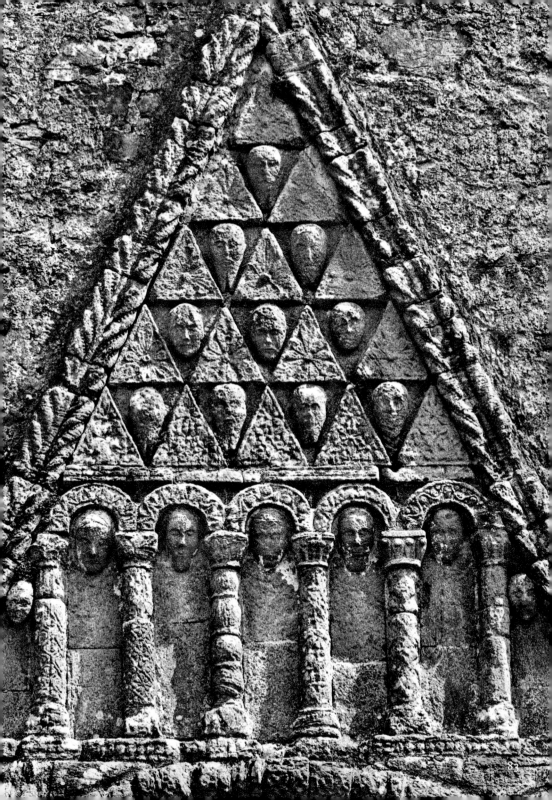

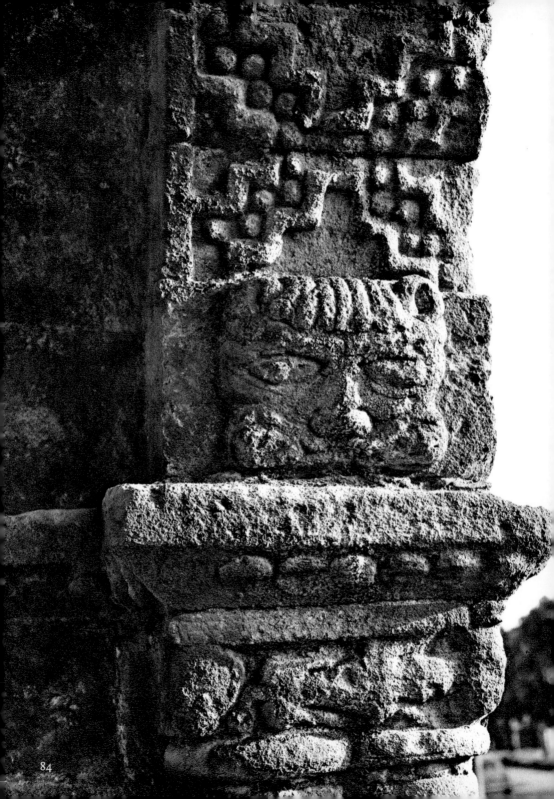

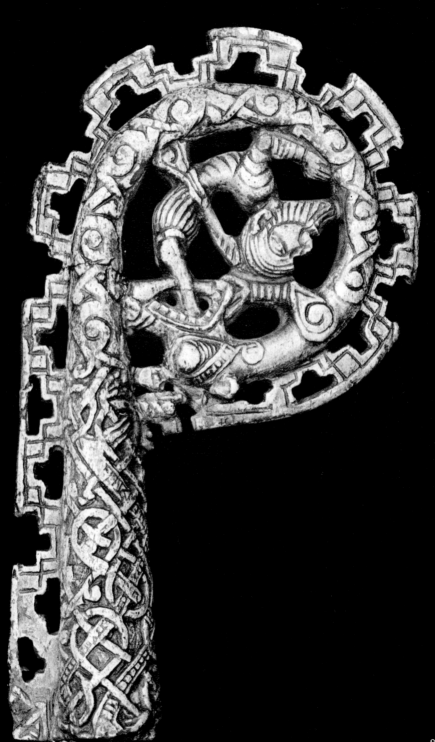

85

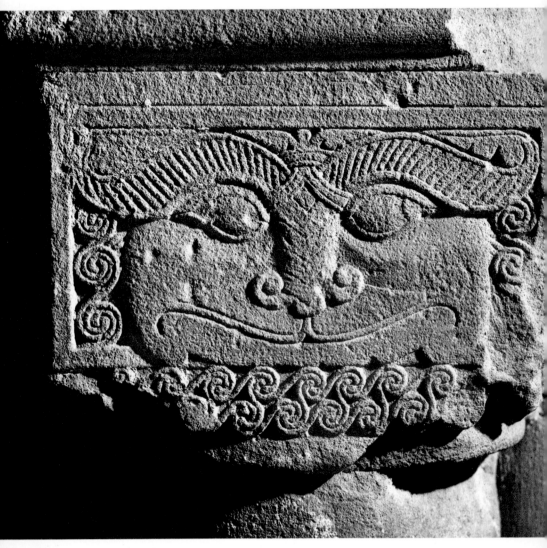

86

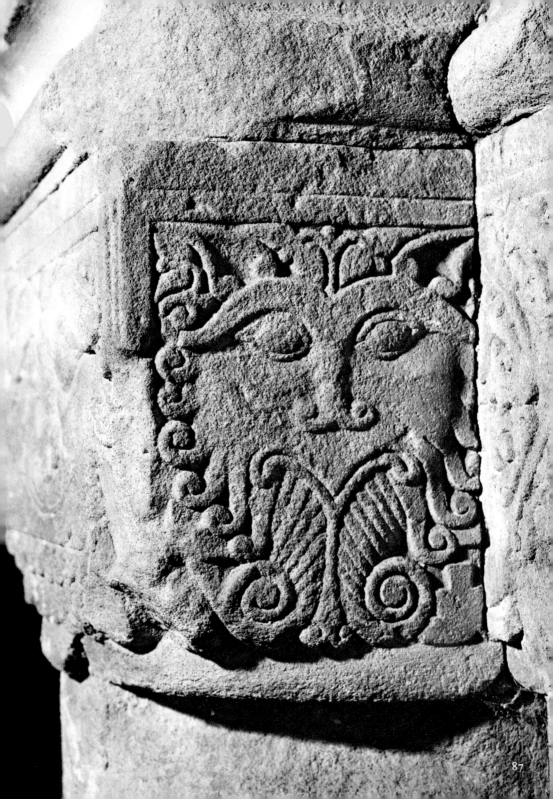

87

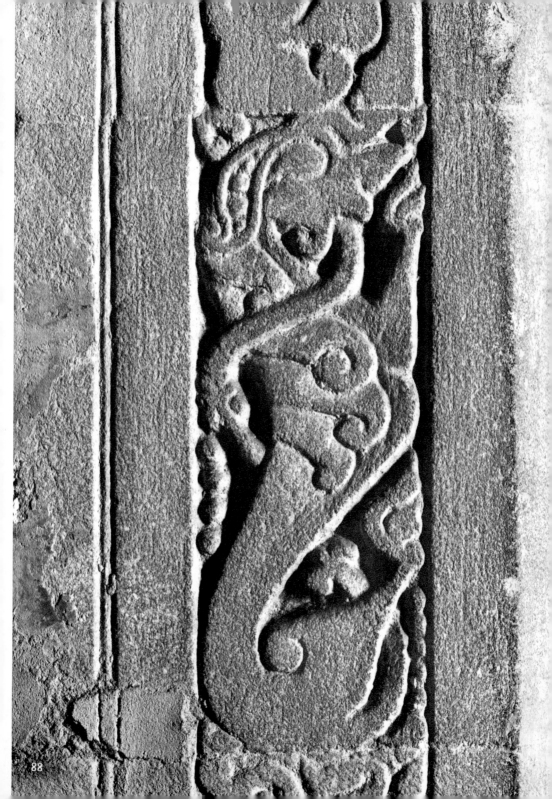

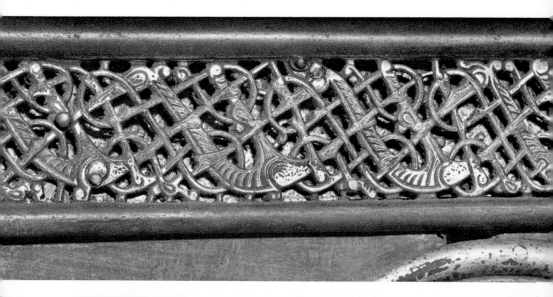

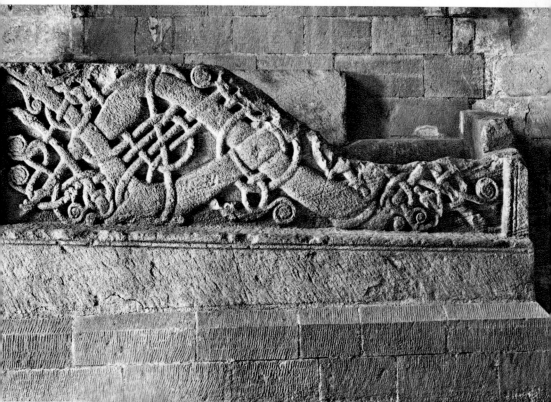

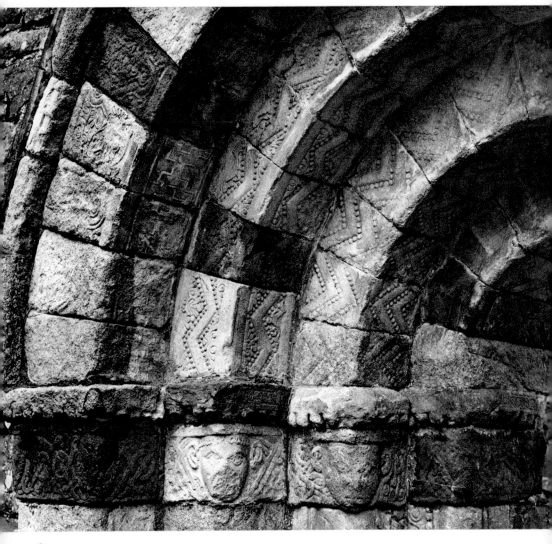

90

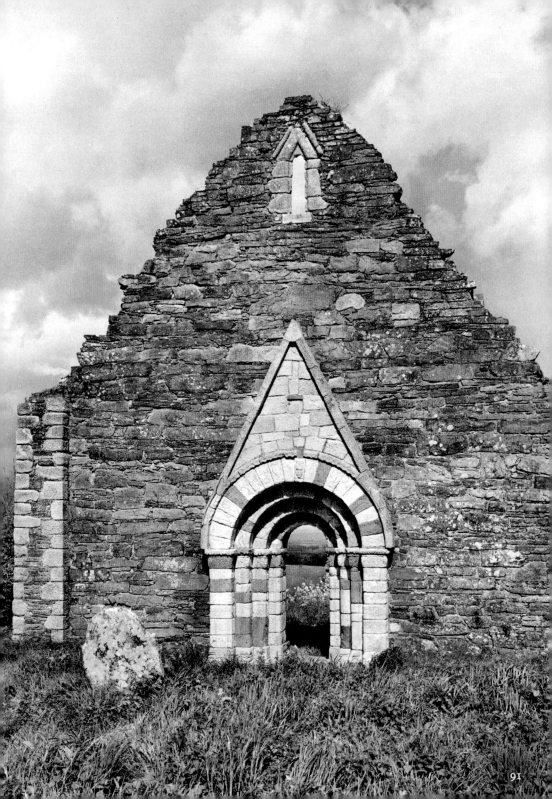

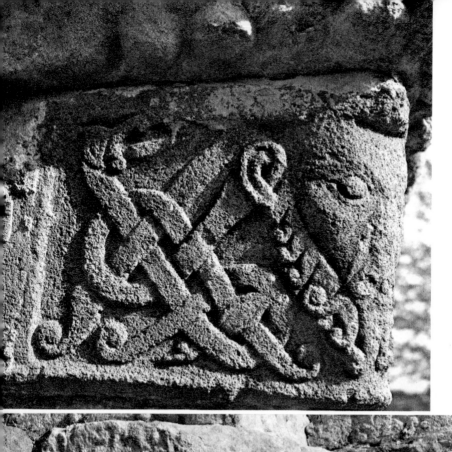

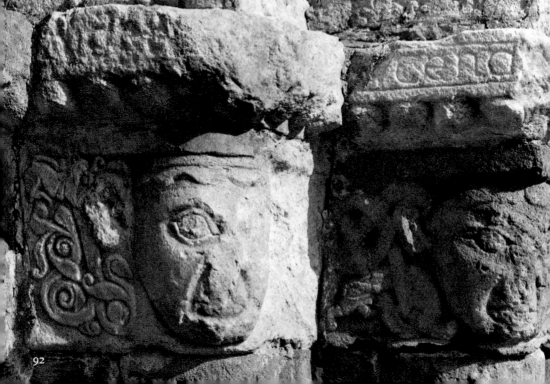

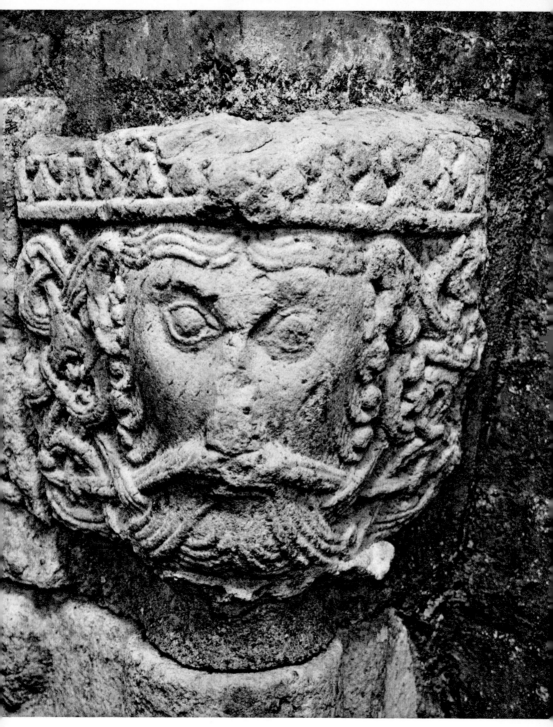

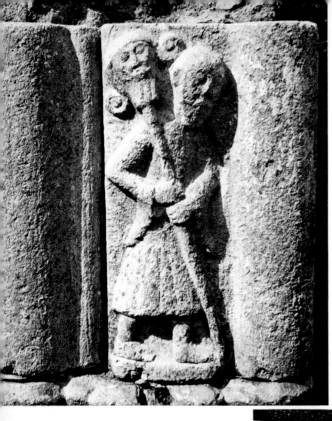

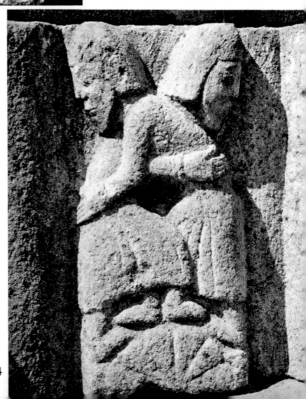

94

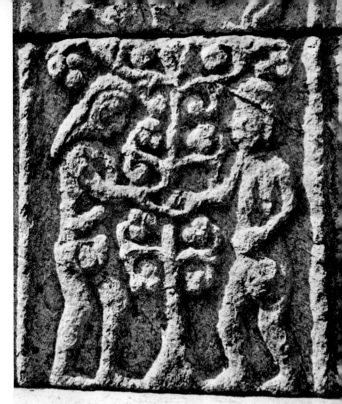

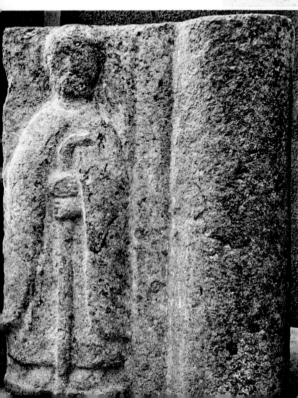

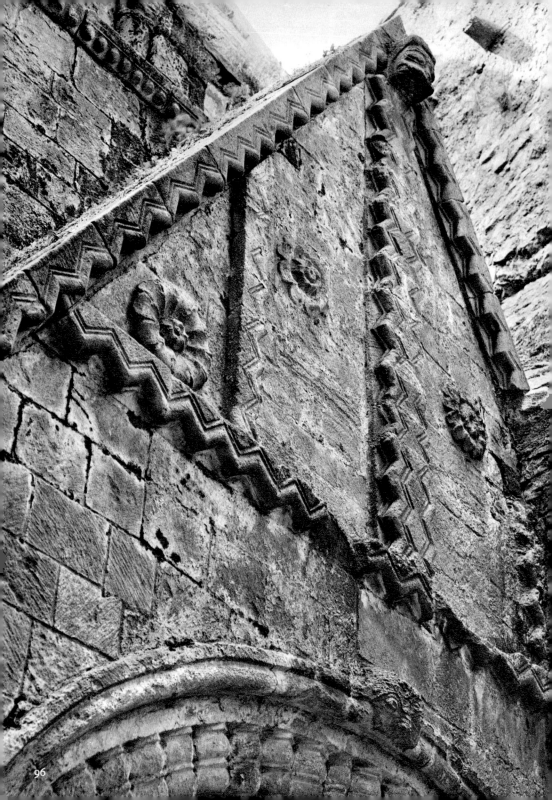

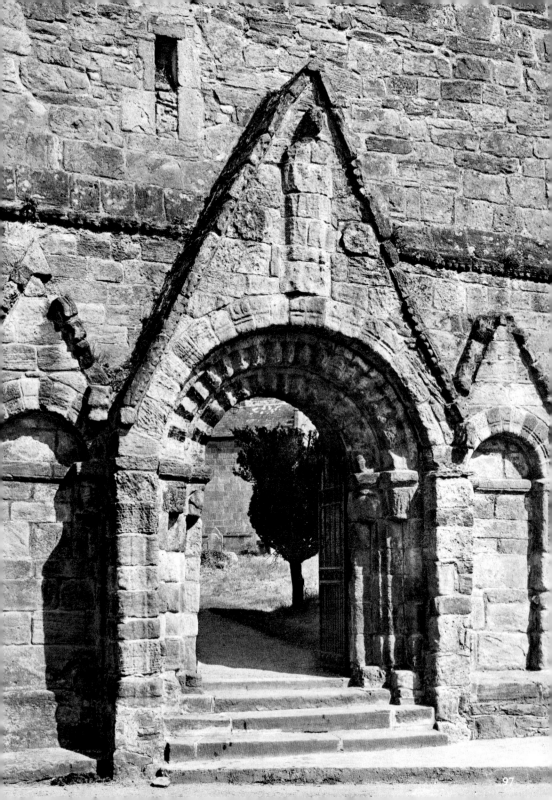

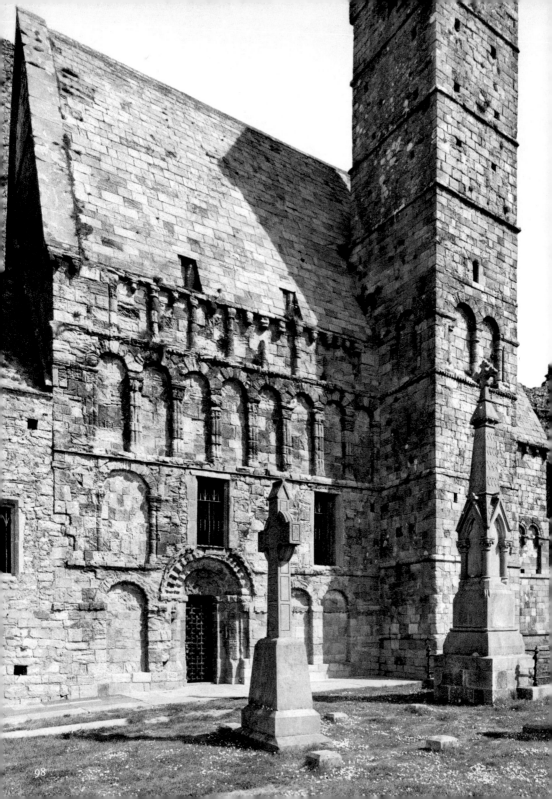

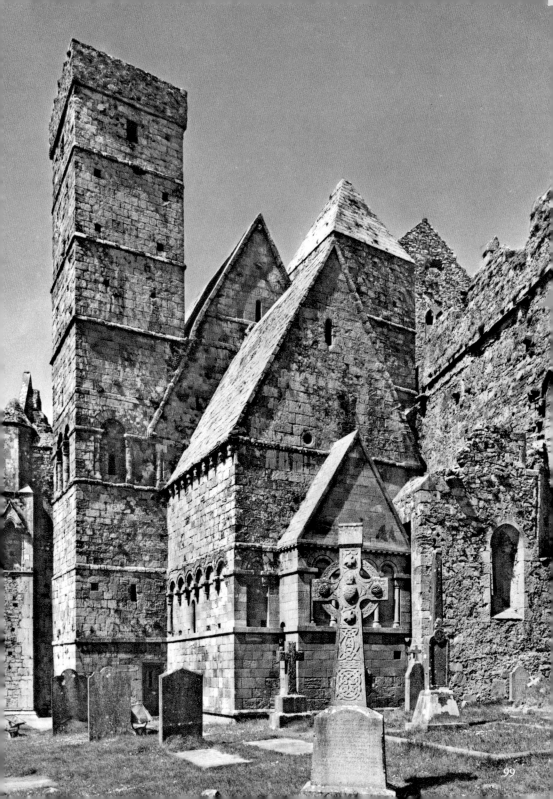

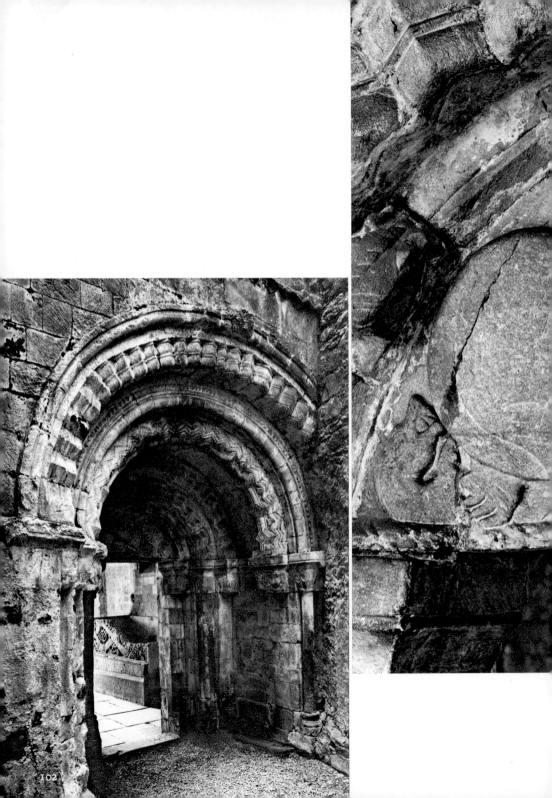

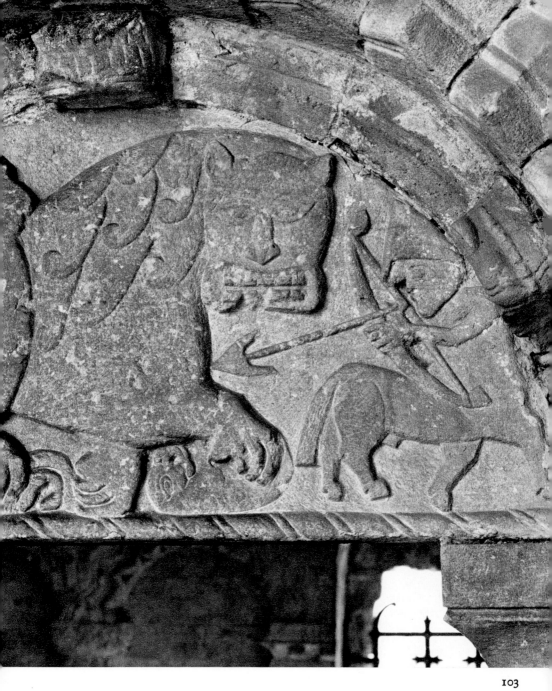

103

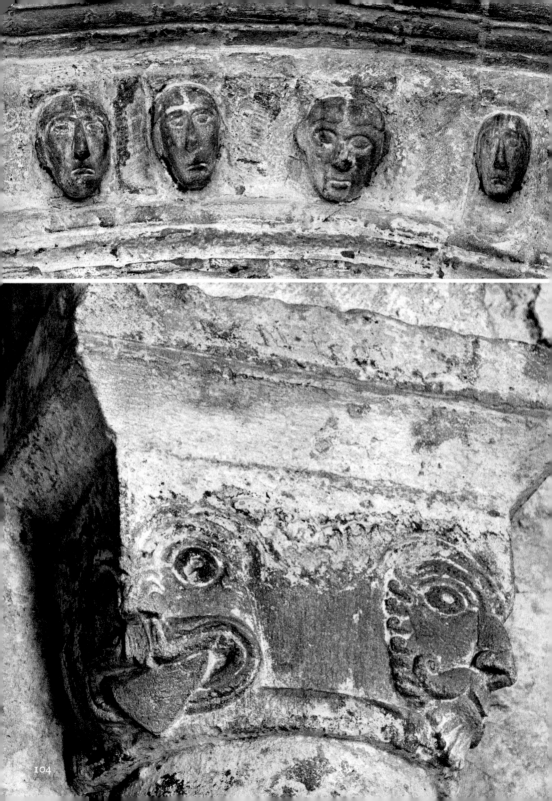

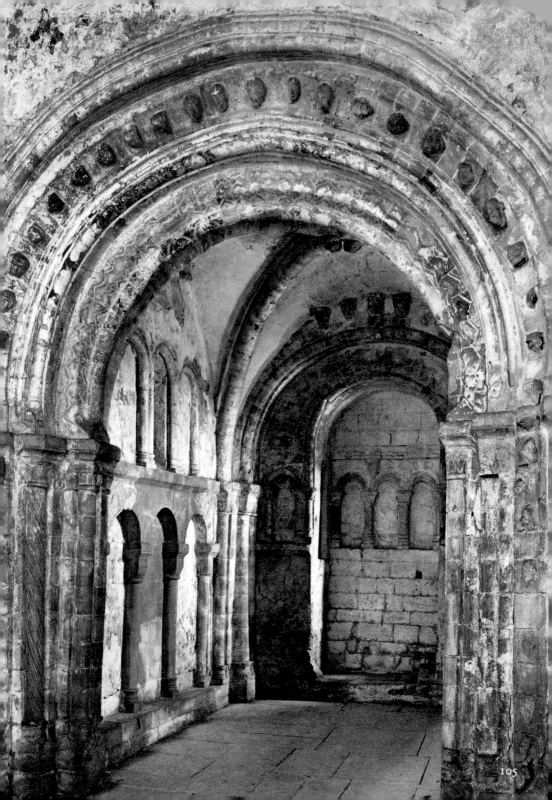

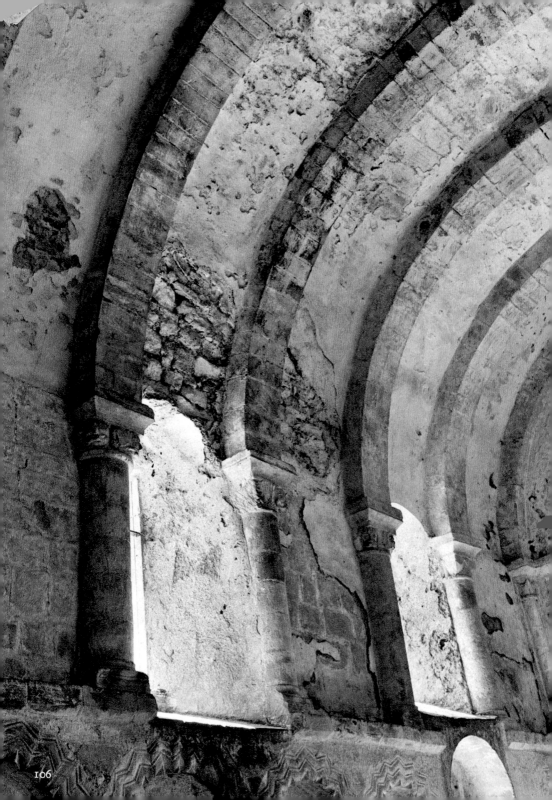

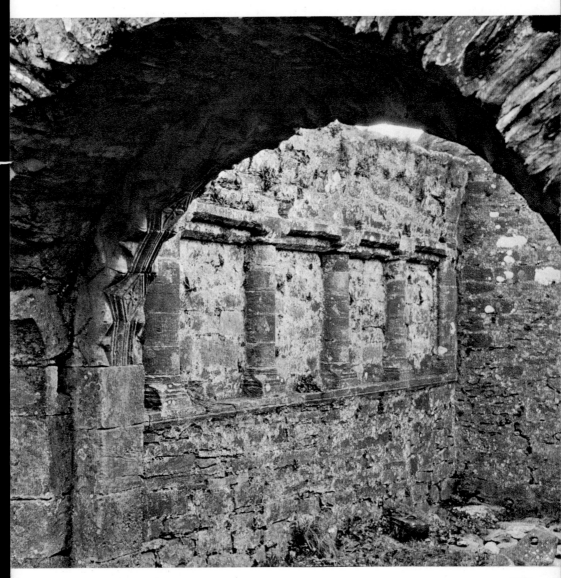

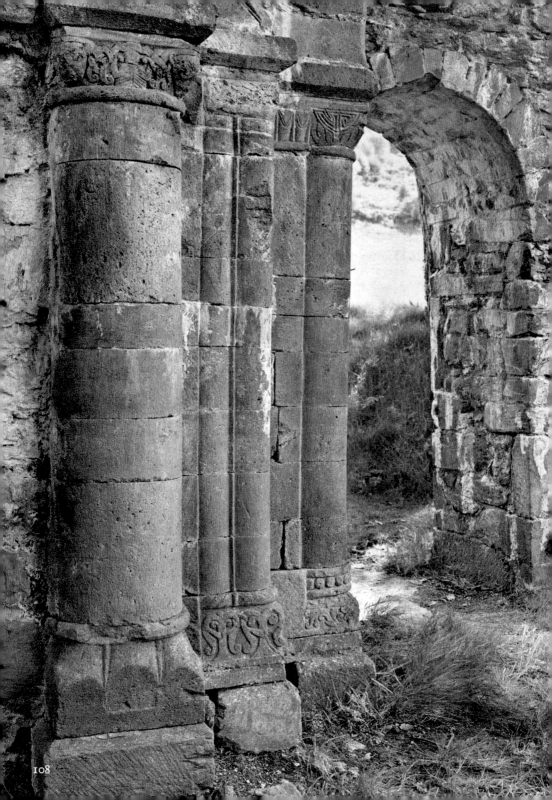

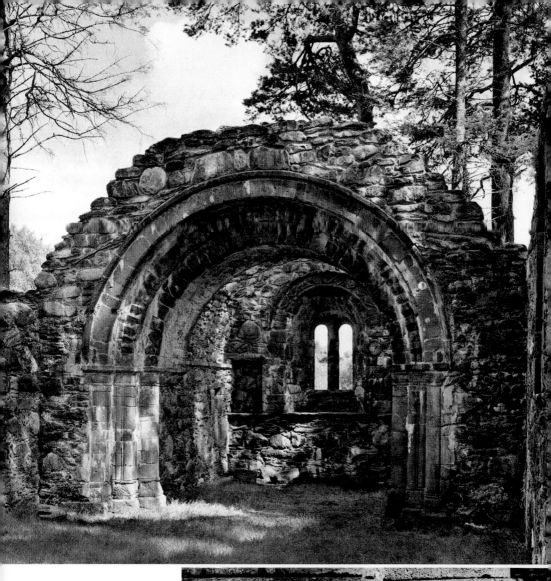

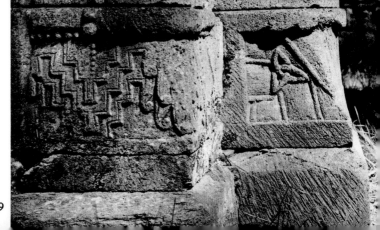

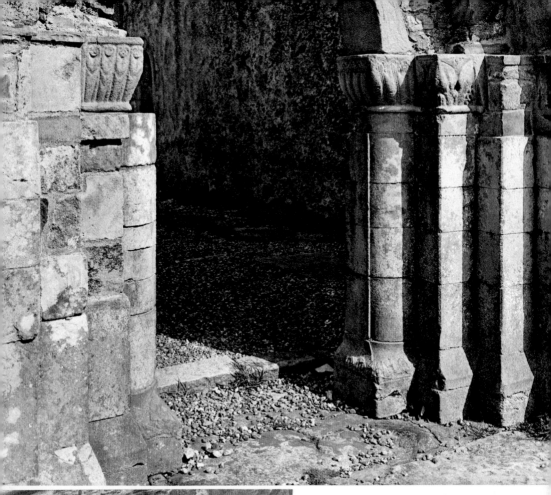

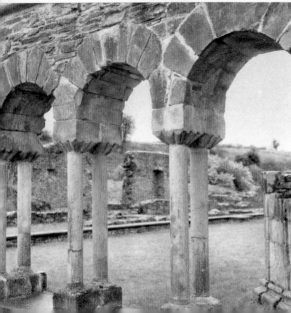

110

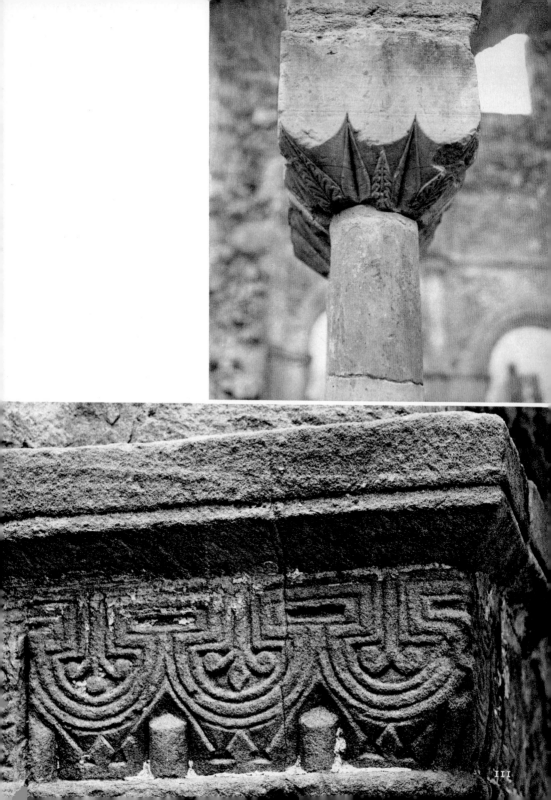

III

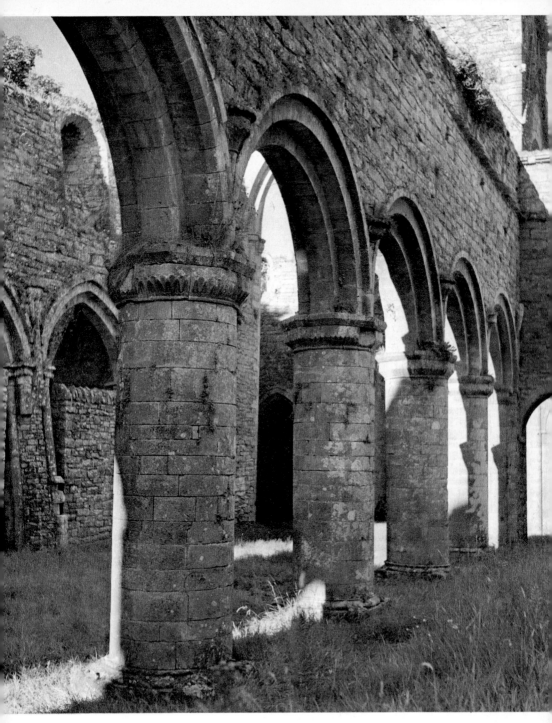

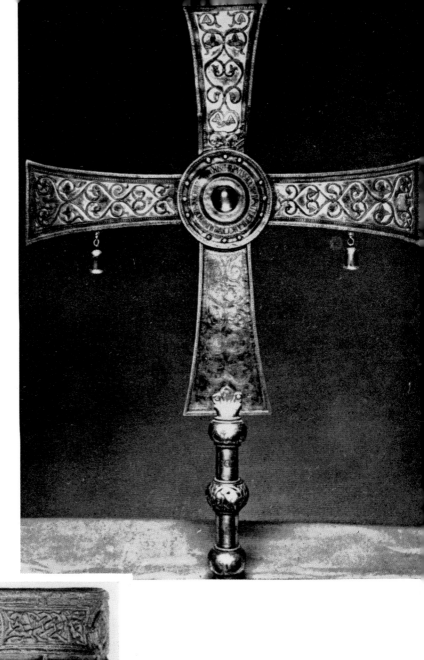

I

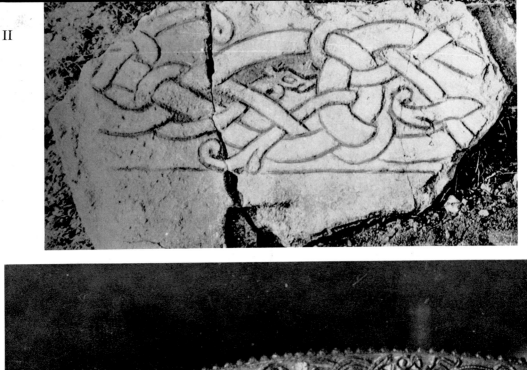

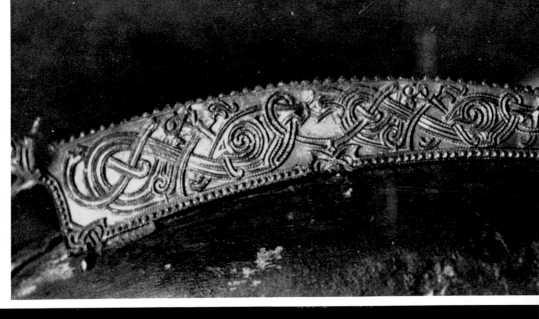

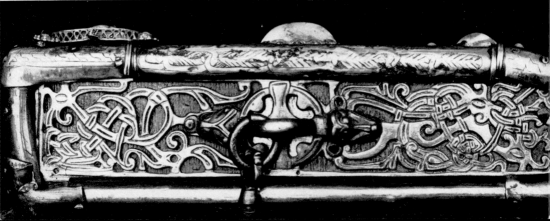

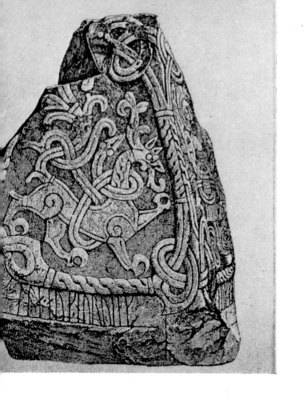

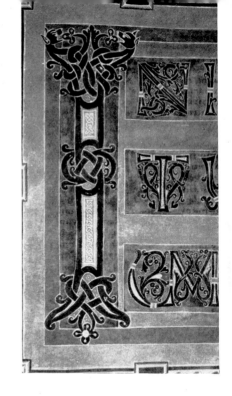

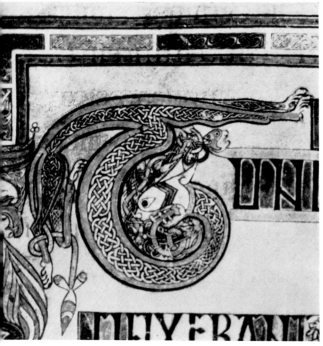

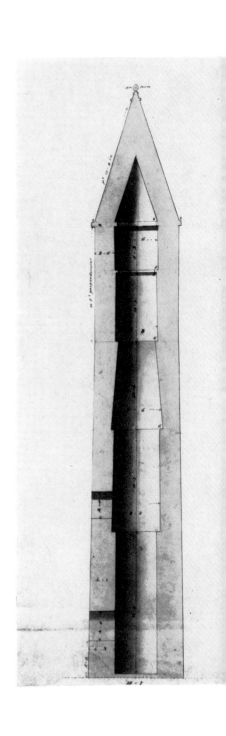

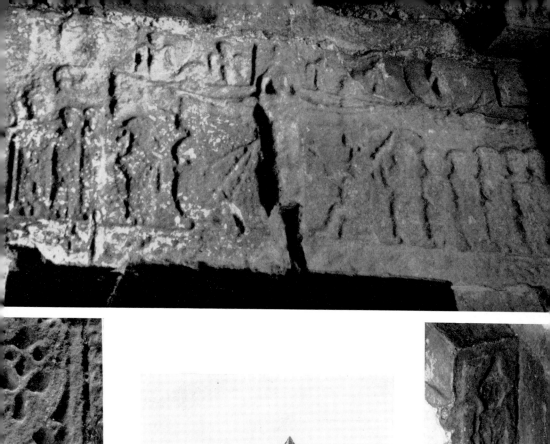

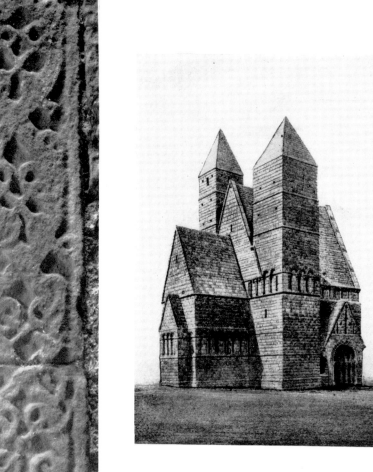

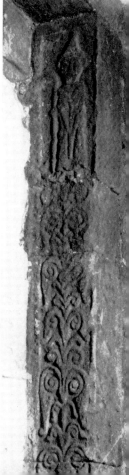

V

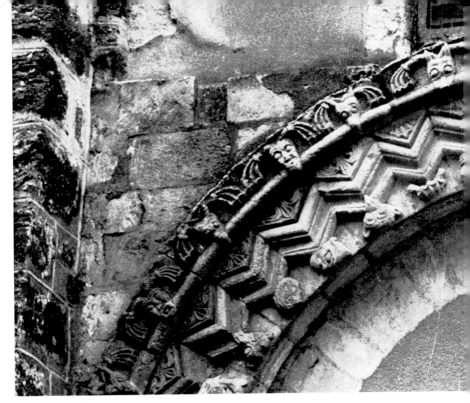

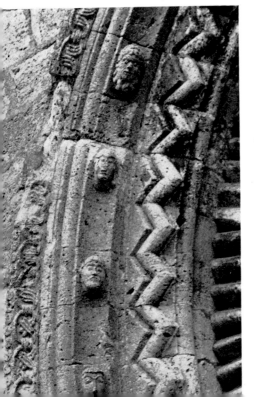

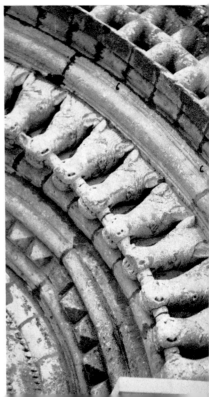

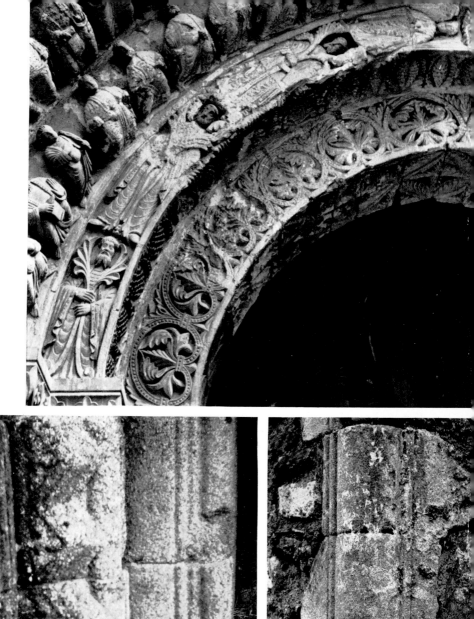

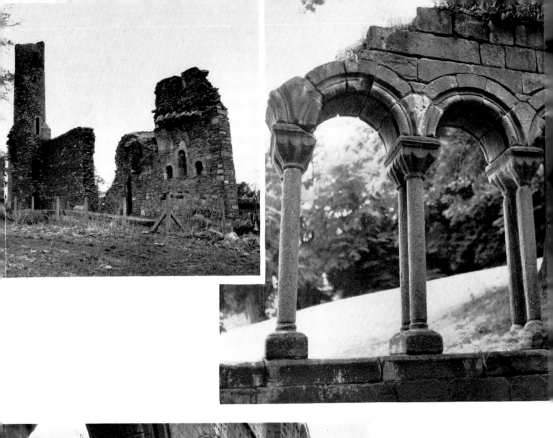

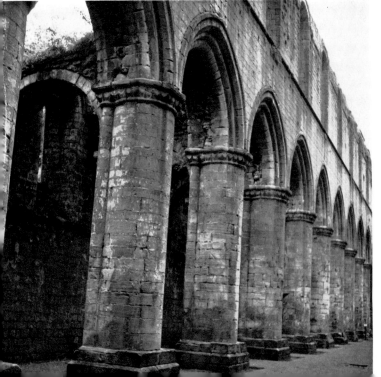